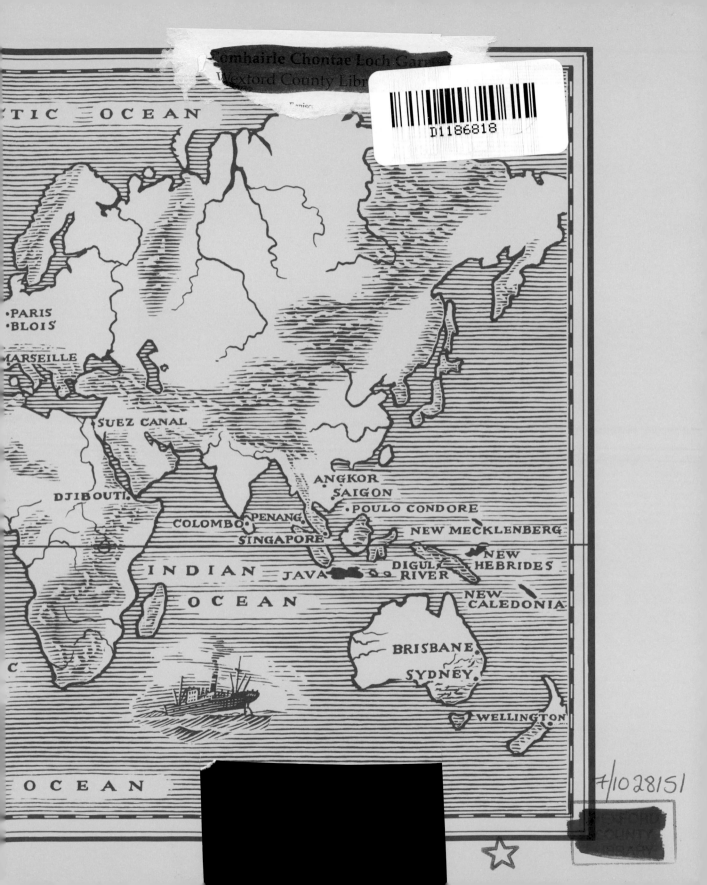

RCTIC OCEAN

•PARIS
•BLOIS

MARSEILLE

SUEZ CANAL

DJIBOUTI

COLOMBO PENANG
SINGAPORE

ANGKOR
SAIGON
•POULO CONDORE

NEW MECKLENBERG

NEW
HEBRIDES

INDIAN JAVA DIGUL
RIVER

OCEAN NEW
CALEDONIA

BRISBANE
SYDNEY•

WELLINGTON

OCEAN

Ghost Ships

A Surrealist Love Triangle

Ghost Ships

A Surrealist Love Triangle

ROBERT McNAB

Yale University Press New Haven and London

For
Caroline Villers

¡Este placer de alejarse!
Londres, Madrid, Ponferrada,
tan lindos. . . para marcharse.

Antonio Machado, *El tren*

For information about this and other Yale University Press publications,
please contact:

U.S. Office: sales.press@yale.edu yalebooks.com
Europe Office: sales@yaleup.co.uk www.yaleup.co.uk

Printed in China

ISBN 0300-10431-6

Library of Congress Control Number: 2004109279

A catalogue record for this book is available from the Library of Congress
and the British Library

10 9 8 7 6 5 4 3 2 1

Contents

Acknowledgements

A documentary film-maker by trade, I was attracted to this story out of curiosity, for fun, and with a view to making a film about it. The research piled up until there was far more than any documentary could take. Something had to be done. It was Christopher Green who did it. He examined the evidence, and from his office at the Courtauld Institute of Art he directed it to John Nicoll at Yale University Press. This book would not exist without them. Chris tested my wonky text and helped make it roadworthy. John took the risk.

I must also thank others, living and dead, who helped me on my way. The journey began in the London Library, a favoured departure lounge for armchair travellers. A regular port of call was also the National Art Library at the Victoria and Albert Museum, as was the Library of the Courtauld Institute of Art. On the look out for traces of vanished tramp steamers one soon drops anchor at the National Maritime Museum, in particular at the old Brass Foundry, tucked away by the River Thames at Woolwich. The memory of long lost vessels is preserved in that haunting place. Richard Cobb, who knew a thing or two about the Paris of Max Ernst and Paul Eluard, kept me going whenever those two threatened to give me the slip. "It has been an almost obsessive urge with me," he wrote "to get my foot in the door, to get behind the facade, to get inside. That, after all, is what being, or becoming a historian is most about—this desire to read other peoples' letters, to breach privacy, to penetrate into the inner room."[1] In one such inner chamber are traces of the love triangle at the heart of this study. Its window overlooks a cloister of the Musée de Saint-Denis and some of Paul Eluard's papers now live there. I am grateful to Sylvie Gonzales, their keeper, for letting me in. Pierre Baptiste shared his knowledge of Khmer art at the Musée Guimet, Paris. Rosemary Crill showed me the Rajput printing blocks at the Victoria and Albert Museum. Christopher Fagg edited the text and Beatrix McIntyre designed the book. The Dutch concentration camps of New Guinea were traced with help from Victor Schmidt at Groningen University. Werner Spies, who knew Max Ernst and is the leading scholar of his work, has written the Preface, which is a privilege.

This book was shaped by the example of others and by friendship:

Lutz Becker was the first to sit through it all with me;

Jake Auerbach was always ready for the next instalment;

Pippa Rubinstein led me into publishing and showed me the ropes;

Richard Kendall set the pace;

Tino Tedali took lots of photos. *Ci vede bene?*

Anthony Storr died before I could tell him how grateful I was;

Bill Sanderson's poetic maps and illustrations tell the whole story and David Perry, as ever, brought clarity.

Hannah Rothschild consistently favoured art history that is a good read.

I have also worked with both Kenneth Clark and Robert Hughes on numerous documentary films about art. Their work shares an enviable benchmark: simple language for complex pictures. Easier said than done.

Thank you.

London–Paris–Saint-Martin-d'Ardèche–Marseille–Sedona

Author's Note

Let's begin with a warning signal taken from the Author's Note to a novel, *The Singapore Grip*, by J G Farrell:

> Odd though it may seem to attach a bibliography to a work of fiction, this novel depends very heavily on primary research conducted by others, as well as on opinions and personal experiences recorded by those who travelled, worked or fought in the Far East before or during the last War. Nevertheless the Singapore of these pages does not pretend to be anything but fictional: although many of its bricks are real, its architecture is entirely fantastic.

Forced to imagine Max Ernst's journey to Saigon via Singapore, I was able to draw on my own memories of the liners I travelled on via Suez as a child. But I also had to depend very heavily on primary research conducted by other travellers; and when the bricks I gathered leaned towards each other but wouldn't quite meet, my mortar *tried* to be factual. The Saigon of these pages therefore aspires to the condition of fact, but doesn't make it because the city Ernst explored no longer exists and survives only as a capital of the imagination. The art history that accompanies it, however, is a different matter as it's raised on firmer ground and is built with concrete evidence provided by Ernst's pictures and Eluard's books.

Preface

by Werner Spies

Paysage à mon goût

This book literally takes us into new territory. Its protagonists, Max Ernst, Paul Eluard and Gala, whose lives were so exhilaratingly entangled at the time, said next to nothing about their journey to Indochina in 1924. They were driven by *l'Amour fou* (Mad Love), by a horror of religious dogma and by a sense of alienation. Robert McNab's discoveries take us far beyond the personal side of the story. The voyage was coloured by an urge to drop everything and begin again, an urge also described in *Lâchez tout* by Breton and subscribed to by his friends as well. Journeys of the imagination and those in the real world itself encouraged the Surrealists in their quest for the heightened awareness often produced by chance encounters. Their aim was to escape from the jaded and mundane routine of daily life. Ahead of them in this had gone Gauguin, Loti, Rimbaud, Segalen, Cendrars and Malraux, likewise fleeing the established security of Eurocentric ways. The Surrealists were drawn by anthropology not by the picturesque. The journey to Indochina therefore did not emerge only from an autobiography enacted by three protagonists. The Surrealists were committed to breaking out of the Eurocentric boundaries they saw as restrictive and dangerous. We can see this in the famous world map they published in the journal *Variétés*. Captioned "Le Monde au temps des surréalistes" (The World at the Time of the Surrealists), it shows a world dominated by Surrealism and redrawn in its image. Areas of special interest stand out, in particular Asia, a region of untapped energy that could destabilise the status quo. Also apparent is a taste for the "barbaric", one they often associated with Asia and evident in the group's declarations, especially in those inspired by Artaud and issued in collaboration with such journals as *Clarté*, *Philosophies* and *Correspondance*. One such reads: "We must be Barbarians because we are repelled by civilisation of a particular kind . . . We are attracted to Asia because we reject the Law, because we believe in a new underground counter culture that will disrupt History and break the ludicrous grip of Fact . . . The utterly predictable routines, actions and lies of Europe have finally exposed its repellent cyclical pattern."

Ghost Ships also sheds light on the nature of identity, on role reversal and on the creation of personal mythologies. The voyages on the *SS Antinous* or the *SS Paul Lecat*,

the visits to temple cities and to the jungle were not, we now realise, in search of exotica but were a quest for self-knowledge. After their return to Paris, Max Ernst's pictures and Paul Eluard's writing were deeply affected by what they had seen. They were marked by the spectacle of colonial corruption, by the unforgiving nature of the tropics and by the tragic atmosphere of an Angkor Wat redolent of a "time before Time". Max Ernst's experiences in Southeast Asia made a particularly deep impression. His life, after all, had been and would always be dedicated to the quest for other worlds. We can now measure the impact of the voyage on him by the way it recurs in his work. His wonderful prose poem *Was ist ein Wald?* (What is a Forest?) for example recalls the tension and alienation of the journey. The text alternates between "delight" and "dejection": "The wonderful pleasure of breathing freely in the open, while at the same time feeling oppressed, imprisoned and encircled by hostile trees. Both within and without, free and in gaol." His encounter with historic ruins smothered in jungle was described by him as "The trees eat their way through the horizon", a phrase that encapsulates the jungle paintings that followed his return.

The discoveries contained in *Ghost Ships* not only add to our enjoyment of Ernst's celebrated pictures, they also confirm the intellectual clarity that underwrote the painting of his Forests, Suns, Seas and Ruined Cities.

Significantly, twenty years later, while in exile in America, Max Ernst included a pagoda in his great autobiographical painting *Vox Angelica*, placing it alongside the Eiffel Tower and the Empire State Building. Sidney Janis then observed, "Ernst's *Vox Angelica* portrays his Wanderlust." The painting evokes much more however: it is a kind of ship, a Noah's Ark loaded with the artist's memories, passions and fears. Max Ernst used the world he created to oppose chaos. The title of an early painting of his, *Paysage à mon goût* (Landscape after my own Heart.) reminds us of the way he turned his sense of alienation to redemptive ends. This book proves the voyage to Indochina was itself an act of redemption as well.

Prologue

BETWEEN THE TWO WORLDS

There are good biological reasons for accepting the fact that man is so constituted that he possesses an inner world of the imagination which is different from, though connected to, the world of external reality. It is the discrepancy between the two worlds which motivates creative imagination.

Anthony Storr, *The Act of Creation*

I believe the best to do is to have one eye closed and to look inside, and this is the inner eye. With the other eye, you have it fixed on reality what is going on around you in the world.

Max Ernst

For three years, between 1921 and 1924, the French poet Paul Eluard, his Russian wife Gala and the German painter Max Ernst were entangled in a love affair that began in Germany, continued in Paris and ended in Saigon. This three-way relationship took place against a background of unparalleled creative activity, as the Parisian art circle of Surrealists, of which Eluard and Ernst were leading figures, was developing the project which came to fruition in the Surrealist Manifesto of October 1924. Such were the internal pressures generated by the affair that, one night in March 1924, Eluard got up from a restaurant table in Paris, walked out of the door, and effectively vanished from the scene, much to the consternation of his Surrealist friends. His desperation to escape sent him round the world by ship, via the Pacific, to the Far East, where he met Gala and Ernst some months later. Yet the affair was barely mentioned by them, nor was the long steamship journey that led to its conclusion, and so the episode came to be forgotten. When, on his eventual return to Paris, Eluard was asked about the journey, he dismissed it as a *voyage idiot*, a stupid trip. The Ernst-Eluard Saigon *rendez-vous* turned into a kind of Black Hole, created deliberately by the travellers themselves, and historians simply accepted the idea that because the protagonists said nothing about the trip, there was nothing to be said. Brushing things under the carpet, however, is possible only if there is something there in the first place. Could it be, I wondered, that two close friends, unusually sensitive and articulate artists in their prime, both in a state of heightened

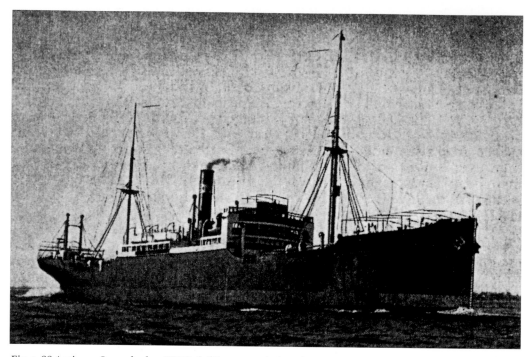

Fig. 1 *SS Antinous*. Launched as *SS Wachtfels*, recommissioned as *SMS Wolf*. Gross Registered Tonnage 5809. Built in Flensburg 1913. Scrapped 1931.

awareness induced by their passion for the same woman, had travelled across the world, to places they had never seen, and yet had returned unaffected as artists? Eluard and Ernst were then not only at a significant point in separate careers, they were helping to define the mood of the time. Self-expression was their supreme idiom, in poetry and paint, and after their return to Paris both produced remarkable work significantly different from that which preceded their departure.

An event which generated enough emotional heat at home in Europe to propel the trio to Asia must, I believed, have affected both Ernst's painting and Eluard's writing. What had they made of the world they had seen? How had it been converted into art? Such transformations would be most obvious if specific works could be compared with specific experiences. This would reveal the discrepancy between the world of external reality and the inner one of imagination. The art survived with its cargo of meaning, but the facts about the voyage, against which to test the art, were missing. It then occurred to me that *transport* might help, and so I turned to the ships that had taken the travellers to Indochina and back to France.

Chance encounters fascinated the Surrealists. André Breton, for instance, wrote three books, based on personal experience, that struggled to explain the nature of coincidence, *Nadja* (1928), *l'Amour Fou* (1937) and *Arcane 17* (1944). In each case Breton had been struck by the way chance encounters and coincidences lined up to form a network

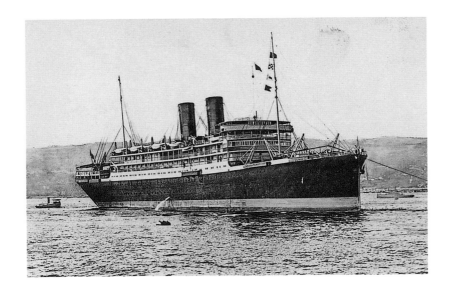

Fig. 2 *SS Paul Lecat.* Gross Registered Tonnage 12989. Built in La Ciotat 1911. Scrapped 1929.

of predictive signposts that seemed to expose the way fate was at work in his life. These indicators suggested a parallel reality running in the shadows alongside the everyday world. The exploration of this covert world fascinated Surrealists, and to map it they experimented with séances, the paranormal, studied premonitions and tried prophecy, all of which, together with multiple coincidences, are a striking part of the story of the voyages of 1924. Coincidences pepper the story like unexploded mines. Chance encounters are a slippery subject for the historian, who must nevertheless accept that Breton and his friends maintained an open-minded approach to the mysteries of what they defined as "objective chance," and that this principle therefore must cast a shadow over our reconstruction of events.

Paul Eluard had left Paris first, with dramatic abruptness, unable to cope with a love triangle at home. He was also at odds with the life he was leading, at odds with his father and with his job. He escaped to the Far East on board the French steamer *SS Antinous*. She was far from what she seemed, having had a dramatic past life as a wartime armed raider in the German Navy, and her part in the story turned into something as unsettling as "the chance encounter of a sewing machine and an umbrella on an operating table." That well-worn metaphor, coined by the enigmatic nineteenth-century writer Isidore Ducasse, also known as the Comte de Lautréamont, had long been a favourite of the Surrealists. My investigation therefore began by exposing the chance encounter of a Surrealist poet with a legendary German pirate ship; a start worthy of Ducasse. It was soon clear that the experience had a prolonged effect on Eluard. He was that rarity among Surrealists, a man of means. If he was sometimes resented and envied by his colleagues, he nevertheless also encouraged them by collecting their work, and influenced the development of Surrealism in other ways too. His journey across the Pacific, which he experienced in relative comfort, changed him, and therefore changed what he chose

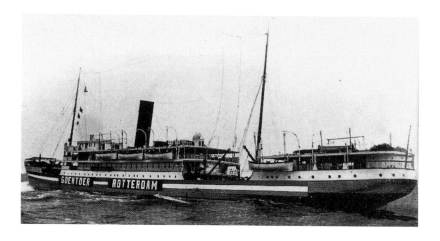

Fig. 3 *SS Goentoer*. Gross Registered Tonnage 5891. Built in Flushing 1902. Scrapped 1925.

to write about and what to finance on his return. These changes in turn affected the group as a whole. Eluard's graceful leadership of the Surrealists favoured the carrot over the stick chosen by André Breton, his co-leader. The effect of the voyage on Eluard's contribution to Surrealism has not been measured. Nor has its effect on Max Ernst, who joined Gala to meet Eluard in Saigon. The story of their journey not only shows us how Gala turned the lives of her lovers upside down, it also reveals how the experience affected Ernst.

This was overlooked thanks to the persistent and unanimous silence of the travellers. A blanket of fog rolled in for eighty years, during which few asked who might have been where when, nor what they might have seen there. Mists began to clear only after steamship timetables confirmed the movements of Eluard and Ernst during the critical period. Such research allows us to reconstruct their experiences and tease out new connections between what they may have seen on their travels and their subsequent work. Curiously enough, even historic details of the vessels themselves offer correspondences with the lives and characters of the travellers, including the enigmatic Gala, the least communicative of the the three, whose powerful presence so affected the lives and art of the artists involved with her.

A long sea voyage in the 20s was an intense physical and psychological experience. Air travel has almost closed that book, so an effort of imagination is needed to estimate the unique effect of ocean travel on a painter like Max Ernst or on a writer like Eluard. The art historian Richard Kendall has wryly observed that this study turns tramp steamers into a site of hyper-textual anxiety. Up to a point, for the superstructure of our investigation also rests on the reassuring basis of Lloyd's Register of Shipping and its copper-bottomed statistics.

The information so gleaned reveals in each case a parallel between steamer and passenger. Paul Eluard, for example, had set sail on his own, as a lone wolf, aboard a vessel that had recently also been a solitary wolf herself, both by name and design. In her pre-

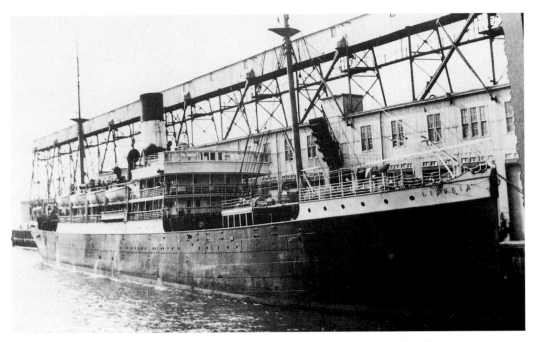

Fig. 4 *SS Affon*. Launched as *SS Liguria*. Gross Registered Tonnage 5112. Built in Sestri Ponente 1901. Scrapped 1928.

vious guise the French steamer *SS Antinous* had been a raider in the German Imperial Navy called the *SMS Wolf,* whose adventures had earned her a place in naval history. At the end of the First World War she was surrendered to France by the German government in part payment of war damages, at which point her name was changed. This is characteristic of a story which involves several cases of multiple identity and the covering of tracks. Max Ernst left France, with Gala, in the style to which she was becoming accustomed, on board a comfortable French liner, the *SS Paul Lecat.* It has been said of Gala that artists painted and wrote better when she was their lover, although in retrospect her influence was not as benign as Eluard's more generous patronage. We can detect an aspect of her contribution to Surrealism from the ships she took in 1924. For her, artists became the means to an end: luxury. Her voyages to and from Indochina introduced her for the first time to the comfort she later went on to enjoy on her annual transatlantic pilgrimages to New York in the 50s and 60s. She was to sail in style, leading Salvador Dalí to market in the US, he the Golden Goose, she the Gander.

Leaving Max Ernst in Saigon, Gala returned to France with Eluard on a comfortable but ageing Dutch liner the *SS Goentoer.* The parallel between this ship and our travellers lies specifically in her condition. The *Goentoer* was heading for the breaker's yard, as was the Eluards' marriage. There is an equally striking similarity between Max Ernst and the vessel on which he returned to Europe. He sailed from Saigon, after Eluard and Gala, shaken and broke, on board a battered steamer, the *SS Affon,* that had weathered many

storms. Perhaps he identified with her, for the *Affon* was also on her way to the scrapheap, to which Gala had effectively consigned him. Gala should have known better, for his return was followed by a most productive phase, full of memories of his ocean voyages and of the wildlife and flora of the tropics. The story of the Saigon journey as a whole, therefore, with its dramatic locations and intense inner life, is both exotic and mysterious. It is ripe for treatment as a novel or a film, which makes me wonder how, despite the trio's silence, it was overlooked for so long.

Looking within and without: the Surrealist voyages of 1924

The popular view of Surrealism is dominated by the "hand-painted dream photographs" made by Dalí and Magritte which describe dream life with realistic precision. To achieve such effects Surrealists looked *into* themselves while keeping an eye on the *outside* world. Max Ernst described this double-game as painting with one eye closed, to look into himself, while the other was open and looked out, so echoing Anthony Storr's point about the discrepancy between the two worlds being what drives the creative imagination. In his broken English, Ernst told Roland Penrose during a televised interview for the BBC, "I believe the best to do is to have one eye closed and to look inside, and this is the inner eye. With the other eye, you have it fixed on reality what is going on around you in the world. If you can make a kind of synthesis of these two important worlds you come to a result which can be considered as a synthesis of objective and subjective life."[2] This synthesis was a lifelong preoccupation. He felt Impressionism, for example, had limited itself to one line of sight, the external one. The Impressionists did not question ". . . the infallibility of the little screen we call the retina, a spot where two worlds meet, the world of subjective impressions and the objective one. They never questioned the relative reality of those two worlds. The retina was a source of endless pleasure for them . . ."—an approach which, in his view, had excluded evidence from the imagination.[3] This was not for Ernst.

However, the dream-like quality of Surrealist painting tends, in the popular imagination, to obscure the Surrealists' fascination with the waking world, so that we must remind ourselves Surrealism is based on Realism, on the Open Eye. This fascination with the objective, material basis of the visible world was there at the start, in 1924, when the group left their studios for the open road with the enthusiasm of Mr Toad and the curiosity of Sherlock Holmes. Three of the group went to Indochina and four others walked hundreds of kilometres across central France. Other expeditions explored Paris by night as if it was a foreign city seen for the first time. The Surrealist migrations and other minor wanderings of this period provide a context for the story of the *ménage à trois*, and the *voyage idiot* in which it culminated.

These largely forgotten voyages changed the way Surrealist travellers recorded what they saw, as we can see from their work. Surrealists not only commemorated their travels in books and paintings, they turned travelling itself into a surreal activity related to

their experiments with random notation, or "automatic" writing. In 1924 they learned to practise both at once, writing as they travelled. Such journeys were exercises in "automatic" travelling that began with sudden departures in search of the unexpected; a deliberate redirection of daily life at the unknown.

These jump-starts were designed to convert landscapes of fact into landscapes of the imagination, the traveller using his voyage to accelerate inspiration, as if riding a Metaphor Express. The early journeys of Surrealism also had an unexpected effect on the political development of the movement, for they revealed, at first hand, the realities of life in European colonies. The voyages of Paul Eluard and Max Ernst to Indochina in 1924 offered glimpses of an exotic tropical paradise, but also passed by many key locations attesting the dark side of the European colonialist adventure, from scenes of past massacres to grim prison colonies. As the Surrealists came to support national struggles against colonial powers, such travels contributed to Surrealist politics.

That Eluard and Ernst should have chosen Saigon—the colonial capital of France's empire in Indochina—as their destination recalls the earlier find of the region's principal monument, the ruined city of Angkor Wat, a site which haunts our narrative. For centuries Angkor Wat had been forgotten in the tropical rainforest. Its rediscovery is emblematic of our investigation, which confirms that the ruin lies beneath the tangled vegetation of Ernst's jungle paintings, as well as in the work of other French artists such as Gustave Moreau and *le Facteur* Cheval, both admired by Ernst and the Surrealists.

At the time of the first voyages, the big issue for the Surrealists was not aesthetic but moral. They felt that, in the larger scheme of things, making art-objects seemed a rather trivial response. In their reforming zeal the group aimed to change the world, mainly by loosening the grip reason had on the way things were done, and to replace its rationales with instinct. They were determined to listen to *la bouche d'ombre*, the Voice in the Dark. Reason and logic, as Ernst, a veteran of Verdun, pointed out to Penrose in the same BBC TV interview, planned and managed World Wars. Making art, at the dawn of Surrealism, came second to a revolution with massive social and political implications that would change all that and prevent it happening again. It is why, just before the Surrealists set off on their travels, a Paris newspaper announced "André Breton gives up writing," and why Paul Eluard wrote "To be successful is to disappear." It was a moment to start again, for clean breaks and radical departures, both mental and geographical, inner and external. This rejection of art in favour of a greater good is one reason why the Surrealists left their studios. A few gave up art altogether, some bailed out of one art form into another, while others still, relatively unaffected, returned from their expeditions and picked up where they had left off. The irony is that art is the legacy of a season of escape from it.

The year of voyages, 1924, was, we should never forget, also the year Surrealism "arrived". Many of its abiding interests were made public, among them a commitment to magazine publishing, to issuing public manifestos, to group action, to political agitation and to the defence of the art of so-called primitive peoples, as well as a protective interest in mental disorder and suicide. What is less familiar is that on their travels

the group road-tested these interests in the laboratory of life by tempering Surrealism *au plein air*, outside the studio and beyond the Black Stump.

The history of Surrealism is full of unlikely events, but little has been said about the role of steamships in it. They lurk in the background—cruising the oceans, appearing on the horizon to disappear in a haze. With their cargoes of Surrealists, liners steamed from Marseille to the Pacific, or from Le Havre to New York and back again. Steamers were inspiring metaphors of Surrealist life, meta-freighters of ideas and Q-ships of the mind. They represented creative activity, suspended between the inner world of the imagination and the world of external reality. Out there, in mid-ocean, ship and traveller literally floated between worlds, between departure and arrival, between continents, between dream and the ocean floor. As machines, and as icons, they affected Surrealism and provided Surrealists with both physical and spiritual transport. Joseph Conrad, whose novels often cut across our story, described the poetic side of life on board. "Such were the days," he wrote, "still, hot, heavy, disappearing one by one into the past, as if into an abyss for ever open in the wake of the ship; and the ship, lonely under a wisp of smoke, held on her steadfast way black and smouldering in a luminous immensity."[4]

Travel affects mind and body. In the Golden Age of Steam, ocean travel was a powerful catalyst and Surrealists were, as one might expect, not only active but creative travellers. They explored the world not just by boat but on foot, by car, train and plane, using the experience for imaginative as well as political ends. The journey to Indochina is our main subject, yet it was just one of a convoy of Surrealist voyages. Surrealists were later driven from France by war, chance or necessity, but those subsequent voyages were not as influential as those made in 1924.

While I am aware of the chronological distortion involved, I nevertheless describe Eluard, Ernst and their friends as Surrealists. Some were Dada-ists first and others Communists later, but here they are addressed with the name they adopted officially when they returned from their 1924 travels and by which they will always be known.

"The travels of Surrealism are over," wrote René Char later with conclusive resignation, for "while history laid on railway stations and airports, it was only waiting to shelve all that beauty and dust on some bookshelf"[5] . . . in volumes just like this.

Chapter 1

ITCHY FEET

Someone once told me they'd seen the vast shape of a lost liner, festooned with pennants, but making no smoke, steaming through wild icy mountains, far from the sea.

Robert Desnos. *The Night of Loveless Nights.* 1927

Survivors climbed out of the 1914–1918 war the way you might from a crash. They counted the dead and stumbled off to recover as best they could. Many felt the need to get out altogether, to pack up and clear off. "Comes over one an absolute necessity to move," wrote DH Lawrence at the start of *Sea and Sardinia* in 1921. The 20s in Europe were soaked in this mood.[6] "The fantasies of flight and freedom which animate the imagination of the 20s and 30s and generate its pervasive images of travel can be said to begin in the trenches."[7] Travel became a ruling passion and the Surrealists in France, survivors of trench warfare, felt its pull. To begin with, they did not know where to go, only that they had to make a move; enough of rubble, generals and a conked-out suicidal Europe. So, like Lawrence, they set off on the mental and physical road to the sun, past the debris and the production-line cemeteries, cheering each other on.

"There's never been a Spring as full of hope . . ." wrote one, looking back at the laughter which "sounded like kids on holiday and was so unexpected coming from that bunch of down-in-the-mouth philosophers and hang-dog poets . . . it gave our meetings a special lift."[8]

The dawn of Surrealism was therefore a time of laughter through tears. While new ideas fizzed they were laced with anxiety and driven by an urgent need for drastic change in politics, in art, in everything. Goodbye to all that, buried by the Somme. Early in 1924, Surrealists packed their bags and, feeling an "absolute necessity to move," left Paris. The journeys that followed were the outward signs of inner explorations–voyages in search of inspiration, a better world and, of course, of professional success. The Surrealists knew they shared this with other writers and artists they admired. Some of these fellow-travellers were older contemporaries whom they knew personally, while others were figures from history. All had used travel as a spur and if

some of the voyages they described had been firmly based on fact others were not. These precursors had viewed the world, with its geology and fauna, much as the Surrealists themselves were about to, as a theatre of the imagination on the road to self-discovery.

The Surrealists acknowledged a number of precursors and contemporaries who they celebrated as fellow-voyagers; these were mostly French, the two exceptions being Joseph Conrad (1857–1924), a British Pole, and the Venetian Marco Polo (c.1254–1324), whose account of the twenty-four years he had spent travelling in the Far East had been written in 1298 and first published in French. His *Livre des Merveilles du Monde* is the most influential travel book ever written. Polo, however, has only a walk-on part in our narrative, at an infamous island, a penitentiary near the Mekong Delta that Eluard and Ernst steamed past and abhorred. The earliest of their fellow-travellers was, in effect, Bernardin de Saint-Pierre (1737–1814), while the youngest was André Malraux (1901–1976), an acquaintance from the contemporary Paris art world. In the century and a half that separates them there also appeared the other travellers in our story. These included Paul Gauguin (1848–1903), Pierre Loti (1850–1923), Arthur Rimbaud (1854–1891), Victor Segalen (1879–1919), and Blaise Cendrars (1887–1961). This remarkable school will stay with us, breaking the surface of the narrative at intervals, like dolphins keeping pace with a ship. They pioneered the routes taken by the principal Surrealist travellers, Max Ernst (1891–1976) and Paul Eluard (1895–1952), themselves shadowed by a home team of less vigorous and largely sedentary Surrealist armchair travellers who, on the whole, restricted their adventures to the paper geography of atlases or the cartography of dreams. So while this is largely the story of a Surrealist love triangle that ended in Saigon, it also encroaches on the origins of French tourism. Tahiti began in Paris long before jets and colour film brought them together modern-style. By 1902, for example, Victor Segalen was already halfway there before he'd even left. His first voyage from Paris to the Pacific started as he made for the train and looked ". . . through the gloomy entrance of the Gare Saint-Lazare at the noisy criss-cross tracks to Tahiti's famous glowing skies."[9]

Despite the unique circumstances that drove Paul Eluard to Indochina for the *rendez-vous* with his wife and Max Ernst, they followed others who had already roamed the world, not only for pleasure, but also in search of a less tangible subject, the inner landscapes of the voyager's imagination. This cocktail of two worlds, of the objective world of external reality and the subjective one of the traveller's reactions to it, appealed to the Surrealists as they were drawn to explore the globe.

In their day the oceans were criss-crossed by steamers whose foaming wakes have now been replaced by vapour trails above. But, unlikely as it may seem, as a result of the Surrealists' interest in travel, a record of that vanished Steam Age survives in their work. It is preserved in poems, mind-games, scripts and drawings, in Max Ernst's paintings and in the writing of Paul Eluard. This record proves how real voyages in the objective world crossed imaginary latitudes and led to the creation of a planet of the mind,

beyond Tahiti and the rainforests of Indochina, that added a Surrealist dimension to territory established, as art, by their precursors.

Visions of paradise: *la littérature éxotique*

Bernardin de Saint-Pierre's novel *Paul et Virginie* (1788) is as well known in France as Daniel Defoe's *Robinson Crusoe* (1719) is in the English-speaking world. Both are elaborate fantasies about the relationship of man and nature, set on tropical islands at the edge of the horizon—real locations but beyond the reach of most readers. At the age of twelve, after reading *Robinson Crusoe*, Saint-Pierre went to Martinique in the Caribbean, and at thirty-one visited Ile de France, known today as Mauritius. It became the setting for his most famous book, *Paul et Virginie*. A story of innocence and heartbreak in the Indian Ocean, it invented *la littérature éxotique*—which was to nourish Surrealism. Saint-Pierre was a prototypical "Green" philosopher to whom Eluard referred in his meditation, *L'Habitude des Tropiques*, where he describes differences between the northern latitudes and life in the tropics.[10] Central to the success of *Paul et Virginie* is the idea of a magical place, a Shangri-la, somewhere over the rainbow. The unrequited longing we feel for such places appealed to Eluard, who opens his essay with a quotation from Saint-Pierre on the subject. The power of art, according to Saint-Pierre, lies in its ability to bridge the unbridgeable gap between imagination, with its intangible dreams, and tangible reality: *Le grand art d'émouvoir est d'opposer des objets sensibles aux intellectuels* (The great skill of stirring people is to play off the difference between the physical world and the mental one).[11] *Paul et Virginie* is the first book in French to beguile the reader with an unattainable tropical paradise based on an attainable colony. The Exotic Location, lovely but out of reach, had appeared on the literary and mental map of Europe. Victor Segalen later recognised that Saint-Pierre had made a major aesthetic discovery and singled him out for inclusion in his own projected study of the Exotic. Segalen also spotted the invisible link between Exotic Locations and the fascinating pull of the Unknown, an attraction the Surrealists treasured. "Exoticism is everything that is Other."[12] Otherness or what is different from ourselves is strange, mysterious and therefore surprising. *La sensation de l'Exotisme: surprise*, felt Segalen. The Surrealists agreed, and the Saigon voyage sits at the intersection of the Exotic and the Surreal.

Saint-Pierre's feeling for distant places is also evident in the work of the other pre-Surrealist travellers in our story, Pierre Loti, Paul Gauguin and Arthur Rimbaud. They blurred the boundaries between real voyages and those in dreams, between fact and imagination. André Breton, never much of a walker but a tireless talker, quickly saw that boundaries could be explored using only words, without having to resort to the wear and tear of travel itself. He was after all a poet who believed he could change the world by changing people's minds. To preserve a sense of outward adventure in his work he

was drawn to the same geographical terminology as used by "real" travellers. Here is how he described the Surrealists' first initiatives: ". . . we are now," he said, using directional language, "setting out in search of what has kept us going." He meant, of course, the search for a state of mind which, once isolated, they defined as Surreal.[13] He favoured the language of travel because it was not only the outward expression of the inner journeys he valued, it also allowed for traffic between two different road systems, between armchair travel and the real thing.

Individual Surrealists tended to prefer one or the other. It was a matter of temperament. Georges Malkine was so restless he was barely able to sit still long enough to take part in Surrealist meetings. André Breton was the opposite; he stayed at home and travelled to the interior of himself, seldom leaving Montmartre, let alone France. Philippe Soupault was almost as restless as Malkine and had a life as colourful, steaming around the world and working abroad. Robert Desnos was obsessed with the sea and went to the Caribbean. Jacques Viot went to New Guinea and Shanghai. Benjamin Péret lived in Mexico and travelled up the Amazon. Eluard was closer to Breton in this respect, with the exception of his world trip to Asia. In the run-up to the invention of Surrealism, at the time that concerns us, Desnos in particular was known for his taste for geography and travel. He saw himself and his friends as restless pioneers breaking new ground. "We are now crossing a kind of desert that's not on any maps," he said. "The purity of the pack-ice meets the solemn heat of the desert. Instead of forests, of the sea, of cities, and mountains we have mirages as beautiful and as tangible as reality."[14] The first outbreaks of their travel fever survive in writing rather than in pictures, for Surrealism had not yet invaded the visual arts. The exploration was therefore mostly the work of poets, hang-dog or otherwise. Louis Aragon, for example, used similar language, resorting to a favourite word, horizon. He compared the group's aims to it; "Surreality," he said, "is the horizon that religion, magic, poetry, dreams, madness, intoxication and the dreary grind of daily life all have in common."[15]

Breton also cast the group as pioneers who, like Commandos of the mind, had to "tame the vast unknown territory over which the rule of reason has no remit."[16] For outgoing and energetic types like Philippe Soupault the answer was altogether more simple. Get out more. Too much reading softens the brain. "How can one live with the idea of journeys one's never made and with those that are over? There's a bitter taste to such landscapes. Your cell may be well-built of books you love, but you'll never leave it, as their rich aroma sends you to sleep."[17] These first Surrealists, whom Ernst called the Surrealists of the *première vague*, admired Paul Gauguin and Arthur Rimbaud for having responded decisively to that vector.[18] The adventures of those two precursors affected the Surrealists' first expeditions, which began modestly enough as night walks across the deserted streets of a sleeping capital that cemented friendships and launched the longer voyages to follow.

One of the first works inspired by this travel fever was Robert Desnos' roller-coaster saga *Pénalités de l'Enfer ou Nouvelles Hébrides* (The Penalties of Hell, or New Hebrides), which he wrote in conditions as unsettling as a departure lounge. He began

while killing time in a café, waiting for Roger Vitrac, André Breton and Louis Aragon. "After that I wrote anywhere and everywhere, in cafés (especially in a little bar on the Ile de la Cité used by sailors), on trains, in my room, at the office."[19] Writing on the move was as unsettled a method as he could have devised and maintained a vivid parity between subject and style, between a restless tone and the verve of departure. "Aragon, Breton, Vitrac and I lived in a miraculous house by the railway . . . Péret is waiting downstairs: we're now going to a desert island . . ."[20] The scene changes, injecting a disturbing note of panic and mass migration:

> But there's no-one left in Paris, no-one, just the corpse of an old lady who works at the grocer's. . . . Get me a train, a steamer, a world and I'll be off, because I don't think you can use the exit nor the station windows except with ladders that rise endlessly towards the horizon. . . . At times you could hear the continuous loud whistle of steam engines across the city, whistles that seemed very close. What engines? The Place de l'Etoile was deserted . . .[21]

But ". . . a steamer was waiting. She soon set sail and a few hours later we landed in Casablanca." All this travel also left its mark, literally, on girls as well, "the white stomachs of the women were tattooed with all corners of the world: Africa, America, Asia, Oceania, Europe. Cheers!"[22] The framework of this kaleidoscopic montage of parades, news reports and meetings with friends is a helter-skelter journey by tram, ship, balloon, and plane from Paris to Zanzibar via the Gare Saint-Lazare, set during a Chinese invasion of Paris.

Desnos had only just returned from two years in Morocco when he met the Surrealists through Benjamin Péret, himself fascinated by ocean liners. Péret had published a sumptuous volume of poems, *Le passager du transatlantique* (*Transatlantic Passenger*, 1921), with titles like "Little porthole of my heart," "Asian Starboard," "Second Class passengers and their hair."[23] No wonder Desnos imagined Péret at sea, breaking into his cabin, as if in a movie. "Night fell with the sound of breaking glass. We said good night and I quickly fell asleep. I was soon woken by a faint noise from the porthole. An arm reached in. I recognised Benjamin Péret by the button on his cuff."[24]

Transatlantic traffic headed west from France, but the Trans-Siberian Express rolled east. The famous train had been the subject of a poem by Blaise Cendrars, *La Prose du Transsibérien*, published in 1913, which has retained its magic partly because of its format, being printed on a single folded strip two metres in length, alongside a continuous abstract pattern painted by Sonia Delaunay. Cendrars was one of the vanguard poets of the hour. Older than the Surrealists, he was much better known. His preferred subject was distance, travel and the unattainable:

> *Il n'y a plus que la Patagonie,*
> *la Patagonie qui convienne a mon immense tristesse,*
> *la Patagonie et un voyage dans les mers du Sud.*
> (Only Patagonia's left / Patagonia to match the depth of my sadness / Patagonia and a voyage to the South Seas.)[25]

Cendrars was idolised by Soupault, who in those days managed the import of fuel oil on behalf of the French State at the Commissariat des Essences et Pétroles, an unlikely occupation for a Surrealist night-owl. Between 1917 and 1922 he wrote a long travel poem, inspired by Cendrars, in which he described an ideal world tour using travel as a springboard for poetry. Entitled *Westwego*, it was named after one of the largest tankers afloat.[26] Like Desnos and Péret, Soupault dreamed of global scenes from his desk in Paris, another Mr Toad longing for the open road:

> *. . . je voulais aller à New-York ou à Buenos-Aires*
> *connaître la neige de Moscou*
> *partir un soir à bord d'un paquebot*
> *pour Madagascar ou Shanghai . . .*
> *et j'ai relu les voyages de Captain Cook . . .*
> (. . . I wanted to go to New York or Buenos Aires / see the Moscow snow / to leave one evening on a steamer / for Madagascar or Shanghai . . . and I've reread Captain Cook's voyages . . .)[27]

These armchair travellers were friends, as we see from the way Soupault breaks off from his geography to describe them, asleep in their rooms, scattered across town. His affection is worth noting as it reveals the disarming team spirit that, in those days, still distributed their dreams of travel, as of much else, from one to the other along the bush telegraph of friendship:

> *mes amis endormis aux quatre coins*
> *je les verrais demain*
> *André aux yeux couleur de planète*
> *Jacques, Louis, Théodore,*
> *le grand Paul . . .*
> (my friends are asleep all over town / I'll see them tomorrow / André with eyes the colour of planets / Jacques, Louis, Theodore, / big Paul . . .)[28]

The tonic of departure also featured in an influential article Breton wrote called *Lâchez Tout* (Drop everything), advising everyone to drop their jobs as well as their routine ways of thinking and take to the road.[29] From all this we can see how popular the idea of travel was when Eluard suddenly disappeared in March 1924.

The best indicator of who belonged to this group of poets with itchy feet is their journal *Littérature*, which ran for five years and only folded during Eluard's disappearance. It proves Blaise Cendrars was a true member, despite the fact his name never appears in the roll call of Surrealism. He appears in the first issue, in 1919, and became a fixture.[30] However Cendrars and Breton never got on. Desnos watched them in the spring of 1921 at the Café Certa, the Surrealists' favourite haunt. "That evening Breton, Aragon, Tzara were there . . . and two visitors: Cendrars and Radiguet. . . . Breton spoke. He was very thin and his horn-rimmed glasses made him look just like Harold Lloyd . . . he said to Cendrars 'I can't understand why you stick to those literary ideas of yours and won't join

us.'"[31] Cendrars' daughter knew Breton's attempt to control her father would fail. "It never worked with Cendrars from the start; they were both such strong personalities they couldn't agree about anything, they were temperamentally at odds."[32]

When Breton tried to enlist him, Cendrars was one of the most influential personalities in Paris. The Surrealists must have thought he had beaten them to everything. He was the Commissioning Editor of the stylish publishing house *La Sirène*, whose many authors included Surrealist favourites like Lautréamont, Baudelaire, and Apollinaire. In 1916, together with Picasso and Juan Gris, he had organised a banquet at the Palais d'Orléans in honour of Guillaume Apollinaire, who was not only admired by Breton but was responsible for the friendship between Breton and Soupault. The guest list had included Paris's new cultural élite. Cendrars knew the painters Apollinaire had promoted, such as Duchamp, Léger, Picabia and Braque. Braque had even restyled the paintwork of an Alfa-Romeo Gran Sport 6 for him.[33] Cendrars had also been on the payroll of Jacques Doucet, the wealthy couturier and collector. In this too the Surrealists trailed in Cendrars' wake, for it was only after he had left Doucet's employment that Breton, Aragon and Desnos took his place there. At the time, and ever after, Philippe Soupault was closest to Cendrars, referring to him not as a poet but as *the* poet.[34] Cendrars' acceptance by an extremely ambitious and tight-knit group, always wary of its contemporaries, tells us that it was not just his address book that earned their respect but his work, with its breezy tone, open horizons and its addiction to travel and escape. He radiated hope, a rare quality among a group reeling from the stench of the trenches:

> *Je connais tous les horaires*
> *Tous les trains et leurs correspondences*
> *l'heure d'arrivée l'heure de départ*
> *Tous les paquebots tous les tarifs et toutes les taxes*
> (I know all the timetables / All the trains / all their connections / all arrival times all departures / All the steamers all fares and all taxes)[35]

Cendrars had in fact taken over the escapist wing of the vanguard established by Rimbaud and Gauguin. But then, like them, he suddenly threw in the towel, sick of the ego-wars and careerism of the art scene. In February 1924 he left to recharge his batteries on a trip to Brazil. René Hilsum, the Surrealists' publisher, quickly issued the poems written on that transatlantic journey. They are the most vivid evocation of ocean travel composed in the Steam Age and are fundamental to any imaginative reconstruction of the voyages of Eluard and Ernst that are our main concern.[36]

Cendrars did not overlook the everyday minutiae of travel, and his poems about the trip from Le Havre to Sao Paolo have titles like "The 19:40 Express," "Cabin 6," and "35 Degrees 57 Minutes Latitude North 15 Degrees 16 Minutes Longitude West." The collection, called after the steamer he had taken, *Le Formose*, also featured what has become one of the most popular poems in the French language, "Islands."[37] Since Cendrars set off on his adventures a few weeks before Eluard left for the Pacific, we should bear in

mind the possibility that news of Cendrars' departure reached an Eluard wrapped in misery and that, tipping the balance, it encouraged him to cut loose and go it alone as well.[38] Eluard's journey turned out to be longer than Cendrars' but a quieter, less robust affair. One cannot imagine John Dos Passos writing of Eluard, "It was hair-raising to spin round mountain roads with him. . . . Cendrars took every corner on two wheels."[39] Cendrars drove like a mad thing even though he only had one hand, having lost the other in action in the war. Eluard could not even drive.

The example of writer-traveller Victor Segalen sheds a different light on the group's restlessness. Segalen had died young. He was by then an opium addict, like many Frenchmen of his generation who had travelled extensively in the East. He bled to death from a cut sustained on a solitary walk in Brittany in 1914, aged forty-one. His travels are the link between Eluard's voyage and the earlier peregrinations of Gauguin and Rimbaud. Segalen was the first to investigate, on location, the lives of those two pioneering "evacuees from civilisation," to use Peter Conrad's phrase, and to sense the taste for exoticism they shared, a feeling that also haunted Cendrars' epics about steamships, jungles and rain, with his *Viens! Ô viens dans les îles perdues du Pacifique!*, (Come on! Let's go to islands lost in the Pacific!).[40] Segalen began his career as a ship's doctor in the French Navy, posted to the Pacific. The part played in France by bookish naval doctors such as Segalen and Pierre Loti in coming to terms with indigenous cultures all over the world is an extraordinary story in itself.[41] Segalen's own writing, a kind of poetic ethnography, is at last attracting widespread critical acclaim, and his great unrealised project was the *Essai sur l'Exotisme*. His notes for this were composed shortly before Cendrars and Eluard themselves wrote about Oceania, and they give a vivid glimpse of how the region had already captured the imagination of French writers and painters before the Surrealists arrived.

If Cendrars' colourful adventures and the exoticism of his work evidently affected the Surrealists, Segalen's influence is not so easy to relate. A tribute from Pierre Naville, another Surrealist of the *première vague*, described him as having done more than anyone to restore the self-respect of Westerners after their colonial abuse of other cultures: *Segalen qui sauve l'honneur*, he wrote.[42] It was Segalen who first explored Western responses to independent cultures in the Pacific in a recognisably modern way, akin to the Surrealists' own methods. His urge to connect with non-Western cultures reappears in the context of Eluard's journey, while Max Ernst, too, confirmed that his exposure to the world beyond Europe had changed his idea about "occidental culture."[43] Segalen had not only listed Bernardin de Saint-Pierre as a pioneer, he was also aware of the part played by Marco Polo and Pierre Loti as they ventured out of Europe to observe the intersection of Western culture with those of different origin.

Pierre Loti's success as a travel writer led to his election to the Académie Française, and his widespread impact on the imagination of the French public was prolonged, affecting even the Surrealists. Segalen and Loti were both in the Pacific in 1904 as medical officers. Loti went ashore in Indochina to make the journey up the Mekong River and visit Angkor Wat. *Un Pèlerin d'Angkor* was the first coherent work of the imagina-

tion based on a visit to the site. Even if the Surrealists were contemptuous of his sustained, perhaps glib, romantic tone, Loti's account is nevertheless the closest picture in words of what became the archetypal French response to the ruin. He was amazed by the strangeness of the place and in his practised way summed up its main effects. He spotted what is of overwhelming interest at Angkor and his observations reappeared as the standard staging in guide-books, histories, and novels. These were the literary expression of the French fascination with Angkor that later affected Ernst's paintings of cities lost in the jungle, much as our knowledge of Angkor underwrites our view of his pictures. Of Loti's many travel books, the one based on his trip up the Mekong in 1904 is closest to our subject.

Elsewhere, in the Pacific, Segalen had gone ashore in the Marquesas Islands to explore what remained of Gauguin's last home. He arrived a few weeks after the painter's death, spoke to those who had known him and tried to imagine Gauguin's work in its "exotic" context. The vessel he served on, the *Durance* (which Gauguin had also travelled on), completed her tour and sailed for Marseille in 1905, via Djibouti, at the southern end of the Red Sea. There Segalen went ashore to investigate the closing chapter of Rimbaud's life in the Horn of Africa. In the raddled French enclave of Djibouti, Segalen set about looking for traces of Rimbaud, just as he had looked for Gauguin's ghost in the Marquesas.

"On the basis of the few documents I have found I'm trying to imagine what the explorer was like," Segalen wrote of Rimbaud in his diary, "because others have already had their say about his poetry."[44] He interviewed Greek expatriates who had known the poet and done business with him on the caravan route to the interior. Segalen's notes were worked up and published as *Le Double Rimbaud*, by which he meant the double life of Rimbaud the Artist and Rimbaud the Traveller. The originality of Segalen's study lies not only in his investigation of Rimbaud's movements, which had not been explored before, but also in the way he examines himself at the same time. As he looked into Rimbaud's life after the poet had given up writing for a more physical kind of self-fulfilment, Segalen was himself beating a path to self-knowledge. His search for Rimbaud was a search for himself. He wanted to treat himself as an outsider, as an alien, and "other," just as Rimbaud had wanted to escape from himself, when as he put it, "I is another." As a writer on the move, Segalen monitored himself following another writer, Rimbaud, in a similar situation, and so tried to unravel what makes a dislocated (*dépaysée*) life interesting. In this Segalen was ahead of the Surrealists, especially of Philippe Soupault, who was also to explore the Red Sea coast in Rimbaud's footsteps. By the time Segalen visited Djibouti he had therefore reconnoitred the mental and geographical route Eluard would take in 1924. He had approached the same coasts, sailed the same seas and, what is more, had put in to several of the same remote harbours as Gauguin and Rimbaud. It was a remarkable stroke. He had done so in pursuit of the key ideas which Eluard was himself to learn from his voyage, most particularly the idea of cultural relativism, which values unfamiliar cultures as much as one's own, however technologically inferior they might seem. Segalen also realised the energising effect of

dislocation and exile on the imagination of the traveller. He had discovered the tonic effects of that *dépaysement* twenty years before the Surrealists' voyages of 1924.

Segalen also sheds another light on Eluard's mysterious disappearance. He had been told by Rimbaud's Greek friend in Djibouti, Athanasios Righas, that Rimbaud ". . . wrote a lot; he was working on a book about Abyssinia, but I don't know anything about it."[45] This is the only evidence we have that Rimbaud did not stop writing, even after he had walked away from his meteoric literary career to drift around Aden and Djibouti. Rimbaud's vanished book also haunts us because it contradicts the cliché that he had given up literature, an idea fundamental to the myth about him. It was especially important to the Surrealists, for whom the idea of giving up art had, as we have seen, a special attraction. It had been behind Breton's advice to drop whatever you are doing and leave, it explains why Surrealists like Georges Malkine, Max Morise and Emile Savitry retired from art, and it was even part of Marcel Duchamp's career strategy. Duchamp pretended to have given up art in order to escape the rampant intrusions of a thrusting art world. However, from what Righas told Segalen, it seems Rimbaud had no more given up than had Duchamp. In Duchamp's case the secret world of his final project was revealed only after his death, while Rimbaud's book, whatever it was, has gone forever. In this light Eluard's disappearance from Paris is likely to have been more complex than it seemed, for in addition to his domestic problems, he may also have been taking the French route out of an overheated art world. It was a kind of *reculer pour mieux sauter*, an instinct for self-preservation through self-denial, so that, on close inspection, thanks to Segalen's discovery, Eluard's departure exfoliates to reveal unsuspected layers of motivation.

Segalen returned to France having visited two key locations in the history of French art and travel, and of *la littérature éxotique* that were of permanent interest to the Surrealists. The fact he had preceded them by twenty years reminds us once again that Eluard's Saigon voyage travelled along established French tramlines laid down by French predecessors.

The exception to this exclusively French cultural tradition was Joseph Conrad, whose celebrity in France was at its height when he died in 1924. His work, with its distinctive brand of alienated *dépaysement*, was much admired. It was extremely unusual for the prestigious NRF publishing group, which included André Gide and the authors of the Gallimard imprint, to devote a special issue of their journal exclusively to a foreign author, as they did for Conrad. Gallimard had acquired the French rights to all Conrad's work in 1915, and such was the enthusiasm for it that the publisher was able to dispense with his usual translators because house authors like Gide and his colleagues wanted to translate Conrad into French themselves. Coincidentally, in 1924 Gallimard published both *Victory* and Breton's *Les Pas Perdus*, a title that sounds like one of Conrad's own. Conrad's popularity in France was shared by other English-speaking authors like Jack London, Rudyard Kipling and RL Stevenson, who also used *héros-aventuriers*, men of action, as the vehicle for their narratives. These adventures were fashionable reading in France and may well have put a spring in the step of our

travellers. We know, for example, that André Malraux set out for Indochina, shortly before Eluard, with *Coeur des Ténèbres* (*Heart of Darkness*) in mind, moved by Conrad's bleak view of humankind pitted against the seething forces of Nature. The antics of colonial bosses that so horrified Conrad were to shock Maraux as much as Eluard, and Conrad's feeling for the indifference of nature to humanity was, of course, close to what made Ernst tick. The jungle itself interested Ernst more than the crack of the *chicote*— the deadly whip of sun-baked hide that could kill a man if used with relish. The culture of the *chicote* nauseated Conrad, Eluard and his colleagues, and the Surrealists continued the protest against it begun by Conrad in *Heart of Darkness*. Malraux's actions in particular reveal the hold Conrad's work had, for Malraux was obviously drawn to play the part of the solitary adventurer, as we can see from his autobiographical novel about his capers in Indochina, *La Voie Royale* (1930). It is too closely modelled on *Heart of Darkness* for comfort. Eluard may have been a city boy with a tendency to TB, but he was very well read and while his appetite for pessimistic adventure among the islands of the Pacific, *à la* Conrad, is uncertain, its effect on him in 1924 should not be overlooked. We know, for example, that he read *Lord Jim* and *Typhoon* that year. If the Surrealists' travels were also triggered by the movies they saw, we must also keep Conrad's books, and those of Jack London, in mind as catalysts for the voyages. The thought adds a note of human frailty, of macho posturing, to the blank canvas about the journeys we are trying to fill.[46]

Such highbrow precursors as Segalen, Conrad and Rimbaud were certainly not the only suppliers of exotic stimulus to our travellers. The mainstream of French life was inhabited by shoals of authors selling the charms of *outre-mer* to the capital, the *métropole*. A thriving cultural import-export industry existed and a *littérature coloniale* was supplied by authors specialising in particular colonies. Pierre Mille (Africa), J-A Nau (West Indies), Louis Bertrand (Tunisia), and Marius-Ary Leblond (aka Georges Athenas and Aimé Merlo), who came from La Réunion, were popular. Nau won the first Goncourt Prize in 1903 and Leblond won in 1909.[47] Ary Leblond was the most vociferous and active of these colonials at work in France and represented the sombre side of exoticism, inspired by the jingoistic patriotism the Surrealists deplored. He established the first French Colonial Museum in 1911, at Saint-Denis on the island of La Réunion, where he created a special gallery in honour of Bernardin de Saint-Pierre. He was also responsible for relaunching Saint-Pierre as the *premier écrivain colonial*, the original colonial author, and was awarded the *Légion d'honneur* for his contribution to the Paris Exposition Coloniale of 1931. The vigorously pro-imperialist posturing of Leblond reminds us that, whether they liked it or not, Eluard and his colleagues were within range of propagandists like him. We must therefore imagine the part played by Leblond and others in the French life, accompanied by hit tunes like *Ma Tonkinoise*, in providing some of the background music for the journey to Saigon.

Thirty years before, Gauguin and Segalen had seen through the self-serving talk about the benefits of empire. Like Rimbaud, they had searched the world, hoping to combine freedom of movement with freedom of the imagination. They could not grasp this ideal of illumination-via-displacement, *liberté par dépaysement*, because it was, as

it remains, beyond our reach. The fact is that we are always waiting for ourselves, wherever we go. However, Gauguin and Rimbaud contributed to a new world view, especially in France, and to a global awareness that was both political and imaginative. This was incorporated into the Surrealist Revolution, for which Eluard's *voyage idiot* now seems to have been an exploratory mission. The Surrealists' travels were, therefore, the latest in a procession of voyages of self-discovery that took place during actual voyages across the world.

From a séance attended by the Surrealists in September 1922 comes confirmation that their ruling passion for travel had also taken root in dreams. The séance in question also reminds us that, long before Eluard vanished, the group had been rehearsing such a departure. That autumn evening, just after Ernst had arrived in Paris, and when Robert Desnos had entered a trance with pencil and paper to hand, Breton asked him,

Q Desnos, Breton here. Tell us, what can you see about him?
A The Equator. (He draws a circle with a horizontal diameter.)
Q Has Breton got a journey to make?
A Yes.[48]

Chapter 2

OTHER JOURNEYS

Dada arrived by train and disappeared into Oceania by steamer.
Pierre Naville, *Le temps du surréel*, 1977

The journeys of 1924 were rehearsed on paper, in writing about distant places such as *les îles perdues du Pacifique*, the islands in the sun of popular fantasy. The French word *dépaysement* translates literally as being outside your own country, but its meaning also encompasses exile and disorientation, and has both a geographical and a psychological sense. *Dépaysement* also defined a favoured Surrealist mood, the feeling we all get when we arrive somewhere new for the first time, our senses sharpened by wonder and tinged with anxiety.

This desired state of mind, along with methods of achieving it, pervaded the five years of collaboration and experiment that led to the launch of Surrealism.[49] Surrealism's master of ceremonies, André Breton, claimed the experiments began in the summer of 1919 when he and Philippe Soupault co-wrote *Les Champs Magnétiques* (Magnetic Fields) and ended in the winter of 1924 with the publication of *The Manifesto of Surrealism. Les Champs Magnétiques* is now seen as the first Surrealist work of art, while the *Manifesto* is the movement's first mission statement. The voyages that interest us took place between these two terminals. "In *Les Champs Magnétiques*," wrote Louis Aragon, "Surrealism was invented. The thing itself. Not the word."[50] The book, appropriately enough, was a kind of travel book, as one can tell from a title that suggests both open country (*Champs*) and the invisible forces that steer your compass (*Magnétiques*). Surrealism arrived suitcase in hand. Travel shaped it and remained one of its favourite themes. While Paul Eluard's world trip was a spectacular example, numerous lesser expeditions took place. Some lasted an evening, others much longer. A short one turned into a major book, while the longest was forgotten in permanent quarantine. There were, of course, other trips made for domestic or professional reasons that did not have a creative purpose or a productive outcome. Those that concern us, however, contributed to the *Manifesto* and created Surrealism. Robert Desnos' trip to Cuba, Benjamin Péret's to the Amazon, Breton's to the Gulf of St Lawrence, within

7/102815|

reach of Newfoundland, were unusually interesting. As were Kurt Seligmann's trip to the coast of the Pacific Northwest and Ernst's to the deserts of Arizona, although they belong later in the Surrealist adventure.

The first Surrealist excursion took place a few months after World War One ended and while the battlefields north of Paris were still churned, sprouting bone and shreds of uniform. Early June 1919. The expedition was an all-night walk through the capital, down the Boulevard Raspail, round the Luxembourg Gardens, the rue Soufflot, the Place du Panthéon and on through the dark. André Breton and Philippe Soupault walked and talked in deserted streets and at dawn agreed jointly to write something to evoke the peculiar state of mind the experience had induced. *Les Champs Magnétiques* was composed at great speed. Within a fortnight they had each written independent trance-like descriptions which were edited into a book. At times they wrote for ten hours on end, breaking off for fresh air to roam the streets again in a daze. These dream narratives capture the disorientation and *dépaysement* they felt. The opening chapter entitled "Mirror without silvering" begins, "Trapped in drops of water, we're animals without end. We roam silent streets and the spellbound posters have no effect."[51]

Chapter Four, which Breton entitled "In 80 Days," was written by Soupault. Adapted from Jules Verne's classic adventure, its title tells us we are travelling around the world in the company of "The hero of great expeditions, . . ."[52] We finally drop anchor where "The seaward woods and familiar ports smell far too sweet." A walk through a summer night determined the book's subject, its tone and technique, as well as the mood of things to come:

> We can remember the glow from the bars, and the grotesque parties in ruined hous-es at nightfall. But nothing is sadder than the light gently sweeping rooftops at five a.m. Silence drifts in side streets and boulevards come to life; a late walker smiles nearby. He hasn't seen the chaos in our eyes and drifts past. The noise of the milk-cart brings exhaustion to mind and birds head for heaven looking for food. . . . The great smile of the world itself isn't enough; what we need are even bigger deserts, cities without suburbs, and dead seas.[53]

Daytime expeditions followed. On an overcast April 14, 1921, men in overcoats gathered outside the church of St Julien-le-Pauvre in the heart of old Paris. The outing fell flat. Promoted as a Dada Excursion and Visit, it was one of a projected series of trips to places "which have no real reason to exist." Others were planned but did not materialise, such as an outing to nearby woods and a trip to the Louvre.[54] Travel was more than a literary tonic, it was turning out to have revolutionary possibilities, as Breton soon made clear, when in 1922 he wrote a short piece, *Lâchez Tout* (Drop Everything), "Drop everything . . . Drop your wife, drop your girl-friend . . . Park your children in the woods . . . Drop your comfortable life . . . Take to the road."[55] It is a short piece and often quoted as it encapsulates so much. It helps one understand why Paul Eluard and Marcel Noll suddenly took off one summer night in 1923, during another night-time ramble through Paris. They had been hanging about an echoing railway station, with its

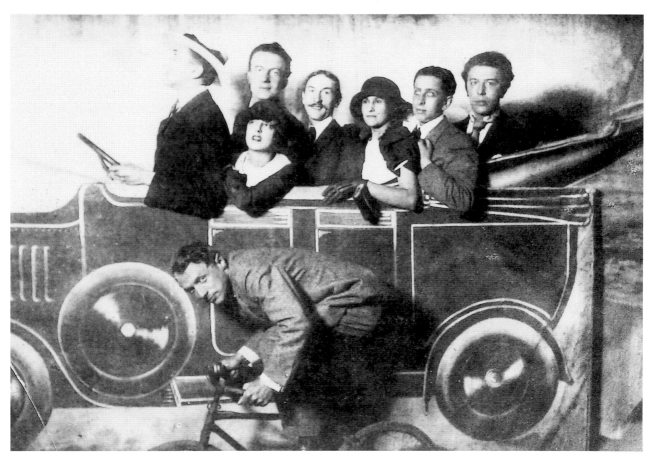

Fig. 5 The Surrealists on the Road. Fairground photograph of Max Morise driving Paul Eluard, Simone Breton, Joseph Delteil, Gala Eluard, Robert Desnos and André Breton. Max Ernst is on the bicycle. Paris 1923.

characteristic tang of coal-smoke and urine, before they jumped on a train for no obvious reason and took off into the dark. "Paul and I left Paris on the spur of the moment without telling anyone," wrote Noll. "Eluard and I left for Lorient on Wednesday night (at 11 from Paris), deciding just five minutes before the train was due to leave. We arrived on Thursday morning, worn out, half-dead and filthy."[56] We can see how Eluard's sudden exit from Paris to Marseille some months later had been rehearsed in a minor key on a night train to Brittany.

However, by then Philippe Soupault had beaten him to it. In 1923 he resigned from his job, just as Breton recommended, and had set off for the backwaters of rural Portugal, a journey described in his long poem *Cruz Alta* (High Cross). Inspired by the isolation he found there, he gazed one night at the moonlit world around him, and waited for dawn. At that moment an image came to mind that catches the spirit of Surrealism itself, as the Earth, our planet, suddenly seemed to him to be a great steamship sailing through stellar seas:

. . . night runs on
the streams babble
a light blinks
a train fades away
the ocean booms
the night replies
Earth Earth
another hour
the sound of breathing
here comes the day
here comes the sun
Earth Earth
Time to go aboard[57]

We can therefore see that by 1923, five years after the end of the War, Soupault, Eluard, Breton and their friends were attracted by the idea of leaving to cross new horizons, both real and imaginary, physical and mental. It was then that Soupault also first met André Malraux and his wife Clara. The couple was on the verge of a long journey; yet more restless young Parisians making a move in the post-war gloom. In October 1923, the Malrauxs, who were not part of the Surrealist clique, set sail for Indochina.

We do not know how frequently the Surrealists prowled the capital at night, but by 1923 they did it often, mostly in search of physical kicks and the stimulus of *dépaysement*. These midnight rambles may also have been enhanced by cannabis or cocaine. Wrote Marcel Noll:

I wandered all night with Eluard, Péret and Desnos from the Halles to Montmartre, from the Porte Saint-Denis to Belleville. On the night of Thursday to Friday, Desnos and I left Breton's at 11 on our way home. But what's the night for? We went to the Bois de Boulogne, into gloomy corners, along paths we didn't know, until four in the morning. We were both frightened, expecting to see a ghost or a nude woman at the foot of some huge tree. We took it in turns to come up with creepy stories and weird ideas.[58]

Louis Aragon himself also began to experiment with travel writing, in imitation of *Les Champs Magnétiques*. He explored the glass-roofed shopping arcades or *Passages* of Paris and turned his expeditions in their twilight zone into the first half of an observational reverie about the city.[59] The opening of *Paysan de Paris* (Paris Peasant) caused a stir when he read it at Breton's studio early in 1924. In fact, that February was the start of the year of voyages, for it was also when Blaise Cendrars set sail for Brazil on board the *SS Formose*. The seventy-two poems he wrote on board included one that confirms how in tune he was with the Surrealists' longing for new horizons, especially with Breton's challenging *Lâchez Tout*:

When you're in love it's time to go
Leave your wife leave your child
Leave your boy friend leave your girl friend

Leave your lover leave your mistress
When you're in love it's time to go . . .[60]

A few weeks later Eluard was also heading across the Atlantic, while, shortly after-wards, Breton, Aragon, Max Morise and Roger Vitrac left Paris together on a cross-country expedition dubbed the *Voyage magique*. During that ten-day walk in Sologne, in central France, the voyages of 1924 reached their peak as Breton, Eluard, Aragon, Morise, Vitrac and Cendrars were all on the move in different parts of the world, while Max Ernst and Gala were preparing to leave as well. After this peak the travels tapered off and concluded in the autumn with the public launch of Surrealism. The Sologne expedition itself, it seems, had helped Breton prepare for the event.

"Soupault, Aragon and I now hope to collaborate on writing a kind of manifesto of the ideas we share," he wrote when he got home.[61] But, as it turned out, he was the sole author of the *Manifesto of Surrealism*, published in October as the Introduction to a collection of his most recent work, entitled *Poisson Soluble* (Soluble Fish), which included writing from the Sologne trip. The publication of the *Manifesto* alongside such work shows how closely the invention of Surrealism was related to travel. The last trav-el writing from that season of itchy feet was Louis Aragon's account of a night walk in the Parc des Buttes-Chaumont, in Paris. It describes one of the major journeys on home ground, in the Surrealists' backyard as it were, and is therefore worth exploring in detail, before we leave the city to follow the longer voyages further afield.

The voyage in the Parc des Buttes-Chaumont

"Works like *Le Paysan de Paris . . .* give one a quite good idea of the mental climate in which the taste for wandering about was carried to its furthest limits. We gave free rein to a continuous search: to see and reveal what is hidden under the surface."[62] To date, Surrealists had roamed a city in which they occupied modest rented accommodation, for the majority could afford no better. Encased in an urban environment, their studios contained and compressed their collective energy and ambition. Such a pressurised concentration of talent and high spirits needed outlets beyond the demonstrations and brawls for which the group was also known.

One such vent has been described by Breton's biographer, Marguerite Bonnet, as *la grande aventure mentale*.[63] The impetus for this *aventure*, as for the group's hooliganism, came from their appetite for reform, especially from their desire to replace the rational lines along which we tend to try to organise the world. Thinking along those straight lines, rationally, had disqualified itself in their eyes. That kind of thinking had planned, organised and maintained the trenches they knew only too well. Looking to change this mind-set, individual Surrealists delved into their mental processes and found escape both from the straitjacket of city life and the mental habits of an industrialised European culture. The organised mind games and séances, during

Fig. 6 Parc des Buttes-Chaumont

which they did this delving, took place behind closed doors that folded the participants deeper into themselves, further compressing their imaginative life. Louis Aragon shows us how they combated its claustrophobia. Evasive action was taken by seeing such cloistered events as unrolling in open spaces, in the wide-open world of the imagination. We know how intense the introversion was from the fact that once the group was in session no-one was allowed in or out and the doorbell was not answered. Yet Aragon remembered these exclusive mind games being played out not behind locked doors, in seclusion, but on "Those beaches of the unknown and of surprise that fringe our mental world."[64] This comment exposes how the inward world of metropolitan Surrealism was complemented by a fascination with open horizons. We can call this reciprocal would-be *plein air* outlet *la grande aventure mondiale*, and see it as the flip side of the internalised *aventure mentale*.

We get an idea of the traffic between these two parallel adventures, the internal and the external, from a letter Simone Breton wrote to her cousin Denise in September 1923. She described how her husband would be forced to take a break from his introspection and get out for a breath of fresh air. As Simone implied, things tend to go flat if you sit about indoors too long.[65] Louis Aragon described something similar. "Suddenly boredom raised its head and chased me from the room. I decided to go and see my friend André Breton."[66] He found friends sitting about stupefied after yet another round of mind games and, like him, in need of a change of air. "That was when André Breton decided to accompany Marcel Noll and I," and they set off into the Paris night to indulge their "taste for wandering about."[67]

Breton was the most rigorous thinker but the least outward-looking of the group. He lived in the same building most of his adult life, surrounded by art and books. The city streets were world enough for him. Marguerite Bonnet described him as "an *internal* voyager."[68] "If one must associate Breton with a particular place that is both real and symbolic," she continued, "it is the forest, . . . for which the city streets were very soon to feature in his imagination as a substitute."[69] The city's towering walls and narrow streets stood for his favourite landscapes, those of northern Europe, with their "natural fortifications of granite and mist."[70] This metaphorical Paris represented Nature. Its quasi-wilderness of squares and streets was enough to satisfy the traveller in him.

In 1924, he made a revealing statement on the subject of physical adventure, in relation to André Malraux's antics in the rainforest of Indochina. "While some of us, like him, are still in search of the adventure of poetry, it's clear that it is not to be found on the road to Angkor."[71] For Breton, major discoveries were not to be made chasing about the world like a Rider Haggard adventurer-hero, but in the solitude of the mind. However, it is an indication of the powerful undertow exerted on the Surrealist group by *la grande aventure mondiale* that in 1924, despite his sedentary nature, Breton was nevertheless forced out of Paris, like Eluard, Aragon and Cendrars, to lead an expedition of his own. He was not to venture as far as Indochina, Portugal or Brazil, but left for a backwater in central France. Even a world-class armchair traveller like him was to find it a year of real, physical travel. "Comes over one an absolute necessity to move."

The night in question Aragon, Breton and Noll stepped out of Breton's studio into Rue Fontaine and wandered off through neighbouring Montmartre. Eventually, "André Breton didn't want to go any further. Marcel Noll suggested we go to Montparnasse, and all I could offer was a drink. That sunset of indecision dragged on until we reached the roundabout at Chateaudun, where accidents like to happen . . . there André Breton suggested a visit to Buttes-Chaumont which was bound to be closed."[72] Breton had chosen a gloomy suburban park with a macabre reputation. In 1871, at the end of the war with Prussia, French troops supporting an independent government in Paris, the Commune, had been stationed at the top of Montmartre, where the Church of the Sacré-Coeur now stands. They refused to surrender to government-backed forces and fought bitterly for two months before admitting defeat. From the heights of Montmartre the victors then blasted neighbouring pro-Commune positions still dug in on the chalk bluffs at nearby Buttes-Chaumont, in newly landscaped parkland. There the Commune rebels made their last stand, turning the gardens into a battlefield. The old chalk quarries had been tidied up four years before, in 1866–67, during the last phase of Baron Haussmann's radical remodelling of Paris. On the map the park resembles a shark's fin skirting the heart of the capital and it encloses a lake, in the middle of which rears a steep rocky island some 80 metres high, topped by a little temple. A bridge across the lake links the temple bluff to the rest of the grounds and was popular venue for suicide, a fact that made it especially attractive to the Surrealists.[73]

Aragon and the others were in search of big feelings: "We went into the Parc like conquerors, so keyed up and prepared for anything, it made us high."[74] Shadowy figures lurked in the gloom; muggers, lovers? "Noll's silent. The path snakes round a steep hill at the top of which a street lamp glows. Against the backdrop of the park at night, let's follow the three friends haunted by weird feelings and by longings welling up from deep in the earth."[75] Aragon's appetite for mighty vistas soon imposes itself on the enclosure. He transformed its fenced lawns and flower beds into a vast landscape, ". . . this park," he said, "will be Mesopotamia to them."[76] He then went on to refer to London, the Crimea, the Black Forest, Ephesus and even reached round the curve of the earth to bring Angkor Wat into focus as well.[77] The trio, it seems, were on a world tour in the suburbs of Paris, dreaming of Angkor Wat, whose vast silhouette, curiously enough, was to materialise nearby, seven years later, during a Colonial Trade Fair.

By the time Aragon wrote these words in the autumn of 1924, the process of integrating the excitement of travel into a new kind of literature was almost complete. Three years before Benjamin Péret had described an imaginary journey in *Le Passager du Transatlantique*, while the following year Robert Desnos had written about another in *Les Pénalités de l'Enfer ou Nouvelles Hébrides*. These experiments with travel writing were now to be capped by Aragon's account of the imaginary, mental voyage that had taken place during a physical expedition in the "real" world.

"Of the forces of nature there is one whose time-honoured power has always been a mystery that affects men deeply; the night."[78] The Surrealists chose the hours of darkness for their walks because, to quote the film-maker Vincente Minelli, the dark has a

life of its own. Once darkness had fallen and the city emptied, side streets could turn into a theatre of the imagination. Aragon reveals how the Surrealists used such night-time expeditions to force inspiration. He subtitled his description "The Feeling of Nature at the Buttes-Chaumont." This seemingly reassuring reference to external reality, to nature, is not what it seems, and deliberately misleads the reader, who is instead shown the real world dissolving into fantasy.

To begin with, the park reminded Aragon of "the sea, mountains, rivers. Travelling. The pleasure of gardens."[79] Yet, as night falls, their outlines blur, and he uses this to lead us away from the external world into his imagination. He was unequivocal about this sleight of hand, bluntly stating "and as for nature, one can see what becomes of her: nature is my unconscious."[80] This was so important he repeated the point. While for most people nature "stands for the exterior world, . . . to me it stands for the unconscious."[81] The hills and waters of the Buttes-Chaumont, like the rivers and mountains of the continents beyond the park, have become props on the stage of Aragon's imagination. This full-blown reissue of the pathetic fallacy reminds us how the radical novelty of the Surrealist Revolution was bound by Romantic tradition. Aragon turned the park, which was a pocket of objective nature in the middle of Paris, into a huge three-dimensional model of his subjective unconscious, through which he wanders as if in a dream. The expedition had begun by taking the travellers out of the internal world of their studio-bound imaginings, into the external world of a public park. No sooner had they arrived, than they transformed it into a metaphor of the very interior world whose airless grip they were trying to escape. It was a juggling act typical of Surrealism, during which the introspective and the extroverted, the subjective and the objective, traded places unpredictably to mutual advantage.

The night was a vital technical aid repeatedly used by the Surrealists to accelerate this transformation. Night blurred the exterior world with a sombre and mysterious glaze resembling the world of dreams. This deliberately induced blurring of the inner and the external world was repeated during the other major expedition of 1924 in which Aragon joined with André Breton, Roger Vitrac and Max Morise. However, the agent blurring the data of the external world on that occasion was not to be the dark, but exhaustion. Like the dark, exhaustion too has a life of its own, one that leads the waking mind into a trance. Its dazed detachment was a feature of this voyage.

The Sologne journey

In the spring of 1924 the Surrealists could also be found experimenting with a new technique.[82] It involved cutting words, phrases and headlines from the press and gluing them to the page, more or less at random, in the form of free verse. Players were issued with newspapers, scissors, glue and a school exercise book into which they pasted their cut-ups. The following vivid collage about the excitement of travel was composed at that time:

Adventurers from Paris
They're about to go . . . They're off
To where joy
elegantly
TRANSFORMS
the din
All that noise . . .
STRANGE THINGS FROM DISTANT FRANCE
The power
of the sea
will come through the gates of Paris
Elusive tones
The law that disrupts the law
The City needs
A TOUCH OF
dream[83]

About two weeks after this was written, the "Adventurers from Paris" walked off the page and out of Paris. While others had already responded to "the power of the sea," four more now left in search of "strange things from distant France." André Breton and the others caught a train to Blois, a destination apparently chosen at random on the map, and set out from there. Their route was also to be random, a strategy designed to maintain a feeling of disorientation that would set the imagination adrift. "We all agreed at the time that a great adventure was within our grasp," wrote Breton,

> "Drop everything . . . Take to the road"; that's what I preached in those days. We hadn't forgotten Rimbaud, . . . But what roads could we take? Physical roads? Hardly. Spiritual ones? Hard to imagine. Nonetheless we thought we could combine these two kinds of road.[84]

The expedition lasted ten days and was a quest on two levels. The travellers crossed real landscapes while exploring imaginary ones, mind and body wandering in synch. The voyage took place at the intersection of inner life and outward being. It was therefore related to experiments with randomness recently conducted with scissors and paste, associative word games, night walks and last-minute train journeys.

The reason for the Sologne expedition was largely mental, to explore "the possibility . . . of escaping the constraints that weigh on supervised thought."[85] We should therefore see it as an attempt to integrate the *grande aventure mentale* with an *aventure mondiale*. The trip took them to a part of France they did not know, where they could easily lose their way, and experience the effects of disorientation. They would then drift along between conscious and unconscious thought. The walk would be "the systematic resumption of the quest . . ." which aimed to "force open the doors of mystery and fearlessly advance over uncharted terrain. . . ."[86] Once again, Breton turned to geographical and directional language to describe mental exertion (a quest, doors of mystery,

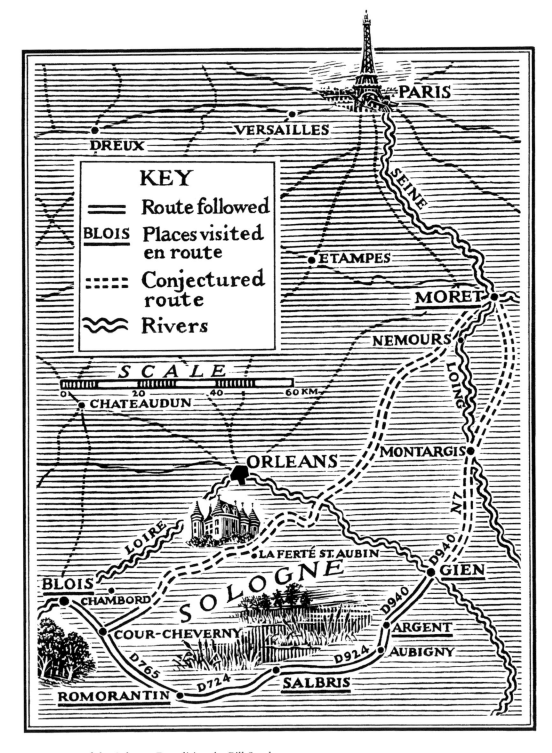

Fig. 7 Map of the Sologne Expedition, by Bill Sanderson.

CONTEMPORARY FILMS PRESENTS *JEAN RENOIR'S MASTERPIECE*
"LA REGLE DU JEU" (A)
(THE RULES OF THE GAME)
starring **MARCEL DALIO** . **CARETTE** . **& JEAN RENOIR**

Fig. 8 Lobby Card. A view in Sologne from *La Regle du Jeu*, directed by Jean Renoir, 1939.

uncharted terrain). This time it involved physical effort. The walkers were more used to café life, desks or darkened rooms where they would decipher each other's cut-ups and hold séances. The walk in Sologne took this experimental activity and tested it for days on end in the open, fuelled by exhaustion.

"We agreed to head off at random on foot, and to keep discussion going all the time, and that the only things we would have to do would be to eat and sleep."[87] Before they left Paris Breton had also made them re-read Eluard's poems, partly because his recent disappearance was so strikingly similar to Rimbaud's. It is another clue to the Sologne trip.[88] The expedition was evidently another way of "doing a Rimbaud," but in Eluard's footsteps. It may even be that Breton took the uncharacteristic step of leaving his studio for the open road *because* Eluard's actions forced him to practise what he had preached when he had written "Drop Everything . . . Take to the Road."

The trip was described by Louis Aragon in *Une Vague de Rêves* (A Wave of Dreams), by André Breton in *Poisson Soluble* (Soluble Fish) and by Roger Vitrac, who wrote an evocation of the *Voyage magique*.[89] These accounts were composed during or soon after the walk. The Paris Four arrived in Blois on Sunday May 4 and headed south. They completed the first thirty-six kilometers, passing through the village of Cour-Cheverny to reach the market town of Romorantin, where they spent the night. It was to be the focal point

of the journey, which started there and finished in the same place on Wednesday May 14, nine days later. On arrival Breton went to a stationery shop, the Librairie-Papeterie Graillot, and bought a school exercise book. He liked school exercise books, and on this journey used two. The literary experiments he conducted in Sologne took the form of short pieces, about 500 words in length, and of those Breton selected two for publication in *Poisson Soluble*. They did not include the first thing he wrote.[90] That Monday in Romorantin he had written, "A car of straw circles the square and bleeding couples who don't know each other are sheltering inside. When the sky is right you can see the fresh shapes of the wind glowing as they fall from high on a rock, in tight green swimsuits."

Romorantin is the capital of Sologne and has been associated with *la France profonde* (olde worlde France), for a long time.[91] "Strange things from distant France" had been a line of the collage composed in Paris shortly before. The place represents just that sort of distant France, an unspoiled backwater and the setting of fairy tales. Breton could not have chosen a more appropriate destination, and this makes one wonder if it was indeed "picked at random on the map" as he claimed. The region's history, geography and character suggest that the declared randomness of his choice of Sologne was in fact the result of undeclared deliberation. The area was unusually appropriate for an experiment that ventured into unknown states of mind, as it was recognised as a place of mystery and disorientation, where, as one writer had recently put it, "there stretched straight and easy as a well-known path, the road to the Lost Domain."[92] The phrase is taken from *Le Grand Meaulnes*, the novel by Alain-Fournier (Henri-Alban Fournier, 1886–1914), which had caused a stir ten years earlier when, as the author's first book, it had almost won the Goncourt Prize. It had located Sologne as a land of reverie and of the quest for an elusive "Lost Domain," the book's title in one English translation. Alain-Fournier was regarded by the Surrealists as a contemporary, and it is hard to imagine that such well-read, ambitious writers as Aragon and Breton were unaware of him and his book's entrancing theme. The disorientating atmosphere of Sologne itself had inspired Alain-Fournier, a native of the region. The book is famous for its intoxicating sense of place which frames "an endless and imperceptible moving to and fro between dream and reality."[93] The phrase sways with same rhythm as the journey on the "two types of road" described by Breton. We may assume therefore that Sologne was carefully chosen (consciously or unconsciously). We should also remember that Alain-Fournier's brother-in-law and literary mentor, Jacques Rivière, was an influential figure in the Paris literary scene. He had helped promote the novel and its unknown author. Breton and Vitrac knew Rivière, and Vitrac had recently published newspaper interviews with both Rivière and Breton. Close to André Gide and to the powerful journal *La Nouvelle Revue Française*, Rivière was admired by Breton, and his death some months later, in February 1925, came as a shock. The close ties between Rivière and Alain-Fournier were common knowledge. This reinforces the view that Breton and his friends explored Sologne in the wake of *Le Grand Meaulnes*.

There was also the lure of vampires drawing them there because the walkers knew Sologne for its creepy chateaux, severed heads and wild criminals from the hugely pop-

ular ten-part film serial *Les Vampires*. Released in 1915 by Gaumont and produced by Louis Feuillade, *Les Vampires* starred the alluring vamp Musidora in a provocative head-to-toe black body-stocking that was an enduring hit with the Surrealists, who wrote a screenplay for her as a result.

Les Vampires opens in Sologne in a chateau where the secret passages are used for the storage of human body parts. The place clearly had an aura.

Sologne is a land of lakes, where woodland and watery reflections stretch for miles in melancholy solitude. It's a huntsman's paradise, with silent paths through quiet forests full of game, enclosed within jealously patrolled estates. Close to the Loire Valley, Sologne is also the location of one of the greatest castles in France, Chambord, and of the perfect waterside chateau at Cheverny, just off the road from Blois to Romorantin taken on the first day by Breton and his friends. Curiously Romorantin is also the site of a famous unfulfilled dream, as unfulfilled as Alain-Fournier's. King Francis I commissioned Leonardo da Vinci to rebuild the town and its chateau, a scheme that however came to nothing, halted by a calamitous epidemic. Romorantin is in the southwest of Sologne, where it is hard to walk cross-country because of fenced-off estates and lakes. Having followed the straight plateau road to Romorantin, lined by claustrophobic woods, next day the travellers continued eastwards through a wooded landscape. For centuries it had been unfit for human habitation. Poorly drained, it used to be known for the *maladie de Sologne*, which caused severe anaemia in sheep as a result of the dire conditions in which they were reared. There "the marshes, designed to swallow all footprints, reveal no trace of those whose burning feet had trampled them at night. And many women have therefore vanished altogether. The place is haunted," wrote Vitrac. "A ring of horrified peasants escapes making the sign of the cross, lambs clutched in their arms."[94] "Metamorphoses are common in the marshes of the region. There's nothing to stop them," he continued, "Travellers can say they've seen lakes sprouting golden swords with mechanical birds flying above and who's to say they're wrong."[95]

The area is criss-crossed by minor roads taken by our travellers. Details of their route survive to help us plot their course. Postcards were sent along the way and the clues they offer, when combined with what Breton and Aragon wrote elsewhere, help us follow them through towns and villages, revealing the general direction of the tour, if not the precise sequence of roads followed. Sticking to the open road and heading northeast, they passed through three *départements*, starting in Loir-et-Cher, continuing through Seine-et-Marne, then turning back southeast through Loiret, before ending in Loir-et Cher once more.[96] The walk covered approximately 380 kilometres (c. 237 miles) in ten days.

From Romorantin they went to Argent-sur-Sauldre, taking the D724 and D924 via Salbris. They probably spent a night in each before heading northwards on the D940 to Gien, where they crossed the Loire on the long bridge from which the town on the far bank, under huge skies, can be seen reflected in the river. It is likely they spent a night there too. The next stretch took them north to Moret-sur-Loing, the furthest point of the expedition. This was a much longer stretch than the previous two and suggests they

spent a night somewhere unidentified between Gien and Moret, possibly at Montargis. The route back south from Moret to the next recorded stop on May 12, at Cour-Cheverny, is so long that two more unidentified overnight breaks would have been needed. On May 13 and 14 the walkers were back in Romorantin, from where they took a train home to Paris.

If we are to get an idea of their pace we should average the distance they covered by the duration of the walk, which suggests they walked about forty kilometres a day. It is unclear what other form of transport they used.[97] The hikers were used to café life and not to prolonged exercise in the open, day after day. Exhaustion and irritation may explain why Aragon and Vitrac had a fight.[98] "But at night Sologne sheds its metallic reflections," wrote Vitrac. "The moon's done with its cold harvest. The frogs are in control, and there's an unnatural link between their croaking and those big crystal needles which grow slowly on church spires."[99]

The road to Salbris runs east for twenty-five kilometres (just over fifteen miles). It meanders by the River Sauldre and the railway line, through forest and open fields, before reaching Argent-sur-Sauldre, mentioned in a postcard Breton wrote to his wife.[100] He also referred to it in the exercise book he'd bought in Romorantin. "The town of Argent began where inspiration ended, well after the rooms set aside for strife and plague. The town of Argent was so long that we'd spent over an hour sheltering behind what's shameful when a bunch of white lilacs was offered to the Judas at the convent."[101] Louis Aragon remembered something else about the place. "There's a surreal light: the one which falls on a counter of salmon coloured stockings, as the cities start to glow. . . . If the houses of Paris are like mountains its because they're reflected in Max Morise's monocle: at Argent [Cher], didn't he vandalise the big crucifix in the railway station?"[102] This helps us picture our group strolling through villages and towns, looking for a drink or sheltering in a waiting-room.

By then they were in the heart of *Grand Meaulnes* territory, with its quiet rivers and distant views; "on the bank where we stopped, the slope shelved gently and was divided into little willow groves, enclosed like tiny gardens. The far side of the river was steep, rocky and grey; and in the furthest distance one could see among the pines little turreted romantic-looking castles."[103] We should, however, remember that this tranquil, barely populated external world of silence and huge forests affected the introspective and invisible character of each Surrealist's experience. The meandering roads and solitude had, after all, influenced Alain-Fournier profoundly. His words apply to our walkers with uncanny precision, "here I am," he wrote, "also on the road to adventure. I'm looking for something even more mysterious. It's the path they write about in books, the old lane choked with undergrowth, the one the worn-out and exhausted Prince could never find."[104]

On Friday May 9 Breton and company reached Moret-sur-Loing. Breton loved this waterside town, first having been posted there in the summer of 1918, during World War One, attached to an artillery regiment. He was moved by its peaceful river setting. Later, in the winter of 1934, he was to return once more and write a series of love poems

there.[105] Moret's charm is familiar thanks to the elegaic pictures of Alfred Sisley. Breton wrote two pieces about his 1924 visit. These were included in *Poisson Soluble*, five months later, with the recently completed *Manifesto of Surrealism*. Such is the dream-like allusiveness of his text that we should not look for obvious parallels between the place and his writing. On this question Breton preferred the word "reflections" to "similarities", which is particularly appropriate given Moret's riverside location. He later claimed the two pieces in *Poisson Soluble* "were set at the Hotel Robinson in Moret and show traces of the reflections of the Loing at the precise spot where Sisley caught them."[106] The sight of Breton by the river stayed with Aragon who wrote "if I close my eyes, I can see him in Moret, by the Loing, in the dust of the powdery tow-path."[107]

Days roaming unknown country blurred the travellers' sense of time and place. It was Louis Aragon who evoked this *dépaysement*, the sunlit counterpart of the darkness in the parks of the capital. "We enjoyed the experience of exhaustion, the disorientation that followed. Visions then appeared," he wrote, comparing this state of mind to shark-infested waters, which he called "surreal."[108] The exhausted walkers, he said, focused on their frayed visions as if diving "into the sea, and like a treacherous sea Surrealism threatened to drag them out into the deep where the sharks of madness cruise. . . . And once they were totally exhausted . . . the first Surrealists saw marvels appear, the great hallucinations that come with religious highs and chemical stimulants."[109] Breton felt the same. "The absence of any goal soon removed us from reality, gave rise beneath our feet to increasingly numerous and disturbing apparitions."[110]

The hallucinations accompanied something else. The aimless roaming was also a way for the travellers to "collage" themselves, at random, to the ground beneath their feet, much as they had cut and pasted newsprint to the page before setting out. In Sologne they therefore engaged in automatic writing and automatic travelling, in search of a Lost Domain which they finally defined as "Surrealism."

Despite Breton's claim that the walk took an unplanned course, its route reveals a coherent circularity. If we have doubts about the randomness responsible for the choice of Sologne, the knowledge that it encompassed Moret and formed a satisfying circular trajectory suggests the guiding hand of Breton at work throughout:

> In the morning, everything comes together with the dew. Ducks paddle about. Oxen wander towards the pond. They wear scarlet dresses with long trains. Cowherds grow with the blood of work. . . . Their silhouette brushes past statues of mist."[111]

Sologne's fortune was secured in the nineteenth century by the advent of the railway, encouraging wealthy Parisians to invade its wilderness for pleasure with newly built chateaux, as the Victorians invaded the Scoltish Highlands at the same time. A quarter of the castles in Sologne date from 1880–1914. The easygoing slaughter of game, the neo-medieval decor of the chateaux and the way of life within, was captured by Jean Renoir in his film *La Règle du Jeu* (1939). Renoir's black-and-white masterpiece, with its tangled woods, open fields and uniformed gamekeepers, brings the Sologne expedition to life, much as Cendrars' poems about life at sea in *Le Formose* help us imagine Eluard's

transatlantic voyage. The moated chateau at la Ferté-Saint-Aubin, where the film was shot, is off the road to Cour-Cheverny which the walkers took on May 12, on the last leg of their tour.

The Sologne expedition was followed, a few months later, by the orchestrated launch of Surrealism. Aragon has given us an idea of how the two events were linked. Looking back he remembered the walk and what it had felt like to plod along on the verge of collapse. During those hours of dazed walking he watched himself, trying to monitor the distortions created in his mind by exhaustion. Intermittent glimpses of the way his consciousness slipped out of sight of itself were all he could manage. It was as close as he got to the controlled use of surreal vision, and it was a discovery almost impossible to describe. When he tried, he slipped back into the language of travel again. "It's only then that you can appreciate the surreal," he remembered, "But you can only describe it by analogy, at best it's an idea which, like the horizon, always keeps ahead of the walker, for, like the horizon, it lies between your imagination and some where you can never reach."[112] And once more Aragon sounds as if he is quoting from *Le Grand Meaulnes*.

Years later Breton looked back at the expedition. "All things considered, the exploration was hardly disappointing." It had worked "no matter how narrow its range, because it probed the boundaries between waking life and dream life."[113] He saw the episode as an attempt to combine two states of mind like traffic on two types of road, one flowing through the conscious mind, the other through the unconscious. They merged in Sologne, probably because Alain-Fournier had revealed it as a place that encouraged the "endless and imperceptible moving to and fro between dream and reality."[114]

Even as spring unrolled around them in the Solange, thousands of miles to the west, under Caribbean skies, Eluard was making for the Panama Canal and the Pacific, on a quest of his own.

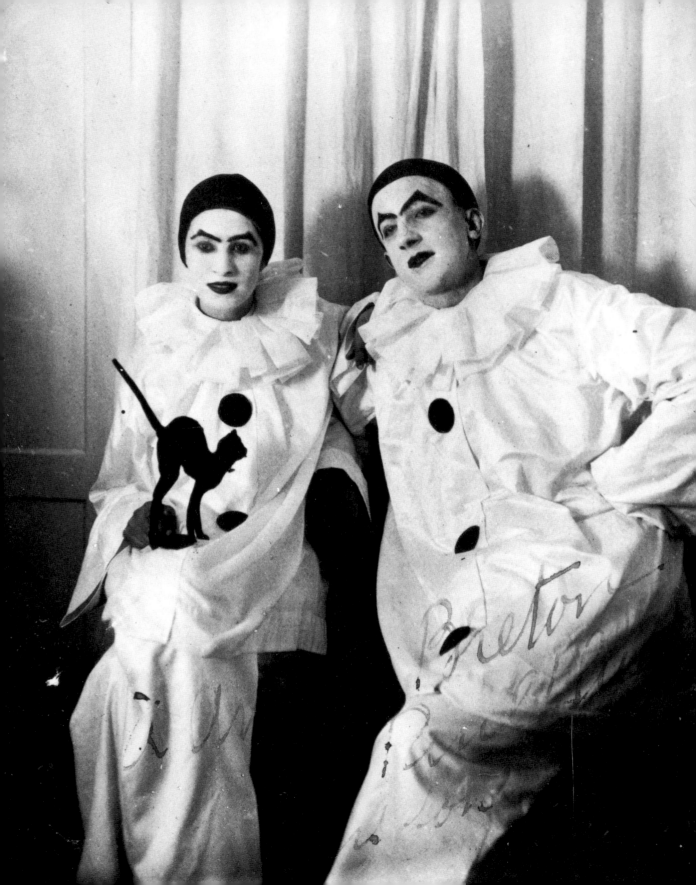

Chapter 3

A LOVE TRIANGLE

It is vital to read between the lines and feel the warmth of their lives We are only entitled to talk about Surrealism if we have had a taste of that reality first.

Jacques Baron. *Autour de Littérature.* 1978

There is a sense in which Eluard's world tour of 1924 began in Cologne, three years earlier, when he first met Max Ernst, an encounter that changed the lives of both men. The meeting turned into a travel-stained friendship that lasted until Eluard's death three decades later. Eluard and Gala had gone to Cologne only to meet Ernst, arriving on November 4, 1921. By then the couple had been married for seven years and had a daughter of six, Cécile. They had met as teenagers, in 1912, in a TB clinic at Davos in the Swiss Alps. Helena, known by her family as Gala, was Russian, while Eluard was the only child of a parvenu and successful Parisian property developer. They had heard of Ernst from their friends, but had missed the Paris opening of his first one-man show in the group's gallery in May that year. The *vernissage* had caused a stir, attended by some 200 people, a slice of *le tout Paris* including André Gide, René Clair and Van Dongen. Because of visa problems in post-war Germany, Ernst could not attend. His pictures did not sell, but Eluard was as impressed as Breton, who had organised the show. Breton and the rest were also in touch with other painters and writers across Europe; the traumatised and angry survivors of war aiming to establish a coalition of protest against such folly.

Soon after Ernst's show some of this informal and subversive *internationale,* including a French contingent, decided to spend the summer together. They chose Tarrenz, a little village in a valley of the Austrian Alps, close to the town of Imst and the River Inn that flows to Innsbruck, about fifty kilometres to the east. Breton, Tristan Tzara, Hans Arp, Ernst, their partners and friends were already dispersing by the time Eluard and Gala arrived on October 3. Eluard was particularly disappointed to have missed Ernst, who had been there since May and had only just gone home to Cologne. Having made sure Ernst was there, Eluard and Gala set off on a journey that, eventually, led to Saigon.[115]

Opposite: detail of Fig. 9 Paul Eluard and Helena Dimitrievna Diakonova.

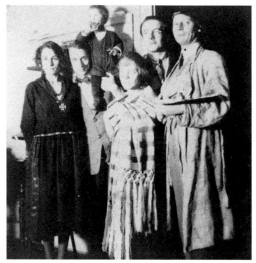

Fig. 9 Paul Eluard and Helena Dimitrievna Diakonova. Clavadel Sanatorium, Davos, Switzerland, c.1913. Musée d'art et d'histoire, Saint-Denis.

Fig. 10 Gala, Max Ernst, Jimmy Ernst, Louise Ernst, Paul Eluard and J T Baargeld at the Ernsts' home, Cologne, November 1921. Musée d'art et d'histoire, Saint-Denis.

The inexplicable predictive streak that haunts the story of the Saigon *rendez-vous* surfaced for the first time when Ernst saw Eluard's visit to Cologne as a stop on a much longer journey. "Eluard on his trip around the world came through," he wrote with absolute precision, although he could not have known it, for Eluard was actually on his way to Paris.[116] It was cold, and photographs reveal that the visitors and their hosts explored the city wrapped in coats, scarves and slouch hats. Ernst was thirty, four years older than Eluard. He was lean and handsome, with blue eyes, fair hair and a physique that has been compared to that of an international tennis player. His diminutive wife Louise Strauss-Ernst was the daughter of a prosperous Jewish milliner, who disapproved of his son-in-law. Ernst had recently been in trouble with the police for creating a public disturbance with an exhibition of contemporary art. The pair had met as students, attracted by a shared interest in the visual arts. Lou was to become a museum curator and an art critic, until outlawed by the Nazis. After working in the resistance she was arrested and died at Auschwitz. She was very different to Gala, being motherly, fair in appearance and open. A set of matchbox-sized contact prints survive of the Cologne visit, shot in the apartment occupied by the Ernsts and their little son, Ulrich (whom Ernst called Minimax, to complement his own alias, Dadamax). One reveals an instant shared by Ernst and Gala. She is wearing the German Iron Cross (the military decoration designed by the Romantic painter and architect Karl Friedrich Schinkel) which

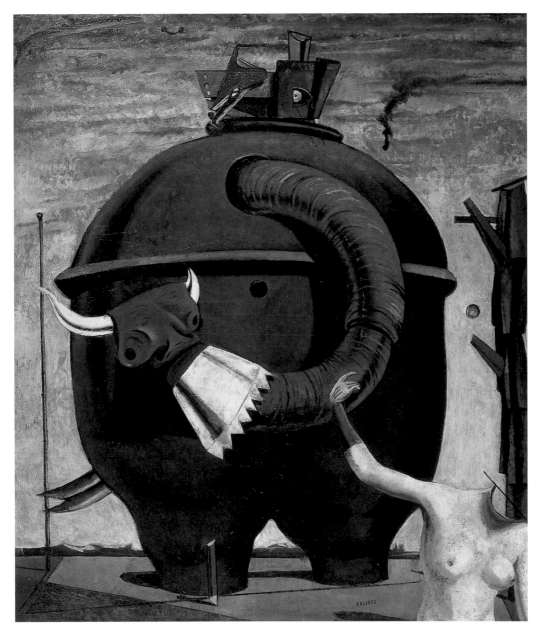

Fig. 11 Max Ernst, *The Elephant of Celebes*, 1921, oil on canvas, 125 cm x 108 cm. Tate, London. S/M 466.

may be taken as a sign of disrespect. It reminds us that until recently the two men had been at war, fighting on opposite sides, as Eluard remembered; "Max and I were at Verdun together and used to shoot at each other."[117] Their friendship was reinforced by this discovery, revealing their mutual rejection of everything about that war; the generals, ministers, bishops, lawyers and industrialists who had made mincemeat of a gener-

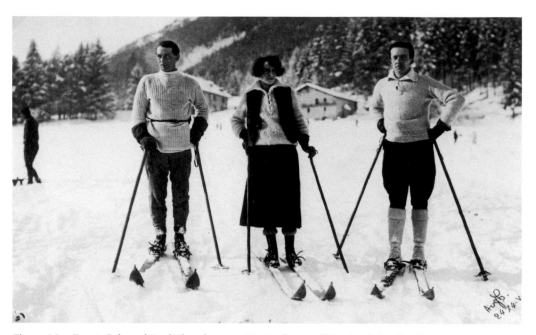

Fig. 12 Max Ernst, Gala and Paul Eluard, *c*.1922. Musée d'art et d'histoire, Saint-Denis.

ation but themselves survived. The imaginative and moral sympathy of the two men was immediate. They also felt an instant urge to collaborate, to improvise like jazz musicians, so that Eluard quickly selected eleven collages by Ernst as illustrations for his next book of poems, *Répétitions* (Rehearsals). He also bought a large canvas, the *Elephant of Celebes*, that accompanied him to Paris with Gala. These were the first of many collaborations in book form and the first of hundreds of works Eluard purchased from Ernst.[118] The couples horsed around, took photographs, travelled to Dusseldorf to see a show of Ernst's pictures, and in Cologne visited a show of work by another artist familiar to Eluard, the American expatriate, newly settled in Paris, Man Ray. The international avant-garde to which they all belonged was increasingly centred on the French capital, now also the focus of Ernst's ambitions—as was Gala herself.[119]

It is clear that, even as the men flared-up imaginatively in each other's presence, something else was moving between Ernst and Gala. The week must have sped by. When it was over, and Eluard left for Paris with Gala and the *Elephant*, Ernst was sad, his feelings apparent in a strange but moving drawing of a hammerhead shark weeping in the deep, captioned "the sadness of those left in Cologne," now among Eluard's papers at Saint-Denis. The ocean, which was soon to play such a part in their lives, made its appearance for the first time in this way, as soon as they met, and was associated, as it would be, with separation. The four months that followed ended when Eluard and Gala returned to Cologne in March 1922 with copies of *Répétitions* hot off the press. In the meantime, Eluard's friend Philippe Soupault published *Westwego*, his long poem about travel, while

Breton was composing *Lâchez Tout* in praise of making a fresh start. Eluard, who could afford to travel as he pleased, was already beginning to put this into practice. His second visit to Cologne was longer, lasting two weeks, and may have included a skiing trip during which Gala was photographed standing on the slippery slope between her two admirers. The photographer may have been Lou, recording their impending slide.

A second collaboration between Ernst and Eluard was agreed, designed both to abolish and yet capitalise upon the distance that was again to divide poet and painter. The medium they added to the process was the mail. Their new book was to be more complex, as Ernst also helped to write the text as well as supply all the images. The experiment incorporated the distance between Paris and Cologne. Through that spring their work developed as the text shuttled by mail across the border to be read, adapted and sent back. The combination of image and text was rehearsed by remote control, with Gala part of the exchange, reading Ernst's work as it appeared, as she was used to do with all Eluard's writing. Ernst would have drawn closer to her as she monitored his correspondence with her husband. This second separation was even shorter than the first as the two couples met again, joining their friends in Tarrenz for the second time, a few weeks later, to spend June, July and August 1922 in the Tyrol. By the end of July the second collaboration was completed. *Les Malheurs des Immortels* (The Misfortunes of the Immortal) was printed nearby at Innsbruck and sent to Paris for distribution.[120] It was a productive moment and for the first time reveals a characteristic of both men, that they could work well under pressure, as they detached themselves from the fuss which filled the summer air, and for which they were responsible. "Summer holidays at Tarrenz again," wrote Ernst later,

> with Eluard, Arp, Taeuber-Arp, and Tzara as usual, . . . Americans arrived by the dozen: writers, painters, musicians, intellectuals and semi-intellectuals; some nymphs among them, two Fates armed with watercolour boxes, a handsome young model (who posed alternately as St Sebastian and the Apollo Belvedere) and numerous hangers-on. Everything was turned upside down. Friendships were made and unmade.[121]

The simmering excitement between Gala and Ernst erupted publicly and, as Ernst said, turned everything upside down. It shredded his marriage, broke Lou's heart and challenged Eluard's equilibrium. There were many witnesses, including one of the young Americans. Matthew Josephson, editor of an avant-garde magazine, the English-language *Broom*, wrote his memoirs in the 60s and has left a sketch of Gala's commanding bad temper and Eluard's sweetness, both characteristics destined to become more apparent with time:"When I first saw Max Ernst he was living with his wife and infant son in a dilapidated apartment of a half-ruined villa by the lake at Tarrenz; he was clad in some worn Tirolean lederhosen and sandals."[122] Overlooking a placid lake surrounded by forest, the lovers slipped the leash. "A powerful electromagnetic current sprang up between the handsome Max and the high-powered Gala Eluard, with the consequence that Max separated from his wife and child and moved into the Eluard

quarters right next door to his own."[123] Lou remembered the decisive part her husband played in unfolding the triangle:

> One rainy day we were all sitting in a room together. M. was helping the Russian with the translation of a book she was reading and he was a bit rude to her. I teased her casually: "Why do you let him speak to you in those terms? He wouldn't dare treat me like that." I realise it wasn't very tactful. M.'s reply was so cruel I'd never known anything like it. He looked up and said: "But I've never loved you as much as I love her." I realised that minute it was all over. And nothing that followed hurt me as much.[124]

Matthew Josephson looked on as "Paul Eluard, having obviously sacrificed his attractive wife in his generous enthusiasm for his friend, made such shrift as he could to play the cheerful cuckold, but sometimes looked restless and nervous . . . saying with a brave grin; 'Well, I love Max Ernst much more than I do Gala.' But we knew he was devoted to Gala."[125] For Eluard the affair began as it would end, by splitting him in two. In this trio the men were as involved with each other as with Gala, and while she brought them together in herself, their relationship outlasted hers with both of them. They were by no means alone in their *amour à trois*. A trio of contemporaries, artists like them, was made famous in *Jules et Jim,* the film François Truffaut directed in 1962, starring Jeanne Moreau. It is based on the loves of the author, Henri-Pierre Roché, one of Marcel Duchamp's lifelong friends. Duchamp, who knew both Ernst and Eluard, also took part in yet another *ménage à trois*, this one involving himself *and* Roché, an inveterate womaniser, like Duchamp. Their *ménage* was explored in *Victor,* another of Roché's writings on the same subject. Love triangles are not uncommon, but their stability is. In the Tyrol

> the affair proceeded openly and stormily, becoming quite a drama in the heavy Russian style—hence somewhat wearisome for the rest of the company. Max carried himself with much aplomb in a difficult situation, as he is wont to do. But Gala showed all the manifestations of melancholy, emotional tension and changeable moods suited to her situation. "Ah, you've got no idea what it's like to be married to a Russian woman!" Eluard sometimes exclaimed.[126]

Gala's frightening rages were to mature. The older she got the worse they became, and her fights with Dalí, involving physical violence, terrified those who saw the decrepit couple yelling abuse and thrashing at each other in public with their walking sticks.[127] Her performance was assessed by a witness to her first extra-marital affair. "Tzara arrived in July, . . . and took in the situation at a glance 'Of course we don't give a damn what they do, or who sleeps with whom. But why must that Gala Eluard make such a Dostoyevski drama?'"[128]

As Eluard had recently been to Vienna with Breton, who had gone to meet Sigmund Freud, we should remember his interest in psychoanalysis. The unfolding affair should

therefore be read in a Freudian light, for Eluard and Ernst would not only have understood what was happening in such terms, they also communicated their dismay and excitement in words and pictures which used them. The results are, as one might expect, ambivalent. The affair is distinguished by its artistic legacy, with its Freudian tinge, and a few examples dealing with the love the men felt for each other shows how they incorporated a psychoanalytical approach in their work. They sent a cheerful postcard in March 1922 to their friend Tristan Tzara, the picture doctored in pencil by Ernst. On the back Eluard wrote, "The king was dancing over a tree. Max, he said before having drunk, I am no longer the only son."[129] Eluard's suggestion that he is no longer an only child, but has acquired a brother, brings with it the baggage of incest because the newly found brother, Ernst, must therefore be sleeping with his sibling's wife, his own sister-in-law, Gala. Not only were the "brothers" sharing the same wife, but Gala could also be considered as their mother, as she was the woman who cared for them, she "mothered" the "brothers." An orthodox Freudian analysis would therefore see Gala as a mother who was having sex with her two sons. The incestuous subtext of such intimacies, which would have been familiar to the two friends, and delighted them, is confirmed by the opening poem of their first collaboration, *Répétitions*, entitled "Max Ernst" that begins, "In a corner agile incest / prowls round the virginity of a little dress. . . ."[130]

Gala played her part in the partnership of her lovers by provoking the mind and body of both artists at once. However, she was not one to share things. She had a feline, exclusive presence that Ernst found challenging, and she liked to focus on her lover and for him to focus exclusively upon her. Apart from her sister, she never had a close woman friend, or indeed any confidants. Her life was a sequence of single-minded relationships, almost exclusively with artists, whose careers she liked to control. She found she had bitten off more than she could handle when she started sleeping with Ernst and Eluard, because each of them was pleased to offer her to the other, thus creating a situation beyond her control. In their eyes she was a token of intimate respect for each other, a position she did not like because she was not in charge. This may explain the Dostoevskian scenes that made her so difficult in Austria and then in Paris. In Lou Strauss-Ernst's understandably jaundiced view, Gala was clearly responsible for the situation. Knowing she had brought this uncomfortable division upon herself may have made Gala even more irritable. Lou wrote of "this slippery, scintillating creature with cascading black hair, luminous and vaguely oriental eyes, delicate bones, who, not having succeeded in drawing her husband into an affair with me in order to appropriate Max for herself, finally decided to keep both men, with the loving consent of Eluard."[131] Dominique Bona, her biographer, has described Gala at this time as "the benchmark of their friendship, as their means of communication with each other, as their shared wife. They made love to each other in her."[132]

The poetry and the pictures born of this union present many insights into the ebb and flow of the affair. Its history, and the welter of feelings generated by passion, jealousy and tenderness, is encoded in the art, but a full account falls outside the scope of this volume, concerned as it is with their voyages to Asia. The three-way relationship

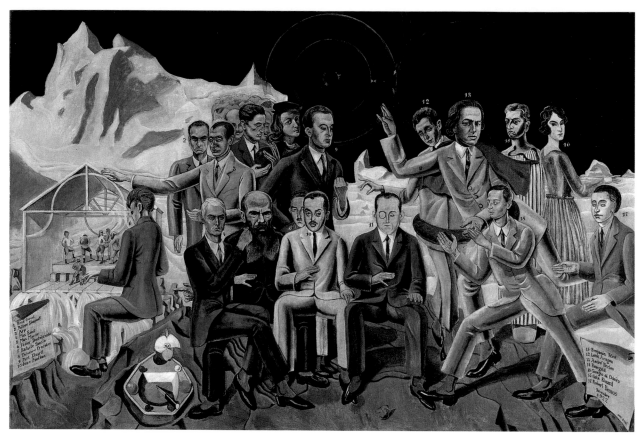

Fig. 13 Max Ernst, *Au Rendez-vous des Amis*, 1922. Oil on canvas, 129.5cm x 193cm. Museum Ludwig, Cologne. S/M 505.

drew closer at the end of August, when Ernst, Lou and their son returned to Cologne as a family for the last time. A day or two later Ernst arrived in Paris, literally as Eluard's double, matrimonially and diplomatically speaking. He came to set up home with the Eluards, having travelled on Eluard's passport; a wolf in sheep's clothing as it were, but wearing the fleece offered by the sheep, thanks to the poet's generosity.

Ernst's painting developed quickly in Paris, so that by the time Eluard disappeared eighteen months later, in the spring of 1924, Ernst had produced an extraordinary body of work. It helps to see this growth in terms of size. Ernst had already begun the process of scaling up his work. To begin with he had concentrated on scissors and paste, cutting up and altering small black-and-white illustrations and photographs from magazines, some of the results being included in the books he and Eluard had just produced. The bizarre combinations of imagery that resulted were often tiny, about the size of a matchbox, and some were hand-coloured.[133] Before he left for France Ernst had enlarged a few of these, turning small tinted reproductions into fully modelled large oil paintings. Eluard had bought one such enlargement, the *Elephant of Celebes*. Thanks to

Eluard's generosity, Ernst accelerated this process and produced many big paintings. Ernst had entered Eluard's world in the guise of an illustrator contributing small monochrome pictures as book illustrations. This diminutive black-and-white world was admired by Eluard and under his care it spread onto canvas in colour, and from there, like a creeper, Ernst's paintings came literally to cover the walls, doors, staircase, bathroom, bedrooms, sitting-room and hallway of Eluard's home. Eluard's roof, his wife, identity, money and friends, everything in fact that Eluard possessed was offered by him to Ernst, who took them and rapidly developed as an artist.

One of the first things Eluard did was to introduce Ernst to his friends, who Ernst commemorated in his large oil *The Meeting of Friends*, 1922. It shows the first Surrealists and their heroes under an ominous sky, only one woman among them, Gala. They are formally dressed, yet something's not quite right, because we know these men in sharp suits, white shirts and slick ties, like Tarantino's *Reservoir Dogs*, are the opposite of what they seem, as their weird hand gestures reveal. Ernst's confident use of a large scale is evident, but is not the only indication of the energy he committed to the picture. The scene is packed with strange objects and gestures that reveal considerable planning.[134] The portraits, which we know are often exceptional, must also have taken time, whether drawn from life or taken from photographs. One portrait is of the *eminence grise* of literary Paris (sporting a dapper moustache) who had done Ernst a favour, as Ernst acknowledged, "Jean Paulhan managed to provide him (Ernst) with an identity card in the name of Jean Paris . . . ," and Ernst continued, as usual writing of himself in the third person, "in Paris he had a rather difficult time. . . . He painted when he could, which was usually on Sunday. Paul Eluard helped him as much as possible by buying pictures from him."[135] Ernst also had to work for a living, doing odd jobs, such as being a film extra in a production of *The Three Musketeers*, or working as an assistant in a plant turning out cheap decorative goods. During the week, Gala would say goodbye to her two men as they were collected by the chauffeur-driven car belonging to Eluard's father and were taken to the station where "They used to catch the suburban train every morning, Paul to go to his father's office and Max to the fancy-goods workshop"[136]

The father realised something unconventional was going on at his son's house, and it made him uneasy. He spoke his mind, as befitted a bluff character, proud of his success, with a fierce temper; he must therefore have disliked Ernst for sponging on his family and compromising them. One can imagine the lowering effect on his son of this paternal suspicion. Eluard spent the day as a property developer, helping to buy, build or sell houses. On occasion this routine was broken by a visit to cafés in Montmartre, where Ernst got to know the other Surrealists and found his feet. They knew all about his life in the suburbs. Barely a week after he arrived Ernst met one of them in the street, who then described seeing Ernst "accompanied by Eluard and their wife."[137] This was the period when the Surrealists were fascinated with séances, and a few days after that meeting in the sheet, the questions put to Robert Desnos during one such psychic session confirm how familiar the others also were with what was going on *chez* Eluard. On September 22, three weeks after Ernst's arrival, Eluard asked Desnos, who was in a

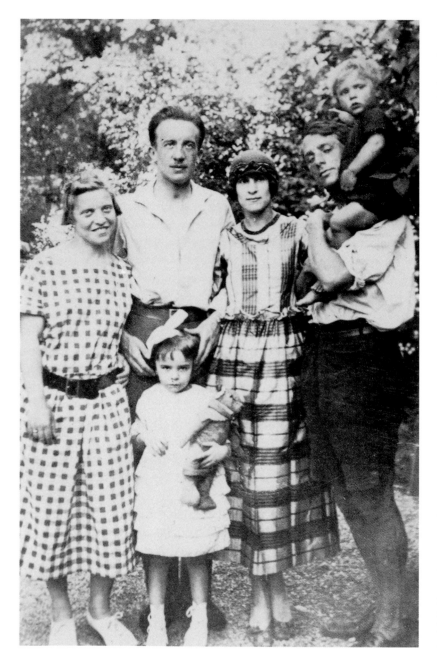

Fig. 14 Louise Ernst, Paul Eluard with Cécile, Gala, and Max Ernst with Jimmy Ernst, 1923–24. Musée d'art et d'histoire, Saint-Denis.

Opposite: Fig. 15 Max Ernst, *Two Children Threatened by a Nightingale*. Oil on wood, 69.8 cm x 57.1cm x 11.4 cm Museum of Modern Art, New York. 1924. S/M 668.

trance, "What can you see about Eluard?" "He is blue." Ernst then introduced himself and asked, in the third person, "What is he (Ernst) going to do?" "He's going to play with loonies." "Will he be happy with those loonies?" "Ask that blue woman," came Desnos' silky reply, referring, of course, to Gala, who was in the dark beside them[138]. Desnos was quick, very well informed and had a wicked sense of humour. For some rea-

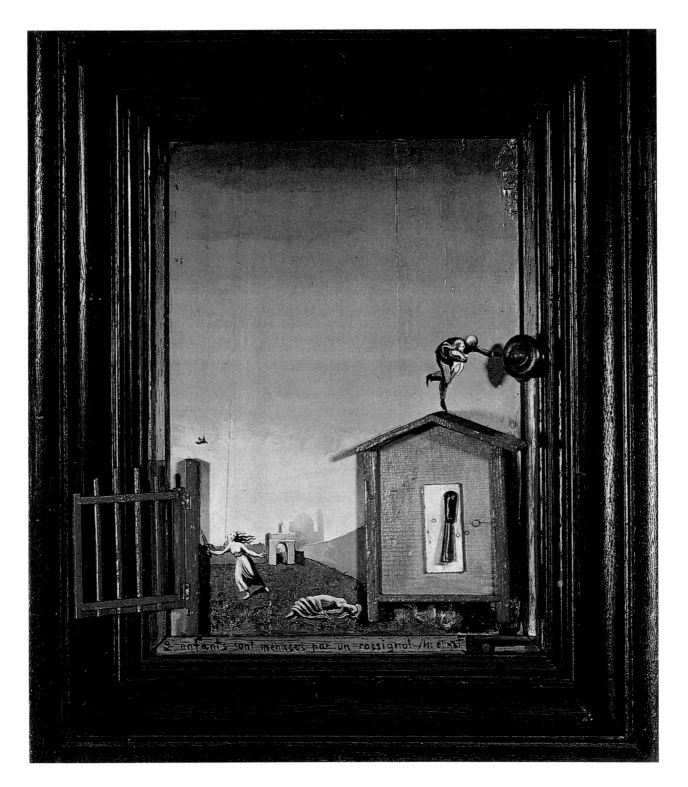

son, he liked needling Eluard, and on another occasion, during a séance at Eluard's home, in the suburb of Saint Brice, where they lived for a while when Ernst arrived, he jumped up, seemingly still in a trance, and chased his host into the garden with a knife. There he was grabbed by Ernst and Breton, the episode giving a twist to the idea of the vanguard being at the cutting edge. Desnos was not the only wit to joke about the love triangle: Benjamin Péret had a go too, coming up with "Paul Eluard loves St Brice & Saint Brice loves Max Ernst." [139]

These quips about the trio were followed by the sexually explicit collaboration Ernst and Eluard soon submitted for publication in the December issue of *Littérature*.[140] Exercise diagrams, drawn by Ernst, show a nude woman and a clothed male, and accompanying ambiguous instructions drafted by Eluard. The article, despite its corny sexual innuendos, reveals the "brothers" going public with the intimacies, real or imagined, they had practised with Gala, or that she, and they, might yet wish to explore. "Seat the lady on the table, holding her arms and legs in a position in which she feels comfortable. Attract her attention to the object, which you should hold over her head. Now begin moving it, lowering it to the right, continuing this movement over her head. . . . Always keep the object far enough away from the lady for her to be unable to grab it. Give it to her only when you wish to reward her for her effort." The identity of the lady cannot have escaped anyone.[141]

Everyone knew that Ernst could do no wrong in Eluard's eyes, as one can tell from what Breton wrote to his wife, "Ernst is finishing a large obscene painting which Eluard says is marvellous; as usual."[142] There is a trace of irritation here, enhanced by the semi-colon, as if Breton wished Eluard would snap out of it. By then there was no going back. Ernst's star was rising. He was asked to provide all the illustrations for the October 1923 issue of *Littérature*, in which Eluard's sad elegy *Sans Rancune* (No Regrets) includes the lines, "He's not asking for anything, he's knows what is going on / He's sad in gaol and sad when free." Another poem, *Nudité de la Vérité* (Naked Truth), runs, "I'm motionless, / I'm not looking at them, / I'm not talking to them, / But I'm just as alive as my love and my despair."[143] Ernst turned his attention to a series of remarkable oil paintings, some of which he must have produced at night and at weekends. These included *Castor and Pollution*, *The Tottering Woman*, *Men shall know nothing of this*, *Pietà or Revolution by Night*, *Ubu Imperator* and *La Belle Jardinière*. Eluard's father was prosperous enough to encourage his son move to a new villa, with a walled garden, and so in April 1923 the trio and little Cécile Eluard moved from Saint Brice to nearby Eaubonne where they stayed until, following Eluard's disappearance, Max and Gala departed for Saigon. The villa, 4 Avenue Hennocque, was quickly adapted by Eluard to suit Ernst. To his father's dismay, Eluard asked a builder to reconfigure the layout of the top floor with new windows, not as a nursery for his daughter, as would have been proper, but as a studio for Ernst, who painted some of his best-known work literally under Eluard's roof. Ernst's famous picture *Two Children Threatened by a Nightingale*, painted at this time, shows a front gate opening onto a walled garden, and the picture may refer, consciously or not, to the attempt Lou Strauss-Ernst had made to resolve

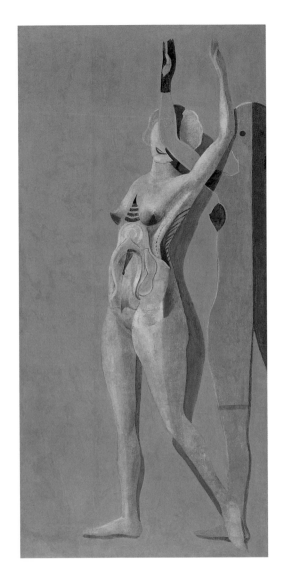

Fig. 16 Max Ernst, *Don't See Reality As I Am*, 1923.
Oil on plaster transferred to canvas,
175cm x 80cm. Musée National d'Art Moderne,
Centre Georges Pompidou, Paris. S/M 643.

matters when she had visited Paris with her son. She would have stayed with Ernst at the Eluards with their young daughter Cécile. The domestic stability of the two children was being threatened by the behaviour of the adults. Ernst may therefore have thought of himself, Gala and Eluard as bewitched by love, as if possessed by the mesmerising song of a nightingale, the songbird so often associated with romance, but here tinged with menace. Ernst and Lou finally divorced in 1926, which did not stop Minimax visiting his father in Paris thereafter.

Soon after the trio had moved to Eaubonne, in the spring, Ernst's painting spilled out of the studio to invade the rest of house. He was to decorate many of his homes later in life with sculptures and murals, but none was colonised as thoroughly as Eaubonne.

On November 10, seven months after the move, the results were shown, at a private view, to a group of their friends. Disturbed by the large nude of Gala and the veiled allusions to life at Eaubonne, Breton took against Ernst's decoration, which he felt " . . . surpasses in horror anything that one could imagine. It's enough to make you miss Boucher." Breton must have been at his most irritable, for Boucher's bouncy eighteenth-century palace girls are no match for Ernst's acid scenes. "To think that the suburbs, the countryside conceal such goings-on," he fumed.[144] The Eaubonne murals are a puzzle; their effect is of a giant hand-painted jack-in-the-box the size of a house, full of surprises veiled in Ernst's visual code. Research has begun on establishing their meaning which will, however, never be fully explained, even if it is clear that the pictures "harbour reflections on the *ménage à trois*."[145] The images are among Ernst's most impenetrable yet easy-to-read pictures. The mysterious scenes are a way into the gathering tension within, but there is no key to the door. We have to experience the images, absorb and decipher, tentatively. Gala, nude and full length, so offensive to Breton, smiles enigmatically over the scene. Some murals may illustrate Eluard's recent poems, so that Ernst by then had not only illustrated Eluard's books, but his house too, turning it into a huge 3-D poem, with walls as pages, which the trio and Cécile inhabited.[146]

For Eluard, going home became more difficult, and he gradually adopted the life of a barfly in the company of his bachelor friends Aragon and Marcel Noll. Word got out that he was throwing money around, buying champagne in night-clubs and then falling asleep at his friends instead of going home, where Ernst and his wife seemed the resident couple.[147] This is when Eluard wrote the mournful and disoriented poems about being an outsider excluded even by those who knew him best. Published in the collection *Mourir de ne pas Mourir*, Eluard feared they might be the last poems he would write, perhaps because he had felt so low for so long it seemed he would never again have anything uplifting to say. In contrast Ernst was on song and his inspiration constant, which Eluard could see better than anyone. It must have tested his reserves of hope and generosity as he faced a future in his father's footsteps, selling low-rent apartments. His treasured friend had occupied every corner of his life, from the recesses of his imagination as a poet to the intimacy of his bedroom, from the front door of his home up to the attic. He was also making the running with his friends. Eluard had given Ernst everything and now stood empty-handed, a hollow man. Then, one Monday evening in March, he got up from the bistro table to buy some matches, walked out and vanished from Paris.[148]

Chapter 4

TO SAIGON

I wanted to go to New York or Buenos Aires
See the Moscow snow
Catch a steamer some evening
To Madagascar or Shanghai . . .

Philippe Soupault, *Westwego*, 1922

For the next twenty-two days Eluard waited by the Mediterranean, in Nice then Marseille. This suggests that after leaving the bistro he had made for the Gare de Lyon. It was, as it remains, the railhead for the Côte d'Azur, its restaurant dominated by an elaborate ceiling painted with snow-capped mountains and sunset seas, where far away is close at hand in images of elsewhere. Nursing his misery by the Mediterranean, he kept in touch with Gala, to whom he later wrote about "the Hotels Beaulieu and de Hollande, where I stayed before my voyage, five years ago, I cried there—how I cried. . . ."[149] There he calmed down and started to plan ahead. We know this from the way he granted Gala power of attorney.[150] What Gala knew about her husband's activities Ernst must have known too. As for Eluard's parents, they had heard from their son at once and his *pneu* to them survives.[151] We should treat it as a farewell *à la* Rimbaud, as well as the gesture of an unhappy husband. It was a complex, ambivalent message:

> 24 March 1924. Dear Father, I've had enough. I'm going travelling. Take back the business you've set up for me. But I'm taking the money I've got, namely 17.000 F. Don't call the cops, state or private. I'll see to the first one I spot. And that won't do your reputation any good. Here's what to say; tell *everyone* the same thing; I had a haemorrhage when I got to Paris, that I'm now in hospital and then say I've gone to a clinic in Switzerland. Take great care of Gala and Cécile.[152]

The curt tone reveals the strained relationship between the self-made property developer and his intellectual son. Eluard's father had made a great deal of money in the northern suburbs of Paris, laying out streets in what had been open country and building terraces of modest homes. Eluard named the streets, often after Surrealist heroes; thus there were the rue Jacques Vaché, the rue Lautréamont, and rue Arthur

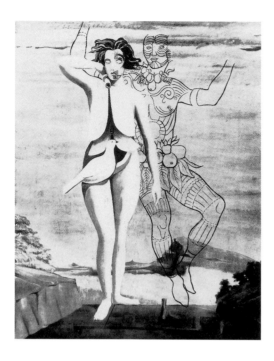

Fig. 17 Max Ernst, *The Beautiful Gardener or The Creation of Eve*. Oil on canvas, 196cm x 114cm. S/M 615. Painting lost, presumed destroyed.

Rimbaud. Eluard offered no word of consolation for his doting mother either, just instructions to look after his wife and child and to tell "*everyone*" a lie about his whereabouts. He underlined the word. Yet somehow, three days later, the news was out and Simone Breton, not someone close to Eluard's parents, knew everything, down to the amount of money he had taken. It was a considerable sum, nearly £16,000 ($27,000) in today's terms.[153] These details must have reached her from someone Eluard's parents trusted, for by sharing the contents of his message they had disobeyed his orders, and presumably only did so with someone close. They would, of course, have kept in touch with their daughter-in-law, so it is possible that Gala was responsible for the leak. There is no doubt she would have told Ernst everything she knew, so he may have been the conduit who passed the news on to Breton, but it is unlikely. We shall never know how word got out. The shock may have loosened Gala's tongue, but it is improbable she told anyone the full story, let alone Breton, when she met him by chance a few days later, as his wife Simone had noted. "Gala's left with 400 F., the little girl, and in an impossible situation on account of Max Ernst. Her parents-in-law will only look after her if he leaves. And he's all she's got. André saw her today, calm. She's looking for work."[154]

The contents of the *pneu*, whoever leaked them, were to be the last his friends heard of Eluard for six months. His departure was a way of putting pressure on Gala and Ernst and of asserting himself. The secrecy he demanded forced his wife and his friend to focus on him. This gesture may have been provoked by the recent exhibition by Ernst of a large painting of a nude woman, *La Belle Jardinière* (The Beautiful Gardener). The picture had been on show at the Salon des Indépendants a few weeks before, in February. We must

Fig. 18 Photograph. The Exhibition "Degenerate Art", Munich, 1937. *La Belle Jardinière* with Adolf Hitler and Joseph Goebbels.

imagine the effect of this on Eluard, who was increasingly unhappy about the way things were going. Ernst's life-size painting was similar to the nude of Gala he had just painted on the wall of the dining-room at Eaubonne, *Il nefaut pas voir la réalité tel que je suis (Don't see reality as I am)* (see illustration 16). Both show a full-length standing nude, arms raised, womb exposed. *La Belle Jardinière* is a picture of Woman in general, as well as of the unique woman in the life of the two friends painted in the summer of 1923, at the height of the affair, for which Gala had posed naked.[155] Eluard could not fail to recognise her.[156] He would have seen the exhibition of *La Belle Jardinière* as the public announcement of his wife's affair. Acting as a dreaded solvent on his intimacy with her, it accelerated his anxiety about losing Gala. His worst fears seemed to be coming true and the exhibition probably felt like another isolating blow. Curiously, the male figure in the painting signposts the direction in which the *ménage à trois* would go, for he is a native of the Pacific, marked with characteristic Marquesan tattoos.[157] He is another example of the way Eluard's voyage via Tahiti to Indochina was prefigured.

To make things worse, *La Belle Jardinière* was popular. Ernst remembered that the work made a favourable impression and had appealed to the collector Jacques Doucet, who would have bought the picture but for his wife's objection to having naked women about the home. Ernst wrote that his work also "met with the approval of the Cubist painters, particularly Braque, Gris and Marcoussis, and of several writers... Breton, Paulhan, Aragon, Ribemont-Dessaignes, Cocteau and others."[158] The exhibition forced Eluard to accept he was not only sharing his wife with Ernst, but with visitors to the Salon as well.

Soon after the Salon Eluard had bolted. From his hotel in the south he then tried to win her back, which he did by drawing her away from Paris and persuading her to meet him outside France, on the *tabula rasa* of neutral ground. This would eliminate intrusions on their partnership, of which the exhibition of *La Belle Jardinière* was an

example, one that may well have been the last straw. The picture itself was destined for even greater notoriety. Ernst took his painting to Dusseldorf for sale soon after Eluard vanished. It was acquired by the Kunstmuseum, Dusseldorf, in 1929, from where it was confiscated by the Nazis in 1937. *La Belle Jardinière*, also incidentally the name of a famous Parisian department store, then went on tour in the Nazis' propaganda show designed to ridicule modern art, *Entartete Kunst* (Degenerate Art).[159] The picture then disappeared and was probably destroyed in the war. "That the Nazis destroyed The Beautiful Gardener infuriated me to such an extent I couldn't resist the temptation to produce another version."[160] In 1967, forty-four years after he had cast Gala in the role, Ernst recreated the painting, but with a subtle difference, exorcising the memory of Gala by masking her face, thus returning the figure to his original vision as the emblematic Woman of his dreams.[161]

To make good the theft of the 17,000 francs, the couple agreed to sell Eluard's art collection, pay back the money and let Gala keep the balance. This is probably why she had been granted power of attorney as recorded in the notes made by a friend, which give a thumbnail sketch of what was going on:

> Scandal. The father furious. Paul disappears one day after sending his father a pneumatique taking 17.000 F. Mme Grindel [Eluard's mother] finds out he's in Nice from where he has sent Gala the power of attorney authorising her to sell everything. She discovers he is going to Tahiti. Max Ernst is living at Eaubonne. Paul writes to Gala asking her to meet him in Tahiti, then in Singapore. Rows between Mme G. and M. G. [Eluard's parents].[162]

Eluard also knew Cécile would be cared for by her grandmother, his mother, Mme Grindel, on whose recollections the thumbnail sketch above was based. Indeed the old lady already took as much care of Cécile as did Gala, who was to prove an indifferent mother.

Why, having waited three weeks by the Mediterranean, did Eluard not wait a little longer and set sail with Gala? The answer, as so often, has to do with money, or the lack of it. Without Eluard, Ernst would now have to pay his own way, and finding the money to do so took time, as did the auction of Eluard's art collection. Eluard may also have wanted to retain the psychological momentum he had established by maintaining a lead and going first. Whether he wanted Ernst to follow is uncertain. Ernst, however, was sure. We have little idea of how Ernst and Eluard felt about each other then. We can assume they were deeply entangled on every level and that tension and stress sometimes led to irritation. We know Eluard's parents wanted Ernst out of the way, but this did not affect the friendship of the two. They kept in touch, independently, and presumably via Gala too, although all trace of the letters and telegrams between them has vanished and only survive by implication thanks to Dorothea Tanning's account. "Exchange of telegrams, Paul, Max, Max, Paul," she remembered.[163] Ernst made a considerable effort to raise the money needed to join Eluard in the East.[164] The twelve weeks between Eluard's disappearance from Paris and the departure of the lovers for Saigon must have been caused by the financial problems Ernst and Gala had to solve.

Point of departure

In the 20s the port of Marseille was the biggest in the Mediterranean and served the steamers that linked France's colonies. On arrival Eluard found himself joining a national ritual: the endless procession to and from *la France d'outre-mer*, on the road to Empire. The port was the capital of *dépaysement* and the effect of its atmosphere on him, as he packed his bags, checked his ticket and worried about Gala, must have been considerable. We get an impression of it from the autobiographical novels of Cendrars, who loved the city.[165] In the words of another enthusiast the port was recalled as

> a place in which waiting was above all demoralising, a sort of twilight zone in careers spent in the colonies or in the colonial armies; the threshold, neither one thing nor another, neither quite the *métropole*, nor quite the African or Far Eastern shore, but suspended in a point of time and space between the two, and so a time and place for uncomfortable self-awareness and self-examination, doubt, bewilderment, hope, and fear.[166]

Similarly bewildered and anxious, Eluard boarded the *SS Antinous* on Monday April 15 and set sail at 5 pm, into the sunset. It would be wrong to imagine him wrapped in a suicidal gloom, however tense he may have felt. To a degree his emotional crisis had been managed before he climbed the gangway, even if the outcome of his claim on Gala was uncertain. Equally uncertain is the extent to which he set off hoping the journey would resolve the tension between his professional obligations as a property developer and those as a poet. The voyage was to affect him, but in ways he cannot have expected. The docks he saw still survive, though much reduced in importance, and were the ship still in existence the visitor would be more likely to peer down the throat of the *SS Antinous'* funnel from above, from the flyover straddling the old dockside road below. Departure from Marseille in the 20s was vividly described by Roland Dorgelès[167]:

> Marseille was completely grey the day I left. The pavements shone in the wet and the clouds were so dark one felt the rainy streets were lighting up the sky. . . . One boards ship at the far end of the city, past miles of warehouses, noisy streets, and jammed docks, where over-loaded trucks and crammed trams rumble by all the time. Coal is everywhere, in heaps, in sacks, as dust. Cranes swing about, ships boom, and flayed old freighters with raw iron hulls exposed in dry-dock are given a lick of paint. . . . My steamer dominates the quay, like an overweight building.

Written at the time of Eluard's voyage, Dorgelès' *Partir* (Departure) is set on board a French liner to Saigon, and is typical of a genre the French call *la littérature d'escale*, port-of-call books, steamship stories.

We know where Eluard went during the next six months because he marked his route on a map in black ink. It took him fifteen days to cross the Atlantic and reach landfall. The *SS Antinous* was bound for Noumea, capital of the French Territory of New Caledonia, on the far side of the western Pacific, and arrived at her first port of call in the

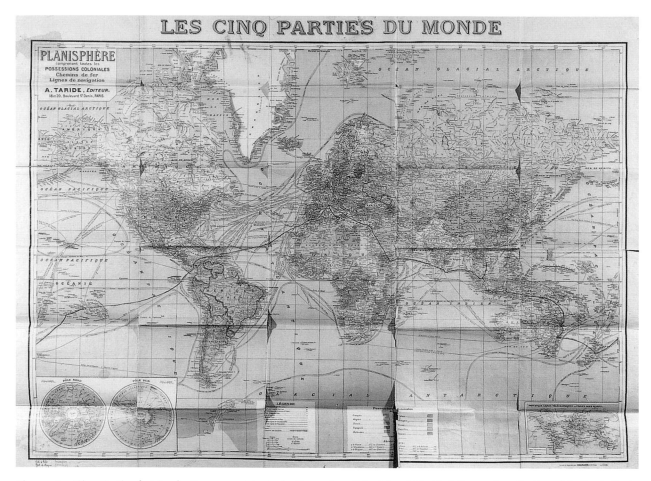

Fig. 19 *Les Cinq Parties du Monde. Comprenant toutes les Possessions Coloniales. A Taride Editeur. 18-20 Boulevard St Denis, Paris.* Musée d'art et d'histoire, Saint-Denis.

Caribbean, Pointe-à-Pitre in Guadeloupe, on May 1.[168] Five days later she put in at Fort-de-France, Martinique, where she remained with engine trouble for some days before continuing due west across the Caribbean to the Panama Canal, during which time Breton and the Paris Four were trudging about the Sologne. At Colón Eluard posted a letter to Gala that not only sheds light on his state of mind, but also poses problems.

Postmarked Cristobal, May 12, 1924, it is addressed to Mme. Helene Grindel, 4, avenue Hennocque, Eaubonne (Seine & Oise), France. The postmark is consistent with his timetable as the *SS Antinous* was recorded by Lloyd's arriving in Colón on May 12 and departing the next day.[169] The Caribbean end of the Panama Canal has Cristobal on the west and Colón to the east. Christopher Columbus is Cristobal Colón in Spanish. Eluard's letter is worth considering carefully because so little evidence of the voyage survives. Its published form, however, is questionable. The envelope is franked and that evidence unarguable, but some of the note it contains may be of a later date, as Eluard's

biographer Jean-Charles Gateau believes. It is in two sections, one from Eluard to Gala, the other jointly addressed to her by Eluard and his friend Roland Tual. Gala is asked by them to visit an art dealer in Berlin and collect a tribal art mask. We do not know if Tual was also travelling on the *SS Antinous*, but it is unlikely, for Tual was a famous gossip and one of the Surrealists' inner circle who would have found it difficult to resist spilling the beans if they had travelled together. Writing of him Victor Crastre said "he was a brilliant talker, he could go on for hours . . . he was easygoing, someone who talked his life away. He went on to a career in films."[170] Tual was one of a number of Surrealists who went into the film industry. He was the Producer of *Espoir* (1939), a dramatised account of the Battle of the Sierra de Teruel in the Spanish Civil War, written and directed by André Malraux and based on his novel of the same title. By that time Malraux had fully developed his taste for adventure that began with his expedition to Indochina, a voyage already under way when Eluard was in Colón .[171]

In his note, Eluard added, "My darling little girl, I hope you'll pass this way sometime soon. I'm bored. I've always written to you. You should have done the envelopes before you left. But you will be consoled by the way I'm going to love you. Wait till you get here to see the presents I have for you. You alone are precious. I love only you, I have never loved anyone but you. I can love nothing else."[172] This fragment suggests Eluard found life on board tedious and that he had already been ashore in Guadeloupe and Martinique to buy presents for Gala. We also learn that husband and wife (with Max Ernst as the unspoken third party) were preparing to meet sometime somewhere in the East, for as Eluard wrote from the Panama Canal, ". . . I hope you pass this way sometime soon." In fact Gala and Max Ernst did not leave France for another eight weeks and when they did so it was to travel through the Suez Canal, not via Panama.

Under two flags

The *SS Antinous's* itinerary was French. Not only had the French conceived the Canal through which she would pass, the ship had called only at French ports. Yet beneath this Gallic exterior, as we have already learned, was an alien core.[173] Eluard's surroundings during his voyage would always be interesting, and not only in terms of geography. For two months he travelled on one of the most unusual vessels there has ever been. In photographs, she looks like an ordinary mixed-cargo and passenger ship managed by the Societé des Services Contractuels des Messageries Maritimes, the mainstay of France's merchant navy. However she had been built in Flensburg, Germany, in 1913, and launched as the freighter *Wachtfels*, before being commissioned in 1916 as an Auxiliary Cruiser by the German Navy and renamed the *SMS Wolf*. The *Antinous's* previous incarnation as a German raider was summed up as follows on the dust jacket of the English edition of one account of her adventures; "The bare facts of the raider's voyage, with its extraordinary setting of deserted islands, coral atolls, secret rendez-vous

Fig. 20 Cover of *SMS Wolf* by K. A. Nerger.
A. Scherl, Berlin 1918.

and hairbreadth escapes makes her story as exciting as any invention of Stevenson. . . .
It is the story of one of the strangest and greatest sea adventures of modern times."[174]

If the *Antinous* could not be taken at face value, neither could her quiet passenger
Eugène Grindel. Paul Eluard (his *nom de plume*) travelled as Eugène Grindel (his offi-
cial identity), while the *SS Antinous* (her present name) had been the *SMS Wolf* (her
nom de guerre). The question of the old *Wolf's* identity is even more complicated, for
she had been a Q-Ship, a naval term coined by the British.[175] While resembling a harm-
less freighter, she had nevertheless been extensively refitted with seven 5.9 inch guns
concealed behind false bulkheads. She also had four torpedo tubes, a device for making
a smoke screen, mine-laying equipment and was the first such German ship to have a
spotting seaplane on board, the *Wolf-cub*. As if this was not enough she shape-shifted
too. She confused her enemy by remodelling her superstructure at will. Her funnel
could be moved, and her masts telescoped. She also carried enough paint to change
colour. For her astonishing round trip via the Arctic to the tropics her cargo holds were
filled with four times as much coal as they thought she could carry. To keep going for a
year and a quarter she had to cannibalise more coal from vessels she captured before
sinking them, and as a result she never entered port. On November 30, 1916, she set off
on a journey that ranks with those of Francis Drake and Vasco da Gama. Her captain,

Karl August Nerger, relaxed by reading Kant and Hegel in his cabin and brought her back to Kiel on February 15, 1918, after a journey lasting 445 days, having steamed 64,000 miles, the equivalent of three times round the world. The *Wolf* had laid half a dozen minefields, sunk twenty-seven ships totalling 112,389 tons, tied up millions of pounds in cargoes and hundreds of millions in the efforts of those who tried to catch her. She brought 40 million marks' worth of captured cargo back to Germany, as well as all the crew and passengers of the ships she had sunk. It was on her deck that Eluard paced for eight weeks, unsure of himself, and, like the old *Wolf*, he too was not what he seemed. He longed for Gala as the distance between them grew.

The *Wolf* had been acquired by the Messageries Maritimes in 1921, as part of German reparations after World War One, and was renamed the *Antinous*. Her veiled past clarifies something else. Such post-war Franco-German traffic in steamships reminds us of the wider context of war damage and reparation and of the barely suppressed hostilities that provided the background for Max Ernst's entry, as a German, into France and therefore into the lives of Eluard and Gala. In the year the *Wolf* was turned over to France, Eluard also bought some pictures by Braque and Gris at auction in Paris. They had been confiscated during the war from enemy aliens. In this case the aliens were two leading Paris art dealers of German nationality specialising in modern art, Wilhelm Uhde and D-H Kahnweiler.[176] At the same time as this xenophobic traffic in confiscated art and steamers, the Surrealists had invited Max Ernst to exhibit in France for the first time. In doing so they deliberately disregarded current anti-German feeling and, as we have seen, Eluard and Ernst later made no secret of their contempt for the authorities that had made them face each other in the trenches at Verdun.[177] Ernst's German

Fig. 21 Broadside view of *SMS Wolf*. From *SMS Wolf*, K. A. Nerger. A. Scherl, Berlin 1918.

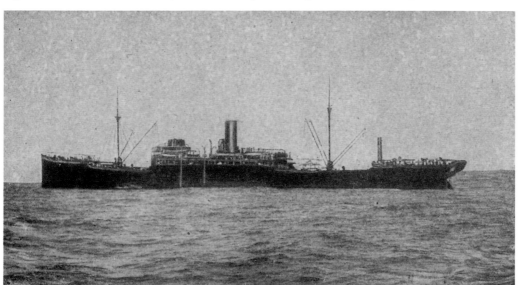

Fig. 22 Fore-deck of the *SMS Wolf*. Her guns are disguised under canvas, behind false bulkheads. From *SMS Wolf*, K. A. Nerger. A. Scherl, Berlin 1918.

nationality was also soon to be used by the Surrealists as the excuse for a demonstration.[178] Ernst had accepted the Surrealists' invitation to exhibit in Paris, but had been refused an exit visa. He eventually arrived the following year, but only after changing his name, like the *Wolf*, and only after Eluard had slipped Ernst his own passport. It was more than gratuitous coincidence for the German *Wolf* to turn into the French *Antinous* and for the German Ernst to disguise himself as the Frenchman Grindel. The ramifications in our narrative of this post-war dance of identities can be measured as much by the German engine pounding under a French *tricolore*, as by Eluard's support of Ernst or Breton's pro-German outlook.

Towards Oceania

The *Antinous* took the Panama Canal. She nosed her way through the jungle from Caribbean Cristobal to Pacific Gatún, gliding cautiously through a man-made landscape of giant locks, her superstructure at odds with the densely tangled rain forest. The

bizarre contrast once again recalls the metaphor attributed to Isidore Ducasse, *Beau comme la rencontre fortuite sur une table de dissection d'une machine à coudre et d'un parapluie* (As beautiful as the chance encounter on an operating table of a sewing machine and an umbrella).[179] Or as peculiar as the presence in the Panama Canal of a surrealist poet on a German raider.

The *Antinous* emerged into muddy coastal waters off Panama City and headed into the blue Pacific, where Eluard found himself in a world very different from anything he had known. His friend Roland Penrose wrote "Eluard loved travel, especially to places he did not know. His imagination was stirred by the disorientation (*dépaysement*) he felt during long train journeys in foreign countries in the company of travellers who were complete strangers."[180] However, the long crossing that followed must have tested Eluard's patience, for it took two weeks to cross an empty ocean before landfall at Tahiti. The pleasures of travel described by Roland Penrose would have dimmed with the stupefying circularity of shipboard life. Eluard's predicament is palpable in a poem he wrote which describes those long days in Oceania, days of suspended animation and inertia:

Jours de lenteur, jours de pluie,
Jours de miroirs brisés et d'aiguilles perdues,
Jours de paupières closes à l'horizon des mers,
D'heures toutes semblables, jours de captivité,

(Days so slow, days of rain,
Days of splintered mirror and of needles lost,
Days of eyes closed to the sea's horizon,
Of hours all alike, days of captivity,)[181]

The lines recall refracted sunlight bouncing in dazzling splinters off the glistening surface of the sea, the unending days, the passing rain and, above all, the moments during which Eluard, eyes shut, tried to remember who he was, surrounded by the dizzying spectacle of a horizon that emptied his mind. It was an experience familiar to many Frenchmen and women who visited Tahiti, among them a surprising number of Surrealists. They joined a procession established by Paul Gauguin in 1891, when he announced he was going to research material for a series of illustrations to Pierre Loti's Pacific idyll, *Le Mariage de Loti* (1880). Gauguin had made the region famous, illustrating the mental map of the Pacific now shared by the French with the rest of the world.

The French exploration of the islands of Oceania had begun in the eighteenth century. The first French explorers of the Pacific are as well known in France as Captain Cook is to an English-speaking reader. They include Louis Antoine, Comte de Bougainville (1729–1811), Jean-François, Comte de La Perouse (1741–1788), Louis Isidore Duperrey (1790–1842) and Jules Dumont D'Urville (1790–1842). Their adventures seeped into French memory, so that by 1913 the archetypal landscapes their work had helped create in the minds of many at home were revisited by Cendrars:

Come on! Come!
Spring in Fiji never ends
Relax
Couples swoon in the tall grass and
 warm syphilis creeps through the banana plantations
Come to islands lost in the Pacific!
To Borneo and Java . . .
And to the island of Celebes that's shaped like a cat . . .[182]

French traffic to those islands, many of which Eluard was to see, grew heavier in the 20s thanks to the shipping lines, whose extravagant advertising further fuelled popular fantasies about the South Pacific.

Tahiti was a particular favourite with those escaping from what Rimbaud had dubbed *l'Europe aux anciens parapets* (the Europe of antique masonry).[183] Gauguin's friend Daniel de Monfried had first voiced the link between that Old Europe and Polynesian myth in a letter designed to cheer an ailing Gauguin:

> you're now the extraordinary, legendary artist who sends back unsettling unique work from the depths of Oceania, the work of a great man who has, so to speak, disappeared from the face of the earth . . . you enjoy the immunity granted those other great men who are no longer with us, you've entered art history.[184]

The fabric of France's Pacific dreams, of which Gauguin's life remains the mainstay, was spun as much on the spot as in Paris. A vital link in that process had been Victor Segalen, who had been advised to visit Gauguin there by the writer Saint-Pol-Roux. Saint-Pol-Roux is the conduit between the Surrealists' interests in the Pacific and the work of their predecessors, and his actions kept France's nineteenth-century past there in touch with the Surrealist present. He was the poet whose banquet the Surrealist famously wrecked, despite their admiration for him.[185] Having acted on Saint-Pol-Roux's advice, Segalen was able to return home with evidence of Gauguin's Pacific.[186] At the posthumous sale in Tahiti of the artist's goods in 1903, Segalen had bought twenty-four items. He gave Saint-Pol-Roux the lintel Gauguin had carved above the door to his house, most probably in recognition of the poet's help in publishing what he had written about Gauguin. Segalen's moving description of Gauguin's last days, *Gauguin dans son dernier décor*, stoked French fantasies about Polynesia with which Eluard was familiar before he left.[187] French culture is a tightly woven, highly inter-connected world, as we can see from the fact that Breton visited Saint-Pol-Roux during 1923–4, and published his work alongside that of Gauguin.[188] The wash from Gauguin's voyages touched Segalen, Saint-Pol-Roux and the Surrealists, especially during the travels of 1924.

The framework that links them was clearly exposed during a speech Segalen had made at another literary dinner in honour of Saint-Pol-Roux, held in 1909. Segalen had himself recently returned from his visit to Gauguin's home in the Marquesas and from Djibouti, where he had traced Rimbaud's last days. In his speech he used the same travel-based language later favoured by the Surrealists to describe the imaginative quest of

Fig. 23 Cécile Eluard, Gala and Max Ernst at Eaubonne with *Woman in the Wave* by Paul Gauguin.

Fig. 24 Eluard in Tahiti wearing a *pareo*.

the two exiled Frenchmen in whose footsteps he had just been travelling. "I am speaking to you tonight," he said to his audience of France's leading artists and poets, "simply as a traveller, treating you not as travellers of the well-worn roads of the world out there, but as explorers of the landscape of ideas."[189] Segalen focused on the parallels between intellectual adventurousness (the *aventure mentale*) and the adventure of travel itself (the *aventure mondiale*), parallels that also propelled the Surrealists. Segalen described his search for the two principal pioneers of that parallel adventure:

> in the jungle and in the sun, in a bright light or in gloom, Arthur Rimbaud, one of your number, left no trace beyond that of an average businessman. Much further away, at the very antipodes of Europe, in mid-Oceania, I almost succeeded in tracking down the other one who had also disappeared.

Speaking of Rimbaud and Gauguin to that gathering of intellectuals in 1909, Segalen had introduced players that inspired the Surrealists, more than ten years later, when they took to the road themselves. In his address Segalen had also been careful to stress

the common ground between actual travellers and those in their armchairs at home, a link of which the Surrealists were only too aware.

Segalen had realised that both Gauguin and Rimbaud had tried to fuse action with contemplation, and to combine an active inner life with an adventurous engagement with the physical world. This had attracted Segalen as it was to attract the Surrealists, who were also caught in the crossfire between action and contemplation. As we have seen, they resolved this, briefly, by combining the two as "automatic travel," perhaps their only original contribution to the practice of *dépaysement* that goes back, via Rimbaud, to Bernardin de Saint-Pierre.

When Eluard neared Tahiti he knew he was entering Gauguin's world. We know this because he owned a painting by the artist. A photograph of the interior of Eluard's home shows it hanging in pride of place, Max Ernst blowing a conch shell, Pacific style, in the foreground. *Woman in the Wave* (1889) is now in the Cleveland Museum of Art. "The large island now rose from the sea, as if dripping wet with white surf pouring from its coral reef," wrote Thor Heyerdahl of his own visit, shortly after Eluard had been there:

> Mountains wilder than shark's teeth bit into the trade-wind clouds of the blue sky. . . . Gauguin, Melville and Hollywood had not exaggerated. Nature itself had exaggerated. . . . Finally we heard the surf. Soon we saw a red church spire piercing the compact roof of the tropical vegetation. More houses. Papeete, the capital of French Oceania. The engine slowed down. We slid through an opening in the coral reef, the surf frothing around us. A little calm harbour. A huge warehouse with a metal roof and a wharf packed with people.[190]

The *SS Antinous* put into Papeete for five days, leaving on June 5. A sweet smell of copra, the sun-dried split coconuts that were the island's main export, filled the quay. Tons of it were to go on once the cargo from Europe had been unloaded. Eluard went ashore. Like Gauguin, he enjoyed the company of Tahitian girls. He photographed some and they may even have accompanied him to a beach where he, in turn, was photographed in an outrigger canoe and wearing a patterned cotton *pareo* wrapped round his waist. Eluard could now experience, if briefly, the Tahitian scene Gauguin had painted. Papeete was the capital, but it was a modest place. There was no road around the island, just a bumpy track stretching some kilometres on either side of town, along which there trundled a few cars and buses piled high with luggage, boxes and passengers. Travel was mostly on foot or by horse. Between the islands transport was random.

Oceania, the Surrealists and *le cinéma éxotique*

The steep green mountains of Tahiti and the islands of French Polynesia are scattered across the horizon like vast jagged fins and form one of the most dramatic views on earth. "The usual backdrop," wrote Segalen on board the *Durance*, "and always the same

great verticals sweeping down."[191] Other photographs by Eluard reveal the tangled vegetation that clung to sheer mountainsides and show him on an expedition wearing a pith helmet. Tahiti was remote and very few ships went there, yet within a couple of years a detachment of colleagues followed him from Paris, with consequences that were to merge elements of the Surrealist project with the new cinema of documentaries exploring exotic locations, peoples and places. The first to follow Eluard, in 1925–26, was Jacques Viot, art dealer, screenwriter, journalist and poet. Viot became Ernst's dealer after the artist had returned from Saigon, and also represented Hans Arp and Joan Miró before disappearing suddenly, like Eluard, to end up in Tahiti. He lived there under an assumed name for two years before vanishing again, via New Guinea and Borneo, to reappear in Shanghai.[192] The second Surrealist to follow was the painter Emile Savitry, the only Surrealist born in Indochina. He made two journeys to the Pacific in the 20s.[193] After the unexpected success of an exhibition of his pictures in Paris in 1929, he set off in search of new horizons. In the Marquesas, where Gauguin had died, he was invited to collaborate on the still photography of the Hollywood dramatised documentary, *Tabu*, directed by FW Murnau. Influenced perhaps by the zeal that had recently gripped his friends, Savitry gave up painting and went into photography.

The third Surrealist to follow was the painter Georges Malkine, who travelled to Oceania with Savitry, where they fell out over a woman. In going to Tahiti Malkine had joined a growing list of artists and film-makers that included Henri Matisse, F W Murnau, and Robert Flaherty. Their overlapping voyages formed a tangled web through which there ran a Surrealist line. A summary is revealing.

The year before Eluard arrived, the documentary film-maker Robert Flaherty, director of the hugely successful Arctic documentary, *Nanook of the North* (1921), had organised an expedition to Samoa to shoot his tropical follow up, *Moana* (1923). This was to have been followed in turn by another Pacific island feature, shot in Bali and co-directed with FW Murnau. This project eventually evolved into the feature film *Tabu*, on which both directors collaborated. Released in 1931, *Tabu* won an Academy Award for its principal photographer, Floyd Crosby, but not before Henri Matisse had arrived and been photographed by Murnau himself. Matisse might even have been photographed by Savitry, who by then had been working on *Tabu*. Matisse, who had no interest in Surrealism, then returned to France having sailed to Bora-Bora, the Society Islands and the Tuamotu Archipelago. His memories of the voyage to Tahiti resurfaced in such pictures as "Oceania, the Sky" and "Oceania, the Sea", produced after the war.[194]

Malkine's 1929 voyage had been inspired by the MGM location feature *White Shadows in the South Seas*. Released in 1928 and known in France as *Ombres Blanches* (White Shadows), it also won an Academy Award for its photography of the Pacific, for which Robert Flaherty was also partly responsible. Eluard, by then back in Paris, but still fascinated by the Pacific, saw the film.

Over the Surrealist voyages flickered the silver screen. Movies entranced the public with images shot by increasingly adventurous cameramen. The sustained travel documentary was invented at this time and an appetite for exotic landscapes became a major

box office attraction. Pioneers like Ernest B Shoedsack and Merion C Cooper released *Grass* (1925), the record of the annual migration of nomadic Kurds in Persia, the same year as *La Croisière Noire* (*Black Cruise*) played to Paris audiences. This was the record of an expedition across Africa, funded by Citroën, the French car manufacturer. Shoedsack and Cooper then released *Chang* (1927), shot entirely on location in the rain forests of Southeast Asia. The French feature film set in the Pacific, *Cain, aventure des mers éxotiques* (1930) directed by Léon Poirier, a veteran of the Citroën Expedition, added to the parade of exotic locations.[195] The hold of such movies on their audience was enhanced by exciting technical innovations like the use of much subtler panchromatic film stock, used for the first time to shoot the lagoons of Samoa in *Moana*, and by the arrival of the talkies, which reached France in 1929. Willard Van Dyke not only directed *White Shadows in the South Seas* with Flaherty's help, but also directed *Trader Horn* (1930) a film with footage shot around Lake Victoria, before directing the first Tarzan talkie, *Tarzan the Ape Man* (1932). It is in the light of this popular fascination with the sights and sounds of the boundless horizon, of distant plains and jungles, that we should also look at Ernst's pictures of oceans and ruined cities lost in the rainforest.

The landscapes Ernst painted after his return, such as *The Great Wall of China*, are framed by this twentieth-century craze for the exotic, which in France had originated in the eighteenth century with Bernardin de Saint-Pierre's *Paul et Virginie*. Saint-Pierre's *littérature éxotique* therefore led to a *nouvelle vague* of *cinéma éxotique*, which was accompanied, in the visual arts, by paintings and illustrations on similar themes, a tradition to which Ernst contributed. When Shoedsack and Cooper turned from documentaries to features and made *King Kong* (1933), they entered territory also occupied by Ernst with his pictures of jungle ruins. These paintings were executed as *King Kong* was released to terrorise moviegoers. The ruined city in the jungles of *King Kong* is an image of great complexity and another example of our theme, being in fact the ancient capital of Judaea, Jerusalem, but a Jerusalem abandoned and overwhelmed by the rainforest. This bizarre creation was the result of decisions taken by RKO Studios, who produced *Kong*, to distress the set they had originally built for Cecil B De Mille's *King of Kings* (1926), and then smother it in jungle, much as Ernst's ruined city was smothered by him. Thus the world of the *King of Kings* doubled as *King Kong's* lost jungle domain.

Eluard had been the first Surrealist in the Pacific, followed by Viot, Savitry and Malkine. To them we must add three photographers with Surrealist credentials. In 1933 Jacques-André Boiffard and Eli Lotar boarded the *SS Exir Dallen* with their cameras for a world trip that took them through the Pacific. Their photographs were then exhibited in Paris. In 1934 Roger Parry published a book of his own photographs, *Tahiti*, that was the result of two expeditions by him to the region. When seen as a group these voyages are strikingly formulaic. Yet this Pacific diaspora of Surrealism is little known, and the story of the decade during which seven Surrealists trailed around Oceania remains untold.

Via the New Hebrides to the Dutch East Indies

The *SS Antinous* left Papeete on June 5 bound for New Zealand. While doubts about Eluard's trip hover like gulls over a steamer, and allow us to speculate that he may have disembarked in Tahiti to wait for a cable confirming Gala's itinerary, it is likely he hurried on aboard the *Antinous*. Steamers heading west called infrequently. As his map shows, the ship took him next to Rarotonga in the South Cook Islands and then headed southwest. Crossing the South Pacific Basin she approached the Kermadec Islands, the northernmost of which, Sunday Island, had witnessed one of the triumphs in the *Antinous'* previous role as a German raider. The old *Wolf* had captured two ships nearby and sheltered in the lee of Sunday Island to strip them. Captain Nerger took both crews on board before sinking the ships to cover his tracks and sailing for New Zealand. Seven years later, with Eluard on board, the *Antinous* was following the same course as she had when she mined the North Cape of New Zealand, and then laid forty-five more in the Straits between Wellington and South Island. By then she had mined Cape Town, Bombay, Colombo, and Wellington. To reach her final target she had to steam north, straight into the lion's den, and mine the extensive British naval base at Singapore. Unlikely as it seems, these hit-and-run operations also teach us something about what life at sea was like for Eluard and Max Ernst, and therefore offer a clue as to how their voyages affected them and reappeared in their work.

The ease with which the *Wolf* could hunt unseen reminds us of the isolation of shipboard life then, and invites us to imagine its effect on Eluard and Ernst. A strong sense of this oceanic isolation is evident in the seascapes Ernst painted soon after. The solitude of life on board then no longer exists, in an age of global satellite surveillance, rolling news coverage and air travel. The remoteness explains why the *Wolf* was never caught, surviving to sail on as the *Antinous*. On one occasion she avoided fifty-five ships of the Cape, East Indies and China Commands, and on another slipped away from fifty-one ships of the Japanese and British Commands sent to find her in the Indian Ocean. Did Eluard know of the *Antinous'* previous existence? Since this voyage was only her second on a new route across the Pacific, it is likely her epic previous history would have been discussed on board. One of her biographers, Roy Alexander, was captured by Captain Nerger and held as a prisoner of war on board the *Wolf*. He wrote "I did not go near her when she returned to the Pacific as the liner *Antinous*, flying the French flag." Her remarkable history had caught up with her and was therefore public knowledge.[196] Eluard disembarked in Wellington, after a run of eight weeks and two days, leaving the *Antinous* to continue her voyage north to Noumea in New Caledonia and its infamous penitentiary, from where she turned about and headed home to Marseille.

Although we can follow the rest of Eluard's journey from his map, we cannot tell how long he spent in the ports he marked, nor how he travelled. It is likely, but not certain, that he took a Dutch boat, for he called at ports in the Dutch East Indies. Leaving Wellington he reached Sydney, then Brisbane, before skirting the Great Barrier Reef northwards to the Coral Sea. Ahead lay New Guinea and, to the north of that, the

Bismarck Archipelago. He was entering territory of great imaginative and cultural value to himself and to the Surrealists, not only on account of its distinctive art, but also because of the attraction the Archipelago exerted on Surrealist armchair travellers.

By now Eluard's friends in Paris had come to believe he was in the New Hebrides, an island group to the east of his present position. If Eluard was to be as near to the New Hebrides as he ever got, he was closer still to the islands of New Ireland and New Britain in the Bismarck Archipelago. The names of Melanesian islands have changed frequently as European states have argued over ownership, nowhere more than over the island that haunted Eluard as collector and poet, New Ireland. Between 1884 and 1914 it had been the German colony of New Mecklenberg, a name which Eluard sometimes used. However before that it had been known as New France, and the scene of a nightmarish French colonial fraud.

Eluard was therefore not the only Frenchman interested in an island which had, some forty-five years before, featured in a sensational trial at home, just as the French were also establishing themselves in Indochina and building Saigon. In 1877, inspired by a visit to that new colony, one Charles-Marie-Bonaventure du Breil, Marquis de Rays, decided to try his own hand as a freelance imperialist elsewhere on the fringe of the Pacific. The Marquis had little in common with Eluard apart from an interest in New Mecklenburg. Eluard's voyage did however take him close to New Mecklenberg and this nourished a sustained and benign fascination. The Marquis' interest was unscrupulous.[197] He began by declaring himself King Charles I of New France, as he called the southernmost promontory of New Mecklenberg. There was no authority to resist his claim to a place he had discovered in a book by the French explorer Louis Isidore Duperrey (1786–1865). New France would be built from scratch, a brave new world in Melanesia. This Utopia was a lie that killed hundreds of fee-paying French and Italian settlers of modest means. Believing the promotional literature for the phoney colony and its promises of paved streets and trams, subscribers were shipped out to scenes of Conradian horror. The first advertisement appeared in 1877 and the Marquis was finally extradited from Spain in 1883 to stand trial at home. Revelations that he had sent over six hundred men and women, in three large ships and some smaller craft, to starve in the back of beyond caused a sensation. More than three hundred remain unaccounted for to this day. Rays was gaoled for six years and given a modest fine, even though he had collected the equivalent of two million dollars. He died a free man, shamelessly going about as Charles I of New France.[198]

The episode was another, if rancid, expression of French Pacific dreams. However obliquely, the fraudulent colony is related to the Pacific visions of Gauguin, to the voyages of Eluard, Malkine and Matisse as well as to the writing of Cendrars and Loti about islands lost in Southern Seas.

Five years after he had sailed those seas, Eluard was still hankering after them. Isolated in an Alpine clinic, and suffering from tuberculosis as his marriage to Gala unravelled, he wrote to a friend "I'll come and see you before I go. I'll come on my way to Marseille, and please don't tell anyone, but we can't bear it here anymore. We're going

Fig. 25 Man Ray, *Marine*. Reproduced in *La Révolution Surréaliste* 4. July 1925, p.13.

to New Guinea, to New Mecklenberg, to the last really wild places left. Gala loves travel. As for me I'd love it if I never came back . . ."[199] Nursing his illness in the Alps, he read about the Pacific and wrote a poem in prose about *L'Art Sauvage*.[200]

Later, in 1936, in his meditation about the islands of Melanesia, *L'Habitude des Tropiques* (Tropical Habit), he included many photographs of tribal art.[201] Among the masks and the shrunken head of a white man are items from New Guinea, New Britain and New Mecklenberg. The quantity, breadth and quality of his collection of such art has not been assessed, nor has its history; some of it may have been acquired by him en route.[202] Eluard was especially attracted by the art of Melanesia and it was in Australia and in transit through the Dutch East Indies that he had the best chance of acquiring it.[203]

His ship then took a westward course, through the Torres Straits between Cape York in northern Australia, and the southern coast of Papua New Guinea. We must imagine his steamer lit up in the tropical night like the *Marine* Man Ray published a few months later.[204] To the north lay the coast of south-western New Guinea, at the time part of the Dutch East Indies, where the Digul River empties into the Arafura Sea, having flowed some 400 miles down the southern slopes of the Jayawijaya Range.

Fig. 26 A steamer on the Digul River, the only route to the concentration camps of the Upper Digul, *prev.* Dutch East Indies, now Irian Jaya, Indonesia. L. K. A. Schoonheyt, *Boven-Digoel*. Batavia. 1936.

Eluard would later have reason to remember his journey when he discovered, in the 1930s, that the Dutch authorities had constructed a number of concentration camps deep in the jungle of the Digul. Eluard's voyage through the Dutch colony took place as it reached political boiling point. In 1926–27 the Dutch East Indies erupted in a series of Communist-inspired rebellions which came to the attention of the Surrealists in Paris.[205] Convicted revolutionaries were sent to the Digul River camps of Tanah Merah and Tanah Tinggi. The latter was five hours up river by steamer and vividly re-created the desolation of Joseph Conrad's *Heart of Darkness*.

"Escape was impossible because of the location, inaccessibility of transport, and surrounding jungles," wrote one ex-inmate, Soetan Sjahrir, who later became Prime Minister of the Republic of Indonesia. Head-hunters lived in the region, and on the banks of a crocodile-infested river some four hundred political prisoners built their own huts, felling timber in temperatures that regularly reached 100°F (40°C).[206] Over one thousand prisoners were sent into exile there, and the camps remained active through the 30s, when Eluard protested against them in the magazine *Le Surréalisme au Service de la Révolution*. He described the plight of one such prisoner, "the Communist Deputy Sardjono, at present deported to the concentration camp in the Upper-Digul in Dutch New Guinea . . . ," an act which Eluard saw as part of a global culture of repression. "It's like that all over the world," he wrote, "in Morocco, in the West Indies, in Madagascar, in China, in Africa."[207]

Soon after Eluard left the region, Jacques Viot arrived on the north coast of New Guinea. He paddled into the tropical wilderness of Lake Sentani, below the Cyclops

Fig. 27 Prison Camp at Tanah Tinggi, Upper Digul River, *prev.* Dutch East Indies, now Irian Jaya, Indonesia. L. K. A. Schoonheyt, *Boven-Digoel.* Batavia. 1936.

Mountains, and, like Eluard, was moved to protest against the repressive behaviour he observed. The extent of the Surrealists' adventures in the developing world is disconcerting.[208] Eluard's entry into Dutch waters was part of his continuing exposure to the negative effects of colonial imperialism. It is clear from his work that the experience stayed with him. As his visit to the Dutch colony was immediately followed by a period in French Indochina, Eluard found himself directly exposed to a substantial dose of colonial life. We can guess his reaction to it from the tone of reports coming out of the region. The adjacent colonies of French Indochina and the Dutch East Indies watched each other anxiously, as is evident from this article about the rebellion that was to send so many to the Upper Digul. "Let's not forget," wrote a French journalist, "that in a neighbouring colony, in Batavia [capital of the Dutch East Indies], a revolution masterminded in Canton resulted in hundreds of casualties and almost took the whole government hostage. Is this what we want in Indochina?"[209]

Eluard's transition from dreaming of the New Hebrides and New Mecklenberg to the realities of life in the Dutch colonies plots a transition on the mental map of Surrealism whereby the traveller moves from the ideal landscape of poetry to the iron rations of social reform. As he steamed through the islands of the Java Sea, the dream world of the armchair traveller headed for political engagement. New Mecklenberg, barely explored and full of extraordinary tribal lore, stood for the mysteries of the human imagination, while the Digul River represented the state-sponsored violation of human rights. The voyage from one to the other revealed the collision of European colonial culture with native ways. Eluard's response to this experience is to be found in the article he wrote within weeks of his return to Paris, "The Abolition of Slavery," with its reference to Pieter Erberveld.[210] This name reveals the extent of Eluard's knowledge of the political situation in the Dutch East Indies, and tells us he had learned of the life and death

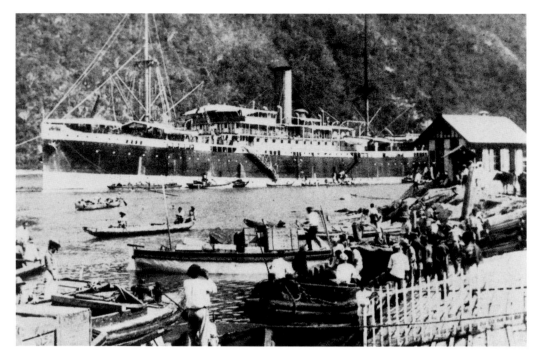

Fig. 28 A steamer of the KPM Line (Royal Dutch Steam Packet Navigation Co.) at Gorontalo, Celebes, *prev.* Dutch East Indies, now Sulawesi, Indonesia.

of a hero of the local independence movement. Erberveld was a powerful Eurasian, executed by the Dutch for his part in an abortive revolution against them in 1722. His skull was then displayed in Old Batavia on the only section of his house that was not demolished. He became a local hero, which explains why Eluard had heard of him. He may even have seen the skull in situ, speared and mounted on a wall, when his ship called at Batavia. Eluard was to visit six Dutch ports, Makassar, Surabaya, Semarang, Cheribon, Batavia and Muntok before reaching British territory in Singapore. We do not know whom he met on his travels and no record survives of his thoughts.[211]

His memories of the Dutch colony would give a personal edge to his anger at the accidental destruction by fire of the display of native arts in the Dutch Pavilion at the Exposition Coloniale in Paris in 1931. As we shall see, the main attraction of this international exhibition was the replica of the Temple at Angkor Wat, a blatant display of colonial power that infuriated the Surrealists. Their frustration at the destruction of so much tribal art displayed as colonial trophies would have affected Eluard deeply, for he knew where the art came from better than most of his colleagues. "The pavilion which without a blush journalists call 'Dutch' housed what were unquestionably the finest examples of the intellectual life of Malaya and Melanesia," read the Surrealists' protest. It also claimed the fire was "the final chapter of a colonial enterprise that began with slaughter and continued through religious conversion, forced labour and disease."[212]

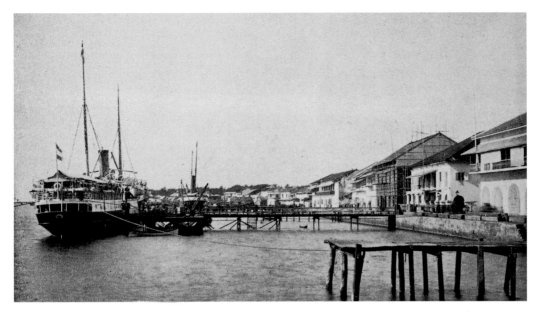

Fig. 29 Port of Makassar, capital of the island of Celebes, *prev.* Dutch East Indies, now Sulawesi, Indonesia.

Eluard entered the island world of the Malay Archipelago through the Arafura Sea. He was on his way to Makassar, capital of the island of Celebes, present-day Sulawesi. He crossed the Banda Sea and the Flores Sea before turning north to the island Max Ernst had referred to in a picture Eluard had bought three years earlier, in 1921, on his first visit to the artist in Cologne, the large canvas *The Elephant of Celebes* (fig. 11). Its low straight horizon and mountain peaks would have come to mind when Eluard saw the island in the distance. Makassar was familiar to Joseph Conrad as one of the sweetest harbours of the Archipelago where he set *Lord Jim*, which Eluard was reading at the time.[213] Makassar looked more European than Asian, and its association with Conrad gives us a glimpse of Eluard's state of mind. Makassar's waterfront was protected by an offshore coral reef that allowed the port to be set directly on the sea, like a Mediterranean harbour. The original Portuguese and Dutch front faced the horizon, and the narrow streets behind had white-washed houses with green shutters and intimate enclosed gardens. So protected was the coast by the reef that the buildings on the quay were only separated from ocean-going steamers by simple wooden jetties. The heavily wooded and mountainous southern coast of the island was very different from what lay ahead in Java. Conrad's vivid description in *Lord Jim* sets the scene of departure:

> The twilight lay over the east, and the coast, turned black, extended infinitely its sombre wall that seemed the very stronghold of the night; the western horizon was one great blaze of gold and crimson in which a big detached cloud floated dark and still, casting a slaty shadow on the water beneath, and I saw Jim on the beach watching the schooner fall off and gather headway.[214]

The northern coast of Java, which Eluard reached two days later, is deeply grooved and studded with volcanic cones, while the undulating coastline is rounded by extensive cultivation. Eluard arrived at the start of the dry season, and his days would have followed a regular pattern. Rain came briefly at sunrise, for clouds that formed at night emptied at dawn and dispersed. Steaming along the coast,

> one sees a small heavy cloud approaching with an opaque curtain of rain hanging from it. As it comes nearer, the sound of falling rain is heard and then, heralded by a squall of wind, it envelopes everything in the immediate vicinity, blotting out all detail; but meanwhile a neighbour a mile away may be free from rain and enjoy a distant view.[215]

As visibility at sea increased in the morning light, the reverse happened on shore, where low-lying land was gradually covered in mist. High above the ribbon of mist, in the clear air, floated the cones of Java's many volcanoes. The rising sun slowly burnt off the mist, but as it did so cumulus clouds began to form, rising higher and higher, obscuring the peaks before emptying as rain. With evening the cumulus high above dispersed, and at sundown passengers gazed at extraordinary sunsets over ocean and coast.

Java and the islands fascinated the Surrealists as much as New Ireland. Two years before, in 1922, they had carried out a survey of their likes and dislikes and published the results.[216] To the fourth question, What is your favourite place? Eluard's answer now looks prophetic, for he named Java, as did Breton. The others were close. Rigaut chose neighbouring Sumatra, Ribemont-Dessaignes New Guinea and Vitrac distant Tahiti.

> Below us the plain of the sea, of a serene and intense blue, stretched with a slight upward tilt to the thread-like horizon drawn at the height of our eyes. Great waves of glitter blew lightly along the pitted dark surface, as swift as feathers chased by the breeze. A chain of islands sat broken and massive facing a wide estuary.[217]

Surabaya was Eluard's first port of call there. It was the busiest port in the colony and a contrast to Makassar, being stiflingly hot and without the cooling offshore breeze. To make the hothouse atmosphere worse, the city was built in a snaking line of tightly packed houses along the narrow Kali-Mas River. Prosperous and full of sailors of every nationality, Surabaya was infamous. It became even more so thanks to Kurt Weill and Berthold Brecht, who added to the city's reputation for sleaze. Brecht wrote the lyrics for "Surabaya Johnny" the following year, 1925, and the song was first performed in public in 1929, set to Weill's catchy score, as part of the hard-boiled musical "Happy End." Eluard left Surabaya and headed west along the north coast. The journey to Batavia (modern Djakarta) generally took two days because of the stops en route. His next port of call was therefore Semarang, where yet another coincidence is added to those we have already noted. The coincidences that pepper Eluard's voyage are tied to some of the most obscure and widely separated parts of the world. We have seen that the visit to Tahiti was prefigured by his ownership of a Gauguin, that his visit to the island of Celebes was prefigured by his ownership of Max Ernst's painting, and that Java had

Fig. 30 Monument to Pieter Erberveld, Old
Batavia, *prev.* Dutch East Indies, now Jakarta,
Indonesia.

been his destination of choice long before. Now, as his friends believed he was "doing a
Rimbaud," he found himself properly in the poet's footsteps at Semarang, an unfamil-
iar backwater if ever there was one. A port with indifferent facilities, it was less fre-
quented than Batavia or Surabaya. Nevertheless, at the beginning of August 1876
Rimbaud had disembarked there, as a raw recruit in the Dutch colonial army. He was
marched inland, did not like what he saw, deserted his post and two weeks later was
back in Semarang looking for a boat out. He escaped, sailing via Cape Horn, but was
nearly shipwrecked before ending up in Ireland.

Eluard found himself off Semarang on a voyage that had something in common
with Rimbaud's escapade. Like him, Eluard was a young French poet on the run from
an intolerable situation at home. It is no exaggeration to say that—despite knowing noth-
ing of Rimbaud's connection with the place—Eluard never came closer to "doing a
Rimbaud" than in the swell off Semarang.[218] Given that Eluard, by his own admission, had
read *Lord Jim*, he may perhaps have recalled that the port had featured in the novel. "I had
come straight from Semarang, where I had loaded a cargo for Sydney," said Conrad's nar-
rator, Marlow, "and in Semarang I had seen something of Jim."[219] Nor was that all, for
Eluard was also in the footsteps of Victor Segalen, who had himself shortly before sailed
past with Rimbaud in mind, but just as ignorant of the poet's aborted visit to Semarang as
Eluard would be. To a Surrealist sensibility, this automaton-like progress in the wake of sig-
nificant precursors was far from coincidence, representing as it did a hidden pattern link-
ing the lives and experiences of aesthetically and politically progressive artists.

Increasingly fascinated with the relativity of cultures, Segalen was the first to realise that Gauguin and Rimbaud had been there before him. Accepting the relativity of culture was subversive, for it dissolved the centrality of European civilisation and so undermined the authority of the colonial administrations it sustained. It was a revolutionary view that the Surrealists would also adopt, and is possibly the most important theme common to the voyages made by Eluard, Segalen, Gauguin and Rimbaud. They were journeys that revealed an alternative to the dominant Eurocentric, technological materialism of the time. The Surrealist revolution, as we now know, matured to undermine that dominance in many other ways.

Eluard's next port of call was Batavia. Once again, Segalen's diary sets the scene:

> Since leaving Tahiti, with the exception of New Caledonia, which I had no chance to explore, all I've seen are volcanic formations. Lava, basalt. . . . We're on our way to Java, beneath a heavy sky and on a motionless sea. . . . Batavia, nearly there; its coaling station is at the harbour of Tanjung-Priok. As we approached the coast at sunset, the low line of trees stood out against a grey-violet storm, with denser clouds than I've ever seen.[220]

His vivid entries give us an idea of what Eluard saw in the Dutch colonial capital, with its

> plain very gently sloping towards a motionless oily sea; a seething mass of identical shacks, all alike. . . . Brown predominates; the skin of the natives, the dust in the endless Chinese-run booths. . . . at the foot of huge mountains one can't quite see in the distance . . . steam-trams, cars on tarmac. . . . In the heavy heat, and beneath a vertical sun, white Dutch-women with milky skin go by, their heads bare.[221]

A few days later Segalen steamed from Batavia and noted one of the key ideas of his life. He did not succeed in developing it fully and it was left to Eluard after his journey in Segalen's wake to resolve some of Segalen's immense intuition. Segalen's flash of insight encapsulated a uniquely French response to the meaning of travel and is therefore worth quoting in full:

> In sight of Java, October 1904.
> Write a book on Exoticism. Bernardin de Saint-Pierre—Chateaubriand—Marco Polo the inventor—Loti.
> Use as few quotes as possible
> Theme; parallels between withdrawing into the past (Historicism)
> and into what is distant in space (Exoticism)
> . . . the feeling of exoticism : surprise.[222]

Within days of leaving Batavia, Eluard was in Singapore, waiting impatiently for Max Ernst and above all for Gala. *Je te baise partout*, he had written, using the untranslatable French verb which, while meaning to kiss, also stands for a more penetrating union, "I've thought of nothing but you."[223]

Fig. 31 Port and entrance to the Kali-Mas River, Sourabaya, *prev.* Dutch East Indies, now Surabaya, Indonesia.

Max Ernst and Gala Eluard's journey

Meanwhile on July 3, as Eluard skirted the Australian coast, part of his collection had been auctioned by Gala to reimburse her father-in-law and pay for her journey. Sixty-one items were sold; six Picasso drawings and five oils; eight paintings by de Chirico; four by Gris; and work by Redon, Derain, Marie Laurencin, and Ernst. While a Picasso painting had fetched over one thousand francs, no work by Ernst sold for more than 180. One imagines the effect of this on the lovers, for Gala liked money. Ernst's failure at auction would have increased the growing tension between them by compounding his poverty.[224] The indifference of the market to his work reminds us how hard it must have been for Ernst to raise the money for his fare. The effort he made shows his devotion to Eluard.[225]

As he and Gala prepared for Saigon, another Parisian, Clara Malraux, was on her way back from there to mobilise help for her husband, who was about to stand trial in Indochina. The paths of Clara and Gala would cross at Djibouti, ships in the night. Gala left her daughter with Eluard's parents, and within a fortnight of the auction was at sea. This suggests that the sale was partly responsible for her delay. There has been some confusion as to whether Ernst travelled with Gala. Patrick Waldberg's view, based on his collaboration with Ernst was that "They met Eluard in Singapore after he had completed his island journey."[226] Waldberg's friendship with Ernst suggests this is the version to

accept. It is unlikely Ernst could have gone to Singapore independently and arrived at precisely the same moment. He would have had to synchronise his arrival with that of the *SS Paul Lecat* which only put in for at most a day and a half. As she arrived in Saigon with the trio on board we may assume Ernst and Gala travelled to Singapore together.

They boarded the *SS Paul Lecat* in Marseille on July 17.[227] She was one of a fleet of liners the French maintained on the busy Indochina run that included the *SS Angkor*, and the Three Musketeers, the *SS Athos*, the *Porthos* and the *Aramis*. The day she left Marseille, André Malraux stood accused in Phnom Penh of looting Khmer antiquities from a small temple near Angkor Wat. Found guilty, he moved to Saigon where he remained pending an appeal and was therefore in Saigon when Eluard and Ernst arrived with Gala, and remained there throughout their visit. His wife Clara meanwhile was in Paris, persuading the Surrealists to campaign on her behalf. "In those days," wrote Clara Malraux of her outward journey, "Saigon was nearly four weeks from France. It meant something if you'd been there: read *Pilgrim to Angkor* [by Pierre Loti]. . . . Distant places were distant."[228] She said her ship "was like a hotel, big enough to get lost in. . . ." On board, passengers could not escape the tourist-trade publicity sponsored by their carriers. She, like Ernst and Gala, would have been tempted with the main attractions that lay ahead. "The world of the Messageries Maritimes." one such advertisement runs,

Fig. 32 Waterfront, Sourabaya, Java, *prev.* Dutch East Indies, now Surabaya, Indonesia.

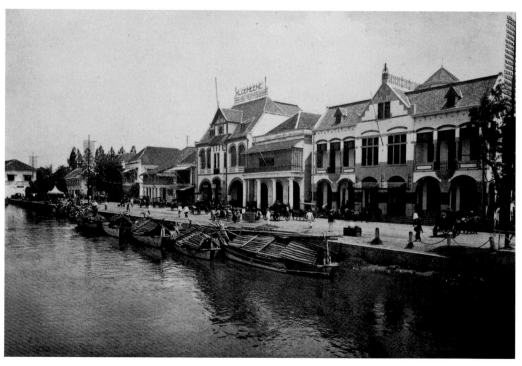

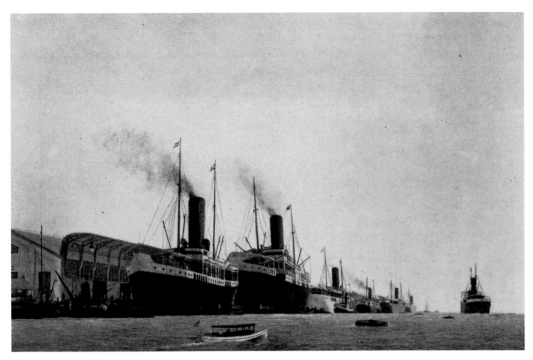

Fig. 33 Port of Tanjung-Priok, Batavia, *prev.* Dutch East Indies, now Jakarta, Indonesia.

is perfectly designed to introduce every tourist to spectacular sites such as the wonders of Ancient Egypt, the cradle of Christianity in Palestine, or the antiquities of Greece by the Bosphorus . . . and today in Indochina travellers can without a care in the world delight in the marvels of the ancient city of Angkor.[229]

The possibility of seeing the ruined Khmer capital for himself would therefore have presented itself to Ernst while sailing to Saigon, with the ruin a reality daily drawing closer and no longer a distant daydream. Pervasive French pride in "their" site was summed up by the popular novelist Pierre Benoit, who had perfected a stylish genre characterised by evening wear, exotic locations and steely heroines. "She's now seen everything in the world that's worthwhile," he wrote of one who was on her way to Indochina to cross Angkor off her list of world-class, must-see destinations. "From Palmyra to Borobodur, from the temples of Egypt to Japanese pagodas, she's seen it all; she knows all about it. Except for Angkor."[230]

For Ernst, as for Gala, the journey was a discovery in itself. They experienced "*la grande semaine,*" the week of entertainment and shipboard romance that was the highlight of the voyage. For students of Max Ernst's work, the weeks on the *SS Paul Lecat* merit a brief digression, for memories of them are buried in his work. "Between Europe and Asia stretched days of reverie, nostalgia, hope, weariness, of heat that was barely dissipated by the fans one had to turn every-which-way to work."[231] "We're crossing the Indian Ocean," wrote Andrée Viollis,

in the last monsoon storms, opaque skies, damp heat, a feeble wind, a gentle swell that makes your heart sink, and empties your head. . . . In the Dining Room, the fans hum, hair sticks to damp foreheads, light fabrics stir on soft shoulders. From table to table glances are traded or avoided. Promises, refusals. It's the "grande semaine", beloved of writers specialising in shipboard romances.[232]

Eventually the daily round closed in, and

. . . one found oneself surprised at the thought of life going on elsewhere. . . . There were also the ports of call, as marvellous as an atlas, in the Near East, Asia Minor, Africa, Asia and for those who kept going, Australia and America beyond. . . . For four or five days, that peculiar half light between sea and grey sky, a monotonous backdrop against which there pass, like shadow puppets, an army of swollen black clouds. At times a pale disc appears that might just as well be sun or moon, only to vanish as fast as it had appeared. Sudden downpour, wind like steam from a kettle: equatorial splendour![233]

The *Paul Lecat* had crossed the Mediterranean, called at Port Said, Djibouti, and Colombo before approaching Singapore. "Then we really began to stifle. The Strait of Malacca is an equatorial corridor. All the heat on earth is funnelled into it."[234] Roland Dorgelès noticed the female passengers. "On deck, women lay barely able to move, their make-up running. . . . Even motionless one pours with sweat. It beads on hands, sparkles on lips, runs down foreheads. If only one could wring oneself out like a cloth. . . . In one's cabin in the afternoon one panted, naked on the bunk. The fan freezes a bit of your body, but can do nothing for the rest so sheets stick to your skin like glue."[235] There was no escape. "We followed the coast of Sumatra for two days; then after a cluster of islets and a channel with sides of velvety green, very Japanese, we're in the Gibraltar of Asia, Singapore." It was quite a sight. "Fuel dumps, kilometres of dock, vast warehouses, quays, threatening bunkers aiming guns in every direction with barracks below, and then, in neat firm lines, the sharp silhouettes of warships."[236] Dorgelès remembered he had "arrived in Singapore in terrible weather. The sky suddenly darkened and the storm broke as we entered, one of those brutal tropical storms which break at once and empty in a flash, falling on you in sections like a collapsing wall." Then it was over. "Leaning over the hand-rail, I scanned the onlookers hanging around on the quay, hoping to spot, even at that distance, an unusual silhouette in that crowd of men in white."[237] Down there Gala and Ernst would have seen Eluard's unmistakable profile.

Chapter 5

IN SAIGON

Wrecks are aground in the bay
They've not gone down at sea, stiff with corpses
 Robert Desnos. *De Silex et de feu.* 1929

GALA HERE LOOKING FORWARD TO COMING HOME AND TO PROPERTIES YOU WERE NOT THE REASON REPLY BY TELEGRAM HAVE ALWAYS LOVED YOU GRINDEL HOTEL CASINO SAIGON. The telegram Eluard sent his parents in Paris survives as one of the few keys to his visit.[238] To begin with its conciliatory tone: we see him manipulating his parents and paving the way for a return. Gone is the truculence of his final *pneu*. There was no mention of Ernst either, for fear of stirring up his father, who associated Ernst with the *débacle*. The message also reveals Eluard had not been in touch since his departure, its fundamental admissions sounding as if they were made for the first time ("you were not the reason . . . have always loved you . . ."). We can also detect Eluard working on his father by letting him know how much he was looking forward to getting back to the family property business, which we know was untrue. It had been one of the things that had driven him away. In this respect the telegram was an exercise in planning, designed to make the father look forward to the return of his prodigal son, and therefore be generous when faced with Eluard's next approach, a message that soon followed requesting 10,000 Francs. Eluard would have known things would work out because he had already received a positive message from his father via Gala. Ernst remembered that before he and Gala had left, Eluard's father "had already asked Gala to tell him [Eluard] he was prepared to forgive and forget his son's rather cavalier behaviour towards him."[239] The date of the telegram, August 12, also confirms that the three travellers arrived on the *Paul Lecat*, for she had berthed the day before, at 11 am. A further clue to the visit lies in Eluard's reference to the Hotel Casino, which introduces us to the city, its streets and way of life.

You knew the estuary of the Rivière de Saigon was close when you neared the small offshore penitentiary island of Poulo Condore and saw the mainland of Indochina on the horizon. Saigon's river is tidal, and its scouring action ensures steamers can sail far

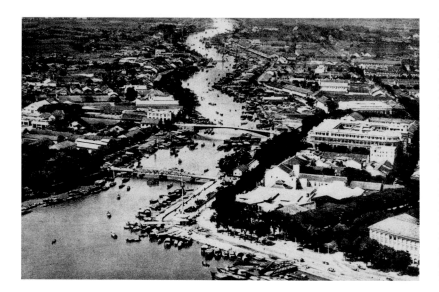

Fig. 34 Saigon from the air, showing the Arroyo Chinois, a tributary of the Rivière de Saigon, that divides the European city from the Chinese District of Cholon. The Arroyo snakes down to meet the Saigon River at the Port. Part of Saigon's waterfront is visible at bottom right. The docks are just out of shot, bottom left.

upstream to the city, some eighty kilometres inland. Once there the big ships used an ageless method to turn round in the narrowing river. They grounded the stern and were swung by the current, like logs, to face downstream, ready for departure.

Snaking up to Saigon, three and a half weeks after leaving Marseille, was an experience often described:

> The ship keeps turning. You wouldn't think you're on a river. It feels more like sailing around islands. Long islands, densely covered in vegetation up to the water's edge. Mangroves and palm. . . . It's a monotonous and gloomy landscape, a landscape of flood, beneath skies which, in Europe, you would call stormy.[240]

The radical journalist Leon Werth, editor of the left wing journal *Monde*, arrived a few months after our travellers. He too had watched the hide-and-seek played by the towers of Saigon Cathedral among the trees, as the steamer took the bends up river. The ship slowed and the docks appeared. High above, on deck, Werth looked down at the quay and saw a glow, the aura of freshly laundered cotton.

> On shore, a white wall, a dazzling wall. It's the Europeans, standing shoulder to shoulder, come to watch the ship arrive. I can spot the different races lined up as if in group photos: Europeans, Hindus, Vietnamese.[241]

Up to forty ocean-going vessels could berth there, bound for Yokohama or Hanoi, others from Shanghai or Bangkok. Saigon was the busiest port in Indochina. Smaller rivercraft also came and went, travelling to and from the interior, while sampans with triangular sails drifted past Chinese junks. Taking their last look high on deck, passengers gazed across a flat landscape, past warehouse roofs, at the dense tree cover of nearby Saigon. There is a photograph of that dark horizontal canopy stretching as far as the eye

Fig. 35 Boulevard Norodom, Saigon.

can see, while in the middle distance, just breaking the surface, is a solitary cluster of elaborate Beaux Arts masonry, pale as a wedding cake. It is the Governor's Palace, which seems to be going down like a liner in a calm sea of leaves.[242]

Disembarking at the wharf of the Messageries Maritimes Eluard, Ernst and Gala went through customs. Their luggage was handled by coolies, "who can be found anywhere near the wharf. They speak basic French and charge very little. . . ."[243] They had reached the "Pearl of the East," and drove in along a tree-lined boulevard. To Leon Werth,

> Saigon looks a bit like Passy, but with all the houses sporting Louis XIII balustrades and fancy columns. The villas with their walled gardens feel like a spa town. You either like Saigon or you don't, and the same goes for Vichy. Here and there the sound of a piano drifts out, as in a provincial street.[244]

The capital of the territory of Cochinchina was laid out with broad avenues, low buildings and large parks. After the French invasion of 1861 the cluster of riverside villages of pre-European Saigon had soon been replaced by a modern city. Imposing buildings such ase the Governor-General's Palace, the Cathedral, and the Town Hall punctuated the crossroads of a low-slung capital. The busiest street was Rue Catinat, which like the Ramblas in Barcelona ran straight up from the water's edge. Tree-lined, with shops and cafés, it was the focus of social life. You got about by rickshaw, or *pousse-pousse*, meaning push-push. To us the rickshaw converts a man into the beast of burden of another. Egalitarian temperaments like those of Eluard and Ernst would

Fig. 36 Rue Catinat, Saigon.

have had their doubts about it, but Gala, one suspects, would have taken to the barefoot taxis.

The travellers were in a centrally located hotel on the Boulevard Bonnard, two minutes from the railway station and fifteen from the docks. European Saigon was small, yet hotels still felt it necessary to advertise their proximity to the station in terms of minutes, revealing the provincial scale of the place. Cholon, as Chinese Saigon was called, stretched along a tributary of the Saigon River and was quite different, a properly oriental environment avoided by colonial families. Packed with the smells and bustle of a native quarter, it was an attraction.[245] It was also the financial powerhouse of the impending revolution. The Hotel du Casino was not the most fashionable hotel in town, a position occupied by the Continental Palace on Rue Catinat (eight minutes from the station). Eluard's reunion with Gala and Ernst took place in more modest surroundings that were dictated by shortage of money. The Saigon Eluard, Gala and Ernst would have explored was built on a grid plan. The streets ran parallel to the river or at right angles and were planted with tamarind trees, which made it both pleasant and shady. We have to imagine a city with few cars, where one heard the clip-clop of horse-drawn carriages, and the passing of rickshaws. French café life was an obvious attraction, although not during the day, when people avoided the stifling heat. Everything closed from 11 am to 2 pm and the streets were deserted.

In her memoirs Clara Malraux remembered how, during their enforced stay in Saigon, she and her husband would retire and make love in the midday stillness of their shuttered hotel room. Gala and Eluard, too, would have been obliged to retire at midday. Together once more, they tested their rocky marriage. Eluard had longed for Gala, as his correspondence shows, and as the couple tried to reignite their passion in Saigon, Ernst's solitude would have been his refuge. The *menage à trois* was undone in the Hotel Casino, even if, as evening came, the trio joined the throng on the Rue Catinat:

> The pavements are packed, people are out for a stroll or going to dinner, the café terraces are full, and this picture of crowds coming and going, and gossiping in the light of brightly lit shop windows has an almost Parisian feel to it. . . . Apart from the middle of the day when the whole town is asleep, Saigon usually bustles like that.[246]

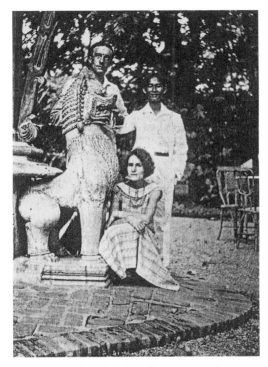

Fig. 37 Paul Eluard, Gala and an unidentified
Cambodian in Saigon.

Fig. 38 Max Ernst in Saigon.

It cannot have been a cheerful time, however, for the marriage never recovered its
original intensity and, as we now know, gradually dissolved as Gala's appetites bypassed
Eluard. Such fractures originally came to light in Saigon, and may account for Eluard's
morose mood in the coming months.

A pair of photographs taken in Saigon of Eluard, Gala and Ernst give us a glimpse
of life there, and advertise the brilliance of its laundries. Ernst's cotton suit gleams
whiter than white and his white shoes are spotless. The pictures were probably taken by
a professional itinerant photographer, of a sort that no longer exists but used to haunt
public spaces all over the world, with a box camera, a tripod, and a placard displaying
examples of his work. He must have used the statue of the Khmer lion regularly as a
compositional device to add a dash of local colour. This type of lion is found through-
out Khmer culture, and commemorates the ancestral lions encountered in India by the
Khmer peoples before their migration to Cambodia, where there are none. This locates
the photo in Saigon, and the locked-off composition, produced with the help of a tri-
pod, is revealed by the identical positioning of the verticals of the pavilion on the left.
The three friends explored the city, and in these souvenirs we catch a glimpse of them,
possibly in the botanical gardens in the northeast corner of the city, where there was a
zoo set among spectacular trees. Tigers, leopards, bears, elephants and reptiles were on

show among the luxuriant vegetation. There was another park next to the Governor-General's Residence, where Ernst saw more wildlife and plants he had never seen before. These prepared him for the excursion he would soon make into the rainforests, to visit Khmer ruins, and observe the way of life of the native Moi people.

As countless imaginary plants and animals appeared in Ernst's work soon after he got back to France, they may recall the impression made on him by the strange specimens he saw in Saigon's parks, in the zoo, and on the menu in restaurants. Equally baffling would have been the markets and the streets where "The flowering trees are stacked with clusters of blazing grenadine and blossom the colour of red lead. In Europe the most spectacular flowers grow in greenhouses or in gardens. But here it's on treetops."[247] We shall return to Ernst's impressions not only of the markets of Saigon, but also of the strange fruit, fish and reptiles he is likely to have seen shortly before in Colombo, Ceylon, now Sri Lanka. Colombo's famous market was visited by the thousands of passengers who went ashore when their ship called, as the *Paul Lecat* had done, to refuel between the Red Sea and Singapore. Its market was a must.

Le Facteur Cheval and Angkor Wat

A week after the trio arrived in Saigon another remarkable old man fascinated with the tropics followed Joseph Conrad to his grave. He was an unknown postman from the village of Hauterives, in southeast France, who died aged eighty-eight. Joseph Ferdinand Cheval, known as *le Facteur* Cheval, or Postman Cheval, had been especially susceptible to the mystery and magic of faraway places. An active imagination and a need to express it outstripped his modest circumstances. Like his contemporary *le Douanier* Rousseau, Customs Officer Rousseau, he was a minor civil servant of little education,

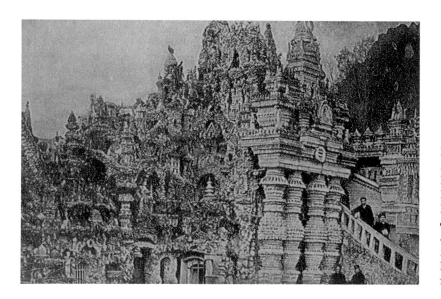

Fig. 39 *Le Palais Idéal*, Hauterives, France. Built by Ferdinand Cheval. Photograph reproduced in *Le Surréalisme en 1929. Variétés*. Brussels, June 1929.

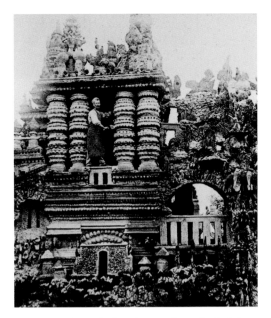

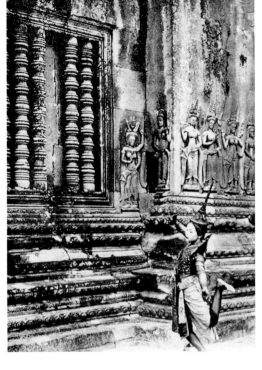

Fig. 40 Ferdinand Cheval at work on the *Palais Idéal*.

Fig. 41 Turned balusters at Angkor.

who reacted with great force to what he read in the press. The work of both men was affected by illustrated journals such as *l'Illustration* and *Le Tour du Monde*, and together the Postman and the Customs Officer had recreated the dream world fostered by such publications in the mind of millions of French men and women at end of the nineteenth century. Rousseau's paintings of jungles and snake charmers are, like Cheval's unique monument at Hauterives, *le Palais Idéal* (Palace of Dreams), inspired by the press as much as anything else. The work of these two visionaries reflects the increasingly global reach of the dreams of average Europeans at a time of colonial expansion and expanding popular journalism. Rousseau even painted a portrait of Pierre Loti in a fez (c.1891), the tribute of an armchair traveller to a professional who was actually to visit Angkor Wat, a site which it is now clear also attracted Cheval and influenced the look of his monument. His Palace of Dreams was admired by the Surrealists, who discovered it at the same time they were growing increasingly aware of the political crisis in Indochina.

Le Palais Idéal was to make its first appearance in the group's work in 1929, reproduced in their latest publication, *Variétés*. Cheval remained a favourite of theirs and was treated as an honoured precursor.[248] As Cheval and Ernst were among the first artists of note to be inspired by Angkor Wat, there was a curious symmetry in the fact that the former died as the latter was in Indochina, falling under the spell of the ruins himself.

It adds another particle of coincidence to the story. The work of Ernst and Cheval brought Angkor into the Surrealist orbit, but no-one noticed, overtly at least, that they shared this interest, even when Ernst produced a portrait of *Le facteur Cheval* in 1932, as he himself was painting scenes of ruins in the jungle. The portrait suggests Ernst sensed this common interest, even if obliquely.

Cheval was possibly the first European to import into his work an architectural motif from Angkor, the turned masonry baluster. Cheval's embrasure, with its set of balusters built to resemble the lathe-turned stone originals that are such a feature at Angkor, are also interesting because they reveal how he responded to the publicity about Angkor. His poetic reaction differs from the literal casts of Khmer architecture that were exhibited in Paris at the time he began his *Palais Idéal* in 1879. To begin with, reconstructions of Khmer architecture were based on moulds used for museum displays, but also for large installations at trade fairs. Such replicas did not respond to the imaginative possibilities of the ruin in the way Cheval did. In fact Cheval, and later Ernst, were both drawn to the mysterious, dreamlike character of the site, and it is that quality Breton and the Surrealists admired. Although Breton was unaware of these coincidences, for he never remarked on the Khmer basis of Cheval's borrowings, he visited the *Palais Idéal* and, significantly, was photographed there in the summer of 1931. His visit took place on the eve of the show organised by the Surrealists in defiance of colonial propaganda in Paris that featured a replica of Angkor made of hundreds of tons of plaster casts. Cheval's fantastical version, and the massive, literal, pedestrian copy in the capital illustrate the seepage of Angkor into the imaginative life of France. Cheval had begun his Palace in 1879 and completed it thirty-three years later in 1912, the year Pierre Loti had published *Un Pèlerin d'Angkor*, which in France consolidated the atmosphere of magic and mystery surrounding the ruins. These and other layers of interpretation of Angkor, deposited by writers, photographers, scholars, architects and government agencies, were the cultural sediment from which Ernst's contribution was to emerge. His work was also a commentary on that sediment. Cheval, Gustave Moreau and Max Ernst harboured the ruin in their work, unnoticed, where else is it also buried?

Colonial life in Saigon

Of the 66,000 inhabitants of Saigon about 6500 were Europeans. An élite ten percent lived in comfort and grew wealthy. Their corruption was so blatant that even brief exposure to it affected Malraux and Eluard profoundly. Ernst seems not to have been as moved, although the political dimension of his pictures has not been explored. Rather it was the look of Indochina that impressed him and found its way into his work. Leon Werth's description evokes the scene:

> It's evening in Saigon. The sky is low, dark blue with touches of violet and white. The
> heavens with their great clouds look as if they are made of some dense material. The

rickshaws trundle through the pink alleys of the park. . . . In Europe I'd say a storm was brewing. Here, at this time of year, its always like that, the storm hangs about without breaking.[249]

Leon Werth also sensed the fault-line on which the whole situation was balanced and described it in prophetic terms:

Any European tourist in Saigon soon realises that relations between Colonials and Vietnamese are like those at a Colonial Trade Fair, where visitors treat natives on duty like exotic servants laid on for their entertainment.[250]

His view of life in Saigon was to be mirrored in Paris by the Surrealists' response to the Colonial Fair of 1931. A great political storm was brewing, inescapable to some, but largely unnoticed at home or in French Indochina itself. In the meantime, tourists interested in local history, and curious about Angkor Wat, could visit the Saigon Museum. It is hard to imagine Ernst and Eluard did not do so.[251] It was open morning and afternoon and on ground level statues stood guard on the verandah outside two rooms of exhibits, with more on the floor above. One room housed the library, where a selection of the photographic surveys of Angkor Wat and Khmer art would have been available. Adjacent to this was the room displaying bas-relief sculptures from Angkor Wat and elsewhere.

Ernst would have come across Indochinese *estompages* there. These large sheets of black-and-white rubbings, made on paper, reproduced Khmer images of plants, fish, animals and people. They were produced by applying the paper to the surface of a relief sculpture and patting the raised parts with a black buffer. The result was a life-size reproduction. These *estompages* were not only useful as accurate records of Khmer art, but also popular decorative souvenirs brought back to France in great numbers. In Ernst's day, the production of *estompages* was already an established tourist industry which continues to the present time. The technique of using a pencil to rub a sheet of paper resting on a textured surface was already familiar to Ernst. However, the large rubbings he saw, with their extravagant scenes of forests and wildlife, were beyond anything he had attempted. The large Khmer *estompages* impressed him and were to encourage him to experiment extensively with the technique and make it his own. The results, his *frottages*, were produced a few months after he returned to Paris, and while the Khmer reproductions were fresh in his mind.[252]

The Musée de la Société des Etudes Indo-Chinoises had been established in 1897. In due course it fell victim to bureaucratic wrangles and was closed the year after Ernst's visit. Its collection was then stored in a warehouse and eventually incorporated, four years later, as part of a new institution, the Musée Blanchard de la Brosse, at which point a catalogue was prepared.[253] Ernst and Eluard would have seen the collection in its first home on the Boulevard Norodom, opposite the Cercle Militaire, near the Cathedral, Rue Catinat and their hotel. Khmer sculptures dragged out of the rainforest had reached Saigon from Angkor during the 1870s and 80s, in the first flush of imperial self-

Fig. 42 An *estompage* made at the Temple of Angkor Wat. Taken from *The Churning of the Sea of Milk*, the bas-relief of a scene in the life of the god Vishnu. This is located at the southern end of the outer gallery of the east side of the Temple.

service. Many were shipped to France, where they are still on display in Paris in the Musée Guimet. The creation of the Société des Etudes Indochinoises and its museum were another sign of France's grip on Indochina, an iron hand in cultural velvet.

The golden age of French Indochina 1880–1920

The French originally arrived in Indochina in the early seventeenth century and today, four centuries later, the region still exercises a powerful hold on them. It was during the

reign of Louis XIV that they first thought of intervening in Southeast Asia, where Vietnam was to have been controlled by the Compagnie française des Indes. French Catholic missionaries were sent, along with merchants, to compete with representatives of the rival British East India Company. Persistent French interest led to a steady infiltration of the peninsula during the nineteenth century until, soon after the discovery of Angkor Wat in 1861 and the establishment of the Union Indochinoise in 1887, France invaded and took over the rest, including the fractured kingdoms of Annam, Cambodia, and Tonkin. For the next forty years they controlled a vast territory larger than any European country, and a quarter as large again as France itself. It united modern Laos, Vietnam and Cambodia. The Golden Age of *l'Indochine Française* lasted four decades. By the 20s, however, revolutionary independence movements were developing in the shadow of relentless French exploitation of the human and the natural resources of the region. As the century wore on, revolution eventually overwhelmed the colonial administration, destroying French military superiority at the battle of Dien-Bien-Phu in 1954, where a garrison of 15,000 French troops surrendered to a Viee-minh army of 100,000. After thirty years of bloody resistance and reprisal, the French finally recognised that they had lost control of their former colonial empire. Two years later, France withdrew, bequeathing the mess to the United States.

The Golden Age was nearly over when Eluard, Ernst and Malraux disembarked and—individually—they sensed this. Having recognised the causes of the discontent, they were then obliged to join the process of reform that eventually ended France's long colonial adventure. Malraux protested on the spot, while Eluard and Ernst joined the protest at home. The political activities of Malraux and Eluard are well known, but only now are we becoming aware that a number of pictures painted by Ernst after his return also reflect the political situation in the colony. This is clearly visible in his pictures of a ruined citadel overwhelmed by the jungle, images of a civilisation that has run out of steam and collapsed.

Angkor Wat and France

Yet, sixty years before the beginning of this imperial sunset, the accidental rediscovery of Angkor Wat had reached deep into French popular and academic culture as an emblem of France's status as a world power. The ruins were rediscovered on January 22, 1861, by a French naturalist, Henri Mouhot (1826–61), who explored the unmapped jungles of Cambodia. Mouhot died during his expedition, but his diaries were posthumously published in Britain and France in 1863. They described his amazement at Angkor Wat:

> Try to imagine what may well be the finest architecture ever made, in the middle of the jungle, in one of the most remote corners of the earth, wild, unexplored, deserted, where the tracks of wild animals have erased those of man, where all you can hear is the roar of tigers, the hoarse trumpeting of elephants and the belling of deer.[254]

The find was widely publicised at once and the news received with great interest everywhere. The idea of a vast city lost in the jungle, abandoned by man but smothered in rampant vegetation, continues to cast a spell to this day. It is a metaphor of endless fascination and complexity. While Angkor also assumed a far-reaching symbolic role in France's colonial empire and was the jewel in its crown, Khmer art also represented an intellectual and cultural challenge to the French academic community which made Angkor the focus of one of the most sustained research projects of the time.

Mouhot's account introduced Angkor Wat to the world and tempted others to see it for themselves. The first expedition to follow was sponsored by the French Minister for the Navy and led by a group of naval officers under Doudart de Lagrée (1823–1863). He was assisted by two others who went on to lay the foundations on which Angkor Wat's celebrity was built, Francis Garnier (1839–1873) and Louis Delaporte (1842–1925). Lagrée's expedition took two years, from 1866 to 1868, during which he, like Mouhot earlier, fell ill and died. Garnier took over. The journey up the Mekong to Angkor and beyond, in search of a trade route to China, returned with more evidence. It was not long before Khmer art was shipped, with great difficulty, out of the jungle to arrive in crates in a courtyard of the Louvre. It was then put on public display at a number of venues. The first *estompages* of Khmer scuptures were made during those pioneering voy-

Fig. 43 Engraving from Francis Garnier, *Voyage d'Exploration en Indo-Chine. Relation Empruntée au journal Le Tour du Monde.* Librairie Hachette. Paris, 1885, p.45. Ruines du Mont Bakheng. - dessin de H.Clerget, d'après un croquis de M. Delaporte.

ages and survive in the Musée Guimet. Moulds were also made and shipped to France. Louis Delaporte, the young naval lieutenant on the Lagrée expedition, did more than anyone to bring Khmer art to the attention of the French public. He was the first person to make a sustained visual record of Angor Wat, and his drawings were the basis of the first published pictures of the site. They received widespread distribution in popular publications like *Le Tour du Monde*.

Delaporte also published the first picture of a European artist (a self-portrait?) at work there. He lobbied tirelessly for the display of the Khmer art he brought back, eventually establishing the Musée Indo-Chinois of Cambodian antiquities based at the Trocadero, overlooking the Seine in the heart of Paris. He was its curator, fundraiser, designer and publicist. The collection he assembled was eventually transferred to the Musée Guimet in 1925. By then it had been visited by thousands of school parties and

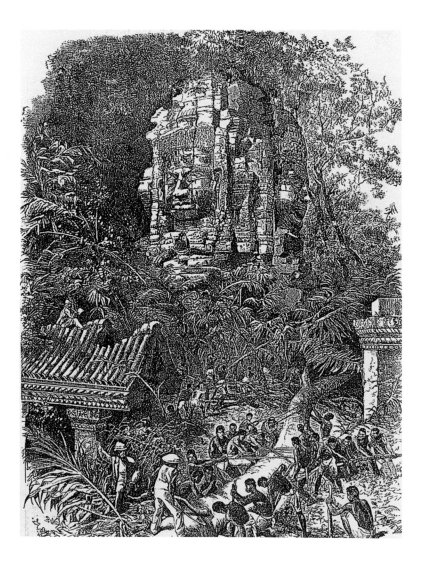

Fig. 44 Engraving from Louis Delaporte, *Voyage au Cambodge*, Charles Delagrave, Paris, 1880, p.101.

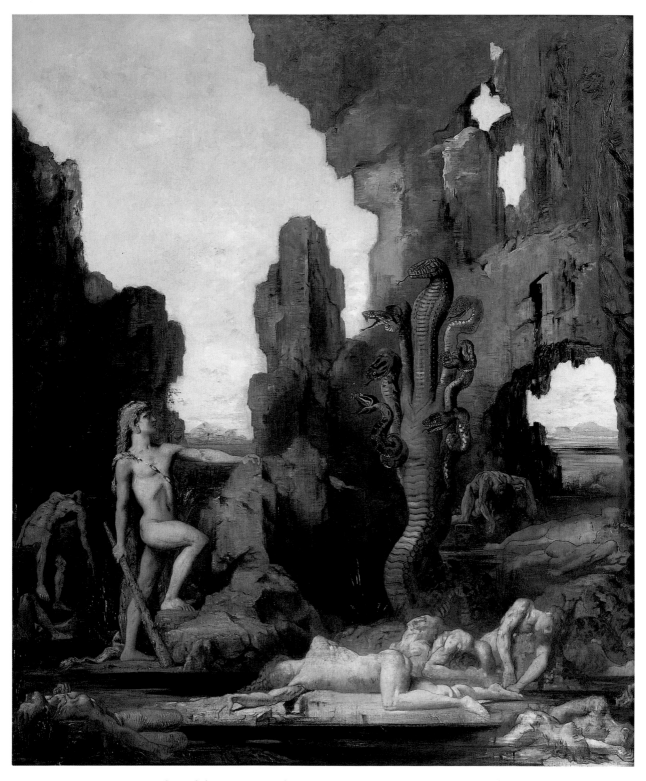

Fig. 45 Gustave Moreau, *Hercules and the Lernaean Hydra*, 1869–76, oil on canvas, 155cm x 132 cm. Musée Gustave Moreau. Paris. Cat.26.

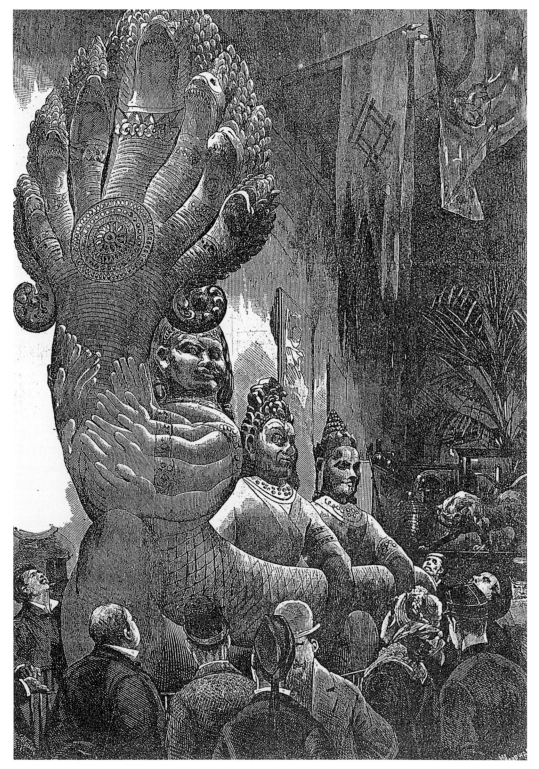

Fig. 46 Engraving from Louis Delaporte, *Voyage au Cambodge*, Charles Delagrave. Paris, 1880, p.245.
Captioned *Les Antiquitées Cambodgiennes à l'Exposition Universelle de 1878.*

adult visitors, and by artists too. We know for example that Picasso was inspired by the adjacent collection of African carvings, which suggests that passing traffic like him also saw Khmer art from Angkor. Although Delaporte's passion for displaying reconstructed installations based on the extensive use of casts has its critics, he was responsible for bringing Khmer art to the attention of ordinary Europeans.[255] In 1878 he supervised the display of Khmer sculptures at the Exposition Universelle de Paris (see illustration 46). In 1900 a pastiche of a section of Angkor Wat was built at the Exposition Internationale in Paris. The huge scale of that Indochina Pavilion is visible in a photograph Emile Zola had taken of himself, dwarfed on the massive stairway, next to casts of Khmer lion sculptures.[256] In 1922 another reconstruction opened at the Exposition Coloniale in Marseille. This parade of reconstructions, big enough and tough enough to withstand public wear and tear, was designed to place France at a competitive advantage in the arena of international trade, and in each case French interests paraded in Khmer finery. The parade was to climax, much later, at the Exposition Coloniale in 1931, when in a final display of French imperialism the near-replica of the entire central temple at Angkor Wat was erected in Paris.[257]

Garnier and Delaporte were quick to publish illustrated accounts of their activities in Indochina.[258] These publications were followed by others, often lavishly illustrated, such as Auguste Pavie's five-volume *Mission Pavie*.[259] Angkor Wat entered the imagination of France and of the world through illustrated books and articles like these that made it one of the most systematically photographed places on earth. Heading the list was the incomparable photographic record undertaken by the Ecole Française d'Extrême Orient, begun at the turn of the century. The Ecole was founded in 1899 in Hanoi to complement the venerable French Schools in Rome and Athens. It was an intellectual arm designed to grip the region and unpack it. Never a teaching school but an institution dedicated to research, the Ecole was responsible for surveying, clearing and restoring the antiquities of Indochina. Its magnificent scholarly and photographic surveys of Angkor were books Max Ernst would have seen in Saigon and in Paris. The Ecole was also responsible for maintaining Angkor and opening it to visitors, and therefore played a major part in encouraging international tourism.

The combination of the newly developed techniques of photographic reproduction and the intensely photogenic appearance of Angkor continued to fuel an unprecedented publishing bonanza of travel books, guide-books, scholarly volumes, archaeological and architectural surveys illustrated with astonishing photographs. Many of the images were superbly detailed because taken by large-plate cameras. The success of the French military in subduing the country gradually encouraged more visitors to Angkor, and the first such cultural tourist to express the haunting power of the ruins at the time, and stoke Angkor's growing celebrity, was Pierre Loti (1850–1923). He represented a new type of traveller, part of the first wave of tourists who arrived expecting to enjoy the site and benefit from the work of scholars and archaeologists. Loti had already written about French dreams of the Orient and the Pacific. *Un Pèlerin d'Angkor* (Angkor Pilgrim), published in 1912, described his 1904 expedition. It reveals that his fascination

with the site had started in childhood, when as a boy in the 1860s he had marvelled at the first articles about it published in the French press. These must have included Mouhot's 1863 account. Ferdinand Cheval's fascination is likely to have begun in the same way, for he started work on his *Palais Idéal* in 1879.

Angkor Wat and Gustave Moreau

Another French artist was as quick to respond as Cheval, the equally eccentric but infinitely wealthier painter Gustave Moreau (1826–98). Mouhot's discoveries were absorbed by Moreau almost as soon as they became public, and emerge in the terrifying shape of the Hydra which suddenly appears unannounced, centre stage, in *Hercules and the Lernaean Hydra*, 1869–1876.[260] Moreau was a voracious reader of the same illustrated magazines as appealed to Cheval and Rousseau, and his collection is part of his bequest to the palatial museum he endowed in Paris. His huge and frightful seven-headed Hydra is descended from the great seven-headed *nagas*, sculptures of mythical serpents that rear up at intervals in Angkor, and in particular from the example, recovered by Delaporte, that still alarms visitors at the entrance to the Musée Guimet. Thus a few French artists at least had responded swiftly to the discoveries. The stream of reproductions that we must assume had inspired Ferdinand Cheval and Gustave Moreau, was later to affect the work of Max Ernst.

There are numerous affinities between Moreau's work and that of Ernst in terms of imagery, design and technique. These stem from the first years of Ernst's life in Paris, those of the *ménage à trois* that concerns us. The way Ernst absorbed and transformed Moreau's influence is unexplored territory, rich with surprises. We catch a glimpse of this in the way Angkor Wat is referred to by both. This is not the place to follow the largely subterranean course of Moreau's wider contribution to Surrealism, which is also uncharted. But it seems Ernst was shown Moreau's work by Breton soon after he arrived in Paris to live with Eluard and Gala. Breton was a lifelong admirer of Moreau and would have introduced his new German recruit, a painter, to the pictures in the Musée Moreau, just as he had earlier shown them to Philippe Soupault, whom he had taken there in person.[261] Those visits affected Ernst profoundly and immediately, yet he could not have predicted that when he came to revisit Moreau's work, at the outbreak of the Second World War, the subject he explored persistently, with Moreau in mind, was to be Angkor Wat. Moreau and Cheval were unusual in having been inspired by Angkor so quickly, a fact Ernst did not *consciously* know. Ernst's nose for such affinities is explored in Chapter 9.

The Malraux expedition

If images of Angkor Wat inspired the visual arts in France, for the Parisian writer and intellectual André Malraux they offered the prospect of further romantic—and profitable—discoveries and adventures in Indochina. The story of his expedition, jointly with his wife, Clara, to the Mekong in search of booty has been told elsewhere, but the many correspondences between his motives and experiences and those of Eluard and Ernst make an instructive counterpoint.

Malraux knew of Eluard and his friends, whom he saw as rivals. His path had crossed theirs in the competitive world of Parisian vanguard magazines, in which he and the Surrealists were active. Malraux would have been familiar to them because he had reviewed *Les Champs Magnétiques* by Breton and Soupault, as well as *Les Chants de Maldoror* by Isidore Ducasse. He had also contributed to the magazine *Dés* (Dice) which published Eluard and other Surrealists.[262] *Dés* was edited by Malraux's friend Marcel Arland, member of a literary network to which the Surrealists also belonged. However, it was his wife Clara who was to bring Malraux and the Surrealists together. She established contact when she asked Breton to help her husband. Clara quickly made friends with Breton's wife Simone, a friendship that was long-lasting. Simone Breton and Clara Malraux were Jewish, which is relevant as this sheds an interesting and unnoticed light on events. A writer associated with the Surrealists at the time, Drieu la Rochelle, who himself also married a Jewish girl, observed there were many *fiancées juives* (Jewish fiancées) in his circle.[263]

Before setting out, Malraux had studied enough Khmer history to impress leading scholars in Indochina. That degree of knowledge was unusual, although interest in Angkor and Indochina was widespread in France and helps explain why Eluard and Malraux were drawn there. "Interest in the Far East had grown rapidly during the decade following World War I. Young people avidly read not only the exciting accounts of adventurers who had visited those far-off lands, but also scholarly translations. . . ."[264]

Malraux had not only made himself unusually well informed, he was also bent on action and adventure *à la* Joseph Conrad, whose novels, as we have seen, were popular in France. Clara Malraux remembered her anxiety when she realised what lay ahead in the jungles of Angkor, "Suddenly the project darkened like the sky clouding over. We'd read too much. Memories of 'Heart of Darkness' frightened me, or perhaps it was foreboding: we'd go up river, and turn back on ourselves. . . ."[265] Marcel Arland was also aware of the adventurer in Malraux. "At an age when some waste themselves posing and talking and looking for instant celebrity in trivial controversies," he wrote, for Malraux "literature was not enough."[266] This of course was something many of the voyager-artists in our story would have recognised, from Rimbaud to Cendrars, from Gauguin to Eluard. There had to be more to life than art. Nevertheless, Clara Malraux confirms she and her husband were students of Khmer culture:

> What did we know about Cambodia except what Loti had taught us? . . . All the travel books available today didn't exist then; those who weren't scholars didn't have

much to go on; if they liked a good read and wanted to dream about Cambodia, they had Francis Garnier's "Voyage d'exploration en Indochine," or (Mouhot's) "Voyage dans les royaumes de Siam, Cambodge et Laos," the one dating from 1873, the other from 1863; . . . As far as I was concerned I was looking forward to the wonders promised by the pages of 'l'Illustration,' across whose glossy paper my finger had traced the sharp points and smooth curves of the temple.[267]

With this knowledge, backed by his scholarly research, Malraux deviously worked the system of government patronage to get to Angkor Wat. He had mined the accumulated scholarship of the Ecole Française d'Extrême Orient and used it to camouflage his real plan to strip sculptures from a small and little-known ruin near Angkor Wat. He chose the site after studying the most detailed publication on the subject.[268] His reading also revealed the possible existence of an ancient Royal Way, a King's Road, along which Khmer history had unrolled. Trading on this, Malraux declared to the authorities that his mission was to study it. While the plan did not fool the local civil servants, who had him followed, the idea had an afterlife as the basis of his novel *La Voie Royale*, set in the rainforest of Cambodia. He was to turn his journey into a book much as Max Ernst incorporated his travels into art, each reworking the jungle in their preferred medium:

> "What is it?" [asks the hero of Malraux's novel, looking at a line drawn on a map of Indochina]
> "It's the Royal Way, the road that linked Angkor and the lakes of the Menam Basin. It was as important in those days as the route along the Rhine and the Rhone was in the Middle Ages . . . : if Europe was covered in jungle now it be would hard not to find ruined churches on the road from Marseille to Cologne. . . ."[269]

Max Ernst's *Europe After the Rain II*, painted in 1940–42, illustrates Malraux's apocalyptic scenario. While the painting expressed Ernst's reaction to the devastation of Europe by the Nazis, it did so partly in terms of what he had seen in Indochina. It was the latest picture in a sequence of paintings of jungle ruins inspired by Angkor—landscapes of ruins smothered in vegetation. Above this decomposing geographical transposition of Angkor the monsoon clouds are clearing.[270]

Malraux's expedition had used ox carts and a team of Cambodians. Leaving Angkor Wat he and his wife travelled into the jungle for two days before reaching the isolated temple of Banteai Srei. They spent three days removing seven carved stone blocks intending to ship them by boat to Saigon, and onward to France, where they would be sold. However, on Christmas Eve 1923, in the dead of night, the adventurers were arrested. The sculptures were impounded. Forbidden to leave pending trial, the couple sweltered for many months in the Cambodian capital and ran out of money. This part of their adventure coincided with Eluard's mounting despair in Paris and with his embarkation for Tahiti, as well as with Blaise Cendrars' sudden disappearance by steamer to Brazil.

Fig. 47 Max Ernst, *Europe After the Rain II*, 1940-42. Oil on canvas, 54.6cm x 147.8 cm, Wadsworth Athenaeum, Hartford, Connecticut. S/M 2395.

While Eluard had been steaming across the Atlantic on the *SS Antinous*, Clara had starved herself in Phnom Penh, until she had deteriorated visibly enough to be sent home in mid-July 1924. Eluard, meanwhile, was in the Dutch East Indies making for Singapore when, on July 16–17, Malraux was tried and found guilty of theft. When Clara arrived in Paris she found her very proper family desperate to dissociate themselves from her scandalous husband. She needed help:

> It was six in the morning, place Clichy. It was light as I got into the taxi. In my hand I've got the address André Breton had given in his letter: rue Fontaine. . . . Looking back at that moment for years afterwards was like a tonic, it acted on me like a drink, a glass of wine that gives you strength to keep going–in that case to go up the stairs without stopping and tell the young woman in a dark dressing gown, who eventually answered the door after I had given the bell a good ring: "I'm Clara Malraux."
>
> Then my head started spinning. From the sofa where I lay I heard a woman's voice shouting: "It's Clara Malraux."[271]

A friendship took root. "Lying on the sofa it felt good to have the two of them on my side. When I opened my eyes there were Breton's strong features and his thick head of hair; Simone is petite."[272]

News of her adventures and of her husband's problem in Indochina spread among the Surrealists. Five days after Gala and her lovers had arrived in Saigon, Breton published an article on the front page of a French journal under the headline *Pour André Malraux* (In Support of Andre Malraux). He defended Malraux's expedition to Angkor Wat as the work of a writer in search of inspiration.[273] Breton, Aragon and Soupault also signed a second petition that appeared on August 25.[274] This was followed by a more impressive appeal bracketing the three Surrealists with establishment figures. The

names of Edmond Jaloux, André Gide, Francois Mauriac, and Gaston Gallimard appeared with those of the radicals.[275]

Clara was quickly taken up by the Surrealist circle: "I was surrounded by new friends; the Bretons went on taking care of me, I remember a morning at the Café Cyrano where the Surrealist group used to meet." Clara met Louis Aragon, and René Crevel but "As for the others, Baron, Péret, my life was in such a state I found it hard to tell them apart."[276] No mention was made of Eluard and no questions were asked about Ernst or Gala. Malraux's appeal against the verdict got nowhere and began to gather dust. Rather than wait, he returned to France, arriving in Paris soon after Eluard and Gala, and thanked the Surrealists for their support. He was, however, too ambitious to join them or to take any part in their activities. We do not know if he met Eluard and traded experiences of Indochina.

Malraux soon raised enough money to return to Saigon and establish a modest opposition newspaper. Eluard, who had not been as exposed to the corruption of colonial culture but had seen enough, wrote critically about what he had seen. It was the first expression of his growing political voice.[277] This commitment deepened and he became the managing editor (1930–1933) of the frequently anti-colonial Surrealist journal, *Le Surréalisme au Service de la Révolution*. He joined the Communist Party and later distinguished himself in the French Resistance during the Nazi Occupation of France.

Malraux's anti-colonial journalism was fiercer and put him at risk. He edited two radical newspapers, *l'Indochine* and *l'Indochine Enchainée* (Indochina in Chains) which exposed the corruption of the French administration so effectively that his co-editor barely escaped assassination in his sleep. Worn out by police harassment and by threats, Malraux returned to France at the end of 1925. He won the Prix Goncourt in 1933, led an airborne expedition across the Arabian Desert in search of the lost capital of the Queen of Sheba, commanded an airforce squadron in the Spanish Civil War and was General de Gaulle's Minister of Culture. For him, as for Eluard, Indochina had paved the way to politics.

There is an unexpected coda to the overlapping presence in Saigon of Malraux, Eluard and Ernst. It concerns the most famous statue of its day at Angkor, the figure of the Leper King. Word about Malraux's expedition spread and it became so notorious that within two years Pierre Benoit, the specialist in chic thrillers, based a novel on it. Clara said Benoit's book was "written as a result of our expedition."[278] The title of Benoit's book, *The Leper King* (1927), referred to the statue itself, which crops up in his plot like a Khmer version of Dashiell Hammett's Maltese Falcon. Undeterred by the success of this smooth yarn modelled on him, Malraux wrote his own darker version of events as *La Voie Royale* (1930).

A few years later the Leper King reappeared, this time associated with Eluard, when the sculpture inspired Max Ernst to paint a picture about his friend's journey which he called *Le Déjeuner sur l'Herbe* (illustration 121). So in the end, the visits of Malraux and Eluard to Indochina were commemorated by reference to a sculpture at Angkor. The

sculptures Malraux had removed from Banteai Srei were restored to the site in 1925, where they were unfortunately destroyed in 1970 during a battle between Khmer Rouge forces and troops of the Lon Nol government.

As for Max Ernst, he summed up his visit in a sentence. "Rendezvous with Paul and Gala Eluard in Saigon and it was Max who persuaded Paul to give up his idea of *disappearing for ever*."[279] Ernst's widow, Dorothea Tanning, saw the Saigon *rendez-vous* overshadowed by Gala's cat-like gaze. But by then for Ernst, "it was a simple matter to deliver the eyes to their mate, no hard feelings, and to wave them farewell as he stayed on to absorb alone the heady east-west concoction of Indochina."[280]

Interlude

ELUARD'S ABSENCE

Plague sailors stars the sea
Reefs and the ghost ship . . .
 Robert Desnos, *De silex et de feu*, 1929

Eluard's disappearance stunned his friends. "Serious questions are raised when people disappear," wrote Pierre Naville. "I'm not talking about death, which is straightforward. But suddenly, that vacuum. Where is he? What's happened to her? A clue . . . Gone with the wind. They've vanished into thin air. Have they gone to live somewhere else? We'll never know if it's in some hell-hole in the back of beyond, or in paradise regained."[281]

Various explanations were floated, ranging from suicide to an Arthur Rimbaud-style change of career. Confusion was fuelled by the silence of those that knew but said nothing. Louis Aragon, for instance, waited nearly thirty years, until after Eluard's death in fact, before admitting he had been with him the night he vanished.[282] Those closest to Eluard, Gala and Max Ernst, kept especially quiet.

What can we learn from Ernst's silence? Eluard's friends liked him. "He was polite, but extremely reserved," remembered one, "He never said much and was hard to understand because . . . he'd only just arrived from Germany."[283] A naturally reserved person, speaking broken French, Ernst could be discreet without causing offence. His silence was probably the result of anxiety. There were Eluard's parents to worry about, for they took a dim view of the way he, Ernst, had compromised their daughter-in-law and sponged off their son. He had been financially dependent on Eluard for two years and now, after his son's disappearance, Eluard's father wanted Ernst out. Gala herself would have lost the financial support of her parents-in-law if they found Ernst was still living with her, at their expense. Then there was his status as a clandestine immigrant, which threatened arrest and deportation if he was reported. A low profile would have seemed wise, essential in fact. Dorothea Tanning later described the growing tension between the lovers, no doubt part of the gathering gloom at home that had weighed on Eluard. Gala's controlling gaze was aimed at both Ernst and his work. "It lasted long months, during which the burning cigarette eyes ground against him, not with him."[284] Ernst was poor, and although he was painting better than ever he did not earn enough to sup-

port Gala in the style to which she had grown accustomed with Eluard. In addition to this, Ernst's affection for and his debt to Eluard, both moral and financial, obliged him to respect Eluard's call for silence, and so he let the rumours ride.

Robert Desnos got closest to what was really going on, because Ernst asked him for help.[285] Desnos, a streetwise Parisian, was approached by Ernst for advice about getting a false passport, and it is likely he then began to put two and two together. After Eluard had vanished, Ernst was forced to go home to Germany to raise money, return to France, and join Gala for the sea journey east. He could not do this without a passport. His trip back to Germany was an excursion he summed up, using the third person as, "He sold the works done during his years in Paris to old Mutter Ey of Dusseldorf, for very little. . . . Max was then able to set out for Indochina."[286] This suggests Ernst approached Desnos soon after Eluard had left Paris.

At that moment Desnos was also the group's leading medium, and proud of his role in their experimental séances. This position encouraged him to veil what he had learned from Ernst and to suggest instead that he had discovered Eluard's whereabouts thanks to his exceptional paranormal gifts. So it was that "Desnos told me," said Pierre Naville, "that his clairvoyance (*il en avait la voyance*) had revealed Paul was in the New Hebrides." Desnos' performances as a medium were some of the most important events to take place before and during Eluard's absence, and the atmosphere of mystery and imagination spun by him coloured the group's reactions to Eluard's disappearance.[287] While Eluard's friends were shocked by his departure, others had already sensed something unstable about him. Desnos, once again, was one, and Soupault another. Soupault had published an imaginary epitaph for Eluard four years before that read:

> Wave your walking stick and gloves
> stand up
> close your eyes
> fluffy clouds are far in the distance
> and you left without saying goodbye[288]

The poem was the first of several premonitions related to the journey. Desnos came up with the next. In a 1922 review of Eluard's book *The Misfortunes of the Immortal* he had asked "Is Eluard interested in suicide?"[289] Two years after this, with Eluard's trail going cold, it would have been seen as yet another possible sign of Desnos' clairvoyance. "It is typical of the coincidences and serendipities which haunt the Surrealists, Breton, Ernst and Eluard in particular."[290]

We can see how seriously these coincidences were taken from an article Breton published in July 1924, four months after Eluard had vanished. "In our time, on the intellectual front, there are, I believe three fanatics of the first order: Picasso, Freud and Desnos." Breton went further, "Surrealism has come of age and Desnos is its prophet."[291] Breton adopted an extremely open-minded view about the possibilities of human perception and was prepared to make radical assertions about "the prophetic value of surrealist language."[292]

Desnos was not only the star of Surrealist séances and prophecy, he was fascinated by the sea, by steamships, shipwrecks and ocean travel. The sea kept breaking into his work: "... my friend Robert Desnos, that unique modern sage," said Aragon, "with strange ships in every fold of his brain."[293] Aragon also described him in full prophetic flood, not in the hushed atmosphere of André Breton's darkened studio, with attentive Surrealists holding their breath, but bold as brass in a Paris café, "amid the shouts, the bright lights, the jostling, Robert Desnos has only to close his eyes and speak, surrounded by glasses and saucers, for his loud prophecies to be accompanied by the pounding surf and steamers festooned with flags."[294] Eluard's decision to take a steamer coincided with the fascination that the sea held for Desnos, a coincidence that explains the accuracy of the guess that he had gone to the Pacific. This plausible explanation does not however apply to most of Desnos' visions. Eventually his insistence on holding *séances* alarmed Breton, who had worked in a psychiatric hospital, and he banned Desnos, fearing he might otherwise suffer a breakdown. But for the moment, while Eluard was at sea, Desnos' visions were treated as legitimate forays into unknown regions of the mind, and were central to the group's methodical exploration of such unmapped mental territory. These expeditions into the land of dreams, part of the Surrealists' *aventure mentale*, coincided with the real journeys of their *aventure mondiale*. In this way traffic flowed back and forth between the parallel adventures. If these two different, though related, journeys could intersect, the group's travel-fever might integrate dream life with workaday waking existence. The result? A revolution in consciousness—precisely what the group was after.

Desnos' idea that Eluard was at sea also decanted the ocean into the psychological vacuum he had left behind. This was a convincing suggestion on another level because the sea is a notorious metaphor of the unconscious, and so would pour effortlessly into that void. It gave his friends grounds for *feeling* he might have taken a steamer, the transport associated with exploring foreign territory.[295] Since Desnos was an enthusiast and a good man, as his grim end revealed, we should be as open-minded as he was about his ability to navigate between levels of consciousness. How straightforward Desnos *always* was will never be answered, for he was ambitious, and his trances were occasionally calculated.

Pinpointing Eluard's whereabouts on the globe was undoubtedly also influenced by the fact Desnos had already made the New Hebrides the setting for a travel story the group would have known, *Pénalités de l'Enfer ou Nouvelles Hébrides* (The Penalties of Hell or the New Hebrides). This vivid ocean-going saga was completed in the winter of 1922, shortly before he collaborated with Breton and Benjamin Péret on the script of a play called *Comme il fait beau!* (What good weather!).[296] *Comme il fait beau!* was also set in the tropics (thanks to Desnos again?) and contains another startling premonition. It opens with the following dedication, "For Max Ernst. In the tropical forest." At the time of writing, March 1923, Ernst had never been out of Europe and there was nothing to suggest he would soon be in the tropical rainforests of Vietnam. Whatever we make of Desnos' visionary skills, we should remember *The Penalties of Hell or the New*

Hebrides had been published in the group's journal *Littérature*.[297] Observant readers would therefore be able to puzzle over the fact that it had not only predicted Eluard's destination, but had sensed the matrimonial *Penalties of Hell* he had known before making for the New Hebrides.

In the end, irrespective of whether or not his colleagues accepted Desnos' paranormal gifts, his verdict prevailed.[298] As no news of any kind about Eluard reached his friends during his absence, we must assume Desnos was responsible for the idea he was in the Pacific.[299] What is striking is the tact of Eluard's friends, even in the privacy of their letters. They saw his unhappiness, but no malicious gossip survives, except for a quip or two and a few snide asides from Desnos in one of his trances.[300] They were idealistic enough to accept that Eluard's disappearance had more to it than Gala's infidelity. The group, after all, had been immersed in the revolutionary zeal of the Dada protest movement. "Dada was invented out of moral necessity," wrote Tristan Tzara, "by an unstoppable need to find an absolute moral position. . . . Dada was a protest, typical of all adolescence, which demands the total commitment of the individual to his deepest feelings, without regard to history, logic or the morals of the moment."[301] The longing for such an absolute moral position survived with individuals who rejected compromise as robustly as Gauguin, Rimbaud and Cendrars.

The latter, as we know, had left Paris ahead of Eluard, to board ship for Brazil and escape the art-world rat race, "what really revolts me is literature—its obligations, its point scoring—and the phoney, conventional life writers lead," he wrote in mid-Atlantic.[302] The inner horizons towards which Desnos escaped in his trances, the steamship, taken by Cendrars, and the empty deserts around the Red Sea chosen by Rimbaud, were some of the escape routes from the phoney careerism still on offer to the Surrealists. Of these routes, Rimbaud's was the most popular.

Early the previous year, in the spring of 1923, Roger Vitrac had published the newspaper interview that read "André Breton will never write again."[303] According to him Eluard and Desnos agreed. They were all giving up writing, just like Rimbaud.[304] "Good intentions, broken promises," said Pierre Naville later, reminding us how hard it was for them to detach themselves from their career.[305] Eluard's disappearance had immediately touched that nerve. "André's so sad, worried, nostalgic and more detached than ever," Simone had noted three days after Eluard had vanished.[306] We also know how disturbed Breton was thanks to Marcel Noll, one of the shooting stars who sped through Surrealism and then vanished without a trace, like the mysterious Dédé Sunbeam. Noll's letters are some of the surprisingly few clues to this period that survive. "I wonder what Eluard's doing now," he wrote,

> Here no-one's talking about it anymore; I'm sure André's thinking about it all the time . . . it must be what's causing his outbursts and fits of giggles (the day before yesterday he laughed as I've never seen him laugh before; he was in tears). . . . As for me, I think I'm the only one who is really disturbed by the business, . . . I can't talk about it and it's all beyond me.[307]

A day or two after Eluard vanished, Breton himself made the following cryptic note: "Which one is he? Where is he going? What's become of him? What's happened to the silence around him, and to those stockings which were his most chaste thoughts, that pair of silk stockings?"[308] Breton was employed as cultural adviser to the couturier Jacques Doucet, and in two *pneus* to him Breton revealed his feelings about Eluard's departure, "it's extremely relevant to the attitude my friends and I promote, and it has had such an effect on me I cannot get over it."[309] Two weeks later he was as confused, writing that "some of my gloomiest concerns have been confirmed by it, . . . so much so I can barely make sense of anything."[310] Breton clearly felt Eluard's disappearance in more absolute terms than those of a collapsing *ménage à trois*.

Eluard's friends in fact had good grounds for fearing he might not only give up life as a writer, but living itself. After all, had he not, on the day before he disappeared, signed off the contract for the publication of his most recent collection of poems, one he defined as final.[311] "To simplify everything this my last book is dedicated to André Breton" he wrote. By disappearing as he completed a book described as his last and entitled *Mourir de ne pas mourir* (Dying of not dying), his behaviour could easily be read as suicidal.

Eluard had borrowed the title from a line of Spanish poetry by St Theresa of Avila, *Que muero porque no muero*, which, however, sends a mixed message. On one hand it refers to the attraction of death, on the other it confirms the author was more aware than ever of the value of life; the words do not imply suicide. A Catholic like St Theresa believes suicide to be a mortal sin that brings eternal damnation. *Mourir de ne pas mourir* was therefore St Theresa's anguished response to the stupefying limitations of normal consciousness. It implied that somewhere, beyond life, beyond the grave, there was a better, purer state. Her phrase is about impatient longing and hope. Surrealists were fascinated by suicide and several even took that exit; men such as Jacques Vaché, Jacques Rigaut, René Crevel, Wolfgang Paalen, Kurt Seligmann and Oscar Dominguez, and women, too, such as Kay Sage and Unica Zurn. It is no surprise therefore that Eluard's disappearance provoked such thoughts. In 1920, for instance, Breton and Soupault, nauseated by the spectacular carnage in the trenches, had jointly written the play *S'il vous plaît* (Please), a project with a terminal curtain. "André Breton and I agreed there was no other way to end the play than by suicide," said Soupault. "We didn't get round to rehearse it. Suicide in those Dada times was tempting. It was, after all, pretty logical as Dada was about saying no to absolutely everything."[312] Two years later, still attracted to suicide, Soupault wrote *L'Invitation au suicide* (Invitation to Suicide). He later destroyed the entire edition of the book because it seemed pointless to propose something you failed to do, so the work has disappeared entirely except for its title. As we have seen, Robert Desnos had reviewed Eluard's book of poems *Les Malheurs des Immortels* (The Misfortunes of the Immortal) and detected a suicidal tendency there. Eluard's recent behaviour had seemed to confirm this. "Noll," he said one night out of the blue, "it's time to die, you've got no choice."[313]

But if Eluard's disappearance had been similarly motivated, he set out to do it in style, which does not make sense. He had said goodbye to his father with a wallet full of cash taken from the family business. Those 17,000 francs guaranteed a comfortable life. We will never know how desperate he was, but the money suggests his *voyage idiot* was not a suicide mission. Pierre Naville, as mystified as the rest, saw Eluard's vanishing act in a positive light, and took his cue from what Eluard had published. "After all," said Naville, "he'd already written in 'Proverbe': 'Success lies in disappearing.'"[314] Some good would come of it.

The idea of jumping ship and withdrawing from life had its attraction for those who had only recently escaped the industrialised abattoir of war and still had doubts about the way things were going. Breton, for example, believed "Everything I love most is in a terrible mess. . . . In fact I think the game's up."[315]

It was Rimbaud, once again, who offered the most palatable solution. What made him so attractive was the way he had bailed out of art to keep in touch with life, added to which so little was known about him that everyone could make up their own version of events. "He didn't set off to conquer the world," wrote Soupault. "He was simply living his life and his shadow led him towards infinity, for which he felt a longing as desperate as a painful illness."[316] Eluard's predicament was to find his absence measured against the slippery benchmark established by Rimbaud. Speaking for most of his friends, Breton said there were those among them "for whom, when we were young, the discovery of Rimbaud was *the great thing*."[317] Soupault confirmed that "At that time I was always, more or less consciously, influenced by what had happened to Rimbaud . . . who had decided that no matter what it cost him, he had to escape from the literary scene. . . . It was Rimbaud's example, and my own desire to escape and to see the world, to get out of Paris . . . that forced me, and I use the word deliberately, to leave."[318] The problem was not only that Rimbaud was a hard act to pin down, but also that Eluard could not escape the comparison. Rimbaud was a cult figure so routinely invoked that people joked about posers "saying goodnight, claiming they were off to *do a Rimbaud*, only to turn up again next day on the terrace of the Deux Magots."[319] Victor Crastre underlined the phrase "do a Rimbaud," and returned to it when recalling his first meetings with the Surrealists, when "Paul Eluard was missing, I think, because he had not yet returned from his trip (to the New Hebrides?), described by some as a trip made by a man who had turned his back on the world, like a new Rimbaud."[320]

Any attempt to do a Rimbaud is doomed, because you are disqualified the minute you try. Those writers who admired him had to ask themselves "Since he walked out on literature, how can I stick around? But if I quit I'll only be accused of copying him." Rimbaud was the ultimate role model, at once inimitable, chic, mysterious, and radical, who had not only disqualified literature, but had also closed off giving it up. Nevertheless, for a time, Eluard's friends were persuaded he had ventured into that Rimbaud-tinted minefield and were able to draw consolation from his attempt.[321] But that comforting consensus evaporated when he walked back in as unexpectedly as he had walked out.

Chapter 6

HOME

Silence has its laws and its demands. Silence demands that concentration camps be built in uninhabited areas. Silence demands an enormous police apparatus with an army of informers. Silence demands that its enemies disappear suddenly and without a trace.

Ryszard Kapuscinski, *The Soccer War*, 1990

Part one Departure: Paul and Gala Eluard's journey home

The average temperature in Saigon is 30°C (86°F). "In July in France you hold your hand out to test the temperature, as if checking the heat of a fire," wrote Leon Werth. "Here, you put your hand into the heat as if into bathwater."[322] It would have been with relief, therefore, that Eluard and Gala boarded a connecting steamer to Singapore. The world map on which he drew his route proves Eluard left Indochina without visiting Angkor Wat (fig. 19). If he left the capital at all it was such a short distance he could not mark it on the map. What he had seen was Saigon's metropolitan élite at work and at play. Unlike Ernst, his exposure to Indochina's landscape and antiquities was restricted. The overwhelming impression made upon him was political, based on city life. The return journey promised escape from the social and climatic heat of the capital once he and Gala reached the open sea and its cooling breezes.

They had to be in Singapore on Friday September 5 to catch the *SS Goentoer* (fig. 3), a Dutch liner bound for Marseille.[323] We do not know which vessel they took to Singapore, but they may have left Saigon as early as August 23 when the French liner *SS Angkor* set off in that direction. From Singapore, on the twenty-eighth, Eluard sent a telegram to his father in Paris asking him to cable money urgently.[324] Singapore was the point of departure of vessels bound not only for Europe but also for Australia, the Dutch East Indies, Siam, and China. Ships sailed to Europe more often there than from Saigon, where the French-owned Messageries Maritimes ran a more limited service home. The

Messageries also maintained subsidiary routes in the region, one of which sailed, every other week, from Saigon to Singapore. The vessels on that run made a stop en route, calling at the island of Poulo Condore.[325] This was one of a cluster of fourteen islets of volcanic origin in the South China Sea, eighty kilometres southeast of the Mekong Delta. Poulo Condore straddled Paul Eluard's route to Singapore. This extra-ordinary place, though seldom spoken of today, was to feature in the Surrealists' journal, *Le Surréalisme au Service de la Révolution*, where it was described as part of Indochina's repressive regime under which "... thousands and thousands are slowly dying on the island of Poulo Condore, in the countless prisons in Hanoi, in Saigon, in Annam."[326] Eluard's part in drawing the Surrealists' attention to the island cannot be ignored.

As he sailed towards Poulo Condore he was not buoyant. He had just left Max Ernst to fend for himself after the painter had travelled halfway round the world to make sure he, Eluard, was safe. Leaving Ernst to his own devices like that must have grated. And although Gala was with Eluard, things were never to be the same again between husband and wife. The departure from Saigon therefore signalled a parting of the ways for all of them. Two years of profound intimacy had come to an end. In addition Eluard had by then been on the road for six months, which had taken their toll, and it is not difficult to imagine the unsettled state of mind such a life would induce. We shall never know what Eluard's feelings were on his journey home, but we know from Marcel Noll that soon after his return Eluard was still suicidal.[327] Breton's wife Simone said that when she first caught sight of him after his return Eluard looked as if he'd shrunk.[328] The troubles he had experienced for the last year must have coloured his journey home and he would have been on edge as the world sailed by.

In the streets of Saigon the behaviour of the French rulers had shocked other visitors too, like Leon Werth. He watched a rickshaw pass. "It's ten-thirty at night. At the corner of the rue Pellerin and the street with Chettys Pagoda a great big colonial type with a fat neck, like a bulging monster, jumps from his rickshaw and punches his Annamese rickshaw boy twice, yelling

"You bastard ... you've kept me waiting all the time, since midday."
The boy doesn't move. You'd think he was there on purpose, by appointment, to be beaten up.
His attacker climbs back into the rickshaw.
They're already a long way off.
And that kind of thing's begun to seem normal.
It's time I left. Time's up. I can't take any more."[329]

Such master-slave behaviour in the streets of the city is likely to have struck Eluard and Ernst in the same way, and soon after his return Eluard went into print condemning it.[330] This anti-colonial response coincided with that of André Malraux. Both writers were back in Paris from Indochina by December 1924, when Eluard inaugurated his political journalism with an article in defence of human rights, *La suppression de l'esclavage* (The Abolition of Slavery). This was composed while his impressions of the

journey were still fresh. "How can you expect even the most patient slave to put up with the half-baked cruelty of whites in a state of terminal collapse themselves," he asked, concluding "in Indochina the white man's a corpse, a dead-man who chucks his rubbish at people with yellow skin; in Java, self-important Dutchmen brag about the number of servants they've got, yet every now and then they have their throats slit by them."[331] Since leaving France, Eluard's journey had consisted of the daily round of shipboard life; the cabin, the bar, an immediate landscape of ventilators, davits, lifeboats and funnels, a succession of colonial ports. On deck he had watched a procession of islands across the Caribbean, the Pacific, and the Arafura Sea. Then as he reached the open waters of the South China Sea, with Saigon behind him, there was Poulo Condore, which he had already sailed past on the way up. It was more than a tropical island.

A visitor described the approach, "Straight ahead, an island . . . a camel with three humps on its back." It was a camel loaded with ever more outcasts and lepers delivered from the mainland.[332] "I could see a wharf over in the most sheltered spot. Beneath the palms; about sixty roofs; walls of rose-coloured beaten earth around long low buildings; that's Poulo Condore and its gaol."[333]

Poulo Condore had been France's first territory in the region, acquired when Louis XVI signed a treaty with the Nguyen rulers in 1787. Because of its security as a naval base by virtue of its isolation it attracted European attention, and features in Marco Polo's book. The British built a fort in 1702 but it did not last, as they manned it with troops from Makassar who killed their European officers. The French secured it in the 1860s during their creation of French Indochina. A depression then settled over Poulo Condore, at the very time the French were also clearing the newly discovered ruins at Angkor Wat, for the island was incorporated into the expanding global network of France's Gulag Archipelago.[334] To begin with few political prisoners were shipped there, but by 1908 it had become the Devil's Island of Indochina, as hundreds of Indochinese troublemakers were sent there. Then in the 1930s thousands arrived. Ten thousand political prisoners were to be held in Indochina's gaols, including Poulo Condore. The number of prisoners on the island fluctuated, but the growing unrest in the country at the time of Eluard's visit soon brought new inmates. "One of the penitentiaries in Indochina was nearly empty," wrote *Le Quotidien*. "Now it's back in business. It's Poulo Condore . . . hundreds of convicts are going to their deaths there."[335] A letter leaked out of the island and reached André Malraux in Paris:

> This letter is sent to you by us, political prisoners on Poulo Condore . . . There are one and a half thousand prisoners here who expect their daily rations of red rice and rotting dried fish, of hellish forced labour, of beatings, and in the end sickness and death . . . On Poulo Condore they will die without making trouble because ocean waves and prison rules muffle their death-rattle.[336]

The place had a momentum of its own, feeding on political unrest, and became "the great anti-French nursery of the Vietminh during the feverish years of 1934–1945."[337] An

eyewitness evoked a weird tidal world reminiscent at times of that invented by Eluard's friend, the painter Yves Tanguy. A satellite island lay off the main penitentiary:

> That rock was barely a kilometre long, by two wide. Beneath the palms blowing in the wind, about a hundred huts. A vision of hell; all prisoners with leprosy, elephantiasis, beriberi, whatever are sent over from the main island. . . . All you see are blistered faces, and deformed, atrophied, huge, monstrous limbs. Everywhere oozing wounds, gigantic abscesses, bulges swollen beyond belief. Even the riffraff from the gaol gets sent over to this island of horrors; invalids, the paralysed, the disabled and those who can't look after themselves any more. . . . And there is absolutely no medical care of any kind.[338]

Today the islands have been renamed the Con Dau. Like Alcatraz, the chamber of horrors has become a tourist attraction and is set for development as an offshore gambling resort. The ex-penitentiary is now to be a casino enjoying the surreal touch of duty-free status and former inmates as croupiers.

As the camel-hump silhouette of Poulo Condore dropped beneath the horizon Eluard may have remembered that if he had not disembarked in New Zealand, his next stop on the *Antinous* would have been Noumea. While Soviets built gaols in the Arctic, the French chose the Tropics. The *bagne* at Noumea, capital of the French colony of New Caledonia, was familiar in France. It had opened for business in 1864 on the islet of Nou, just off the main town. Straddling a Pacific port, its position resembled Alcatraz. In 1873 the new gaol received a shipment of political prisoners from France; a contingent of Communards. These men and women had joined the radical uprising of the Paris Commune, in which Gustave Courbet had also played a part that had then forced him into exile. The uprising had up-ended the lives of many other Parisian artists including Degas, Monet, Manet and Pissarro. The Communards had fought to reform the political system of France in the wake of the Siege of Paris by the Prussian Army. The defeat of France triggered the Communards' disastrous revolt against their government. Between 20,000 and 30,000 French citizens died in Paris, many executed by firing squad. Others were deported to the Pacific. Among them was the writer Henri Rochefort, whose daring escape by boat from Noumea in 1874 made him an international celebrity. Victor-Henri, Marquis de Rochefort-Lucay (1830–1913) was a playwright and journalist exiled to New Caledonia for inciting political unrest. He escaped after four months, held not in the terrifying island gaol of Nou where the criminal élite festered, but on the Ducos Peninsula that was linked to the rest of the island by sea alone. This escape was the subject of a painting by Manet, based on Rochefort's account. Manet also painted Rochefort's portrait.[339]

Between 1864–1896 the French government exported a total of 40,000 convicts to the penitentiary, and only stopped the transhipments in 1896 because the residents of New Caledonia, many ex-convicts among them, felt that importing criminals lowered the tone of the place. Tropical gaols like Noumea and Poulo Condore were the shadow

cast by France's colonial Empire. They formed a global network containing the nation's undesirables. The network went hand in glove with colonial expansion. The covert relationship between the highly publicised triumphs of empire (detested by the Surrealists, as we shall see) such as the Exposition Coloniale in Paris in 1931, and the network of "hearts of darkness" like the island gaols, was an integrated system. Its distant prisons came to the attention of Surrealists. The study of Eluard's itinerary has numerous surprises, none stranger than the story of France's tropical gaols and the Surrealists' outrage at what went on there.

Eluard's journey was not a tour of inspection of the Pacific *bagnes*. It had been motivated by unhappiness, not investigative zeal. Yet it had specific political consequences that contributed to the development of two of Eluard's long-term interests. The first was his fascination with the imaginative life of mankind and its global diversity, and the second was his horror at our taste for stamping out the freedom of others. The voyage opened his eyes to both these things, and did so because Eluard was an observant and sensitive traveller, even if during this journey he was a troubled one.

The most infamous penal colony of all was Devil's Island.[340] Devil's Island is the Atlantic outpost of the much larger *bagne* on the mainland coast of French Guiana, at Cayenne. In France the whole Guiana prison complex was known simply as Cayenne and was still in use in the 1950s. Eluard never visited Cayenne but he knew about Poulo Condore. Its history is therefore worth noting, for it tells us something precise about Surrealist politics, as well as encouraging us to examine Eluard's voyage for other unlikely clues. The Surrealists, Eluard included, went on to protest against such places, drawing attention in particular to Cayenne and Poulo Condore.[341] These and other protests evaporated with the emergencies that provoked them. As new horrors were reported they claimed the spotlight and previous causes were replaced and then forgotten, buried with the efforts and the idealism shown by the protesters.

It is only by exhuming these forgotten cruelties which the Surrealist resisted as best they could, that we can judge and properly admire the group's enterprise. Of course other fair-minded writers and artists in France knew about Poulo Condore and its related brutalities. Together with the Surrealists they formed a chorus of protest. Yet it is the study of Eluard's *voyage idiot* that has brought Poulo Condore into focus again as part of the history of Surrealism. It is a discovery that underlines the commitment of Eluard and his colleagues to external reality, to the reality Ernst watched with an eye wide open, "fixed on reality what is going on around in the world," as he said. The other inner eye he kept shut, and scanned his dreams. The Surrealists read the world news attentively for reports of concentration camps in distant places visited by few, if any, of their group. They were careful to report cruelty in corners none of them had seen. They had a truly modern, global view of oppression and of the need to fight it with the oxygen of publicity and group action. This reminds us that in addition to its other qualities Surrealism was also a tightrope act above the bottomless pit of human bestiality. Despite the mountains of dispiriting evidence about the inhumanity of man to man Eluard and his friends stubbornly believed everything was still to play for, year in, year out. Something, they told

themselves, could be done about things like Poulo Condore and the Dutch camps up the Digul River. One only has to recall how many of the first Surrealists like Pierre Naville, René Hilsum, Francis Gérard, Jacques Baron and André Thirion chose politics over the arts to appreciate the character of the group. Naville in particular was to keep an eye on the situation in Indochina until the French surrendered, as his 1949 book *La Guerre du Vietnam* (The Vietnam War) reveals.[342] Naville was also the first of the 1924 group to sense the complexity of Eluard's voyage to Indochina, and the first to write about its prophetic meaning, fifty-three years later, in 1977.

Part two Arrival: the reaction to Paul Eluard's return

The vessel Eluard and Gala boarded in Singapore offered a suitable metaphor for their marriage. The *SS Goentoer* was a luxury liner that would soon be scrapped. Built in 1902, the Royal Rotterdam Lloyd liner was making one of her last voyages. She had long been a fixture in the Dutch East Indies, ferrying people to and from Rotterdam, her homeport, via Batavia to her terminus, Sourabaya, in Java. She had been the crack liner on that Holland-Java route. Her high superstructure made life sweet for the first-class passengers and her spacious promenade was available for Gala and Eluard to enjoy.[343] It was an uneventful journey via Colombo and Djibouti. "The image of Rimbaud is a constant, which recurs time and again during the journey," Victor Segalen had written as he took the same route back to France.[344] Eluard might have thought the same when the *Goentoer* neared the port from where the desert road to Ethiopia was taken by Rimbaud. "Everything draws us into the bay, wind and the current. And the sky soon looks like the one you get over every sea of sand. I predict a different sunlight tomorrow; pulverising, desiccated, . . . a land harsher and harder than the skies; the ivory route," itself the setting of Rimbaud's last adventures.[345]

We know Eluard's friends still had no idea where he was, nor what had become of him. His last book, *Mourir de ne pas mourir*, was reviewed as he made his way home. In his review Jean Bernier referred to the book's dedication in which Eluard had called it *mon dernier livre*, my last book. This, Bernier wrote, "takes on a special meaning once you know, as André Breton himself told me, that Paul Eluard suddenly disappeared, some three months ago, without a word to his friends and without showing any sign of life since."[346]

The *Goentoer* docked in Marseille on Sunday September 28. The summer was over, autumn in the air. Eluard was back as the seasons turned. He'd been away twenty-seven weeks and seemed to have got nowhere. "Travel has always taken me too far," he later wrote. "The reassuring knowledge that one's got a destination has always seemed like the hundredth ring on the bell of a door that never opens."[347] So he walked back in as if he'd never been away. The shock caused by his resurrection is evident in the reaction of his friends, and in the laconic epithet he devised to cover the confusion. He'd been on a *voyage idiot*, a silly trip.[348]

"I entered the surreal through a door opened by Eluard's disappearance," wrote Pierre

Naville, who described Eluard's return.[349] Naville's eye was fresh, for as a new recruit to the group he did not know Eluard, and so had no axe to grind. He recorded the shock of others without filtering it through his own. He studied the disappearance and placed it in the longer run of things. In the end he concluded that Eluard's disappearance was an important event in the story of Surrealism, as valuable as the militant absurdities of the Dada scene, shipped in earlier by Tristan Tzara from Switzerland to Paris. "That disappearing act makes much more sense to me," said Naville of Eluard, "than the trip from Zurich to Paris . . . made by Tzara. Dada arrived by train and disappeared into Oceania by steamer. That was a development with far-reaching consequences."[350]

Naville's account of Eluard's return from Oceania was based on the correspondence between his wife, Denise Naville, and her friends, who all knew Eluard well. Not only did she receive letters from her cousin Simone, André Breton's wife, but also from several Surrealists who were competing for Denise herself. Aragon, Breton, and Marcel Noll were attracted to her, as was Eluard.

"Great news:" wrote Aragon, breathlessly, "Eluard is back, from Martinique, Tahiti, Java . . . André is depressed, happy to see Paul but. And then anger. . . . As for me, I can't tell you how much I missed Eluard."[351] On Friday October 3 Simone Breton wrote, "First: Eluard is back. No comment. There's too much to say." However, she could not resist and went on at some length, comparing Eluard with Rimbaud, whom she felt had made a more of a clean sweep of it. Eluard's return, she implied, was a sign of failure. In this she seemed to be trying to pre-empt any criticism of her husband, referring to his *Lâchez Tout* article to justify his stay-at-home behaviour. "I will always maintain," she said, "that André really turned his back on much more by writing *Lâchez Tout* than Eluard did when he cleared off for six months."[352] Simone had heard about Eluard's return on Wednesday October 1, when "he delivered a short handwritten note inviting André to meet him."[353] No record survives of that autumnal encounter other than its location in the reassuring surroundings of a favourite café, the Cyrano. If the two friends remained outwardly composed, which is likely, the meeting must have been awkward. We can guess from the stunned tone of Breton's subsequent note to Noll:

Would you believe it:
Eluard, it's a fact, was happily in Tahiti, in Java, and then in Saigon with Gala and Ernst.
The latter will be back any day.
But as for Paul and Gala, it's as if nothing had happened,—Eaubonne.
I know, you think that's fine.
Well, he drops me a line yesterday, to let me know he'd be expecting me at the Cyrano, no more no less.
It's him, no doubt about it.
On holiday, that's all.
He asked after you.[354]

Noll comments "It is a very sad letter, isn't it?"

Eluard arrived home just in time for a series of major Surrealist events and publications, and with so much happening there were plenty of excuses available for not talking about the voyage. Events would also have taken his mind off the stress of readjusting to his life as a property developer and veiled the disappointment he had caused by having been on a world cruise instead of heroically reinventing himself. He put a brave face on it.

"So, there was Eluard, like a comet back again, witty and cheerful, friendly as ever;" said Naville, "and without wasting time (he) got back into the surrealist revolution."[355]

The following week for example, on October 10, he attended the opening of the Bureau des Recherches Surréalistes.[356] The event was photographed by Man Ray, whose group shots reveal the elegance of the Surrealists. Someone had to be on duty there for two hours a day to field enquiries from the public that included not only literary celebrities like Paul Valéry, but random callers in off the street. A logbook survives to give an idea of what went on.[357] The opening of the Surrealist Centrale, as they sometimes also called the Bureau, coincided with the publication, five days later, of Breton's *Manifesto of Surrealism*. Eluard's name seems to have been hastily added to appear in the roll call of founding Surrealists.[358] To these distractions we must add a third, the death of Anatole France, one of the nation's favourite authors; this event generated a self-congratulatory press, in response to which the Surrealists published their own no-frills obituary, entitled baldly, *A Corpse*. It was the first Surrealist Group Press Release and a sign of the squad-like discipline Breton favoured. Blatantly offensive, the four-page pamphlet caused a scandal, thus enhancing the Surrealists' profile. The speed with which they wrote, printed and distributed the document was fuelled, in part, by Eluard's return. *A Corpse* appeared on October 18, three days after the *Manifesto* and a week after Anatole France had died.[359]

The chance to settle scores with Anatole France allowed them to forget all about the awkwardness of Eluard's reappearance. Despite these distractions, Eluard's colleagues were disturbed by his return. Naville realised that when Eluard disappeared "everyone had had to work out for themselves what they would have done in his shoes," which was "A very good thing."[360] Now they had to think again. Initially his disappearance had created a vacuum:

> The vacuum had nothing to offer. That was when the surrealist revolution emerged. I'd even say it took root specifically in that vacuum, . . . It seemed to me that Eluard's rejection of everything was itself then rejected by those around me. . . . Months went by, and we worked our way towards a surrealist revolution. The young and the not so young among us couldn't see any other way out. Disappearing wasn't an option any more, but appearing certainly was, as was going on the offensive.[361]

Eluard's *return* caused alarm because his *departure* had encouraged his friends to think about their aims. Having triggered such thoughts, his reappearance seemed to undo whatever conclusions they had reached. No wonder there was confusion. "He'd taught me so much," wrote Marcel Noll looking back, and now, "I can't take it, I just don't trust him any more."[362]

Eluard's resurrection also affected the group's views on suicide. As we have seen, some thought he had killed himself to escape the evergreen bestiality of the human species and the inevitability of death. The possibility he had chosen Suicide-as-Liberation must explain why Breton told Simone "we'll never see him again."[363] But by Eluard's drifting back home, a major rethink was forced on Breton, who already had his hands full orchestrating the Surrealists' offensive. One can understand why he was as startled and angry as Aragon had observed.

Eluard's arrival coincided with yet another major event, the launch of the journal *La Révolution Surréaliste*. The first issue appeared in December, two months after his return. Its design, content, printing and distribution therefore had to be dealt with at the same time as the launch of Bureau des Recherches Surréalistes, the Anatole France scandal and the public response to the *Manifesto of Surrealism*. Eluard was a signatory of the editorial of the first issue of the periodical, which shows how quickly he got to work. Of special interest was a Readers' Poll, on the same page as the Editorial, which asked, "Is suicide an option?"

Suicide therefore brackets Eluard's journey. It had haunted his departure and now wrapped up his return. But if he had reclaimed his place as a leading member of a newly fashionable group, "It would be a mistake to assume that the deep anguish that had sent him travelling was over."[364] For Eluard returned home even sadder, lonelier and more depressed than before, partly because of his cracked marriage, but mostly due to the ghastly political landscape exposed in the colonies he had seen.

"In my view," wrote Pierre Naville, "the various disappearances associated with Surrealism were premonitions—or warnings." And among them, naturally, he placed Eluard's. "Let's not deprive ourselves of the bigger picture;" he continued,

the glamour of travel used to be associated with its leisurely pace, but has been replaced by disappearances on a vastly increased scale. What's happened to all those charming trips, discreet outings, tours one could go on alone with their chance encounters? Instead, we've got mass extermination organised by the state. . . . Think about it, entire populations have disappeared—where to, when? We will never know, because the whole thing only goes one way. For every dumped corpse, or exhumed face, there are millions of others who took the road to nowhere with no date, no location, no tomorrow. Take the Siberian holocausts, the sophisticated roasts courtesy of National-Socialism, not to mention those vast war graves into which names disappear along with bodies.[365]

Eluard returned unaware that an observant colleague would see his disappearance as an emblem, not only of the road to freedom, but also to its opposite, extermination. Naville saw Eluard's odyssey, past the Digul River camps and Poulo Condore, as the forerunner of an experience countless would share as they too faced the sudden disappearance of someone they loved dragged off to oblivion in a nameless Gulag.

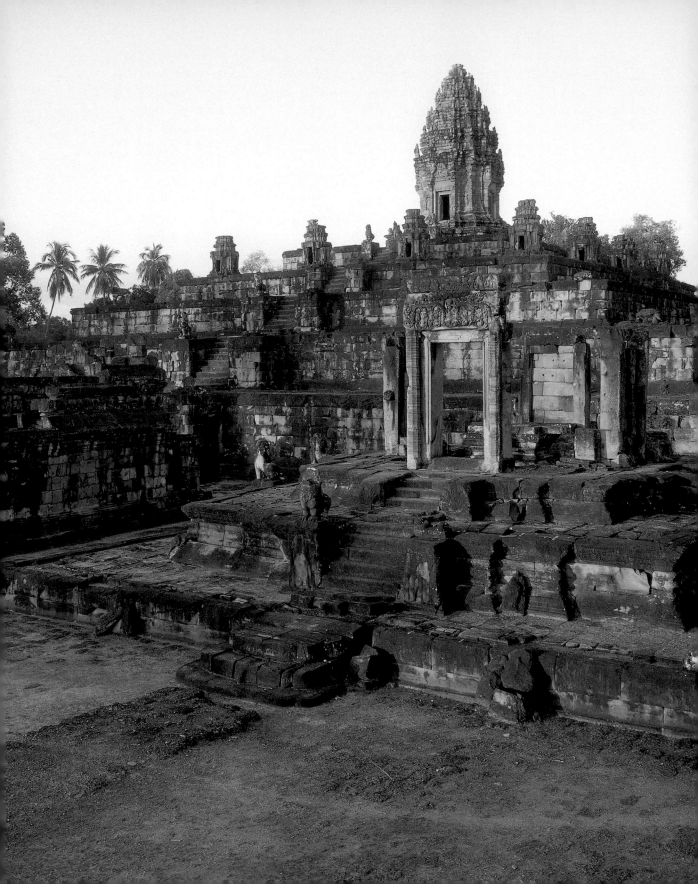

Chapter 7

MAX ERNST IN THE WILDERNESS

Paris in mid-Pacific surrounded by sharks.

Benjamin Péret' *O Pierre Chargée*, 1929

The *SS Affon* slipped her moorings on Saturday September 13 and slid down the meandering Saigon River to the South China Sea. Bound for Marseille, her passengers included one Jean Gondolier, also known as Max Ernst, who could not have gone to Indochina nor returned to France otherwise. While the Surrealist revolution gathered speed, Ernst was leading a double, even a quadruple life of shifting identities as Max Ernst-Eugène Grindel-Jean Paris-Jean Gondolier; the secret life of an agent of change.

He had disembarked in Saigon with Eluard and Gala on Monday August 11, when the *SS Paul Lecat* berthed from Singapore. Between his arrival and departure on September 13, there stretch thirty-three days. Eluard and Gala had gone ahead first, leaving Ernst in Indochina for at least ten days, perhaps even for as many as twenty-one if we accept that Eluard and Gala left on the twenty-third on board the *SS Angkor*. Life in Indochina favoured the French élite,

> especially in the years 1924–25, it was El Dorado. Thanks to an extremely favourable rate of exchange and an economy geared to the profit of the French masters, a not too scrupulous civil servant—even a minor one—could send large sums of money back to France and still lead a life of luxury in Indochina.[368]

The only thing we know for certain about the period during which Ernst was alone there is that he booked a passage home on the *SS Affon*, an old mixed cargo and passenger steamer that left in mid-September. What did he do, apart from getting a cheap berth home?

From July to February the monsoon rains guarantee high water in rivers such as the Mekong, allowing riverboats access to the interior of the country. Ernst was there in August, so while he could take advantage of this, he would also have faced plenty of rain. River traffic was dominated by the Messageries Fluviales, which operated a regu-

Opposite: detail of Fig. 95 Angkor's red laterite masonry. Photo © Michael Freeman Archive.

lar steamer service up the Mekong from Saigon to Phnom Penh. It is therefore possible that Ernst took one of the Fluviales' steamers to Angkor Wat. The excursion to Angkor Wat from Saigon was the major tourist attraction of Southeast Asia. By 1924 it was a very well-trodden path indeed. As an alternative to the river route tourists could also drive in comfort from Saigon to Angkor. "It would be picturesque and fitting to recount the hardship of my journey through the jungles to Angkor, " wrote one, "but . . . I must admit the trip was made in a French motor-car, and that in the late afternoon of the second day after leaving Saigon, I was installed in the *sala*, or government bungalow, separated by only a road and a wide moat from Angkor-Wat itself."[369] Angkor Wat had become so popular by the turn of the century that in 1912 the first guide-book to the site was published in Paris. The *Guide aux Ruines d'Angkor* by Jean Commaille is a remarkable publication because of its innovative portable format, its handy paperback cover, thoughtful maps, generous use of reproductions and clearly organised content.[370] By 1912 it was already possible to book an eight-day round-trip from Saigon to Angkor Wat at a cost of 350 Francs or £14 Sterling. "The sum includes all expenses: the journeys by boat, a twenty-four hour stop over in Phnomh-Penh, transport up river at Siem-Reap, cars to the ruins, accommodation and meals at the hotel at Angkor. The round trip takes eight days," wrote Commaille, who was the first curator of Angkor.

He describes a visit to Angkor in the 20s which suggests what Ernst might have seen:

> The journey from the capital of Cochinchina (Saigon) to the Cambodian one (Phnomh-Penh) takes thirty-six hours by boat, but the sight of the most fertile river landscape in the world cannot fail to fascinate the traveller. Frequent stops break the monotony and quick visits to settlements on both banks of the Mekong are possible.[371]

Accounts of the journey to Angkor Wat and of the site itself are unusually illuminating when read with Max Ernst's subsequent work in mind. The descriptions by Jean Commaille, Pierre Loti and Henri Marchal, in particular, could almost equally apply to the Indochina buried in Ernst's pictures.

As a tourist in the 20s Ernst could also travel to Angkor more economically by avoiding the package tour offered by the *Messageries Fluviales* and make his own arrangements, as a *voyageur libre*. But once at Angkor he would have had to stay in the newly built hotel bungalow by the Temple moat.[372] The site was not equipped with the extensive facilities that exist today. That hotel was the only one. Its terrace offered one of the most famous views in Southeast Asia (fig. 88) which is evoked in one of Ernst's masterpieces, *La Ville Entière* (*The Entire City*), (fig. 89).

There was plenty of time, therefore, for Ernst to visit Angkor by steamer between the departure of Eluard and Gala and his own return voyage. Alternatively, he could also have gone by car on the Route Nationale. His friend Patrick Waldberg wrote the first book about Ernst's life and work in 1958. Ernst was closely involved, contributing specially designed type and supervising the layout. His participation makes the book especially informative. Waldberg was the first person to record what Ernst had to say about

Fig. 48 Max Ernst, *Two Chinese girls singing*, 1924, pencil on paper, 17cm x 10 cm Private collection. S/M 713.

his visit to Indochina and his brief account is like looking through the wrong end of a telescope. A complex view has been compressed into a miniature.

"Max Ernst," he wrote, using Ernst's own words, "travels around, visits Khmer ruins, explores Moi country, takes against the monsoon rains and the jungle."[373] Subsequently, John Russell wrote a second account of Ernst's life, again with the artist's collaboration. He confirmed that Ernst had left Saigon and taken the tourist route inland; according to Russell, Ernst "undertook one or two traditional excursions in what was then Indochina."[374] These minimal clues confirm that Ernst travelled. He visited the countryside where he saw Ethnic Moi tribesmen and women in their own surroundings. The term Moi described various groups indigenous to Indochina, excluding the Chinese and Cambodians. Descended from the early inhabitants, the Moi wore little clothing, had few possessions and avoided contact with foreigners, especially Europeans. In the lowlands Moi men and women wore loin-cloths, and the women, famous for bare breasts, sometimes wore the briefest of skirts. Their hair was often worn in a bun.

From Waldberg's account we also gather it rained a lot and that Ernst was overwhelmed by the rainforest, while according to Russell the artist felt homesick for

Fig. 49 Max Ernst, *Moi woman crouching among plants*, 1924, pencil on paper, 22.2cm x 16.3cm. Private collection. S/M 705.

Fig. 50 Max Ernst, *Crouching boy among plants*, 1924, pencil on paper, 22cm x 16cm. Private collection. S/M 704.

Europe. It seems the confusion in his private life was compounded by the disorientation he felt during that trip to the interior. The jungle pictures he later painted may therefore have been a way of exorcising the memory of those tropical blues.

Ernst was not in the habit of drawing from life. He drew well but seldom did. Few preparatory drawings survive. It is therefore remarkable that several drawings and a sketchbook date from the visit, (S/M.706–727). The pencil drawings are mostly of indigenous inhabitants and include several of a Chinese girl singer. There is also the portrait of a bearded European, (S/M.723). Others are clearly not city dwellers but Moi. The chanteuse, however, was a city girl. The Chinese controlled much of the economy of Indochina from their headquarters in the district of Cholon, a ghetto separated from the French-occupied part of Saigon by a river, the Arroyo Chinois. Chinese entertainers like the one drawn by Ernst formed a recognised professional class, and this suggests that Ernst, accompanied by Eluard and Gala, had ventured there. Generally only the more adventurous westerners, such as the Malrauxs or the journalist Leon Werth, visited the district. Werth's description of his visit sketches the background to Ernst's drawings. "The first time I went to Cholon with some other Europeans I noticed the way the young singers pursed their lips in disgust at the sight of us," he wrote. One then performed. "She sings," he continued, "Long strident deep notes and then short ones.

Fig. 51 Max Ernst, *Moi woman standing wearing ankle decorations*, pencil on paper, 17cm x 10cm. Private collection. S/M 721.

Fig. 52 Max Ernst, *Portrait of a boy, inscribed Thuan*, 1924, pencil on paper. 17cm x 10cm. Private collection. S/M 725.

As she sings all I can make out is the sustained a-a-a with which she ends her words, an a-a that is clipped, lacking in fluidity.... As I can't understand nor pronounce her name I am shown her identity card, required by the French police. *Carte de circulation pour chanteuses et musiciennes chinoises.*"[375] Ernst's drawings remind us of the racial and cultural tensions in metropolitan Indochina.

His other drawings are of another world, away from the fleshpots of Saigon. We see a figure crouching in tropical vegetation, looking like a sketch by Gauguin. The women he drew are naked except for a loincloth. Their hair is in a typical Moi bun.

Werth described an excursion along "The road from Saigon to Phan-Thiet, a road running between two jungles," past "Barbed walls of bamboo and liana. The word inextricable makes sense for the first time. Relentless, uncompromising nature." A group of Moi walks in single file along the road:

Fig. 53 Max Ernst, *Portrait of a woman, inscribed Lina*, 1924, pencil on paper, 17cm x 10cm. Private collection. S/M 714.

Fig. 54 Max Ernst, *Teenage Lightning, frottage*, from *Histoire Naturelle*, 1926, pl. 24.

> They're wearing a loin-cloth wrapped round and tied at the back. . . . We get out of the car. They look at us indifferently . . . the women dressed like girls in a brothel, except that being more straightforward their breasts are completely bare. . . . They've got simple decorative necklaces, wide copper bracelets on arms and legs that wind round and round forearm or ankle.[376]

Ernst's subjects, with their necklaces and copper bracelets, confirm the accuracy of what he told Waldberg; he had been in the bush, where he stopped to draw some Moi, in circumstances similar to Leon Werth's. This suggests that the rest of what he told Waldberg is also accurate, including the reference to a visit to Khmer ruins. His surviving sketches contain other clues, such as the inscription of the word Thuan on the portrait drawing of a boy, and the inscription of the name Lina on a pencil portrait of a young woman. Ernst painted few portraits. The focus necessary to draw from life, as in portraiture, requires the artist to adopt an imitative frame of mind. Ernst avoided such imitative drawing or painting, unless compelled to do so, as by his feelings for Gala, who

exceptionally triggered hundreds of portraits by him. It is unlikely we shall ever know who Lina was, nor what she meant to Ernst. Thuan was probably a transcription (by Ernst?) of the Malay term of respect *tuan*, as in Conrad's "They called him Tuan Jim: as one might say—Lord Jim."[377] The same mystery surrounds the portrait of a bearded European, although the possibility of discovering his identity is greater. There were, after all, only about five thousand Europeans in Saigon, and many were photographed. We have no other drawings by Ernst of Indochina, even of the Khmer ruins he saw.

There are no Khmer sites comparable to Angkor Wat near Saigon; the city is built on an alluvial plain where available materials resulted in brick-built temples which have weathered badly. There are in fact few Khmer ruins in southeast Indochina, a region we call Vietnam, which was then known as Cochinchina. The dominant ancient culture there had been Cham, not Khmer, and its surviving monuments are less remarkable. It is the stone used by the Khmer masons at Angkor, as well as the scale and quality of their work, which make the site unique. For Ernst, as for any tourist, Angkor Wat was synonymous with Khmer civilisation. The ruins around Angkor Wat were *the* Khmer ruins to see, so when he said he visited Khmer ruins, on a traditional excursion, it is more than likely he meant Angkor. To have seen any other Khmer ruins, Ernst would have had to travel some distance from Saigon, towards present-day Cambodia and, moreover, would have had to organise the trip himself, as there was no market in excursions to minor sites. By contrast, in order to see Angkor all he had to do was buy a ticket. The office of the Messageries Fluviales in Saigon was in Rue Catinat, close to his hotel. Other tourist bureaux also existed in Saigon, such as the Syndicat d'Initiative du Sud-Indochinois. "There is a similar office at Phnom-penh, which is known as the Société d'Angkor," advised a contemporary guide-book.[378]

We can judge how popular excursions to Angkor Wat were from Pierre Loti's best-selling *Un Pèlerin d'Angkor* (Angkor Pilgrim).[379] Loti's account had appeared at the same time as Commaille's guide. In 1924, the year Ernst was there, Loti was still famous enough to be targeted by the Surrealists. In their pamphlet, *A Corpse*, attacking Anatole France, they described Loti as an idiot. The title of his book about Angkor evoked the stream of tourists already making the pilgrimage inland in the years before World War One. He described the seething wildlife swarming in the rainforest as he steamed up the Mekong. Upstream lay the jungle and the fabled ruins. "While the talk on board is of markets", he wrote, "a huge red moon rises over there above the infinite jungle. Night had fallen as we set sail." In a cadenced sentence that leaves the reader in mid-air he described the world beyond his cabin. "The hooting of owls, the shriek of animals hunting their prey; an endless concert of insect music, of creatures out of their minds, deliriously drunk on darkness in the tangled grip of greenery . . ."; such writing is evocative of Ernst's jungle pictures of the 30s[380] (figs. 85 and 86). Then, "Around midnight, just as we'd fallen asleep, half-naked and with open windows, a swarm of enormous black beetles appeared covered in prickles, like chestnuts, but harmless otherwise, and they crawled about in a hurry exploring our chests and arms."[381] A similar bug appeared in Ernst's work soon after he got back from Indochina.

Fig. 55 The Saigon river.

If Ernst took against the jungle, as he told Waldberg, it may be because he felt, as Loti had, that the jungle had taken against him. For Loti, it was "A vast uninhabitable region . . . of no use to man but a prodigious reservoir of animal life: shadows full of snares, of traps, of claws, of fierce beaks, of poisonous little teeth, of razor-sharp little darts loaded with deadly stings." [382] The experience of an immense, unfamiliar environment, crawling with unpredictable poisonous creatures of bizarre shapes and sizes, also made a permanent impression on Ernst.

Bateau fou: the voyage home

Ernst returned to Saigon and boarded the *SS Affon* on September 13.[383] Departure from Saigon has been described by many travellers, here by Leon Werth. "I left Saigon on a red morning. The strange reddish light rusted, corroded and burnt through a powdery mist and lent the scene a magical lunar glow. Ships in the distance stood out as if in moonlight."[384] There are similarities between this rusty river light and some of Ernst's later paintings.

The journey on the *Affon* was one of the most unusual incidents in Ernst's eventful life. Two accounts survive. The first is Patrick Waldberg's from the 50s, the second appears in the 1986 autobiography of Ernst's widow, Dorothea Tanning. They share a

Fig. 56 Max Ernst, *But in Colour*, 1962, oil on wood panel, 27.2cm x 35.2cm. Private collection. S/M 3613.

similarity of tone, but vary in detail. The crazed atmosphere of the first version survives in the second, thirty years later. The adventures of the *SS Affon* resemble an old Hollywood B-movie. Ernst had never taken an ocean-going vessel until he left Europe for Indochina, and the impression made upon him by the experience found its way into subsequent pictorial meditations on the theme of the horizon and the sky. We know how deeply the return trip affected him from his two accounts.

We can judge the degree to which he exaggerated and dramatised the experience by comparing the two versions with the record of the vessel's itinerary and history as preserved in Lloyd's List and Shipping Gazette and in Lloyd's Register of Shipping. If we disentangle the dramatic superstructure of fantasy and imagination from the armature of fact on which it rests, we can see what Ernst enjoyed about the voyage and what he did not. We can also detect that the *Affon* episode underpins his seascapes. The ship may also appear in a *frottage*, *Ghost Ship* (fig. 57).

The *SS Affon* was the oldest of the four vessels in our story and the smallest. Built in Italy in 1901, she was launched as the *SS Liguria*. A vessel of 5112 tons, she made her maiden voyage from Naples to New York with accommodation for 56 first-class passengers and 1194 in steerage, making her the finest Italian steamer of her day on the

Transatlantic run.[385] When Jean Gondolier/Max Ernst boarded her she was flying the Russian flag, having been sold by her Italian owners in 1911, and her Port of Registry was Odessa. The *Affon* was finally scrapped in 1928, at the age of twenty-seven. These facts, and the duration of her voyage to Marseille, differ from both Ernst's accounts in which he beefed up emphasis and colour in an effort to convey the drama of the events. Writes Waldberg:

> He books a cabin on the *SS Affon*, making her last journey on the way to the scrapyard. The crew of White Russians dreamed of the good old days, and the only passenger was the Madam of a brothel, a total junkie, who filled the ship with the smell of opium. The crew was drunk, the captain in tears because he was about to lose his job, they lost their way, the cargo broke loose in the hold and crashed about, they weren't so much on course as adrift.

As if this was not enough they were then plagued by delays. "An eight-day stop in Colombo instead of twenty-four hours, they then reached the African coast three hundred kilometres further south than intended, took on poor coal in Djibouti, conked out in the Red Sea, and had to be towed for fifteen days before dropping anchor; *bateau fou, bateau ivre*." [386] Rimbaud's ghost, this time on board his crazy *bateau ivre*, reappears once again to haunt our narrative. His famous cock-eyed ship, drifting on her weird way was, as Waldberg saw, echoed by the *Affon*. Ernst's disregard for the facts adds pace and colour, and while we should not expect him to remember every detail, certain exaggerations are so blatant they must have been deliberate. To begin with, the *Affon* was not on her last journey but staggered on for another four years before she was broken up. She did not stop in Colombo for eight days but overnight. We also know that she was not towed for fifteen days in the Red Sea. Dorothea Tanning's version adds to the drama:

> Stepping onto the gangplank of a derelict Russian steamer for the return to France a month later, he began a voyage unmatched in farce if not in pure chaos. The boat was a "crate," and as if in concern for harmony, its passengers and crew might have been vying for honors in eccentricity of a particularly obtuse kind, paying little heed to the creakings and rumblings of their bark, seemingly prepared to risk all for the joyous hope of some day docking in Marseille.

In addition to the figure of the Swiss academic who came on board with a large snake acquired at a local temple, the *Affon's* passenger list has grown to include a large and colourful cast. There is for instance

> an Association of Bereft Fiancées, banded together in pilgrimage and in common loss: their intended grooms, French soldiers all, had perished in the Franco-Indochina war. On the lower deck, the prim closed door of debauched Mlle Yvonne, a missionary, who lost no time in turning her cabin into a cozy opium den, frequented mainly by members of the crew. Soon something quite unexpected happened.

This later account is richer, more entertaining, and the plot thickens:

> A few hours out of Saigon, the boat was ascream with terrified virgins, Max's words,
> several of whom had seen the hapless snake slither out of its hamper onto the deck.
> General confusion, high-pitched virago voices of wrath and terror. An hour-long
> search did not turn up the creature; the ladies trembled and fumed. But the un-
> principled doctor-professor later learned that his dearly paid prize had gone back to
> its temple, by escape down a toilet and an easy swim across the bay.[387]

To the cast of lost souls and the temple snake in the toilet, we should add the extra-
ordinary figure of the lighthouse keeper on leave. He was travelling home with his accu-
mulated salary. Dorothea Tanning tells the story of the keeper's romance with a ship-
board gold-digger, watched by Ernst, which reveals how closely he observed his fellow
passengers.

Having left Saigon on September 13 the *Affon* reached Georgetown, Penang, four
days later, on the seventeenth. Penang is an attractive island, close to the western coast
of the Malay Peninsula, in the Straits of Malacca. Ernst would have seen wooded hills
along the gentle coast, and as he had not called there on his outward journey it would
have been a refreshing contrast to the massive port installations he had just left at
Singapore. The *Affon* sailed for Colombo, capital of Ceylon, present-day Sri Lanka,
which she reached on Monday September 22, having steamed due west from Penang
through the channel between Sumatra and the Nicobar Islands to the north. It was one
of the longest stretches at sea, slow days of isolation during which Ernst would have had
time to consider past and future. Tropical limbo. He would have followed the regular
passage of sun, moon and stars, with the horizon in every direction. At some point the
weather turned and "for three days the boat was flung against the water with sickening
fury."[388] The ageing vessel must have heaved through a storm during which the cargo in
her hold may have broken loose and crashed about, as Ernst told Waldberg. The storm
made little impact on his painting. Most of his seascapes have clear horizons, high vis-
ibility and a sun or a moon above. The only turmoil in them was restricted to the
swirling crosscurrents far below the surface. They left Colombo, which Ernst was call-
ing at for the second time, on September 23, within a few hours of docking.

Yet Ernst told Waldberg the *Affon* waited in Colombo for eight days. After Colombo
they began the longest uninterrupted leg of the journey, sailing past Cape Comorin, the
southernmost tip of India, and cutting across the Arabian Sea on a northwesterly course
towards the mouth of the Red Sea and the French colony of Djibouti. According to Lloyd's
List the *Affon* reached the Red Sea eleven days later. This was an unusually long time, and
confirms Ernst's statement that the ship did indeed miscalculate her course and
approached the Somalian coast too far south, instead of making for the Gulf of Aden.
During that long stretch Ernst would have had more time to reflect on the difficulties
ahead, in Paris. By returning without him, Eluard and Gala had signalled an attempt
to realign themselves publicly as a couple. Ernst therefore would have known that
upon arrival he would have to move out of the house they had shared at Eaubonne

and find his own accommodation. How? He had no job and we know he had no financial reserves, because he had sold everything he owned and borrowed left and right to go to Indochina.[389] Ahead lay debts, the challenge of making a living and finding a place to live.

Days and nights at sea surrounded by an unchanging horizon that made no headway may have frustrated Ernst, who would have been anxious to get on with whatever the future might hold. This sense of treading water in mid-ocean may explain why his accounts of life on the *Affon* feel as if he was straining at the leash and that time was standing still. It is noticeable that he exaggerates the delays the closer he gets to Marseille. This perceived slowing of time was felt by many travellers, and Victor Segalen recorded something similar on the same stretch between Ceylon and the Red Sea, "Colombo is a long, long way away . . . across days of peace and light such as you get in dreams. A gentle stern breeze, barely noticeable . . ."[390] Ernst's disorientation had begun in Ceylon, where he said they'd waited eight days, instead of overnight. By the time the *Affon* reached Suez he claimed she had drifted for fifteen days, when we know she got there in five.[391] "In the Red Sea she stopped, her engines gasping for coal . . . until, like all the other hallucinations, a rescue ship hove in sight and was unbelievably not paint-ed on the horizon at all but a real ship with real coal to spare. The old boat moved for-ward once more, its passengers waking to their destinies, emerging from the void."[392]

The *Affon* may have been worn out, but she was not the slouch Ernst painted her. If we compare the dates of her journey from Colombo to Marseille with those of the liner Eluard and Gala were on, the *SS Goentoer*, her schedule does not look so bad. The *SS Goentoer* took sixteen days to reach Marseille from Colombo, and the *Affon* twenty. As the *Goentoer* ran on time, Ernst's recollections of a fifteen-day breakdown, shortage of fuel, and a detour of 300 kilometres must be set against reality—the voyage took only four days longer. However her dislocated passage through the Red Sea would have been unusually memorable, as at the best of times the crossing was a trial due to the heat. Vessels carrying horses were known to travel in reverse, steaming astern, to force air into the baking holds by driving it down the deck-mounted ventilators.

> "God it's hot."
> That's all you hear from stem to stern. Canvas awnings run the full length of the sunny side and trap the heat leaving you gasping in a vacuum . . . if you have a drink it turns to sweat and evaporates; if you have a shower the water steams. . . . The air is motionless, the sea's as smooth as glass, and the sunlight breaks into a shifting dazzle of reflections.[393]

Ernst's own Red Sea crossing, as described by Dorothea Tanning, marked his subse-quent seascapes with their glaring suns and moons looming over still waters (figs. 72 and 78). "Days of white suns went by in a delirium of bursting heat," she wrote, making the event seem like a scene in Coleridge's *Ancient Mariner.*[394]

All in a hot and coppery sky,

Fig. 57 Max Ernst, *Ghost Ship*, 1962, *frottage*, pencil on paper, 25cm x 30.9cm. Private collection. S/M 3668.

The bloody sun, at noon,
Right up above the mast did stand,
No bigger than the moon.

Day after day, day after day,
We stuck, nor breath nor motion;
As idle as a painted ship
Upon a painted ocean.[395]

Victor Segalen had also been impressed by the glowing disc of the moon floating above the stillness of the Red Sea: "the wind dropped. Calm 'rose' with the moon, which climbed, round and pale to our right, over the Siniai peninsula. . . . The milky sea grew pale, bluish."[396] Day or night, the Red Sea maintained its composure. "And under the sinister splendour of that sky the sea, blue and profound, remained still, without a stir, without a ripple, without a wrinkle—viscous, stagnant, dead," wrote Conrad. The

SS Affon, something of a ghost ship herself, can be imagined making the passage according to Conrad's description, as she

> passed over that plain luminous and smooth, unrolled a black ribbon of smoke across the sky, left behind her on the water a white ribbon of foam that vanished at once, like the phantom of a track drawn upon a lifeless sea by the phantom of a steamer.[397]

The ship passed through the Suez Canal on October 9 and 10, entered the Mediterranean and steamed uneventfully to Marseille where Ernst disembarked. His journeys had affected him deeply and, on his return to Paris, he quickly started to paint, producing many pictures of what he had just seen. Between 1925 and 1927 he was obsessed with the sea, painting three series of seascapes, as well as drawing it repeatedly. These were followed, over the years, by many more pictures of the ocean.[398]

The record shows that the *Affon* docked in Marseille on October 16, eighteen days after the *SS Goentoer*. Yet, in the final version of his *Biographical Notes* subtitled *Tissue of Truth, Tissue of Lies*, prepared shortly before his death, Ernst said "Paul and Gala returned to Paris, Max following a few months later."[399]

> On the dock at last in Marseille, everyone came alive; porters tussled with trunks, and people behind the barriers screamed exaggerated greetings. A figure detached itself from the bustle on the quay, moving faster than the others, running in fact, arms aloft, turning and running back in zigzags through the crowds. It was the lighthouse keeper.

Tanning then remembers Ernst saying

> "I almost didn't recognise him . . . he talked so fast: Where is she, where did she go . . . I can't understand, have you seen . . . I couldn't do anything for him. What was there to do? She had vanished. As the man stood there in shock holding his head, he visibly diminished, as incorporeal as a transparent lighthouse window giving onto an infinitely rolling sea."[400]

Fig. 58 Max Ernst, *The Sea*, 1925, oil on canvas, 40.5cm x 31.7cm. Los Angeles County Museum of Art. S/M 977.

Chapter 8

THE VOYAGE AS ART

L'oeil humain est brodé de larmes bataviques
The human eye is decorated with tears from Batavia[401]

> Max Ernst. *Propos et Présence.* Gonthier-Seghers. 1959

The impact of the Indochina voyage on Max Ernst's work
Part one The sea and the jungle

From Marseille, Ernst took the Paris train back to Eluard and Gala. It may seem he was picking up where he had left off, but the coming months were unsettled and many changes followed. Short of money and unemployed, Ernst was in a fix. It is extremely unlikely that he returned to Eluard's house, thirteen weeks after he had left it for Saigon, and we have no indication yet of where he lived instead. Perhaps he stayed with friends, or in a cheap hotel. Gala and her husband had only just reappeared as a couple, under the watchful eye of Eluard's father, who would have hit the roof if Ernst had moved in with them again. We may imagine the queasy atmosphere as the splintered trio readjusted, each looking for a way forward. Within hours of arrival, however, Ernst had visited the Surrealist Central Office, a facility that had only just opened its doors for the first time. The daily log kept there for Tuesday 21 reads *Max Ernst propose de construire (tu parles) pour la Centrale.* "Max Ernst says he'd like to put something together (you don't say) for the Centrale."[402] On duty was Eluard with Benjamin Péret, the latter of whom added that caustic aside in parenthesis, while the rest of the entry reveals Ernst's active search for a constructive role now he was back. Determined to start work, he needed both to earn money and to make the most, as a painter, of what he had seen during his *dépaysement*. He distanced himself from Gala, a fierce process commemorated in an extraordinary group of portraits. A whirlwind romance with a beautiful teenager followed. Ernst married Marie-Berthe Aurenche after an exhilarating courtship that weathered the fury of her parents (who called the police on the pretext Ernst was inter-

Opposite: detail of Fig. 72 Max Ernst, *A la Derive*, 1960.

Fig. 59 Max Ernst, *The Pampas*, *frottage*, from *Histoire Naturelle*, 1926, pl.6.

fering with a minor) and ended when the couple dashed off, eloping in a flurry with the collusion of some Surrealists. It sounds like a René Clair movie, especially as the bride's mother insisted that her daughter was a member of the Royal Family of France.[403]

Although Ernst was still supported to some extent morally and financially by Eluard, he had to go back to the disagreeable manual jobs he had known before, as he put it "Once again Max found himself in the position of a 'casual worker,' with pretty sombre prospects. And once again it was Eluard who came to his aid."[404] Their friendship, as we shall see, soon produced two more remarkable illustrated books, *Au Défaut du Silence* and *Histoire Naturelle*. However, the key moment for Ernst occurred when Jacques Viot, one of the Surrealist circle, unexpectedly offered to become his dealer. This must have been at the end of 1924 or at the start of 1925. On the strength of the retainer Viot offered, Ernst moved into a studio in Rue Tourlaque, Montmartre. There he produced hundreds of pictures that reflected not only his recent voyage, but also his pleasure at being a full-time professional artist for the first time in his life. The fact that Viot suddenly absconded to the Pacific in June 1925 did not deter Ernst.[405]

In August 1925, ten months after he had got back and while on holiday on the Atlantic coast, Ernst made a major technical advance using a method he called *frottage*. He started it with pencil and paper, but once in Paris switched to oil on canvas. With this new technique he drew and painted many seascapes and jungle scenes that were soon exhibited in several shows, a body of work that incidentally also confirms his industriousness.[406] The most significant one-man show took place in Paris in March 1926, sixteen months after his return. It attracted attention thanks to the growing interest in Surrealism, which had suddenly become fashionable. Ernst's pictures caught the eye of the impresario Serge Diaghilev, who commissioned him to design the sets for a new Ballets Russes production, *Romeo and Juliet*, with music by Constant Lambert. Significantly, the designs Ernst submitted for these backdrops were seascapes. By the time he had married Marie-Berthe and moved to the Paris suburb of Meudon in 1927, he had therefore transformed his work, life and status, a change coloured by the voyage.

The silence maintained by Eluard, Gala and Ernst about the trip explains why we have not recognised the traces it left in Ernst's work, even when they loom as large as the life-size horizons that were to fill Diaghilev's stage.[407] There were other reasons for this oversight and, in addition to the trio's silence, these so successfully obscured the voyage that even though Ernst was to win the Venice Biennale (1954), and despite extensive studies of his work, the connections were never made.

Ernst's natural reserve was partly to blame. He was different from the professional extrovert Dalí, who succeeded him in Gala's life. Ernst's widow, Dorothea Tanning, was conscious of her husband's discretion and has described how, apart from a handful of anecdotes, he preferred to let sleeping dogs lie. The air of privacy about him was striking. "The presence of this profound and absolutely impenetrable something, this incalculable distance," is how she described it. "It sat upon him always. . . . Save for those funny stories, he seemed not to want to remember anything. The great bulging bag of his past slumped unopened." History could take care of itself. "Its charms and deceptions, so easy for others to drag out and examine, and so hard for him to notice, moldered dankly in their dark nowhere, lost, unfound, and unclaimed."[408] We have already seen how economical Ernst was with information about his past from the account he gave of his visit to Indochina to the two biographers who had his confidence. This reticence persuaded us, also, to accept a void in place of a journey.

The art historian William Rubin, who has exposed many of the hidden meanings of twentieth-century art, once sounded a note of caution in connection with Ernst's friend, the Surrealist painter Roberto Matta. His painting was inspired by native sculpture from the region of New Guinea, but Matta never acknowledged this debt, choosing silence instead. Writing of his discovery about this aspect of Matta's work, Rubin concluded, "I have long since become much more circumspect in regard to what artists say, or don't say, about their work."[409] Ernst's silence about Indochina, therefore, does not rule out the possibility that he "spoke" about it in his work, as Matta had referred to New Guinea in his. The "incalculable distance" sensed by Dorothea Tanning, however, explains why he did not speak about it openly, nor about related subjects that we know inspired him, such as the Haida and Kwakiutl cultures of the Pacific Northwest coast, whose ghosts lurk in his work alongside the Khmer. Ernst wrote well when he chose to, but he preferred pictures, and that is where we should look for traces of his voyage.

We should not be confused by another kind of obstacle. Ernst loved *surprise* and, odd though it may seem, he deliberately concealed things from himself so that his work should catch him off guard. What he concealed from himself was therefore hidden from us. Irrespective of the medium, whether collage, painting or sculpture, he let chance affect his work and catch him out. If the finished work surprised *him* it preserved the surprise that comes with the moment of inspiration. Most artists want to feel their work in this way, to see it as "other," but Ernst was unusual in that, like Picasso and Degas, he developed a striking variety of techniques. These he used, not simply to express himself, but also to catch himself off guard. Thus, if a picture was losing its interest, he could try painting the subject using another technique and see if it came back to life. The

Fig. 60 Max Ernst, *The Feast of the Dead*, frottage, from *Histoire Naturelle*, 1926, pl.28.

techniques he specialised in, *frottage, grattage* and *collage* were not only distinct enough from each other to guarantee a change of gear, they were also chosen because they had one big thing in common, slippage. Each technique introduced its own slide area. As the subject, say a jungle scene, was transferred from collage in paper to oil on canvas, the original version would resemble a character from one play turning up, surprisingly, in another. While he learned how to alternate his special techniques with great skill, paradoxically he trained himself to include chance effects, because too much control, too much deliberate skill, suppresses the spontaneous appearance of the unexpected.

He would try anything. His *collages*, for instance, generated new combinations of images in the same random way as dealing at cards. Images cut from magazines were snipped up, shuffled and then re-combined, *almost* at random. In sculpture he turned objects upside down or inside out, and in *frottage* he would rework a familiar image and find something new. For instance he might treat it in negative, so that instead of a black chalk rubbing on white paper, he'd use white on black paper, turning the same scene from day into night. Despite his fastidiousness, the range of materials he used was so wide as to resemble the contents of a dump; they included old magazines, photographs, wallpaper, string, animal hide, pebbles, cotton wool, broken china, cooking utensils and so on. He was voracious, absorbing images from books as well as pressing into service objects—such as feathers and old printing blocks—brought home by friends. By making rubbings of old floorboards, or building assemblages out of casts made from everyday objects, Ernst transformed the original identity of what appealed to him. He camouflaged his sources. Werner Spies said *il brouille les pistes* (he covers his tracks).[410] The impressions of his voyage to Indochina were therefore not only veiled by his reticence and by his chance-infested techniques, but also by the way he shuffled his subjects about from one technique to another. It was all part of an oblique approach at the service of surprise. Each sculpture or painting had to catch him out, but paradoxically it also had

to conform to something in his mind's eye. This contradictory process is a process the historian excavates at his peril, especially when dealing with a visual imagination as well furnished as that of Ernst.

There are as many reasons for an artist to cover his or her tracks as there have been artists, but iconographic analysis sometimes exposes them. Ernst travelled widely, and what he saw in the natural world, outside the studio, entered his pictures along with the secondary material filtered from the visual experiences he absorbed indoors, in libraries, bookshops, galleries or the cinema, via reproductions, photos or film. He absorbed direct contact with the natural world and man-made impressions of it, and combined them to build a sign-language of his own. Ernst was by temperament a simplifier who reduced a complex subject, such as a sunny landscape, to a circle and a horizontal, to produce a hieroglyph or an icon that stands for *place*. In time such reductive icons grew into a vocabulary of visual motifs, a kind of alphabet with which he spelled out the mystery of the world. Once one is aware of his lasting attachment to certain images, it also becomes clear that no matter how new an image may look to us, seeming to appear in his work as if from nowhere, it will probably have been rehearsed by him before. This makes his work a happy hunting ground for scholars trying to establish Ernst's prototypes, and in this the pictures derived from the voyage to the East are no exception. The Indochina journey stimulated many developments based on earlier use. The excavation of these continuities confirms just how methodical Ernst was. His paintings of the Forest are an example of this, as are the Ruined Citadels. In fact most of the themes Ernst developed after he returned from Indochina are hinted at in earlier work. He had, for instance, painted the sun floating above the horizon some twenty years before he returned to it in a big way in the wake of his trip.[411] However, despite the organic, almost inevitable nature of his development, without the stimulus of the voyage which triggered the extensive series of *Sun*, *Forest* and *Ruined City* paintings, Ernst's work would look different.

Having noted the complex circuitry of his procedures, his taste for surprise, the way he covered his tracks and of the danger of taking short cuts through his work, we must nevertheless simplify our own approach. Let's examine his output from just one viewpoint, and look at his pictures through an Indochina-tinted lens. This reveals that his voyage was both waiting to happen and extremely fruitful, that it looked back and led forward, and that, like Ralph Ellison's *Invisible Man*, it has not been invisible, just unnoticed.[412] The work coloured by the voyage divides into two types; pictures about the *journey to and from* Indochina on the one hand, and pictures about what was *in* Indochina on the other. Images of both types occur in large numbers, mostly painted soon after the trip. There is, in other words, a noticeable chronological relationship between his work and the voyage. The majority of the paintings and drawings in the first category, those coloured by the *journey* itself, appeared in a sequence of extensive series, like waves. The remainder, mostly in the second category of images inspired by what was *in* Indochina, appeared later, in a gradual dispersal made up of several short series that were painted as the voyage itself slipped further into the past. A striking

secondary characteristic emerges from this, a broad easily defined chronological pattern that runs through both categories. The pictures affected by the visit to Indochina proceed from the *general* to the *particular*, from the wide-angle to the close-up. Ernst's journey pictures themselves can be described as a voyage that gets more detailed the closer it gets to its conclusion. To borrow a term from film, he is on a long zoom that goes from macro to micro. The first pictures were of distant views seen far out at sea. Then the coast gradually appeared. Getting closer and making landfall, the artist encountered the rainforest through which he passed on his way to his destination, a city lost in jungle, far inland. He entered and wandered among overgrown ruins, examining them in detail and painting the fabulous detail of nature he found there, peering in close-up at the bugs and the moss carpeting the masonry.

The pictures of the *general* type were done first and are painted from the point of view of a traveller in transit. They occur in two discrete series. The first are of anonymous seascapes and the second of anonymous jungles; they show miles of ocean and walls of impenetrable vegetation neither of which we can locate with certainty. The pictures of the *specific* type followed. They record collapsed masonry and sculpture in the jungle, often in microscopic detail. Joseph Conrad's cinematic description of the approach to the coast of Costaguana at the opening of his novel *Nostromo* resembles Ernst's sweeping trajectory. Conrad, like Ernst, introduces us to his subject far out at sea. "From the middle of the gulf the point of the land itself is not visible at all; but the shoulder of a steep hill at the back can be made out faintly like a shadow on the sky." The pictures that evoke Ernst's days on the road begin, like *Nostromo*, at sea, when land was just a smudge on the horizon, if visible at all. The images are drawn from memory. But later, when he paints the ruins buried in jungle, it seems he not only supplemented memory with photographs of Angkor, but was also affected by the wash stirred up in Paris by the 1931 Colonial Fair. The effect of this international event on Ernst was comparable to the gentle roll of a liner at sea, present if not always noticeable, for the Fair brought the five towers of Angkor to Paris and anchored them at Vincennes, in a torrent of publicity that provoked Surrealist outrage. The silhouette of Angkor, built to scale if not accurate in every detail, dominated the skyline of southeast Paris for almost a year and stirred Ernst's memories of Indochina.

Fig. 61 Contemporary watercolour of the skyline of the Exposition Coloniale, Paris, 1931.

The paintings of ruins he produced after the Colonial Fair relied increasingly on reference material that had not been necessary for the generalised seascapes he had made before. One of the chief constraints and major benefits of the study of Ernst's Southeast Asian voyage is his habit of working in series. Repetition confirms progression and makes it easier to detect change. In series such as the sea paintings, their basis in the voyage is obvious. This is less so with others, such as the sculptures he made in Saint-Martin-d'Ardèche in the late 30s and the illustrations for *Histoire Naturelle*, both series being permeated by the trip in more subtle ways.

The first pictures affected by the voyage were produced in the summer of 1925. Ernst was lying low in the seaside town of Pornic, on the Atlantic coast of France, south of St Nazaire, having added his name to the Surrealists' public declaration of protest against the French colonial war in Morocco. As a clandestine immigrant it was a risky move. On August 10, and he is specific about the date as if confirming its totemic value, Ernst made some drawings that affected him deeply, using a technique of which he was never to tire. He called it *frottage*:

> it was raining and I was staying at a hotel by the sea when I noticed the obsessive visual attraction exerted on me by the grain of some floorboards that had been washed a thousand times. I decided to look into this obsessive effect, and, to stimulate my imagination, I made a number of drawings by laying sheets of paper at random on the boards and rubbing them with a pencil. . . . Puzzled and amazed, using the same technique, I tried whatever was around me: leaves and their veins, the frayed ends of sack-cloth, the brush strokes of a "modern" painting, a cotton reel, etc., etc.[413]

The experiment turned into a series of over eighty graphite *frottages*. The technical requirements of the project led Ernst to standardise production. For a finely detailed *frottage* you need thin paper, as thickness suppresses the details of the contours beneath when the pencil slides over them. Ernst used a sketchbook of fine paper that had the added benefit of a line of perforations running down each page, close to the spine, that made it easy to tear out neatly. It is to this original book-format that we should ascribe the publication of the *frottages* as a portfolio and in book form later. Many of the *frottages* are therefore of the same size, allowing for the slight adjustments dictated by Ernst as he worked within the boundary of the page. They are no larger than 45 cm × 27 cm. The *frottages* were not the first he had made, but correspond to some produced five years before in Cologne, using printers' blocks as their basis instead of floorboards and so on. These are generally around 45 cm × 35 cm.[414]

The many works that quickly grew out of the Pornic experiment were edited and published in 1926, in an edition of 306 copies, entitled *Histoire Naturelle* (Natural History). Publication was accompanied in Paris by a show of the plates. The illustrations often include an empty horizon, broken perhaps by the hump of a distant island or mountain, while sun or moon, or even both at once, float above. The series shows a planet from which the human race has vanished, leaving wildlife in possession to

Fig. 62 Max Ernst, *Eve, the Only One Left to Us*, *frottage*, from *Histoire Naturelle*, 1926, pl.34.

mutate into bizarre and unknown species. There is, however, a single human presence. *Histoire Naturelle* includes a woman turning her back on the viewer, and therefore on the artist as well. Ernst himself, or perhaps Eluard, for Eluard helped to edit the volume and may have underwritten its publication, entitled her *Eve, the only one left* (*Eve, la seule qui nous reste*). This is a portrait of Gala, who had provoked the travels of her lovers, only to distance herself from them both at journey's end. *Eve* is the final illustration in the book, and one closes it with her departure concluding the voyage it illustrates.

Ernst directed an intense creative effort to this series. The publication consists of thirty-four black-and-white images with cryptic captions (*He will fall far from here*; *Enter the continents*). As the pictures of plants and animals and the title of the collection indicate, its subject is natural history. Eluard was still helping Ernst, and seems not only to have acquired Ernst's Indochina sketchbook but also fifty more *frottages* associated with the project, but not included in *Histoire Naturelle*.[415] Ernst was prepared to burn these, but Eluard rescued them and bound them into another volume, entitled after a poem *Est-ce le Miroir . . .* (Is this the Mirror . . .), which was later sold and the pictures "scattered to the winds."[416] *Histoire Naturelle* therefore reproduced less than half of the series. Eluard's continued support for Ernst and his ownership of the majority of the other *frottages* indicates the two collaborated on *Histoire Naturelle*. The col-

lection does not tell a story, but records a journey to another world, something they had recently done. If the visual record made by eighteenth-century expedition artists on the voyages of scientific exploration, such as those of Captain Cook, are compared to the illustrations of *Histoire Naturelle*, many similarities emerge. For example they tend towards a standardised format, whereby drawings conform to a uniform paper size. They isolate the subject, so it is spread out flat, parallel to the surface of the paper, for clarity of representation. They also share the ungainliness sometimes present in the work of expedition artists who have had trouble drawing a specimen for the first time. Ernst's images are not zoological records, but to use a favourite term of his, borrowed from Emile Zola, they are "seen through a temperament." Ernst was not only reimagining the variety and strangeness of the flora and fauna he had just seen for the first time, he was also conveying his surprise at them by inventing life forms as weird if not weirder than what he had seen.

While the story of how *frottage* was "discovered" by Ernst at Pornic is familiar, missing from it is the part played by two elements derived from the voyage, firstly his response to tropical wildlife, and secondly his exposure to the *estompages* produced in Indochina. These elements contributed to the subject matter and to the technique of the series. While we should not exaggerate the importance of his exposure to life-size Khmer temple rubbings, given his previous experiments with graphite, we should not ignore their effect on the *scale* and *subject matter* of his *frottages*. We do not know which *estompages* he saw in Saigon, but among the most decorative and most popular were those of trees, monkeys, and shoals of fish that were a Khmer *Histoire Naturelle* in themselves. They were frequently taken from the bas-relief at Angkor Wat which illustrates the Hindu creation myth in which all life, the cosmos and everything in it, was stirred and whipped up in an event described as the Churning of the Sea of Milk. The churning lasted for a thousand years and produced *amrita*, the essence of immortality. The whirling Sea is filled to the brim with fish, crocodiles, dragons, turtles and snakes. There are horses and elephants, mountains and crowds of gods packed into a carving forty-nine metres in length that visitors to the site could walk past and examine closely before buying an *estompage* as a souvenir.

The practice of producing temple rubbings at Angkor Wat arrived with the French. The first scientific expedition to the site, led by Francis Garnier, made the earliest. Later the demand grew so great that by the 1950s their production was banned as the process was damaging the sculptures. For each *estompage* a sheet of paper was applied to the carved relief and was then moistened thoroughly so that the softened fabric could be pressed into place to make a close-fitting skin, and so produce a good impression when it was inked. However, it was found that peeling it off after the process of inking was completed, and the paper had dried, caused the stone to flake and particles of it to adhere to the back of the paper. Modern *estompages* are made from replicas of Khmer sculpture carved in wood. France is so well provided with *estompages* brought back by visitors during the colonial period that they are now one of the regular sources of enquiry at the Musée Guimet. Some can be several meters in length. The large scale,

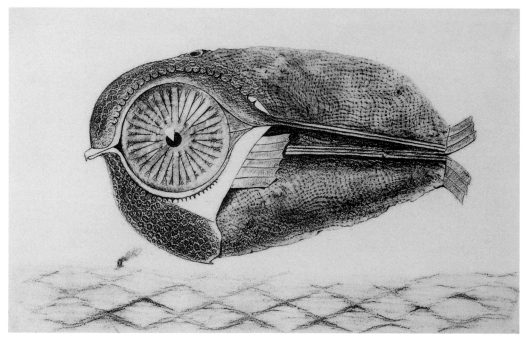

Fig. 63 An *estompage* made at the Temple of Angkor Wat. Taken from *The Churning of the Sea of Milk*, the bas-relief of a scene in the life of the god Vishnu. .

Fig. 64 Max Ernst, *The Escaped, frottage,* from *Histoire Naturelle,* 1926, pl. 30.

visual impact and ready availability of these *estompages*—executed in black ink on white or occasionally on tinted paper—clearly influenced the production of Ernst's *Histoire Naturelle* and his subsequent use of *frottage*.

As he experimented with the possibilities of the technique with pencil and paper, Ernst drew a world unlike any other, with flora and fauna to go with it. He was, in fact, engaged in a double invention, not only exploring a technique, but also its content of bizarre natural history. Ernst was seldom drawn to abstract painting but had an insatiable appetite for narrative, for which the storyteller needs characters and situations. What is remarkable about the *Histoire Naturelle frottages* is the speed and skill with which Ernst devised his subject and technique. The images were to be a continuous source of inspiration for him. Rodin's *The Gates of Hell* (1880) occupy a similar pivotal place in the sculptor's work. The project had encouraged Rodin to assemble hordes of figure compositions with which to decorate the Gates themselves, and the doorway that framed them. The multitude of characters became a storehouse to which he returned, singling out and enlarging them. He poured so much into the project that it sustained him, like a well-stocked arsenal. The same applies to Ernst's *Histoire Naturelle*, made ten months after his return from Indochina. It would be a mistake to restrict the meaning of the collection solely to the journey—it is too open ended for that. But the illustrations encapsulate the sights of his voyage—storms at sea, ocean currents, landward horizons, the sun above the waves and the spectacular wildlife he'd observed for the first time in the tropics—conveyed in a technique with an Indochinese provenance. The subjects he invented included themes he used for the rest of his life, and with customary economy Ernst also published the images like a catalogue, with pages to leaf through for inspiration, while shopping for ideas. As we have seen, Ernst had originally used *frottage* in Cologne in 1919, and he had done so in 1921 in Tarrenz, where he had made a rubbing of some rough wood, *Histoire Naturelle*-wise, to invent a strange animal.[417] This chance survivor, a doodle on the back of a telegram, reminds us once again of the way the voyage propelled prototypes into development, both in terms of subject matter as well as of technique.

As an alternative zoology, *Histoire Naturelle* was also part of Surrealism's revolutionary agenda. Ernst's publication subverted the established notion that nature conformed to rules, to Linnean tables, and that it could be categorised, measured and defined. His Natural History was carrying out what Antonin Artaud had recently declared Surrealism was for, *le reclassement de la vie* (the redefinition of life). Artaud, then in his pomp as the Surrealist Savonarola, had done so in the editorial of the third issue of the group's new journal, *La Révolution Surréaliste*. It is worth noting that this was also the issue in which Eluard published his first protest against the slavery and abuses taking place in Indochina, *La suppression de l'esclavage*, a gesture of *reclassement de la vie* that was *politically* motivated and parallel to Ernst's *reclassement* of *natural history*.[418] We can see from this that both men were incorporating the effects of the voyage into their work in their own way, the one fashioning them to political ends, the other to the study of nature.

Fig. 65 Max Ernst, *Sea and Rain, frottage*, from *Histoire Naturelle*, 1926, pl.1.

We have already seen some of the ways in which the journey influenced *Histoire Naturelle*. Léon Werth, whose picture of Saigon at the time of Ernst's visit has helped us before, gives us another example. Werth, like Eluard, Ernst and Malraux, had a social conscience and a good eye. He had not been East before either and so saw things afresh, like Ernst. Here he is in a market in Saigon, gazing at heaps of strange vegetables, at mango, betel nut and breathing the incense laden air: "The fish stalls are over there. But the fish have made a run for it. Bizarre snake-fish crawling along. Or else moving in leaps and bounds. They've blocked off the passage. The fishwives aren't bothered. In the Far East fish obviously live in the open air." This was something Ernst seems to have noticed too. Werth continues,

> It has not got the same dazzling impact as the market in Colombo, where ordinary life seemed to turn into something different and quite miraculous. There the world seemed transfigured and extraordinary. I felt I was on another planet then, standing in another kind of light altogether. . . . The fruit were massive and the vegetables monstrous. . . . In Colombo market the vast beans looked as if they were growing and spreading themselves out in front of me and the fruit seemed to expand like swelling balloons.[419]

Colombo was visited by most passengers sailing from Europe to Asia or on the way back. The port was an international coaling station, and while the harbour was filled with coaldust during the hours it took to refuel, passengers were encouraged to visit the market, a renowned tourist attraction. Werth's account explains its attraction, and his remarks alert us to the effect of such an experience on Ernst, who was there with Gala on his way to Saigon. The plants and animals of *Histoire Naturelle* are strikingly similar to the hallucinatory displays recorded by Werth. The weirdness of the flora and fauna in Ernst's later work echoed what he had marvelled at in Colombo and Indochina.

The need for *reclassement* is also evident in his captions and titles. The titles of Ernst's landscape paintings, for instance, often refer to his travels, so they should be studied carefully. At the end of his life he collaborated on a catalogue of his whole output, an immense undertaking, and in the process repeatedly stressed how important titles were to him. He rejected a number imposed by others and preferred a picture be listed simply as Untitled if he had not found one himself.[420] "I never force a title on a picture; I wait for it to force itself on me. After I've finished a painting I'm often left under its spell—at times for ages—and the obsession only goes when its title appears as if by magic."[421] Most of the titles we now use are therefore authentic.[422] What do they show us? For a start, that the relationship between his landscapes and their titles is fluid, even when the title is specific. We cannot be sure Ernst visited the places his titles describe, as we can be with a topographical painter like Monet. This is because Ernst's titles define the internal logic of his world as well as its outer reality. Thus the use of a title such as *The Great Wall of China* (1935) does not prove he had visited the monument, but it helps to know that in 1935, when he painted it, Ernst was also painting several other subjects with Asian overtones. We can tell from the evidence of related works (*The Entire City*, 1935, fig. 93, and *The Garden of the Hesperides*, 1935, fig. 118) that when he painted *The Great Wall of China* he was preoccupied with Asia, and that to arrive at this title his imagination strayed north, out of Indochina, to China itself. It is rare for Ernst to paint a landscape that does not oscillate between the imagined and the visible in this way, and his titles are best seen as a wavelength to which the viewer should tune to receive a shifting signal from the picture. Titles as specific as *Moon over Wellfleet* (S/M 2454), *Bryce Canyon Translation* (S/M 2505), *Summer Night in Arizona* (S/M 2456), *Night of the Rhine* (S/M 2460), and *Pacific Clouds* (S/M 2867) certainly refer to places he had seen. The same however is not true of views of the Galapagos, Mount Fuji or the North Pole, all of which were specified by title, but none of which Ernst ever visited.

Ernst was a lifelong and prolific landscape painter, and his wide-ranging geography indicates an unflagging curiosity about our planet, but he was an unreliable topographer. If at times he carefully painted what he had seen, like the Arizona escarpments around Sedona, at others he used titles drawn from real life for invented views.[423] In the end the world of his landscapes is a shifting one, unsuitable for measurement, but conforming to his own double vision, with its combination of the seen and the imagined. However, despite this disclaimer, there is a way of usefully interrogating his titles about the voyage and it lies in questioning the landscapes with vague and minimal titles, like

Forest and Sun (S/M 1168) or *Sea and Rain* (S/M 834). Ernst used many of these titles immediately after his return. They are as vague and monosyllabic as *Sea*, or *Marine*, or like the first plate of *Histoire Naturelle, Sea and Rain*. In March 1926, as Ernst was engaged on *Histoire Naturelle*, he also had a one-man exhibition at the Galerie van Leer in Paris. "The works on show," he wrote, included "some *Forests*, a few *Earthquakes, Suns* and *Seas*, and other works done in the frottage technique."[424] The *Seas* to which he refers are the paintings that blatantly reflect his journey to and from Indochina. The dreamlike effect of this group of more than forty pictures is deceptive, because while his inner eye was free to distort the evidence of his outward gaze, the artist was also free to reflect what he saw as precisely as he could. The immense and mysterious uniformity of his subject is reflected in the title he often chose, *Sea*. He avoided *The Red Sea, The South China Sea* or *The Indian Ocean*, despite having gazed at them for days on end.

Not only are the sea pictures of the late 20s and early 30s the result of two-way traffic between inner and external experience, they show us Ernst once again, post-voyage, stimulated by his travels, capitalising on earlier initiatives, as he had when he turned pencil rubbings into full scale *frottage*. He had rehearsed seascapes in a minor key before the journey, but after exposure to the ocean these prototypes evolved rapidly. The ocean had appeared, for example, in paintings such as *The North Pole*, and in the drawing, once owned by Breton, *The Sea, the Coast and the Earthquake*, drawn the year before Ernst set sail.[425] At least fifty-two seascapes from his first series survive, painted on canvas, board, paper and even on glass, (S/M 969–980, 982–991, 993–1024) and these are separate from yet more executed in pencil on paper. One of these, a *frottage*, is already extremely economical and accomplished. Fifty-two paintings on a single theme denote unusual commitment and give us an idea of the compelling hold the subject had on Ernst. They vary in size from the 64.5 cm × 54 cm of *Marine Verte*, (fig. 67) possibly the first version on canvas, to *The Sea* at 40.5 cm × 31.7 cm (fig. 58). Ernst never again concentrated on seascapes as single-mindedly, but his interest in the subject lasted the rest of his life. In fact painting the sea was to be a kind of turbine for Ernst that provoked technical innovation.

The technical and stylistic development of his pictures of the sea, painted over a fifty year period, await analysis. It will reveal the restlessness of his treatment, exposing the way his technique varied from *frottage* and *collage* to the use of the airbrush, stencilling and traditional brushwork. His means of representation were therefore as fluid and changeable as his subject. Since Ernst never tired of experimenting with seascapes he not only ensured the sea turned into a defining achievement of his maturity, it also became an autobiography. Painting the ocean also allowed him to work a basic compositional device borrowed from an artist he admired greatly, Caspar David Friedrich, whose *Monk by the Sea* exploited the same horizontally banded composition that was later also to attract Mark Rothko, who, like Ernst, found the simple graphic equation of a horizontal strip produces a grounded composition that is also saturated with space. "The fact is that I've always had Friedrich's pictures and ideas more or less consciously in mind, almost from the day I started painting," said Ernst, and Friedrich's famous

Above: Fig. 66 Max Ernst, *The Great Wall of China*, 1935, oil on paper on board, 22.9cm x 31.8cm. Menil Collection, Houston. S/M 2214.

Fig. 67 Max Ernst, *Marine Verte*, 1925, oil on canvas, 64.5cm x 54cm. Kaiser Wilhelm Museum, Krefeld. S/M 969.

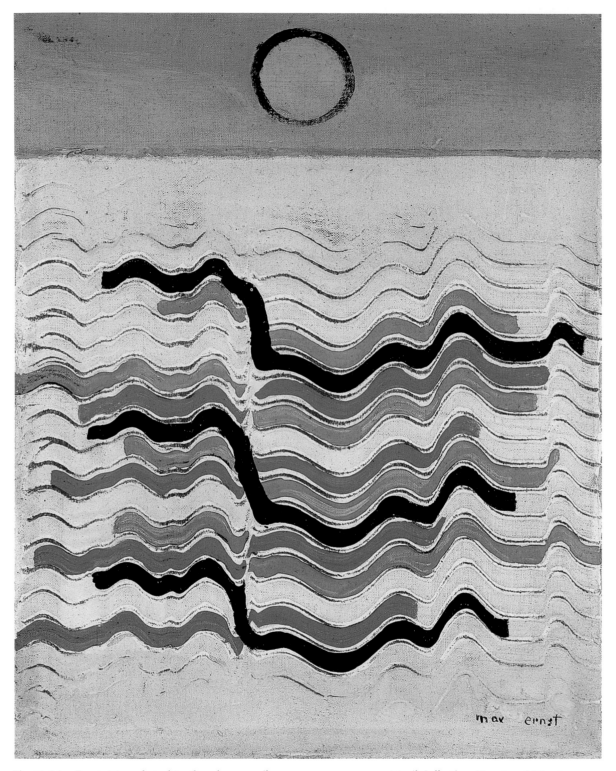

Fig. 68 Max Ernst, *Wave-shaped Earthquake*, 1927, oil on canvas, 24cm x 19cm Menil Collection, Houston. S/M 1287.

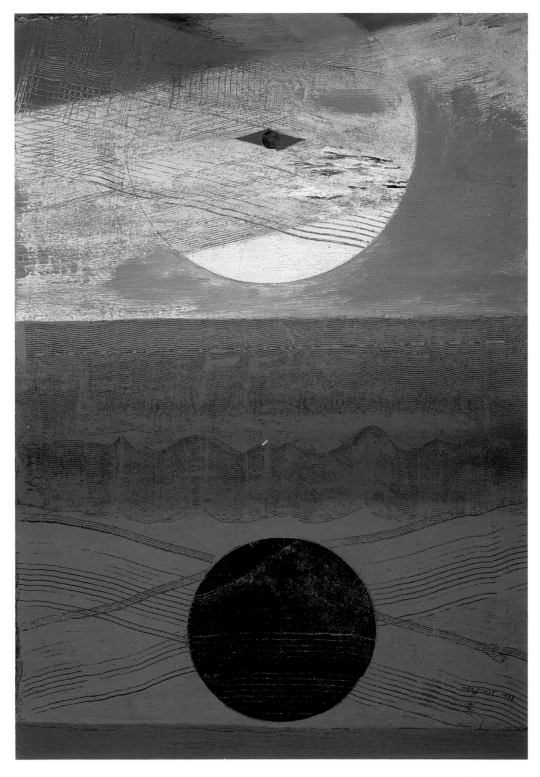

Fig. 69 Max Ernst, *Sea and Sun*, 1925, oil on board, 55.3cm x 37cm Scottish National Gallery of Modern Art, Edinburgh. S/M 976.

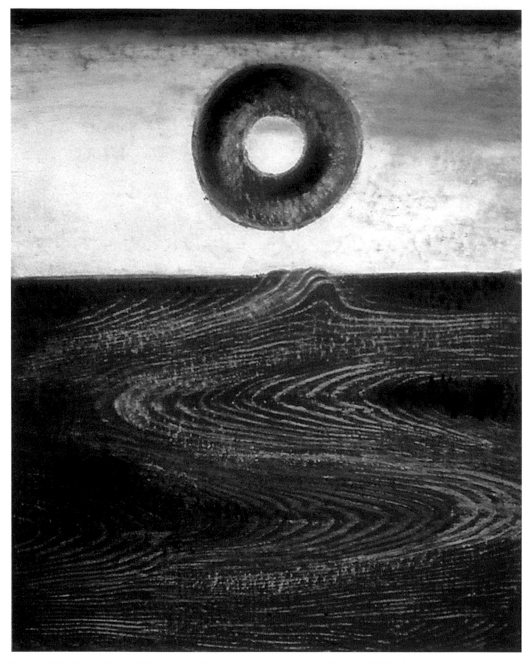

Fig. 70 Max Ernst, *Sea and Sun*, 1926, oil on canvas, 73cm x 50cm. Private Collection. S/M 1023.

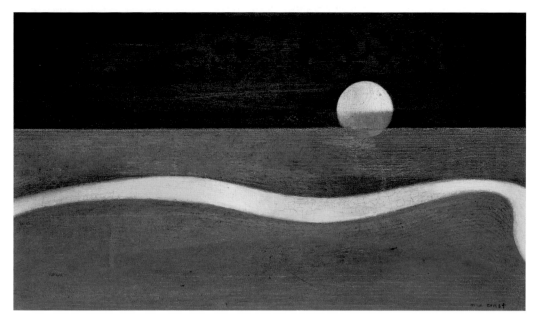

Fig. 71 Max Ernst, *Humboldt Current*, 1951–52, oil on canvas, 35cm x 61cm. Ernest Beyeler Gallery, Basel. S/M 2969.

Fig. 72 Max Ernst, *A la Derive* (*Adrift*), 1960, oil on wood panel, 27.5cm x 37.5cm. Private Collection. S/M 3507.

Fig. 73 Max Ernst, *Demain* (*Tomorrow*), 1962, oil and collage on panel, 33cm x 23.8cm. Private collection.
S/M 3640. Photo. Christie's.

Fig. 74 Max Ernst, *Venus voit de la terre (Venus sees Earth)*, 1962, oil on canvas, 45.8cm x 37.5cm. Private Collection. Photo: Christie's S/M 3538.

Fig. 75 C.-D. Friedrich, *Monk by the Sea*, 1809–10, oil on canvas, 110cm x171.5cm. National Gallery, Berlin.

Fig. 76 Max Ernst, *L'Air lavé à l'Eau* (*Air washed in Water*), 1969, oil on canvas, 116.3cm x 88.3cm. Private collection.

Fig. 77 Max Ernst, *Le Fleuve Amour*, 1925, *frottage*, 26.2cm x 20.3cm. Menil Collection, Houston. S/M 827.

Fig. 78 Max Ernst, *Courtesy of the Moon*, 1946–47, gouache on paper, 9cm x 4.5cm. Private Collection. Photo: Christie's. Reproduced actual size. S/M 3631.

space, minus the monk, haunts Ernst's pictures of the sea. In Ernst's views the monk has vanished, leaving his point of view for us to inhabit. We not only replace the monk as the viewer, we also replace the artists, Friedrich and Ernst, as we gaze directly at the mystery of the endless horizon that beguiled them.[426] There are thirty-four plates of *frottages* in *Histoire Naturelle* and twenty feature the sea and empty horizons. It is hard to untangle the chronological sequence of his work in the months after his return because he switched back and forth between oil on canvas and graphite on paper. He crossed from one medium to the other and transferred his discoveries unpredictably and promiscuously, as we have already noted. He even made *frottages* in pencil on paper, but taken from the surface of an oil painting. In *The River Amur*, he took an impression from the tooth tracks previously created by swivelling a comb through wet paint, a technique he devised and used often for the sea. *Le Fleuve Amour* (*The River of Love*) was not included in *Histoire Naturelle*. The River Amur flows into the Sea of Okhotsk, having crossed most of Eastern Asia. It also appeared in the title of a recent (1922) best seller, *Sur le Fleuve Amur*, by Joseph Delteil. The exotic setting of the book, together with its subject of rape, pillage and incest during the chaos of the Russian Revolution, was attractive to the Surrealists, who drew Delteil into their group at the time of the voyages. Ernst

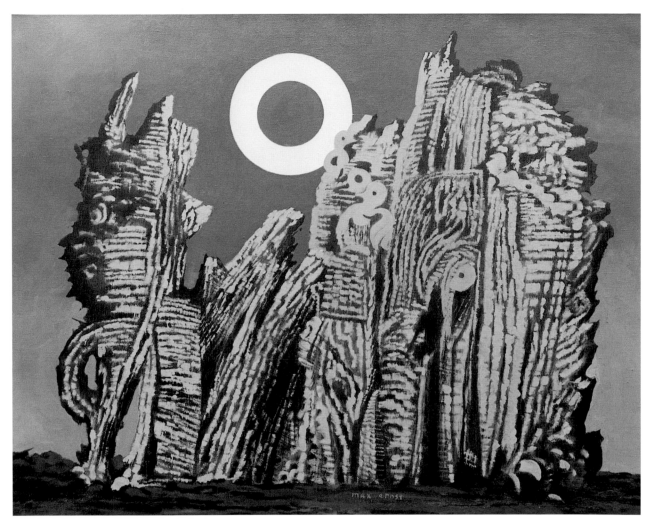

Fig. 79 Max Ernst, *Grey Forest*, 1927, oil on canvas, 80cm x 100cm. Ernst Beyeler Gallery, Basel. S/M 1167.

knew him and the book. His title therefore plays on exotic, geographical, sexual, literary and political implications, and compresses the mental climate of the Surrealist voyages into three words. Then, reversing the process, Ernst took canvas instead of paper and overlaid it on various surface textures and rubbed the raw untreated surface of the fabric with crayon. The result was a *frottage* with much more body, which he could work up in a conventional way with oil paint using a brush. *Marine Verte*, the *Green Marine* (fig. 67), is one of the first paintings on canvas to incorporate the *frottage* discoveries made in Pornic. This may account for its simplicity.

During 1925 and 1926, when Ernst was painting scores of seascapes in this way, we can assume that they not only reflect past experiences at sea but also represent new, imaginary ones, seascapes of the mind. As he painted, he plumbed the mystery of the

Fig. 80 Max Ernst, *The Great Forest*, 1927, oil on canvas, 114.5cm x 146cm. Kunstmuseum, Basel. S/M 1173.

Fig. 81 Jade disc, Yuan. Shang Dynasty, 1523–1028 BC. Victoria and Albert Museum, London.

ocean. Ernst's one-man show of 1926 also included *Suns*, a series that grew out of a feature present in his pictures of *Seas*, the sun itself (fig. 70, *Sea and Sun*, 1926). The great circle floating above the horizon became a favourite subject and was treated to same degree of technical elaboration as his paintings of the sea.

As he steamed north across the Red Sea Segalen had written "the wind dropped. Calm rose with the moon, which climbed, round and pale to our right, over the Siniai peninsula," a view Ernst saw too.[427] While trapped on board following a monotonous routine, the coming and going of sun and moon are very evident. They are a focus of interest and seem interchangeable, as Coleridge had noted in *The Ancient Mariner* where "The bloody sun, at noon / Right up above the mast did stand / No bigger than the moon." Ernst frequently turned the discs of sun and moon into a ring.

These sun rings resemble not only the high-level cirrostratus halos that surround either sun or moon, but also the flat jade rings, up to 15 cm in diameter, which have been found in China in graves dating from Neolithic times to the Zhou period (900–300 BCE). By the Han period (200 BCE–221 CE) they were recognised as symbols of the sky. Such rings, known *bi*, could be seen in Paris at the Musée Guimet, alongside exhibits brought back from Angkor. The sun rings which first appear in Ernst's *Seas* and *Forests* of the 20s may therefore share this symbolic value as emblems of the heavens, and therefore raise the Asian content of his post-voyage work. As we know, he was interested in ethnography and widely read, so we may assume he knew of *bi* discs after his visit to Asia. Ernst was attracted to archetypes and converted visual experience into such symbols, as we can see from the way he abstracted the sea and the forest. His suns and moons are also separate subjects in themselves, but we should not forget the part played by the voyage in fixing his taste for painting them.

The Ballets Russes production of *Romeo and Juliet* with sets and costumes by Ernst and Miró was staged on May 4, 1926, at the Opéra de Monte Carlo, soon after Ernst's one-man show in March at the Galerie van Leer. Ernst had submitted a series of six designs to the Ballets as backdrops.[428] For years they belonged to a member of Diaghilev's corps, the dancer Serge Lifar. One is as near to abstraction as Ernst went, its simplified bands of colour drawn horizontally across the picture like a flag (fig. 82). Their titles, *Sun, Horizon, Night, Sea* and *Sun* remind one of the course of any day on any ocean, and reinforce the abstracted feel of the pictures, as if they were designed to evoke the timeless routine of life at sea. Painted on a variety of surfaces, on board, paper or canvas, the five studies are approximately the same size, one Ernst favoured, about c.30 cm × c.30 cm. The exception was *La Mort de Juliette* (*The Death of Juliet* fig. 83). This has been worked in greater detail. It is the darkest and therefore the most tragic image, in tune with the subject of the ballet. When the ballet opened at the Théâtre Sarah Bernhardt in Paris, Breton took offence, most probably because he felt Ernst, one of *his* team, had been supping with the devils of Café Society and therefore risked contamination. It took Eluard, as usual, to calm Breton and protect Ernst from Breton's bite. Eluard's trust in Ernst was unshakeable. We may register this gesture of support, but we

Fig. 82 Max Ernst, *Horizon*, 1926, oil on canvas, 20cm x 26cm. Private Collection. S/M 996.

Fig. 83 Max Ernst, *La Mort de Juliette*, 1926, oil on board, 35cm x 26.8cm. Wadsworth Athenaeum, Hartford, Connecticut. S/M 1000.

Fig. 84 Max Ernst, *Vision Induced by the Nocturnal Appearanceof the Porte Saint-Denis,* 1927, oil on canvas, 65cm x 81cm. Private collection. S/M 1177.

shall never recover the dialogue that underwrote it, with its inimitable cargo of gossip and cultivated shorthand developed by the two men for their joint creative life.

By 1926 Ernst was confidently juggling a distinctive style which combined oil paint, *frottage* and *grattage,* deploying elements like the horizontal band of a horizon on which, as in *The Death of Juliet,* there sometimes floated a distant promontory "like a shadow on the sky," while in the depths below the surface the snakelike swerves of deep sea currents rippled. The ripples and ribbons he identified by name elsewhere as *Gulf Stream* or *Humboldt Current.* The forces at work under the sea were rendered by him with comb-strokes scratched through the wet paint, like a harrow, a technique he called *grattage,* and which he was to use a great deal in the coming months, as the comple-

mentary effect to *frottage*. They were two sides of the same reality, its positive and negative imprint. If *frottage* scraped the pigment on the surface to find an image with the help of what was hidden beneath the canvas (fig. 70), *grattage* scraped the wet paint to find what could be created with the surface paint itself (fig. 71).

Ernst's opportunity to fill a stage with a monumental backdrop of the ocean was revived forty years later when he was asked by the Paris Opera to design a production of the ballet *Turangalîla-Symphonie*, with music by Olivier Messiaen. One scene was dominated by a huge yellow sun floating in a red sky above a dark horizontal strip of coast. Dancers, dressed in white, moved like gulls through this sunset seascape, which, we now realise, brought with it echoes of a forgotten journey:

> The coast . . . is straight and sombre, and faces a misty ocean. . . . Swampy plains open out at the mouths of rivers, with a view of jagged blue peaks beyond the vast forests. In the offing a chain of islands, dark, crumbling shapes, stand out in the everlasting sunlit haze like the remnants of a wall breached by the sea.[429]

With this coast in mind let us pause and consider our own approach. As we have observed, Ernst's pictures about Indochina move from the general to the particular, from the wide-angle to the close-up. To trace the effect of the voyage on his work we do so within this framework. While it is possible to lay out Ernst's work, broadly speaking, in chronological order, the flow is disrupted by the way he tended to break off in mid-series and switch to another subject, before returning to it again. His serpentine development makes it difficult to pursue a chronological treatment using his technique alone as our thread. This difficulty does not apply as much to pictures of the sea and the forest as to the other voyage-related subjects, because by the time he tackled them he was not working consistently on one subject but was switching frequently and sporadically between several.

For this reason let us continue our investigation of what he found to paint *in* Indochina by using the cinematic approach outlined above. This is not fanciful as its logic corresponds to an aspect of Ernst's imagination. In 1934, when he was deep in his Angkor-related pictures, he wrote *The Mysteries of the Forest*, a short piece in which he used a sweeping aerial view to describe one of his favourite subjects. "Take a trip to Oceania," he wrote, "and you'll see what I mean. . . . Are there still forests over there? From one island to another, from volcano to volcano," he continued, looking down from high above, the forests stretched out "dressed only in their magnificence and mystery."[430] Our chosen cinematic approach allows us to converge on Angkor Wat, but only after we have followed him on the next stage of his journey, after he had made landfall and travelled through the forest which he confronted outside Saigon.

Memories of that sodden, dense jungle haunted him between 1926 and 1928, when he produced a total of ninety-two forest pictures.[431] More followed in the 30s.[432] This series of *Forests*, like the *Seas* before them, had been piloted in prototype before the trip.[433] Forests vary and we have to distinguish them, as Ernst, a connoisseur of wood and jungle, certainly did. The European deciduous forests of his childhood, along the

Fig. 85 Max Ernst, *Joie de Vivre*, 1937, oil on canvas, 60cm x 73cm. Staatsgalerie Moderner Kunst, Munich. S/M 2275.

Fig. 86 Max Ernst, *Joie de Vivre*, 1936, oil on canvas, 72.7cm x 91.5cm. Scottish National Gallery of Modern Art, Edinburgh. S/M 2263.

Fig. 87 Max Ernst, *The Last Forest*, 1960-69, oil on canvas, 114cm x 146cm. Musée National d'Art Moderne, Centre Georges Pompidou. Paris.

Rhine and the Danube, are locations that haunted the poets and painters he admired, such as Albert Altdorfer, Mathias Grunewald and Caspar David Friedrich. Ernst's exposure to the woodlands of middle Europe preceded his experience of the rainforest and his response to each was different. To be entirely surrounded by plant life, by trees, moss, dead wood, undergrowth, and by the creatures hidden there, was a supremely moving feeling, one he defined as *naturgefühl*, nature-feeling or contact with nature.[434] The way these habitats combined in his mind's eye and accommodated each other in his work accounts for the hybrid forests of Ernst country after his return from Asia. His *Forests* are as varied as the woodlands he had seen. The fact that he had explored the subject earlier should not obscure the way that the *Forests* he painted after his return were inspired by the voyage, just as the *Seas* were.

Seas and *Forests* were painted in relays, so it is possible to play back in one's imagination the combined afterimage of both and, to a limited degree, reconstruct the mental environment Ernst occupied as he made them:

> A brooding gloom lay over this vast and monotonous landscape; the light fell on it as if into an abyss. The land devoured the sunshine; only far off, along the coast, the empty ocean, smooth and polished within the faint haze, seemed to rise up to the sky in a wall of steel.[435]

He painted a world of empty horizons, ocean currents, deserted promontories and looming sombre forests, uninhabited by man, over which drift sun and moon. Two forest worlds emerged, the serpentine and the vertical. Some resemble the pinewoods of cooler latitudes, composed of tall tightly packed vertical trunks, many of which he called *Fishbone Forests*. Others are of serpentine tropical undergrowth in full leaf that forms a wall sheltering the wildlife of the rainforest, as in the *Joie de Vivre* series and related pictures of 1936–37 (S/M 2263–2276). The former deciduous *Forests* are technically different from the tropical subjects, being dryer in appearance, their surfaces produced by *frottage*, *grattage* and scumbled paint (figs. 79, 80, 84). Their sombre scenery is derived from Ernst's first rubbings of floorboards that had inspired his *frottages* (S/M 1140–1196 of 1926–27 and S/M 1225–1261 of 1927–28). The pervasive importance of the discoveries associated with *Histoire Naturelle* is confirmed when one learns the first of these vertical *Forest* pictures was also the first *frottage* Ernst produced at Pornic (plate 21, *Rasant les Murs* [literally *Shaving the Walls* but perhaps also *Hugging the Walls.*]). The first *frottage*, of wood, therefore paved the way to many more, painted woods.[436]

The second forest type, the serpentine undergrowth that resembles tropical vegetation, dates from the late 30s and includes the *Joie de Vivre* scenes, which have a sleeker, glossy finish, distinct from the dry surface of *frottage*. These are produced by the careful use of oil paint, smoothly applied to disguise the brushstrokes and create a surface as slick as wet leaves. In the decade after his return Ernst produced about 115 paintings of the forest. There were many others in which trees also featured in a subsidiary role and a large number of drawings. This established a lifetime's attachment to a subject inextricably linked with the *Seas* series. It is as if the woods and waves migrated through Ernst's technical discoveries, possessing them one after the other.

Ernst went on painting tangled *frottage*-inspired undergrowth, and his enduring fascination with its secret life made a final dramatic appearance in a picture painted between 1960 and 1969, which he called *The Last Forest* (fig. 87). It was his farewell to a treasured theme, a farewell that took nine years to complete, the image developing as slowly as the growth of a forest itself, and it ends a journey begun after his return from Indochina, forty years before.

Part two The ruined city

Ernst had completed over fifty *Seas* and a hundred *Forests* before he turned his attention to the city hidden in the trees. The visitor's first view of the vast complex of Angkor Wat is from a distance, a view Ernst painted. You then move in to explore its causeways, statues and vegetation. The pictures inspired by Angkor Wat also have a family resemblance beyond their material basis in the site because the paintings were equally about the menace of nature. "Time and again," wrote Werner Spies, "Max Ernst devised new variations on the theme of man threatened by nature."[437] Ernst painted several series that used Angkor as his vehicle. The most distant views are the three large versions of the series he called *The Entire City*, and they commemorate the visitor's first glimpse of the vast site. Moving closer, he then painted the *Joie de Vivre* series to which we have referred, before he produced a clutch of images, inspired by specific locations within the site, known as the *Garden of the Hesperides* and *Déjeuner sur l'herbe*. Approximately ten years separate these paintings from the trip, so Ernst tackled the subject only after his journey had slipped into the past. A similar delay is apparent in Pierre Loti's treatment of Angkor, as almost a decade separates his book about it from his visit. By the mid-30s Ernst was producing fewer pictures on a single theme than he had with his *Seas* and *Forests* a decade earlier. The later work was more varied and intermittent, consisting at times of a couple of images, without an attendant brigade of variants. *The Stolen Mirror*, which we shall explore in detail, is the most obvious example, as it not only lacks direct parallels but is also the last of Ernst's paintings discernibly about Angkor.

There were two ways to Angkor in Ernst's day, by steamer or by car. "It's about 560 kilometres from here to Angkor. You'll do it in two stages. Of course I'll put a car at your disposal," said his host in Saigon to Pierre Benoit's narrator in *Le Roi Lépreux*.[438] He duly sets out on the Route Nationale, breaking the drive for a night at a hotel. The recommended route brought one to Angkor at six in the evening the next day, fresh from a midday siesta that avoided the heat: *offrez-vous une bonne sieste, et vous serez à Angkor vers six heures. C'est le meilleur moment* (have a good siesta, and you'll be in Angkor around six. It's the best time).[439] Dawn and dusk were the magic hours there, as they still are. The alternative was the approach from Phnom Penh by steamer across the great lake of Tonlé Sap to Siem-Reap, *Un village paradisiaque, une véritable évocation de l'Age d'or*, according to Benoit. Siem-Reap is now a global tourist terminal with an airport, but in Ernst's day was the kind of tropical paradise treasured by film-makers, and it reminded Benoit of two travellers as familiar to us now as to the Surrealists. "Everyone looked so happy, nobody was doing any work," he wrote, "It was pure Gauguin. A page from Bernardin de Saint-Pierre."[440] This mention of Gauguin reminds us of the drawings in Ernst's Indochina sketchbook, in particular the studies of figures seated among vegetation that may have been executed nearby (figs. 49 and 50). That Bernardin de Saint-Pierre was referred to at Angkor in the 20s, in a novel as popular as *Le Roi Lépreux*, confirms his position as a founding father of French tourism and as the patron of travellers, armchair or otherwise, tuned to the *éxotique*. Eluard and Ernst, Malraux and

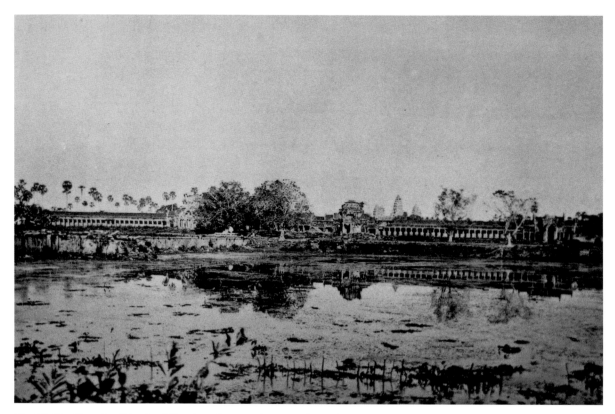

Fig. 88 The Temple of Angkor Wat viewed across the moat, from the west.

Benoit, Segalen, Gauguin and Rimbaud had enacted a French routine *outre-mer* that followed his lead.

The first vista to reveal the scale of what lay ahead unfolded on arrival at the hotel, a low building at the southern end of the western side of the Temple of Angkor Wat itself. The hotel was positioned to take in the view across the main causeway to the chief entrance to the Temple. It also benefited from the golden sunset that bathed the west-facing side of the ruin. Guests flattened by the heat would be encouraged by the vista, and by the slight drop in temperature, to embark on an evening outing. The view, beyond the hotel lawns, overlooked a stretch of open water to the massive wall of the Temple enclosure, ribbed with detailed masonry flanking the principal gate, itself distinguished by a cluster of towers. The five larger towers of Angkor Wat were grouped enticingly in the background, to the right. This setting was familiar to most visitors, for tourists who wanted to explore the site had little alternative but to stay at the only hotel. The view across the shallow moat to the long low walls beyond was therefore well known and appears in Ernst's own versions, among his largest paintings as well as his most compelling, which he called *The Entire City*. The largest was painted in 1936–37. Like its companions it is in oil on canvas and combines traditional brushwork with

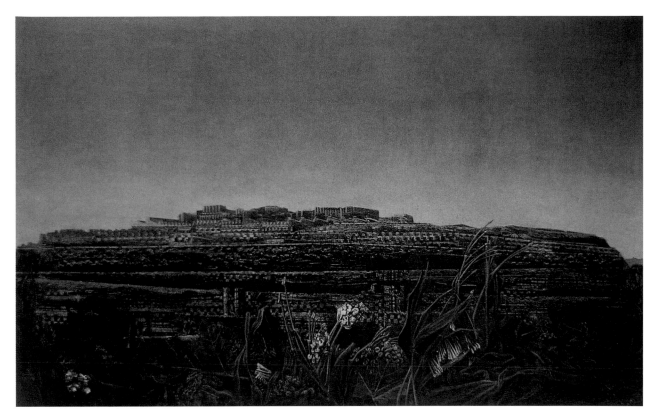

Fig. 89 Max Ernst, *The Entire City*, 1936–37, oil on canvas, 97cm x 146cm. Private collection. S/M 2261.

frottage. The second is a little smaller, being 14 cm narrower. These two images are twice the size of the third painting in the series.

To begin with we should consider how these three distant views deal with the visitor's first impression. This raises the issue of scale. The large versions of *The Entire City*, for there are many smaller ones too, cunningly solve the problem of conveying the monumental size of the location. They evoke the first moment when the idea of Angkor turns into wide-angle reality, when expectation becomes fact. In relation to the overall canvas size, the ruin occupies a small part, and to take in the full view we must stand back, thus reducing the scale of the detail relative to our field of vision. The question of how Ernst has dealt with the scale of the experience leads us to the way in which this was done, and when. The fact that the three views occur late in Ernst's work about Angkor allowed him to use techniques he had perfected in earlier trials. Technically, Ernst created the city by scraping it into being, like an archaeologist, using *frottage*, whereby an upper layer of wet paint is removed by a palette knife that skims over those areas of canvas forced up into its path by the projections of what lay underneath the fabric. Partially scraping off a topcoat of fresh paint, often a warm rusty tone, exposed a sand-coloured undercoat. It was a quasi-archaeological technique used with sophisti-

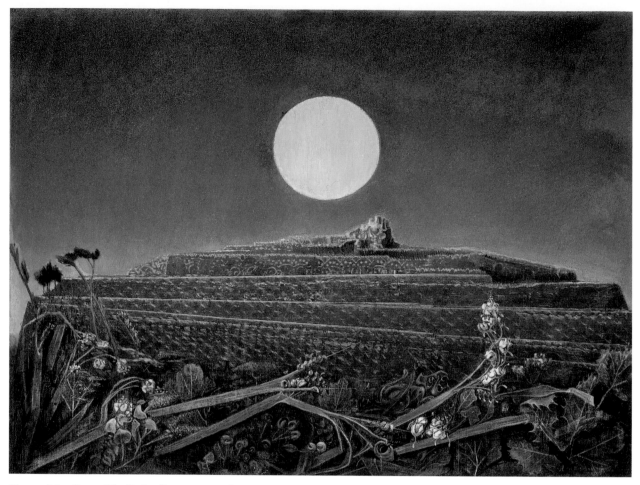

Fig. 90 Max Ernst, *The Entire City*, 1935–36, oil on canvas, 60cm x 81cm. Kunsthaus, Zurich. S/M 2220.

cation, allowing Ernst to work his way up or down through various layers to achieve complex effects of light, shade and colour.

Using this method, Asia was introduced into the pictures, like a kind of bedrock, from beneath the canvas. This was thanks to Ernst's friend Roland Penrose, who remembered that, after his own return from a journey to India in 1932, he had shown Ernst objects which the artist used to create the masonry of his *frottage* cities. In India Penrose had acquired "wood blocks used in Rajputana for printing muslin. They were just the material he (Ernst) needed for frottage, and in many canvases in the early thirties it is easy to see these designs emerging in the foreground of paintings such as La Ville Entière."[441] Penrose's printing blocks became Ernst's building blocks. The originals were lost in the war, but similar ones survive in the Victoria and Albert Museum, London, and give us an idea of what Ernst used. The repeated use of Rajput hand-carved designs to create vegetation and masonry reveals that Ernst's cities are therefore

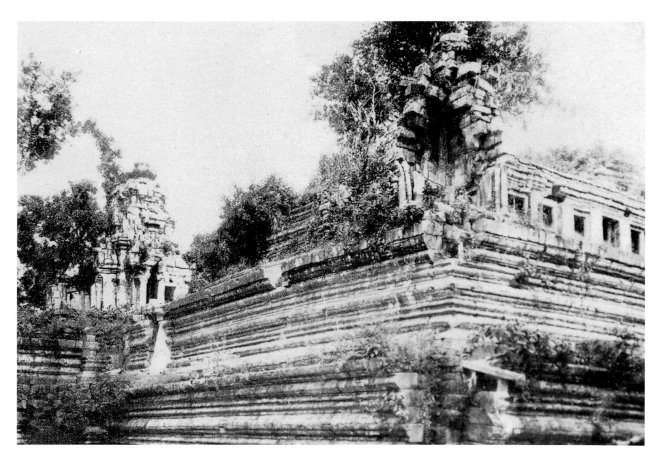

Fig. 91 The Pyramid of Bapuon, Angkor Thom.

more Asian than we thought. They also remind us that *The Entire City* is not exclusively about Angkor, but refers to other citadels, like the massive walled enclaves high above the plains of Rajastan in northwest India, where the wood blocks were made.[442]

The Rajput blocks fuelled Ernst's experiments with *frottage*. He produced many city views, laying siege to the theme in smaller operations before he attacked it in a big way with the three large paintings that conclude the series.[443] The Rajput blocks were about 6 cm × 12 cm. He tried them first in small compositions such as *The Great Wall of China* (fig. 66), where a few passes of the palette knife over oil paint on paper were enough to cover the picture surface and, despite its small size, produce a monumental effect. By increasing the size of his image, but limited by the fixed size of the blocks, Ernst was able to position them, scrape his palette knife across, reposition the block and repeat the process many times to create the detailed vista of a large ruin seen from afar. In the two largest versions (figs. 94 and 89) the printing blocks were repositioned again and again, at times even being placed vertically to act as towers. We can see how Ernst's city grew, for it was only by gradually scaling up the size of his canvas, and with it the number of times he reused the blocks, that he

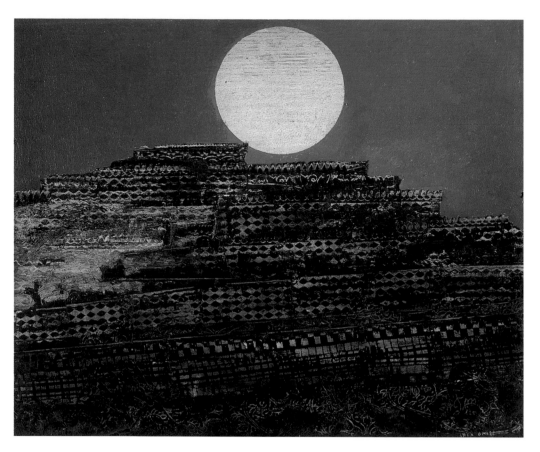

Fig. 92 Max Ernst, *The Petrified City*, 1935, oil on paper, 50.5cm x 60.9cm. Manchester City Art Gallery. S/M 2219.

was able to convey the scale of the city. This development seems to have been planned from the outset, for even the first small fragmentary compositions were entitled *The Entire City*, long before the large and final versions that warrant the title were painted.[444] One picture in the series does however have a different title. *The Petrified City* may have been suggested by Roland Penrose. Being British he was more likely to have kept up with the English-language press in the UK and the US.

The title of Ernst's picture refers to the Warner Brothers' gangster movie *The Petrified Forest* (1936), starring Humphrey Bogart. The play on which it was based had opened on Broadway on January 7, 1935, and was an instant hit. Written by Robert E. Sherwood, the theatrical production had also starred Bogart, and it was running as Ernst was painting his version. When it slipped into Ernst's work, Sherwood's title and play were therefore in the news, the talk reinforced by pre-release publicity for the subsequent movie. Bette Davis played opposite Bogart in the film, as a waitress who longs to study art in France, but is stuck living in a desert service station located in the

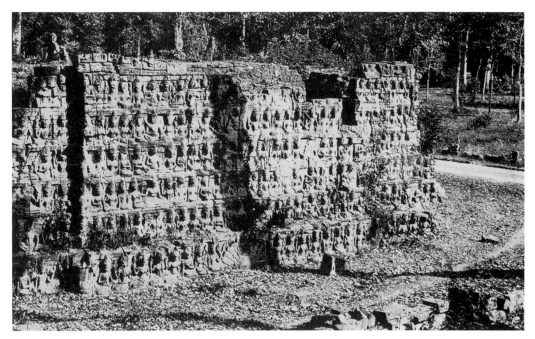

Fig. 93 The Terrace of the Leper King, Angkor Thom.

Petrified Forest National Park. Penrose, who knew Ernst's painted forests, could not have failed to make the connection between the title of Sherwood's play and Ernst's images of stone forests and jungle cities.

We get a clear view of Ernst's layered technique if we examine the foreground of the large versions of *The Entire City*. He has overlaid a band of rich vegetation painted with a brush, with great attention to detail, over the *frottage* of the Rajput blocks that define the buildings. This traditional brushwork had also been rehearsed in a separate series (provoked by his experience of the rainforest), the *Joie de Vivre* pictures. These (figs. 85 and 86) and related jungle scenes recall the rampant vegetation that had obliterated Angkor before its rediscovery. Beneath the green of Ernst's vegetation lies red laterite masonry (fig. 90). Much of Angkor is built of this iron-rich stone that glows with special intensity at sunrise and sunset. It comes as no surprise therefore that Ernst has chosen a rust-red colour for the masonry of *The Entire City*, and the coincidence adds weight to the claim that he knew Angkor and had been exposed to its effects. No amount of black-and-white reference photographs could prepare him for that sun-soaked laterite. Ernst chose this warm tone from the start, as in the *The Petrified City* (fig. 92), before repeating it in his large versions. The faithful rendering of the limpid skies of Angkor (fig. 90), translucent after rain, and of the dark shadows created by the raking light of daybreak or evening, also confirm that Ernst's views are a response to the physical conditions of the site.

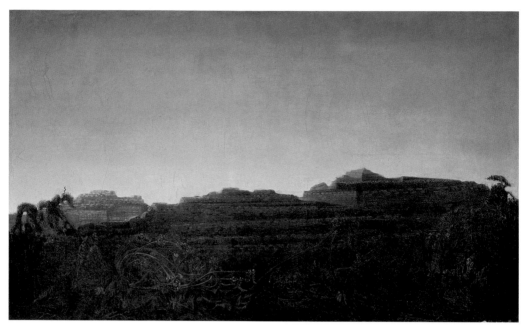

Fig. 94 Max Ernst, *The Entire City*, 1936–37, oil on canvas, 97cm x 160cm. Peggy Guggenheim Collection. S/M 2260.

The three big canvases of *The Entire City* are an appropriate introduction to Ernst's Angkor because they allow us, as imaginary visitors, to start with the first panoramic view, and then to set off on our tour in the knowledge they were, in fact, the last ones he painted. The chronological order in which they were produced reveals, paradoxically, that he portrayed the moment of arrival only after he had learned to paint what had followed. Taking Ernst's pictures as our guide, let us now look at Angkor. The paintings are our Ariadne's Thread, but we may only cling to it knowing that while we revisit those parts of Angkor that intrigued him, we will also be making unlikely detours. For, as with his *Histoire Naturelle* collection, we should not be too prescriptive about the similarities between the appearance of Angkor and Ernst's work. His approach was seldom literal. The striking parallels therefore should not trap us into thinking of him as an artist whose output was biographical, a reflection of events. As usual, Ernst combined various sources of inspiration when he dealt with Angkor, treating it both as a destination and as a point of departure. It was a specific location of study and a symbolic site that ushered the imagination in other directions. He painted it, one should remember, years after his experiences in Indochina, by which time his imagination was familiar with the subject and able to rework it with confidence, combining it with other sources of inspiration.

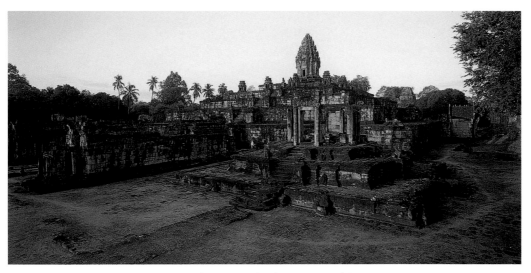

Fig. 95 Angkor's red laterite masonry. Photo © Michael Freeman Archive.

A tour of Angkor

The visitor to Angkor in 1924 relied on experienced guides. Anyone interested in Angkor would have been offered the choice of two tours, *le Grand Circuit* or *le Petit Circuit*. In addition to the regulation stops at the Temple of Angkor Wat and the Bayon, these two tours involved visits to other specially chosen parts of the 100 sq.km site, visits that would otherwise have escaped the ordinary tourist. Nobody could have made sense of a place so vast, in temperatures that, at midday, could fell a horse. The new circuit road which made this possible had been built in 1920, transforming the visit. Tourists could now speed from the hotel, through the jungle, from one spectacular sight to the next. It was an exhilarating ride, taken by Roland Dorgelès at the time Ernst was in Indochina,

> I can't stop, I've got to see everything, to feast my eyes and cram my imagination with it all. The car speeds on, then suddenly, we're at the Bayon, as impressive as a cathedral. . . . Then we get to the Royal Enclosure, a vast empty lawn, where the car swerves . . . all around us the jungle's full of ruins.

He pelts past the Elephant Terrace, past the Terrace of the Leper King, past

> towers of pink brick, others of grey stone smothered in vegetation. . . . All around me, in front, behind, yet more ruins appear then vanish, it's like a cinema with ten screens going at once. Don't stop! Keep going; on that first day I've got to see the whole of Angkor; to get an idea of its incredible layout; . . . and so on we hurtle.[445]

Henri Marchal, Angkor's curator, wrote a new guide in the 20s that catered for the increasing number of visitors and featured the two tour options in his title, *Guide*

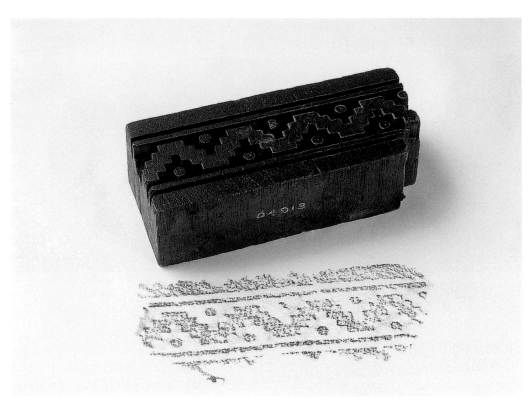

Fig. 96 A Rajput printing block with a graphite *frottage* made from it. Victoria and Albert Museum, London.

Fig. 97 *Frottage* combining two Rajput printing blocks. Graphite on paper.

Archaéologique aux Temples d'Angkor, Angkor Vat, Angkor Thom et les Monuments du Petit et du Grand Circuit.[447] The two *circuits* had been orchestrated to highlight locations that might otherwise be missed. As a result, reproductions of them frequently appeared in the books, periodicals and photo albums of the day. This is worth bearing in mind, as reproductions seem to have been a factor in Ernst's pictures. "Unlike his cubist predecessors—and even more than most of his Surrealist colleagues—Ernst was a great amateur of ethnology and possessed a considerable library on the subject," writes William Rubin.[447] In Ernst's library, or in the books readily available in Paris libraries and bookshops in the 20s and 30s, he would have found photographs of those spots on the Angkor *circuits* that he recalled in his paintings.

From the hotel terrace, guests saw the towers of Angkor each time they set off or returned in one of the chauffeur-driven Renaults. "Fifteen years ago one couldn't begin to think of using the tracks that wandered between the various monuments at Angkor unless one had plenty of time and did so by ox cart or on horseback, which would have been the only way," wrote Marchal. "Now a network of motor roads links the main monuments . . . and they are known as the Grand and the Petit circuits."[448] We do not know which Ernst was interested in, but on the evidence of his pictures it seems he was impressed by at least six locations. They are the Temple of Angkor Wat itself, the Bayon, the Elephant Terrace, the Terrace of the Leper King, the island monument of Neak Pean and the site known as Ta Prohm. Ta Prohm was maintained as a monument to the forces of nature, and the overgrown temple was deliberately not cleared of undergrowth so visitors should have an idea of what the whole site had been like when first discovered. Ta Prohm was therefore just the place to appeal to Ernst. Today, some eighty years later, Ta Prohm survives in the same form, not simply something of the original as experienced by the European Rediscoverers of the site, but also of the images which had first entered the world's imagination.[449] While an earlier artist, Gustave Moreau, had incorporated details of Angkor in his work without going there, Ernst got much closer. Some of the views in Ernst's pictures are instantly recognisable, but others are less obvious. Such fluctuations are partly the result of his way of seeing, something we have touched on when noting the importance he placed on the objective study of the external world through the subjective lens of imagination. The unusual precision of some of his Angkor-related images suggests that they were influenced by reproductions. It is unlikely, though not impossible, that he made pencil studies of buildings, even if, as we know, he did draw people in Indochina. Neak Pean is a striking example of a monument reproduced with surprising accuracy. Ernst's painting reproduced the Temple of Neak Pean more accurately than most of his other views provoked by Angkor. The *Joie de Vivre* pictures, on the other hand, create an *impression* of Ta Prohm. They are more atmospheric, archetypal; the product of looking through the closed eye of imagination, one that looks inward, subjectively, dominating the open eye that scans objective, retinal reality. In this way, the Angkor pictures expose the oscillation of Ernst's vision between these two ways of seeing.

The tour of Angkor began with a visit to the most famous part of the site. It involved a walk over the moat, across the main causeway, through the principal gate of the enclo-

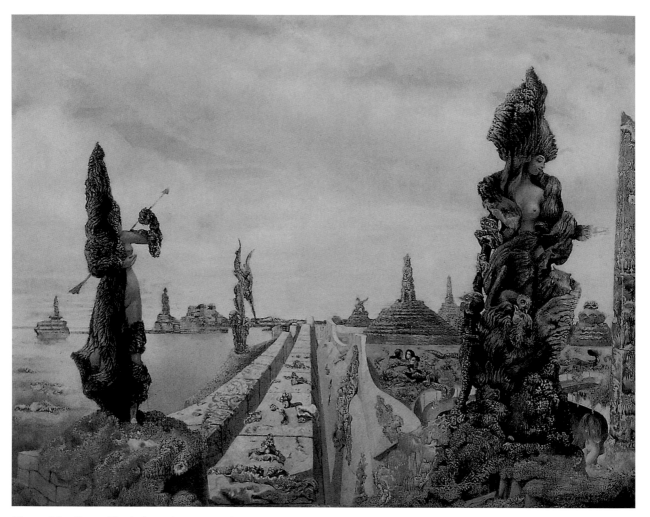

Fig. 98 Max Ernst, *The Stolen Mirror*, 1941, oil on canvas, 65cm x 81cm. Private collection. S/M 2376.

sure into the Temple of Angkor Wat. The moment is commemorated in *The Stolen Mirror*. The instant the visitor stands in the shade of the *gopura*, or entrance pavilion, to gaze down the long avenue at the five towers of the temple at the far end of the enclosure, s/he knows s/he has arrived. It is a defining view photographed and reproduced often. No studies or related compositions for *The Stolen Mirror* have come to light. The painting combines various aspects of the site, knitting them together within the grip of an architectural framework, provided by the processional avenue, that leads the eye into the distance. The view is framed on either side by the twin verticals derived from the columns of the *gopura*. Ernst transformed them into moss-covered standing nudes, and preserved the great stone causeway that runs symmetrically between them. Moss, fungus and creeping vegetation have engulfed the figures, and scattered growths are every-

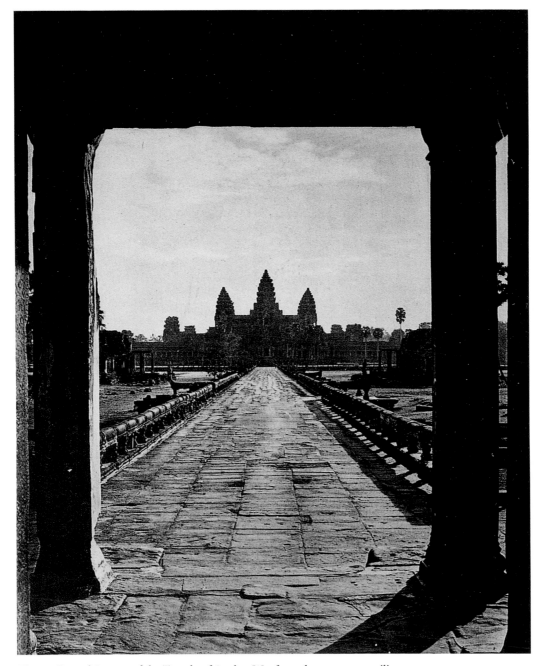

Fig. 99 Central Avenue of the Temple of Angkor Wat from the entrance pavilion.

where taking root. The reservoirs or *barays* beyond the Temple are also brought into the frame, even if they are not in reality visible from within the enclosure. The Temple enclosure does, however, flood during the rainy season, which is when Ernst was in Indochina. We can be sure that the vast moat, spanned by the causeway, would also have

Fig. 100 Max Ernst, *Vox Angelica*, 1943, oil on canvas, 152.4cm x 203cm. Private collection. S/M 2448.

been flooded, and to reach the great Temple and its entrance portico Ernst would have had to cross a sheet of water as extensive as he has painted on the left of his picture. Ernst's view resembles Pierre Loti's description, twenty years before:

> To get to that ghostly basilica, an ancient bridge, built of cyclopean blocks, crosses a lake full of reeds and lilies; two monsters, eaten away by time and trailing beards of moss, guard the entrance; it is paved with large lopsided slabs which look as if they are about to slide into the greenish waters.[450]

The two monsters at the gate refer to two great *nagas*. Ernst, like Loti, converted these huge sacred snakes into something more to his taste, two naked girls wrapped in moss. Above the flat plain that stretches away to the horizon in *The Stolen Mirror* as at Angkor Wat, Ernst painted a monsoon sky, streaked with stratocumulus and cumulus cloud.

Pierre Loti had an eye for the enclosure:

> Monsters everywhere, monsters fighting; sacred nagas sliding their undulating bodies all over the balustrades, and then raising their alarming seven-branched viper heads![451]

Fig. 101 Gustave Moreau, *La Vie de l'Humanité*, 1886, oil on wood panels, 290cm x 150cm. Musée Gustave Moreau, Paris. Cat. 216.

The huge *nagas* have moved across Ernst's scene, and one is clearly visible slipping away behind the two figures in the moat, to the right of the causeway. Behind them Ernst has introduced the unmistakable temple of Neak Pean, transferred from elsewhere at Angkor. The towers of the Temple have been separated and spread out like chess pieces, but still dominate the skyline at the end of the causeway as they do in life. Ernst's reconstruction of Angkor Wat, seen through his mind's eye, was painted under pressure in wartime Europe, before he escaped to New York, and when his life was threatened by gendarmes sent after him by the Vichy Government at the behest of the Gestapo. The lethal conditions in which this painting was made must be taken into consideration if we are to understand it. What was he doing recalling Angkor Wat as the Panzer Divisions blasted their way around Europe? For an answer we should look to the right and examine the broken column he has placed there. This relic refers not only to the laterite pillars on either side of the west entrance at Angkor, it is also a clue to the presence behind this picture of an artist with whom Ernst had something in common, Gustave Moreau.

Many striking affinities exist between them, and those that specifically bind Moreau, Ernst and Angkor are worth noting. The first is a love of columns as emblems of vanity. *The Stolen Mirror* recalls Moreau's taste for such props. In the work of both artists, polished columns of richly veined mineral are also contrasted with areas of smeared, abstract paint. The contrast between finished and unfinished painting is an unusual taste and characteristic of both artists. It is most obvious when they paint nude women, as Ernst has in *The Stolen Mirror*. Both men relished the sight of the smooth flesh of sleek, half-naked females emerging from encrusted amorphous paint, their limbs like polished ivory set in tripe.

Moreover both were also attracted to the same kind of woman; veiled girls, withdrawn and deep in thought. Ernst's *Bride* and Moreau's *Salome* are sisters.[452] Both artists enjoyed painting provocative nudes in ruined settings, where the contrast pits desire against decline, renewal against decay. We have already noted this taste for decomposition *à propos* another wartime picture, painted at the same time as *The Stolen Mirror* and *The Robing of the Bride*, namely Ernst's *Europe after the Rain II* (fig. 47), which Dawn Ades sees as "a rotting landscape, using decalcomania and something of Moreau's technique of conjuring ghostly images out of a landscape."[453] A further example of the way Moreau, Ernst and the voyage to Indochina overlap can be seen in the early 40s, as Ernst was painting *The Stolen Mirror*, when he also produced another picture with references to Indochina, *Vox Angelica*. This is closely related to a striking work by Moreau also in the Musée Moreau, *La Vie de l'Humanité*.

Vox Angelica is an anthology of Ernst's techniques and a kind of *curriculum vitae*. It refers to a city overwhelmed by vegetation (Angkor), as well as to Paris and New York (represented by the Eiffel Tower and the Chrysler Building). There are suns over oceans, forests full of wildlife, and the night sky above, with planets drifting in the Milky Way. The narrative, such as it is, is arranged as a sequence of panels, like a comic strip. Each one, large or small, is carefully framed within a grid of slim *trompe l'oeil* beading, and the overall effect resembles an elaborate medieval altarpiece with colourful pendant

scenes and subsidiary side-bars, each of which tells its own story within an orderly over-all design. The idea of organising a painting as a series of related panels, like a European altarpiece, had also attracted Moreau. In the Musée Moreau, Ernst would have seen how Moreau had adapted the traditional compositional format of the altarpiece for his own *La Vie de l'Humanité*. Moreau's polyptych is composed of panels of identical size set in an elaborate gilded frame that only a man of Moreau's wealth could easily afford. It is worth stressing that Moreau is also presenting the viewer with an anthology of his own favoured subjects and techniques, one which represents the predicament of mankind, not of an individual, as Ernst had done by focusing on his story, that of *un homme* as opposed to *l'humanité*. *Vox Angelica* is also close in size to *La Vie de l'Humanité*. Memories of Moreau's morbid world haunted Ernst's work and Moreau's various techniques, which Ernst had studied in his studio-mausoleum, keep reappearing in his own. Moreau was one of the memories Ernst revisited in the early 40s, as if these forays down memory lane were an alternative to the present, with its horrific world war that was too much to think about. The wartime paintings, such as *The Stolen Mirror* and *Vox Angelica*, look back and show us Ernst remembering Gustave Moreau and Angkor Wat as he painted the remains of a civilisation, reclaimed by nature, from which mankind has been obliterated. A similar obliteration was actually underway as he placed the column, an emblem of the collapse of Europe and of the triumph of nature over man, in *The Stolen Mirror*.

Having explored Angkor Wat, the visitor returned to the *circuit*. The road runs north from the causeway entrance and makes for the immense walled enclosure of Angkor Thom. You know you are nearing it when on your left, to the west of the road, there looms one of the few hills in the plain. Phnom Bakheng, as the hill is known, is unusual for another reason; its summit is covered in ruins and the view magnificent. A visit, including the fifteen-minute climb, can take an hour, and, as ever, the time to be there is at dawn or sunset, when the towers of Angkor Wat emerge from a forest, and are defined by raking light:

> I keep climbing, almost at a run, and the forest, dominant, seems to climb with me; it encircles and spreads itself in every direction like the sea on the horizon. . . . Up there, in such high-altitude seclusion, you can't forget you're above that infinite sodden jungle.[454]

The similarities between a contemporary photograph taken from the hilltop of the oceanic horizon of rainforest and Ernst's painting *Totem and Taboo* are noticeable.

It is as well to consider these correspondences between photograph and painting in studying Ernst's use of *decalcomania* during the Second World War. The introduction of this technique to the Surrealists in the mid-30s is credited to the saturnine figure of Oscar Dominguez, the only front-line Surrealist from the Canary Islands. Instead of resorting to friction, as in *frottage* and *grattage*, *decalcomania* relied on compression. Two surfaces, of paper, card, glass or canvas, were squeezed together like a sandwich, with wet paint as filling, and were then peeled apart. This dismantled sandwich-effect

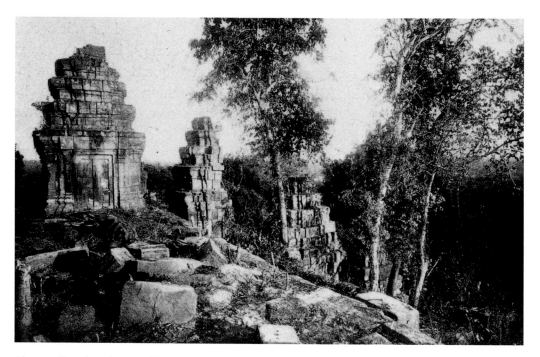

Fig. 102 Temple ruins at Bakheng.

left swirls and ripples of paint that looked organic or mineral and were transformed by Ernst into whatever they reminded him of. In these decomposed-looking surfaces his imagination found faces, horses, rotting tree trunks, naked girls, a dream world—all in fabulous detail. This technique produced many of his Angkor-related pictures of the early 40s, *The Stolen Mirror* and *Totem and Taboo* among them. It may be that the practice of searching for an overall composition with which to organise the chaos of the *decalcomanic* paint surface was structured by the memory of an intriguing image, perhaps a photograph. Such an image may have provided the initial framework within which Ernst developed a painting based on *decalcomania*. Supposing such a structure was adopted, it would leave the artist free not only to work on surface detail, but also to hunt for objects in the primeval slime of his paint surface, a taxing and creative part of the technique. It is easy to see why Ernst might turn to Angkor when exploring paint surfaces that looked as if they were themselves rotting. We should therefore see this obvious affinity between subject and technique as part of the reason why he painted Angkor-related images during the war. However, there is no reason to assume such pictures are *exclusively* about Angkor, even when the parallels between painting and photograph are as exact as they are in the cases of *The Stolen Mirror* or *Totem and Taboo*. Ernst liked layered meanings and could think of more than one subject at a time. He thought in several languages at once, after all, which is why his titles are often bilingual puns that are impossible to translate and why thinking in a straight line, logically, was

Fig. 103 Max Ernst, *Totem and Taboo*, 1941, oil on canvas, 72.5cm x 92.5cm. Bayerische Staatsgemälde-sammlungen, Staatsgalerie Moderner Kunst, Munich. S/M 2383.

of limited interest to him. It is essential to think of his Angkor-looking images as being about Angkor-plus. *Totem and Taboo,* for example, has also been related to *Dead Giant Oak,* an etching by the Romantic artist Carl Wilhelm Kolbe.[455] So, while we consider these aspects that are rooted in Angkor, we must leave room for other interpretations, too. Ernst wanted his work to defy categorical and prescriptive readings so it would occupy territory in which the viewer can also legitimately manoeuvre his/her own pre-occupations and meanings.

The hill of Bakheng is about 400 metres from the southern gate of Angkor Thom, and having climbed back down, tourists sped off in that direction. "Suddenly we were in, as if swallowed up in a cavern. Entering the vast capital we kept on the straight road, on either side of which stood the blackish-green walls of dense jungle."[456] At its centre were a number of beauty spots included on the *circuits* that seem to have impressed Ernst. Pierre Benoit hurtled through at the same breakneck speed as Dorgelès, the local drivers expecting it. "It took us less than ten minutes to cross the vast enclosure from one end to the other," he wrote. At that speed it was possible to tour the whole site in no time:

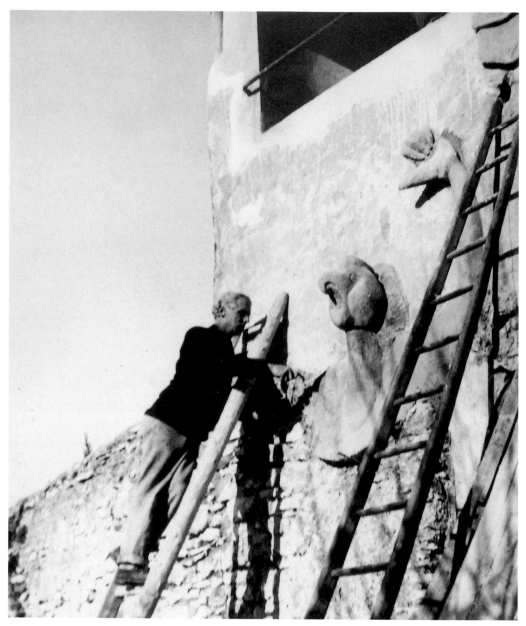

Fig. 104 Photograph. Max Ernst at Saint-Martin-d'Ardèche. Private Collection.

Fig. 105 A *garuda* from the Elephant Terrace, Angkor Thom.

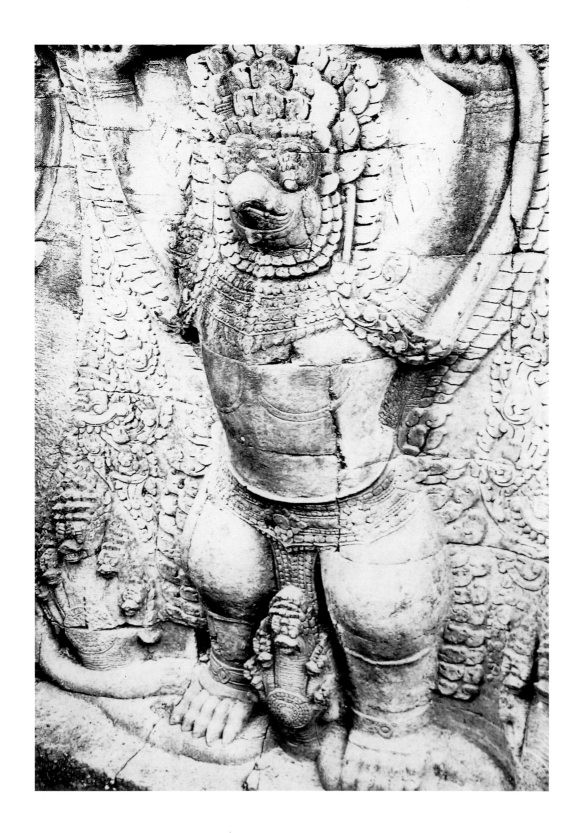

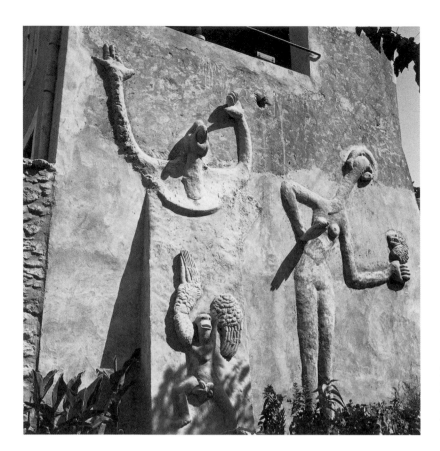

Fig. 106 Lee Miller, Max Ernst Sculpture at Saint-Martin-d'Ardèche. Lee Miller Archive.

Fig. 107 The Elephant Terrace, Angkor Thom.

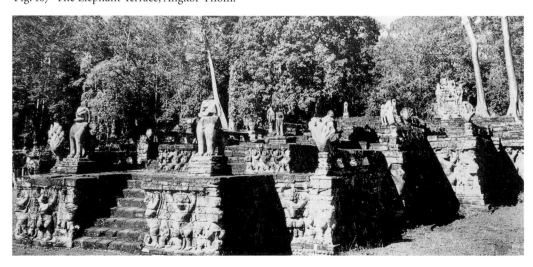

Fig. 108 Lee
Miller, Max Ernst
Sculpture at Saint-
Martin-d'Ardèche.
Lee Miller Archive.

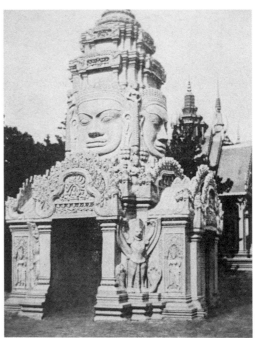

Fig. 109 Sculpture of a garuda at the Paris
Colonial Fair, 1931.

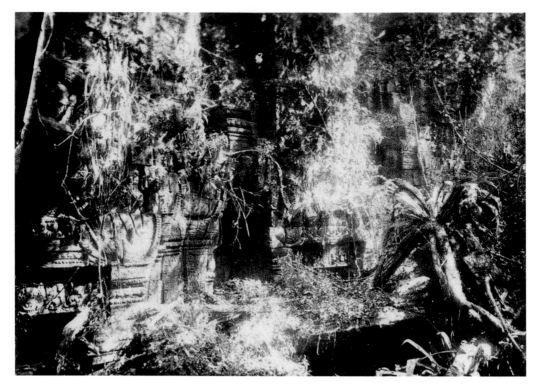

Fig. 110 Ruins at Prah Khan.

The driver turned round:
Do we go back the same way, *Moussie*?
Not on your life . . . let's take the right hand fork through the forest. The Temple
 Road.
More than 25 kilometres, Madame.
Shouldn't take more than half an hour.[458]

Less frantic visitors would stop at the Royal Square, in the heart of Angkor Thom, to
find a place in much worse repair than Angkor Wat. The jungle had heaved and seethed
so that the buildings had buckled, risen and fallen in the swell of the soil. It is the great
collapsing terraces of buildings like the Bapuon and the temple of Phimeanakas that
Ernst recalled in the pictures of *The Entire City*. This is evident if we compare the small-
er of the three large versions (fig. 90) with a contemporary photograph (fig. 91). A fea-
ture of Khmer architecture is the raised base, a course of ribbed masonry used to define
the individual levels or floors. In Ernst's views the foundations have given way and the
terraces slipped apart, leaving the apex as precariously balanced as the top of the ruined
pyramid of the Bapuon, with its five crumbling tiers. These sliding terraces became one
of Ernst's favourite motifs, and through the use of the Rajput blocks, which also came
in lengths, like a terrace, they were portrayed with surprising accuracy. We can see this
by comparing his pictures and a popular spot in Angkor Thom, the Terrace of the Leper

Fig. 111 Max Ernst, *The Eye of Silence*, 1943–44, oil on canvas, 108cm x 141cm. Washington University Gallery of Art, St. Louis. S/M 2453.

King. *The Petrified City* (fig. 92) is painted in oil on paper laid on a plywood support. Ernst used oil paint on paper in preference over canvas, so that his *frottage* should be as sensitive as possible to the contours of the printing blocks under it, paper being thinner and more sensitive than canvas. Paper is also more susceptible to damage, so once the painting was complete it was fixed to a firm base. A comparison between the painting and another contemporary photograph (fig. 93) reveals Ernst's skill. He used the chequerboard pattern of the blocks to mirror the surface of the Terrace. Across the centre of the photograph falls the long dark shadow-line of a tree trunk, to remind us that light effects at the site are intense, a feature Ernst reflected by using black paint for the shadows. His laterite-red undercoat was covered with a layer of black which *frottage* scraped off to create the deep recesses that parallel those cast by the sculpture *in situ*.

Fig. 112 Temple of Neak Pean in the 20s.

The floral design of the blocks he laid along the bottom of the picture was to simulate the vegetation that grows out of the banked-up earth. It was an effect he used often in this series:

> The destruction takes your breath away; how could that mass have toppled like that, leaning, sagging, jumbled into chaos? . . . And the heavy terraces have buckled. And the soil has risen around them; for centuries the humus has climbed the great steps to try and bury it all.[458]

The Terrace of the Leper King is, like so much of the architecture at Angkor, sagging and damaged, a mass of broken horizontals, as Ernst portrayed it. In the top left-hand corner of the photograph a statue is visible sitting on the Terrace itself. The structure is unexpectedly intimate in scale, no more than twenty-five metres long. The statue just visible in the photograph has now been removed for safekeeping and a copy is in its place, but in Ernst's day it was an important feature of any visit. The Terrace was named after the person the sculpture was thought to represent, the Leper King himself, a legendary founder of Angkor.

Another well-known beauty spot on the Royal Square is the Elephant Terrace, which like the Terrace of the Leper King is readily accessible and a feature of the *circuits.* One can walk right up to it and its carvings. The life-size sculptures are set on the ground, so that they can be approached, as it were, face to face, from the ground up, inches away from the visitor. This is an important aspect of the visit to remember, as the Elephant Terrace sculptures were to surface in Ernst's work soon after he had com-

Fig. 113 Max Ernst, detail from *The Stolen Mirror*, 1941 (fig. 98).

Fig. 114 The Temple of Neak Pean. Michael Freeman Archive.

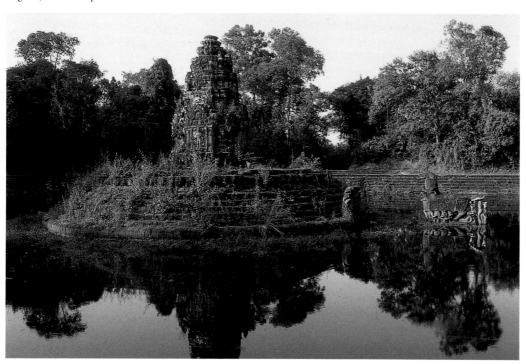

pleted the paintings of *The Entire City* series. He made a number of similarly positioned and posed sculptures after he moved to Saint-Martin-d'Ardèche in 1937. There he had bought a small farmhouse high on an east-facing hill, with a view down the val-

Fig. 115 Max Ernst, *The Garden of the Hesperides*, 1935. Oil on canvas, 55cm x 46 cm. Private collection. S/M 2203.

ley of the Ardèche River to where it meets the Rhône. He decorated the exterior and interior of the building with murals and sculptures, and it is the latter which echo the Elephant Terrace.

The Elephant Terrace is longer, at 300 metres, than the Terrace of the Leper King, but not as tall. At its northern end is a stairway consisting of four projecting bays that diminish in size the further they project from the Terrace. The sides of these bays are decorated with standing figures representing the mythical bird-man or *garuda* who appears often at Angkor. These sculptures are similar and show the bird-man with winged arms upraised. A feature of this parade of *garudas* is that while they are identical in appearance they come in different sizes, corresponding to the increasing size of the four bays. On the parapet above them is positioned a pair of Khmer seated lions.

On the east front of Ernst's house in the Ardèche there is a single large buttress below a small covered terrace; to the right, adjacent to the house and parallel to the

Fig. 116 Bas-relief carving of an apsara at Angkor Wat.

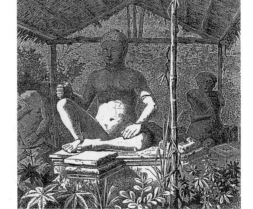

Fig. 117 *The Leper King.* Engraving by E. Tournois after a drawing by Louis Delaporte in Francis Garnier, *Voyage d'exploration en Indo-Chine.* Hachette, Paris. 1873, p.53.

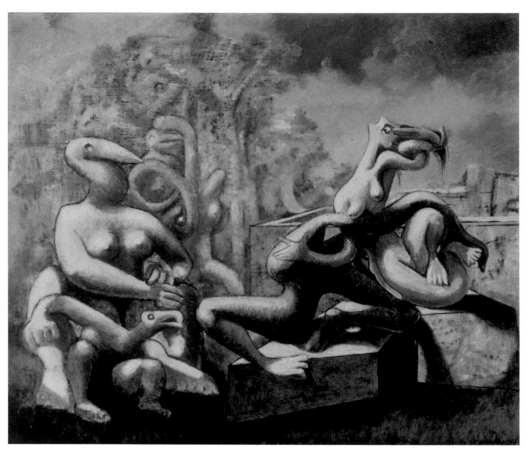

Fig. 118 Max Ernst, *Le Déjeuner sur l'Herbe*, 1936, oil on canvas, 46cm x 55cm Private collection. S/M 2254.

front, runs a rough stone wall. Ernst turned the buttress into a *garuda* by adding to it the head of a bird-man with raised arms. As if to stress its origin he then added another bird-man to the face of the buttress, so that the larger figure now supports a smaller version of himself, who also has raised wings that are heavily feathered. The similarities between the two sites are intriguing. Both Angkor and Saint-Martin-d'Ardèche present the viewer with bird-men sculpted in relief, in diminishing sizes, on buttressed walls, and in both cases the figures stand at ground level facing the viewer. One of the seated lions from the top of the Terrace at Angkor Thom seems also to have migrated and, much leaner, has reappeared (fig. 108) on the wall next to Ernst's terrace and above the *garudas*, in a position that resembles that of the original. Ernst's house has had a chequered history, particularly during the war, when it slipped into the ownership of others, who were responsible for damaging some of his work in the courtyard, including the balustrade of the steps. This used to be decorated with a serpentine creature, reminiscent of the *nagas* that are such a common feature of the balustrades at Angkor.[459] The impact on Ernst of the *garudas* at the Elephant Terrace comes as no surprise if one

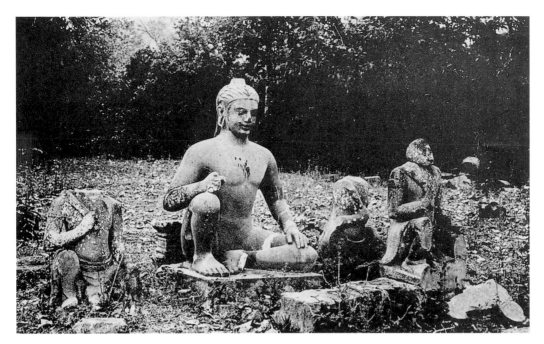

Fig. 119 The Leper King, as displayed at Angkor in the 20s.

remembers that his fascination with birds originated in childhood, and that his identification with them was profound. He even invented an alter-ego, a bird, whom he described as "Loplop (a private phantom attached to Max Ernst's person, sometimes winged, invariably male)." Loplop-Ernst was also known as the *Superior of the Birds* and Ernst produced many pictures about him, and even dressed up as Loplop to attend a fancy dress ball.[460] It is also likely that Ernst confronted large standing sculptures of *garudas* similar to those at Angkor at the Colonial Fair in Paris in 1931, where *garudas* featured as part of the Indochina section. They were not only part of the reconstruction of Angkor Wat, but also of a small pavilion on the public concourse, where they would have reminded him of what he had found in Indochina.

The road out of the vast enclosure of Angkor Thom, with its Terraces and the statue of the Leper King, passes the site of Prah Khan, another of the ruined cities that make up the complex. In Ernst's day it was largely overgrown, a place where "You feel you're under the forest—because the forest has smothered the towers—under a network of multiple and countless roots."[461] Angkor can feel not only alarmingly claustrophobic, it can also be a sodden environment, especially in the rainy season. The combination of architectural decay, mud, slithering wild life and dripping vegetation overwhelmed Loti who saw the place as

a worm-eaten world, of dead gods, of phantom gods, seated or collapsed on top of the buildings. Most are the size of human beings, but some are gigantic, and others dwarfs.

He then had to shelter from the rain inside an overgrown temple:

> But, oh, once you look up, the horror! . . . there's the work of thousands upon thousands of spiders. And from outside comes the racket of the downpour, everything flooded, everything running with water.[462]

His unease in this creepy place increased as,

> centuries of neglect haven't banished the terror; it's still the home of ancient mysteries; the sounds you heard when you stepped in, of furtive creatures, stop dead as soon as you stand still, and then everything crouches in some kind of horrifying pause, all much too silent.[463]

These eerie and silent conditions recall a scene painted by Ernst, *The Eye of Silence,* that evokes the same watchful and mysterious environment of worm-eaten totems, collapsed walls and pools of floodwater. The painting makes extensive use of *decalcomania* and once again resembles a contemporary photograph of Angkor. The photograph (fig. 110) of the site at Prah Khan takes the same frontal view and fills the frame, edge to edge, with a surface in the same plane. That plane is made of overgrown masonry festooned with layers of rampant vegetation. Both painting and photograph are divided into areas of light and deep shadow, both are covered in dense, detailed and varied textures that are hard to define, and also share strong horizontals, derived from elaborately carved masonry, that carry the composition. The horizontals contrast, in both images, with the verticals obscured by plants that cover the ill-defined and extravagant architecture. Here, then, is another intriguing parallel between a painting by Ernst of architecture destroyed by nature and a contemporary photograph of Angkor.

As the circuit road headed east, two kilometres beyond Prah Khan it passed the unique island temple of Neak Pean, a charming and popular attraction. There is no structure like it in the world. It consists of a small stepped circular island, 14 metres in diameter, on which stands a columnar temple, the whole seeming to float in a large square pond 70 metres across. In the 20s the temple was crowned with a huge tree. This extraordinary combination was destroyed in a storm that blew the tree down, taking the temple with it. The temple was rebuilt in the late 30s, using the anastylosis technique, which ensured every piece of masonry was numbered and the blocks reassembled in order. As we have seen, this unique structure appears in Ernst's painting *The Stolen Mirror.* However, since the picture was painted during the war, some years after the storm had blown down the tree, and because Ernst shows the temple returned to its original tree-free form, the picture suggests he was familiar with what had happened to it after his visit to Indochina.

This implies he kept himself informed about Angkor. We may therefore assume that the visual parallels between his work and photographic reproductions may have been the result of reading. The evidence suggests that the work he produced using *decalcomania,* such as *The Stolen Mirror, Totem and Taboo* and *The Eye of Silence,* was infused

with such reference material to a greater extent than the earlier *frottage*-based Angkor-related pictures like *The Entire City* series.

Our tour of the Angkor site has drawn us from the distant views Ernst painted of it into the ruins, and through the jungle to Neak Pean, which he was later to reproduce with care. His increasing interest in painting specific parts of the site can be seen in two other examples, the first of which occurs in *The Garden of the Hesperides*.[464] Hercules, super-hero of Greek mythology, carried out extraordinary tasks as penance for having lost his temper and killed his children. The eleventh task was to gather apples in the Garden of the Hesperides. The Hesperides were women, known as the "daughters of evening," and their garden was in the west, on the slopes of the Atlas Mountains of North Africa, a long way from Indochina. However, protecting the apple tree was a fearsome snake, the serpent Ladon, a Mediterranean *naga* of sorts, which Hercules killed before picking the apples. Ernst's picture of the Garden refers to Angkor in a number of ways that are less opaque than his reference to the legend of Hercules. Let us instead concentrate on the Hindu *apsaras* of Angkor Wat, who while not "daughters of evening" were heavenly dancers who entertained heroes killed in action. There are 20,000 of these divine dancers carved on the Temple of Angkor Wat alone. They are carved in relicf, frequently set in an ornate shallow recess, to form a design that is repeated many times the length of a building. They are often positioned at head height, much as easel paintings are for ease of inspection. Ernst's *apsara* sits with a monkey dressed as a harlequin. He is based on the Monkey General Hanuman who appears in the Hindu legends known as the *Ramayana* and makes frequent appearances too, carved in relief, at Angkor Wat. The similarities between Ernst's composition and the *apsaras* of Angkor are numerous. Both are presented frontally and in shallow relief, Ernst painting his dancer to look as if she is made of the same material as her surroundings, choosing the tones and grainy texture of stone to describe her and her setting. The *apsara* and Ernst's figure are both centred in a frame that has the same proportion of figure to ground. The most striking similarity between them, however, is found in the pose of her raised arm. Both Ernst's bird-woman and the *apsara* have a raised right hand that ends in a pointing index finger, while the remaining fingers are turned downwards. In addition the feet and toes Ernst has given Hanuman the Monkey have the appearance of seal-like flippers, the very shape used to depict the hands of *apsaras*, and in this case perhaps because a monkey's feet are thought of as being as prehensile as hands.

Apsaras are anonymous, lost in a crowd of identical sisters, and none have been singled out for recognition. This cannot be said of the subject of another painting, based on a popular corner of Angkor. The painting is *Le Déjeuner sur l'herbe*, a title that translates as *The Picnic*, or literally as *Lunch on the Grass*, and its subject is the statue of the Leper King (fig. 118). The first sculptural and architectural moulds made at Angkor were exhibited in Saigon in 1866, before being sent to France and displayed at the Exposition Universelle of 1867.[465] They were the work of the expedition, appointed by the Commission d'exploration du Mekong, which also made the first rubbings at Angkor, a team led by the unfortunate Doudart de Lagrée. He was assisted by Louis Delaporte,

who later returned to Angkor twice more to collect further evidence and ship it back for study in France. The Delaporte expeditions of 1873–74 and 1890–91 added to a growing collection of Khmer art in Paris. As we can see from an illustration in a book published immediately, in 1873, about the discoveries, the Leper King featured in an illustration based on a sketch by Delaporte himself. The statue, with its legend, was therefore singled out as soon as Angkor was discovered, and along with its court of fragmentary figures became popular, a character who gave a personal touch to the vast ruin. A cast was made of him and this too was sent to France. His appeal was partly based on his location, on top of an attractive terrace. The sculpture may have acquired its name because of the patchy lichen that had marked its surface and was mistaken for leprosy. Investigation has proved this is incorrect and that the sculpture is of Dharma, god of the Underworld. In Ernst's day, however, visitors knew him as the Leper King and were familiar with his adventures, his celebrity confirmed by the title of the thriller, named after him, by Pierre Benoit.

According to legend the King was young, handsome and a powerful leader who surprised everyone by suddenly vanishing without a word. He had, it turned out, hesitated about abandoning his old life, but had been persuaded to drop everything, (*Lâchez Tout*), by his self-indulgent and capricious lovers. Together they set off on a long journey. They travelled far and wide and the King was warned that, despite the great things

Fig. 120 Ruins of Ta Prohm.

that lay ahead, "in your hour of triumph, you will discover the bitterness of life and will suffer terribly." He did.[466] We should remember the similarities between this saga and Eluard's *voyage idiot* when we compare Ernst's picnic with the sculpture of Leper King.

Ernst painted *Le Déjeuner sur l'herbe* in 1936, when he was also working on pictures of *The Entire City* and on the jungle pictures of the *Joie de Vivre* series, paintings that recall Angkor. The ruins were therefore part of the mental furniture of *Le Déjeuner sur l'herbe* as well. It is also the case that the picture was painted when Ernst's affection for Eluard had deepened once again, after a rift of some years. At the end of the 20s, the relationship between the two men had been under Gala's spell; then, after she had decamped to Catalonia with Dalí, there was a moment of calm before Ernst's second marriage, to Marie-Berthe, in turn disintegrated and war crept over the horizon. In that lull were the "times he remembered most vividly, with the deepest pleasure, when Marie-Berthe and he, with Eluard and his young wife Nusch (whom he had recently married), would leave town and together delight in their renewed friendship."[467] It is in the light of picnics, happiness and shared memories that we should respond to Ernst's picture, which is a tribute to Eluard, and a celebration of their long collaboration, both

Fig. 121 Abandoned locomotive. Canal Zone, Panama(?).

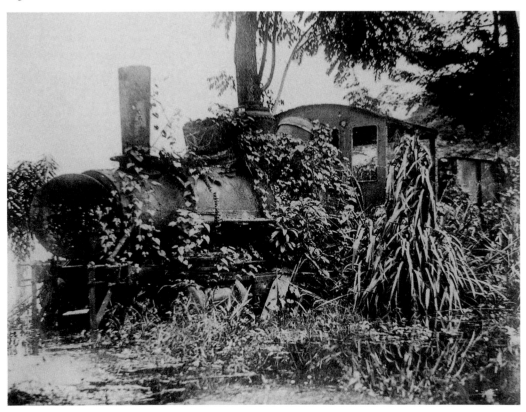

before and in the aftermath of their trip to Indochina. By the time Ernst painted it he was familiar with Angkor, and through research had absorbed details studied at leisure in reproduction. He would have seen the Leper King photographed and reproduced often and would know his story. Ernst's painting shows Eluard as the Leper King, enjoying a *déjeuner au plein air* where picnickers have turned to stone, in imitation of the original group on the Terrace. Both sets of figures, Angkor's and Ernst's, sit on low plinths similarly angled and posed, in a row, in front of a backdrop of trees and sky in the same plane. The composition in both is dominated by a seated figure, who faces left and whose arms rest on its knees, while around and about cluster a group of smaller, mysterious forms. In Ernst's version, the prominent empty plinth that in Angkor stood in front of the King himself, and which appears in Delaporte's sketch, is now occupied. It may be that the strange visitor who occupies it represents the spirit of the famously lascivious Eluard, whose beady eye looks out at us from under the breasts of the woman he is about to enjoy, as his *déjeuner sur l'herbe*.

The last stretch of the *Petit Circuit* continued east before turning south to Ta Prohm, where the jungle was allowed to grip the ruins and show visitors how much had been achieved by clearance elsewhere. It is the only site designed to celebrate the power of the jungle menacing Angkor. The special feature of Ta Prohm is therefore the *frisson* associated with the threat of nature. Ernst's pictures in the *Joie de Vivre* paintings are of vegetation that threatens to spill out of the picture frame, like plants bursting out of a greenhouse, and recall Ta Prohm.[468]

His fascination with rampant nature was shared by his colleagues and also by the most intrepid traveller they knew, Blaise Cendrars. For example Benjamin Péret's article on the subject, *La Nature dévore le progrès et le dépasse* (Nature consumes progress and overtakes it) was published in *Minotaure* in 1937, when Ernst was painting his pictures on the same theme. Péret chose to illustrate his work with the startling image of a steam engine disintegrating in a swamp, overgrown and festooned with vegetation.[469] Péret's illustration also recalls contemporary photographs of Ta Prohm. His rusting train most likely came off the Panamanian rails of the Compagnie Universelle du Canal Interocéanique, established by the French, under Ferdinand de Lesseps, to build the Canal. Overwhelmed by the unforgiving conditions of the Panamanian rain forest the Canal project was brought to its knees, surviving only thanks to capital investment from the US.[470] Similar photographs of the struggle were to fascinate the public. Cendrars, typically, had been one of the first to write about them six years before, in *Le Paname ou les Aventures de mes Sept Oncles* (1918), a poem that reflected widespread curiosity about the nightmare at the Canal. In it he referred to the same subject as Péret's photograph. Cendrars wrote "*Envoyez-moi la photographie de la forêt . . . qui pousse sur les 400 locomotives abandonnées par l'entreprise française*" (Send me the photograph of the forest . . . which now smothers the 400 steam engines abandoned by the French contractors).[471] Like Ernst, both Péret and Cendrars were fascinated by the indifference of nature to man, Péret writing about it again soon in *Ruines*, an article about vast ruins in desolate and majestic locations. *Ruines* also appeared in *Minotaure*, illustrated

with impressive photographs of collapsed monuments, resembling those of *The Entire City* painted by Ernst.[472] These cross-currents reveal the teamwork of Surrealist life and also remind us, once again, of the persistent part played by Cendrars' travels in mapping the Surrealists' view of the world.

We may therefore imagine the Surrealists' feelings when they heard that a life-size plaster-cast of Angkor Wat, its towers mushrooming in the suburbs of Paris, was the star of an Industrial Fair. The ancient Khmer Temple had been hollowed out, like a Trojan Horse, and, as a vast metaphor of *l'Indochine Française,* contained a cargo of French salesmen showcasing machine parts, in search of backers to fund their branches in Saigon.

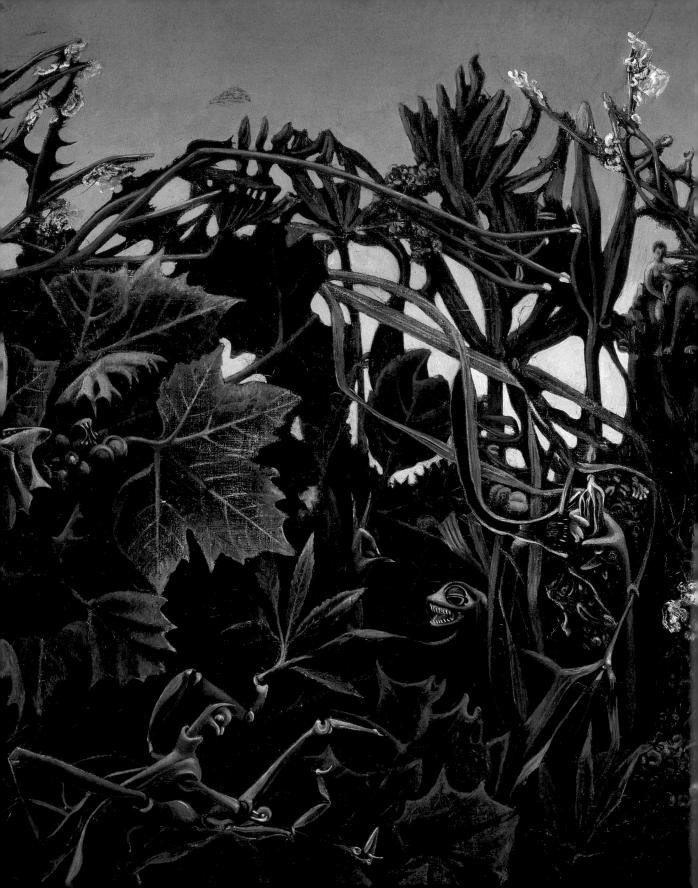

Chapter 9

AROUND THE WORLD IN A DAY

It's a long way to Indochina: that's why we can ignore the screams there.
André Malraux. Preface to *Indochine S.O.S.* by Andrée Viollis, 1935

The International Colonial Fair, Paris 1931

Surrealists did not enjoy the Exposition Coloniale, which is surprising, as its slogan, "Around the World in A Day" encapsulated their love of the absurd, of non-western cultures and of travel. They loved tacky fairground entertainment, burlesque, waxworks and billboards, but they drew the line here. The Expo was rejected largely because of its links with government-sponsored big business. *La Révolution Surréaliste* was, after all, meant to be against all that. By 1931 Surrealists were only too familiar with such Expos, having grown up with them as we have with the Olympic Games and Disney World. They had already taken place, in France, in 1878, 1889, 1896, 1900, 1906, 1907, 1911 and 1922. Many had pavilions *à la* Angkor Wat.

Picabia and Breton, for example, had visited the Marseille Expo during the winter of 1922, and in the lee of an impressive Angkor pastiche, built by the same contractor as would erect the 1931 version in Paris, "*nous continuons à parcourir ce cimetière écoeurant dont nous sommes les Cadavres*" (we roamed that repellent graveyard in which we were the stiffs).[473] The 1931 Exposition has been studied in relation to the political activity of the Surrealists, but it is worth revisiting it to discover how this fair, with Angkor as its main attraction, affected Eluard and Ernst in particular.[474] The pinnacles of this pseudo-Angkor, visible from the Eiffel Tower, comprise another striking coincidence. It is beyond the scope of our investigation to evaluate such phenomena, but in view of the Surrealists' open-minded approach to the irrational, we have to observe them, especially when they occur so repeatedly in our narrative. From Desnos' premonitions about steamships in the Pacific to Ernst's picture of the Island of Celebes, bought by Eluard before he anchored there, coincidences pepper the world map with coordinates that paved the way for Ernst's Angkor paintings of the 30s. The 1931 Fair, like the one in Marseille, reeked of the graveyard for Breton and his friends, who saw

Opposite: detail of fig. 86 Max Ernst, *Joie de Vivre*, 1936.

Fig. 122 The Exposition Coloniale, Parc de Vincennes, Paris, 1931. The Paris version of Angkor Wat is visible at the bottom of the picture.

Fig. 123 *The World at the Time of the Surrealists.* In *Variétés. Le Surréalisme en 1929.* Brussels, June 1929, pp. 26-27.

it as a phoney stunt, operated for the amusement of white zombies at the expense of what we now define as the developing world. Whites paid to poke fun at coloureds shipped in as stooges of empire, turning a fair from fun into an occasion for Surrealist target practice.

How would Eluard and Ernst, with Saigon behind them, have related to the Fair? It would, for example, be hard for them to ignore the bad news from Indochina, which from the start hung over the event like a monsoon thundercloud. The thoughtful minority in France to which they belonged knew about the dire situation in Asia, despite the predictable clampdown by the authorities at home and in the colony. As an example we should remember that, not long before the Fair, the Surrealists had helped stage the tenth anniversary celebrations in Paris of the French Communist Party. Dalí had contributed the design for a bonfire made of crucifixes, armaments, medals, title deeds and so on, the whole event having been staged by Tanguy, André Thirion and Clovis Trouille. Trouille, new to the group, was by profession a painter of showroom dummies, with a taste for camp and subversive pictures in a slick quasi-academic style. Known for his canvases of a raunchy Christ dating nuns in suspenders, Trouille's provocative schlock, of a kind practised today by Robert Williams, was immediately accessible to a wide audience, and its Las Vegas-style anti-clerical vulgarity entertained the Surrealists. For that Communist Ball of 1930, *Clovis Trouille peignit en trompe-l'oeil une guillotine grandeur nature, ruisselante du sang des condamnés de Yen-Bay,* (Clovis Trouille painted a life-size guillotine in *trompe-l'oeil,* dripping with the blood of those

executed at Yen-Bay).[475] Yen-Bay, though largely forgotten today, had been the colonial bloodbath of the hour, having taken place in northern Indochina, near Hanoi. It had caused an outcry, motivating protest in France from the likes of Léon Werth, Andrée Viollis and Malraux, who as members of the Committee for the Defence of the Indochinese, exposed the treatment of political prisoners there, including those on Poulo Condore. Malraux's *La Voie Royale*, set in Indochina, was published in 1930, while Werth's critical *Cochinchine*, to which we have also referred, had appeared in 1926. The investigative journalist Andrée Viollis was singled out, with approval, by the Surrealists,[476] while Malraux wrote the Preface to her influential and furious book, an anthology of violations, *Indochine SOS* (1935). This gives one an idea of the background of agitation to which Eluard and Ernst were exposed at the time of the Exposition. The troubles in Indochina were news.

A general uprising had been planned at Yen-Bay by local troops for the night of February 9–10, 1930. A long-repressed trauma was finally erupting. The garrison mutinied, killed the French officers, but then stalled, and French troops moved in. Reprisals were vicious. For the rest of the year arrests and executions followed, the news of which reached France, as is proved by Trouille's life-size bloody guillotine. "1930 has been called the year of the Red Terror. It was followed by a year of White Terror, which began being practised in early 1931, when the French had at last assembled sufficient military strength in northern and central Annam to go about re-establishing the pre-revolutionary order."[477] As the huge Exposition grounds were prepared in March 1931 the press reported that in Indochina "An unchained soldiery, free to indulge all their instincts . . . now terrorises the entire country."[478] It was the beginning of the long end of *l'Indochine Française*:

> The early 1930s were consequently the blackest period in the history of French Indochina. . . . During 1930, no less than 699 persons were executed without trial, fifty in Yen-Bay alone. Thirty were shot in demonstrations on May 1, forty on the day the Vietnamese celebrated the anniversary of the Russian Revolution, and 115 on the anniversary of the Chinese Revolution.[479]

By the end of 1932, after the Colonial Fair and its plaster Angkor had been demolished, and just before Ernst began his pictures of ruined cities, the number of political prisoners in Indochina stood at about 10,000. Another 10,000 are estimated to have been killed and 50,000 more to have been deported. The Exposition Coloniale therefore took place against a backdrop of insurrection, beheadings and terror. It opened in May 1931 in circumstances that could not have been less favourable, nor better designed, to undermine it, and yet it was a success. *Panem et circenses*. Visitors poured in. In this tense climate, the Communist Party again invited the Surrealists to create an agitprop event, this time to prepare a rival counter-Exposition. It was located in the Pavillon des Soviets near the Gare du Nord, a building made available by the Communists. Designed by Melnikov for the Trade Fair of 1925, it had been re-erected on Avenue Mathurin-Moreau. The Surrealists installed their principal display in the main room on the sec-

ond floor, which opened on September 20. Two blurred photographs, not the usual skilled work of Surrealist photographers like Man Ray or Boiffard, were reproduced in *Le Surréalisme au service de la Révolution*.[480] They show that slogans and tribal art were combined with banal Catholic statuettes, labelled *fétiches européens*, the insipid character of which contrasted with the vigour of the accompanying art from the Pacific and Africa. A gramophone played rumbas, and Surrealists took turns to guard the premises, Eluard among them.[481]

This collaboration between the Communist Party and the Surrealists opened a door that proved the undoing of several, including Eluard and Aragon, who—despite all the evidence that emerged—would never admit they had signed up to a homicidal Russian tyranny. Breton, to his credit, sensed the corruption of Moscow, and soon backed off, creating a fault line that split Surrealism for good. At the time of the Expo though, Russian Communism still seemed sweet to most Surrealists; its raw politics had not been pumped in to drown the ambiguities of art.[482] The Surrealists' first political exhibition is now recognised as a moral victory undermined by poor attendance. The Exposition Coloniale lasted six months, from May to December 1931, and was visited by around eight million, while the Communist-sponsored show mounted by the Surrealists ran from September 1931 to February 1932, a period of four months, during which it received 4226 visitors. Eluard's politicisation, galvanised by his world trip, is

Fig. 124 The Paris version of Angkor Wat, Exposition Coloniale, 1931.

evident in this counter-exhibition and in his contribution to other protests against colonial rule. Ernst's response to the political emergency exposed by the Exposition is, predictably, less obvious than the activity of his colleagues, but still evident in his painting of the time, especially in his apocalyptic visions of a civilisation in ruins. Ernst was never a Communist, for as he told Penrose on BBC TV, in his broken English, "I was born with a very strong feeling of needs of freedom. That means also with a very strong feeling of revolt," which he would not compromise even over Surrealist declarations he judged ham-fisted.[483] Independence was a priority, which meant the multiple meanings and ambiguity of his work were at odds with the cast-iron party lines dished out from Moscow and increasingly adopted by friends of his. He knew what his pro-Communist friends were up to. He knew Eluard was funding the group's latest magazine *Le Surréalisme au Service de la Révolution*, as André Thirion remembered, *L'argent et la generosité d'Eluard comptaient beaucoup dans toutes les entreprises surréalistes*, (Eluard's money and generosity played a big part in all Surrealist business).[484] Eluard was the Managing Editor or *gérant* from its launch in July 1930 and underwrote its costs, and two years later, in 1933, he sold pictures from his collection to pay for the May issue.[485] Ernst also knew Eluard had helped compose the Surrealists' official Protests against the Expo, the first of which began *Ne visitez pas l'Exposition coloniale*, (Do not visit the Colonial Exhibition). Eluard went straight to the point in the opening sentence, revealing his persistent interest in repression in Indochina, *A la veille du 1er Mai 1931 et à l'a-vant-veille de l'inauguration de l'Exposition Coloniale, l'etudiant indo-chinois Tao est enlevé par la police française*, (The eve of May 1, and the day before the opening of the Exposition Coloniale, French Police arrested the Indochinese student Tao).[486]

Knowing about Eluard's voyage, we can sense him behind the first sentence of the second Surrealist Protest, too. Memories underwrote his outrage at the destruction of the Dutch Pavilion at the Expo, in a fire which not only wiped out the Pavilion, but more to the point, destroyed its magnificent display of tribal art, drawn from all over the Dutch East Indies.

> *Dans la nuit du 27 au 28 juin 1931, le pavillon des Indes Néerlandaises a été entièrement détruit par un incendie. 'Et d'un!' sera tenté d'abord de s'écrier tout spectateur conscient du véritable sens de la démonstration impérialiste de Vincennes.*[487]
> (On the night of 27–28 June the Pavilion of the Dutch East Indies was burnt to the ground. Every visitor aware of the real meaning of the imperial display at Vincennes might, initially, be tempted to exclaim, Would you believe it!).

The Surrealists' Protest listed the places from which art had been taken, "Java, Bali, Borneo, New Guinea, etc." Eluard's memories smouldered among those names, and ignited his frustration at the way the Dutch had not only taken over the land and its inhabitants, but had reduced their art to ashes: *Ainsi se complète l'oeuvre colonialiste commencée par le massacre, continuée par les conversions, le travail forcé et les maladies*, (That wraps up a colonial undertaking that began with massacres, and was followed by

religious conversion, forced labour and disease). The Surrealists' protest at the Exposition continued in the first two issues of their new magazine. Some of their best political journalism introduced the statistical clarity inherited by later human-rights publications, such as *Amnesty International* and *Index on Censorship*, both of which continue the work in the same spirit as the magazine Eluard co-founded, managed and funded. "We have already noted," wrote the film-maker Albert Valentin in the second issue, "the 17 protesters beheaded at Yen-Bay; 2 at Vinh; 6 condemned to death at Phu-Tho; 3 in Saigon," and so on.[488]

Lost horizons

The Exposition coincided with trouble in Eluard's private life. The Depression was clawing its way through the portfolio of investments he had inherited after his father's death in 1927, a process accelerated by his own generosity. At the same time he fell ill with a recurrence of the tuberculosis he had suffered from as a teenager, forcing him to a clinic at Arosa, in the Swiss Alps, where he stayed for over a year, from November 1927 until March 1929, alone and increasingly morose. Gala left him to his own devices, in pursuit of her own adventures. Unwell, feeling unloved and marooned in the snow, Eluard returned to memories of the Pacific and escaped his melancholy to read widely about the islands and the tropical sea, which, with politics, became his main interests.[489] It was in February 1929, for instance, that he had written to Joë Bousquet claiming he and Gala were off on a secret trip to New Guinea and New Mecklenberg, *les seuls pays vraiment sauvages*. Such dreams were surely provoked by the discrepancy between the inner world of his imagination and real life in the clinic. A year later he was still fantasising along the same lines. "I'd like to go to the Solomon Islands or to New Guinea," he told Gala.[490] At the same time he committed himself to the preparation of the Surrealists' next publication, a special issue of the magazine *Variétés* that appeared in the summer of 1929. Its strong geographical, intercontinental theme was made for Eluard, undergoing enforced convalescence. The magazine should have been published as an issue of the *La Révolution Surréaliste*, but due to shortage of money it appeared in Brussels, thanks to a sympathetic independent editor.[491] This rogue number of *La Révolution Surréaliste* records the group's fascination with travel; in addition to articles about geography, steamships and ethnography, there are poems on similar lines, including one in which Paris was relocated by Péret to float in the central Pacific, ringed by thousands of cruising sharks. There was also included the *Map of the World at the Time of the Surrealists*, shown as a double-page spread (fig. 123). The Surrealist Equator, as we have observed, resembles Eluard's route around the world, as marked by him on his own map (fig. 19). Published shortly before the Exposition Coloniale, *Variétés* rehearsed the same questions as the Surrealists' themselves raised during the Expo. The magazine focused on the theme of a *Terra Surrealista*, our planet seen not as the venue for a colonial free-for-all, but instead celebrated as the setting for an enlightened Surrealist life. It

contained Eluard's essay *L'Art Sauvage*. We may interpret this article, with its memorable bi-lingual phrase "EATING A FLOWER ou le CANNIBALISME en Nouvelle-Guinée," not only as the result of his reading in the Alps about the island cultures of Melanesia, but also as the dream of an invalid with cabin fever.[492]

Along with ill-health and growing financial problems, Eluard had also to face the deterioration in his marriage. With his consent Gala had drifted into affairs with other men. He was caught out, for she clearly wanted the fun, an appetite he could not curtail, but upon his return to Paris from Switzerland he tried to hold on to her. He knew well enough how to do so, but was unwilling to recognise that his plan would not work. He spent money on her, even as his fortune shrank, by renting a fine apartment on the western flank of Montmartre, in rue Becquerel, and having it redecorated. While the work was done, husband and wife, on those occasions they were together, settled lower down the Butte de Montmartrc, at the junction of the rue Caulincourt and rue Joseph de Maistre, in a hotel which is still there, the Terrass, just across the road from the studio Max Ernst had vacated in rue Tourlaque. For Eluard the streets were patrolled by ghosts: not only was Gala away on her jaunts, but Ernst, too, had moved. René Crevel visited Eluard at the Terrass and found his room cluttered with art and books, while its occupant worked on *Variétés* with Breton and Aragon, the official editors.[493] As he wrote *L'Art Sauvage*, with its Pacific theme, he must, at times, have thought of his days on the *Antinous*. The horizons he had seen from her deck were quite different, but as spacious as the landscape beyond the hotel windows. The Terrass is on a hill and overlooks Montmartre Cemetery, the Place de Clichy and the roofs of Paris, a big view sweeping the southern valley of the Seine to the plains of Brie, Fontainebleau and Beauce beyond. It offers dramatic skies; the silvery world of the Ile-de France. For both Eluard and Gala the sombre villa at Eaubonne had become a thing of the past, its memories unhappy. Their daughter Cécile was not sad to leave it either, later revealing that the place had always given her the creeps and that Ernst's decorations, especially, had frightened her as a child. It was sold in 1932 and the new owners, predictably, obliterated Ernst's murals with paint and wallpaper, which protected them for the next forty years, until Cécile reclaimed them and had them removed in the late 60s.

After the expense of redecorating what was to be a new home for himself and Gala, Eluard decided to economise and accepted an invitation to spend the summer holidays of 1929 in Catalonia. It was bound to be cheap. He and Gala therefore joined the art dealer Camille Goemans and the painter René Magritte and his wife on a visit to a young Spanish painter Goemans represented, Salvador Dalí. It was a fateful decision, for Dalí became the solvent that separated Gala from Eluard for ever. The intense, extravagant encounter of Gala and Dalí at Cadaqués has been frequently described, but for our purposes it is enough to know that at the end of the summer the holidaymakers returned to Paris, with Dalí, and prepared for a show of his work there on November 20. To everyone's surprise Gala and Dalí suddenly disappeared two days before the opening, heading for the seaside in Catalonia. Gala would never return to Eluard, who took some time to accept this. The following spring he moved from the Terrass to a stu-

dio nearby, above the one occupied by Breton next to Place Blanche. The two friends nursed their troubles with women, for Breton was also in the throes of a difficult affair. They found their feet through creative collaboration and prepared the publication of their next venture, *Le Surréalisme au Service de la Révolution*, the first issue of which appeared that summer, in July 1930. Eluard also coped with Gala's desertion by turning to politics. Political action gave meaning to his life as a poet; action braced imagination. Much of the magazine was directed against the oppression he had seen in the East, and an anti-colonial agenda became the magazine's consistent line. A piece by him in the first issue, about the Yen-Bay revolt and the ensuing massacres, reads *Il n'y a que deux races dans le monde: celle des oppresseurs et celle des opprimés,* (There are only two races on earth: the oppressors and the oppressed).[494]

The summer following publication drew Eluard and his new partner, Nusch Benz, to Cadaqués and Gala. Eluard's writing at this time reveals the emotional crossfire he was under, for while his growing affection for Nusch is not in doubt, it was overshadowed, as it always would be, by his enduring fascination with and devotion to Gala. Gala would no longer reciprocate, but she could accept his money. This crude observation is confirmed by the way she returned to Paris with Dalí; like cuckoos, the pair ousted Eluard from the apartment he had prepared for himself and her. Typically, he offered it to the lovers and even seems to have paid the bills. Dalí and Gala were therefore his guests at the time the Exposition Coloniale was drawing crowds to Vincennes. We can tell his financial difficulties made it hard for him to support them from a letter written in February, *L'argent manque terriblement. J'ai vu Ratton hier qui offre de faire une vente de mes objets et de ceux de Breton vers le début de mai,* (Money is desperately short. I met Ratton yesterday who suggested a sale of my objects and those belonging to Breton in early May).[495] He must have been counting on that sale to help him finance the pair, neither of whom had a regular income.

Charles Ratton was an art dealer trusted by the Surrealists, whose appearance at this point exposes another of the strands that bind the Saigon voyage to the Expo, and helps us disentangle the personal motives from the principles behind Eluard's political activity. The sale Ratton managed for Breton and Eluard was to be of tribal art, which Ratton had planned because as Eluard reported, *Il y a à cette époque l'Exposition coloniale et il pense que ça aiderait,* (The Exposition Coloniale will be on then and he thinks it would be useful). In the event the sale took place a few weeks later, on July 2–3, and raised an amount so large, 285,195 francs, that it confounded the experts.[496] Ratton had been right, the Expo had helped. The last day of the sale coincided with the distribution of the second Surrealist Protest, focused on the fire at the Dutch Pavilion which had taken place only five days before. Eluard therefore found himself drafting this statement with Breton, not only as the ashes of Melanesian sculptures were being cleared, but also as his own collection of similar items was going under the hammer. The anti-colonial rancour in their tract was therefore affected by the imminent dispersal of their own treasures, among which were mementoes of Eluard's trip.[497]

The irony cannot have escaped them. Eluard and Breton were protesting against the

trafficking in goods from the developing world at the Expo while engaged in a similar activity themselves. Worse still, they were benefiting from the promotional uplift their sale would receive from the publicity generated by the Fair. We should remember, however, that some of the profits subsidised the production of *Le Surréalisme au Service de la Révolution*.[498] Eluard and Breton may have felt this was using fire to fight fire, which may have soothed pricking consciences. Since some of the objects sold may have been acquired by Eluard on his travels, another aspect of his *voyage idiot* comes into view, namely the way it played into Surrealism in material terms. It generated a financial return ploughed back into a group venture that criticised the colonies his voyage had revealed.

Ernst, meanwhile, was living in leafy Meudon and his life with Marie-Berthe, from what we know, was not yet in turmoil.

The Expo was demolished over the winter of 1931/32. Until then the Surrealists had waited, one suspects relishing the prospect, for the rumoured sale of the plaster Angkor to a film company. Given the garish floodlights that had transformed the Temple into a Hollywood première-style fantasy, it is not surprising that a film-maker's appetite had been whetted. In Surrealist eyes, the Expo had been such a disgrace that nothing could save it from moral bankruptcy. The accounts, they said, "reveal a deficit that will not be made good by what is realised from the sale of the Temple of Angkor to a film company, Surprise, Surprise!, so it can be burned down." (*Ce bilan, accuse un déficit que ne comblera pas le prix du Temple d'Angkor vendu à une firme cinématographique, comme ça tombe! pour être brulé*). In the event, the sale and the spectacular movie moment of Angkor engulfed in flames did not materialise, depriving us of the Surrealists' verbal fireworks at what would have been an emblematic moment of colonial consumerism. The principal cultural icon of Indochina, used as a prop in a disaster movie, would have been too much to ignore, especially, of course, as French Indochina was itself going up in smoke. The movie would have wrapped up an Expo that had begun by accidentally incinerating art from the colonies, only to end by burning down a monumental copy of yet more of the same.

It was soon after this that Roland Penrose helped tip the balance for Ernst. As we have learned, Penrose had been in India at the end 1932 and returned with a number of Rajput printing blocks that he showed Ernst. Inspired by them, and energised by the flak stirred up in Paris by the Expo, Ernst finally tackled his pictures of Angkor. The towers of Angkor above Paris had been the tip of a political iceberg whose vast scale and immediate interest could not have escaped him, and he chose to address those issues obliquely, as *history*; as yet more flotsam on the beaches of Time. We will never know how the Expo and news from Indochina bedded down in his imagination, but their effect on him is evident. Ernst's paintings took the long view, while Eluard's activities chose a more immediate focus on the political emergency of the moment. Neither of them saw the Paris Angkor go up in flames, for the rubble was carted away by the dem-

olition men. Only once the dust had settled did Ernst start painting ruins. His visions of the Khmer capital appeared like the phoenix, if not exactly from the ashes of the Colonial Fair, at least in its wake, allowing us to conclude that if Ernst had not visited Angkor, Angkor would have visited him.

The Surrealists' commitment to the liberation of Indochina outlasted the Expo. Pierre Naville, for example, who wrote with feeling about Eluard's Saigon journey, also doggedly pursued the issue of independence for the colony. Twenty-five years after Eluard's return he was still writing about the chaos there, targeting the same issues as had first provoked him and his colleagues in the 20s.[499] Naville, who became a leading political writer, kept an eye on the panorama of oppression in Indochina and maintained the Surrealists' original position, first defined by Eluard, of linking it with colonial abuse everywhere. Naville persistently publicised the corruption exposed by Eluard, Malraux and their allies, a quarter of a century before. In the end, the change they sought was to come through bloody war and revolution rather than through Surrealist political agitation and propaganda. Naville was to see his prophetically titled book, *La Guerre du Viet-Nam*, re-run as a full-scale military conflict between the US and North Vietnam. Eluard, Ernst, Malraux and Naville had possessed the instinct and intelligence to foresee the catastrophe: they had tried to blow the whistle and stall the carnage, but they failed.

Chapter 10

JOURNEY'S END

"Love is the great enemy of Christian morality," Ernst wrote in 1931. "The virtue of pride, which was once the beauty of mankind, has given place to that fount of all ugliness, Christian humility. . . . Love, as Rimbaud said, must be reinvented." This is not the language of one who should deprecate all reference to his private life.

Cyril Connolly, *Max Ernst*, 1967

Where do you draw the line between the art historian and the voyeur? In this case it runs through not only a *ménage à trois* that shaped the art of interest to us, but also through the most amorous and creative group of the twentieth century. We cannot, in fairness, therefore explore the work of Ernst and Eluard without intruding on their privacy. Private life and public expression joined hands with alarming frankness in this case; as they had done before at Camille Monet's death, when their grip is visible in the portrait of her corpse painted by her unfaithful husband. Having traced the rise of the *ménage* and seen how it nourished the work of both men, before and after Saigon, it is time to bring down the shutters. It is tempting, but false, to assume the affair ended in Indochina. While true for Gala, it was not for Eluard and Ernst, who found consequences more complex. Eluard loved both Gala and Ernst until the end of his life, and Ernst's devotion to Eluard is visible in the sombre image he painted about his death. An enduring affection for each other pervades the work of both men, disrupted for a while after their return from Indochina by Gala's continuing hold on them. Once she withdrew, warmth returned. The Surrealists' fascination with desire is well known; their creative life was fuelled by the discovery of psychoanalysis and its dubious maps. The pervasive climate of what we may call Surrealist love-worship therefore makes it appropriate for us to consider the *ménage* not just at its height but to measure it as a whole, and to end our story with its passing. The two artists did not shed their memories of life as a trio, but stepped over the curdled remains of the affair to enrich their work with the unknowable intimacies they had shared. The story of their subsequent friendship, the afterglow of passion, is therefore worth visiting.

Opposite: detail of Fig. 111 Max Ernst, *The Eye of Silence*, 1943–44.

Eluard and Gala resumed their life in the suburbs as soon as they disembarked in October 1924. Where Ernst lived to begin with is unclear. The couple lived at Eaubonne for the next three years, until Eluard retired to a TB clinic in November 1927, for almost a year and a half. Before that the trio moved cautiously, keeping an eye on one other, the men collaborating on various projects, within sight of Gala, and trying to rebuild a life. As we know, Ernst's star soon rose and he rented a studio where he painted the seascapes and jungles inspired by his travels. However, he remained under Gala's spell for some time, despite himself, as his portraits of her reveal. The numerous *frottages*, oil paintings and drawings he made of Gala show him wrestling both with her hold on him and with his frustration with it. Eluard would have watched the creation of these pictures, because he was working closely with Ernst on publications, as well as meeting him at the spate of events associated with the sudden fashion for Surrealism. This was when Breton asked Ernst to paint *The Virgin Mary Punishing the Infant Jesus in front of three witnesses, André Breton, Paul Eluard and Max Ernst*, 1926. (S/M 1059). This large oil painting, 196 cm × 130 cm, is an unusual Ernst. It portrays the artist with Eluard and Breton as a trio of Peeping Toms, peering through a small window at the Mother of God spanking her son. Designed as a Surrealist Statement, and therefore a public demonstration of the movement's new-found authority, Breton's commission bracketed Ernst and Eluard in a professional context, separate from their domestic circumstances, alongside the group's organiser. The picture not only affirmed their friendship publicly, it also had an unsuspected effect on a young Irish painter interested in Surrealism. Francis Bacon was impressed by the Surrealists in the 20s and 30s and wanted to exhibit his work with theirs. He also lived in Paris when Ernst's reputation was at its height and where Ernst's picture was to be seen and was reproduced. *The Virgin Mary Punishing the Infant Jesus* seems to lie behind several of Bacon's paintings, in particular images like *Three Studies for a Crucifixion*, 1962. (Oil on canvas, 198 cm × 142 cm, Guggenheim Museum, New York).[500]

Ernst's portraits of Gala span the late 20s. There are many drawings of her in pen and ink, often several to a page, numerous pencil portraits, two substantial oil paintings and a series that Ernst collectively called *Eve, la seule qui nous reste*, in which she turns her back. One of this series is entitled *Amour violent*.[501] The Eve pictures record the armed truce between the ex-lovers, a stalemate in which Gala seems to defy Ernst; cold-shouldering him.[502] A majestic portrait of her, with tentacular arms, seated as if on a throne (*Portrait*, 1926. Oil on canvas. 96 cm × 65 cm, Private collection, S/M 957), with her face as dark as night, its features reduced to white eyebrows rearing in anger, confirms Eve is indeed Gala. Both have identical tubular necks and pageboy hair cuts. Why Eve? If his affair with Gala had gone sour, the Eve pictures were Ernst's way of reminding himself that love endured. The love of Adam for Eve, of man for woman, is a timeless, species-defining urge that for a season had been incarnated for him in Gala. Eve was soon recast when Gala was followed by Marie-Berthe, who herself faded away, eventually succeeded in Ernst's world by his wife Dorothea Tanning, the Eve who accompanied him longest and most happily. The way his affair with Gala ended is

Fig. 125 *Portrait of Gala*, 1926, oil on canvas, 92 x 62 cm. Private collection. S/M 957. Photo: Christie's.

Fig. 126 Left: Max Ernst, *Gala Eluard*, 1925, *frottage*, 20.4cm x 18cm. Private collection. S/M 1061.

Fig. 127 Max Ernst, illustration from Paul Eluard, *Au Défaut du Silence,* Paris, 1925.

Fig. 128 Gala Eluard, Photograph by Man Ray, retouched by Max Ernst and used by Salvador Dalí in *La Femme Visible* of which he was the author. *Les Editions Surréalistes*, Paris, 1930. 39cm x 55cm. Private Collection. S/M 787.

beyond our reach, except where it runs on in the pictures. Gala's alarming force is tangible, for example, in a riveting *frottage* from September 1925, where she nails the viewer as she nailed the artist, her eyes based on rubbings of the flat top of a poppy pod or a button.

We can also judge how close, but unsettled, the trio remained in the years immediately after their return, from a slim volume of poems by Eluard, illustrated by Ernst and published early in 1925. *Au Défaut du Silence* is not only a collection of poems but also a picture of Eluard's flayed nervous system, raw to the touch and viewed by him calmly from above. The portraits Ernst contributed look as if drawn by the jumpy needle of a seismograph, his nib recording the shock waves emanating from Gala. Nearly 130 scratchy drawings of her survive as part of this project, characterised by the obsessive way he drew her only to obliterate her again under a whirling cataract of spirals offering graphic proof of his frustration. The book is so powerful because made by two exceptional artists, each using a different medium, united by trust and driven by intimate familiarity with their baffling subject.

Au Défaut du Silence is a minimal book, a collection of fourteen one-liners and four short pieces, two in verse and two in prose.[503] The volume is home of Eluard's most

enigmatic and untranslatable one-liner, *A maquiller la démone elle pâlit*, which, devoid of its magic, in English sounds something like "Make-up blanches the she-devil." The heartbreak and loss conveyed by the book tell us life at Eaubonne must have been tense. A big crack had opened in Eluard's heart as Gala tugged at her moorings. *Dans les plus sombres yeux se ferment les plus clairs*, reads one free-standing sentence. *Et si je suis à d'autres souviens toi*, runs another, radiating cold regret. *La forme de tes yeux ne m'apprend pas à vivre*, is one of the bleakest. Ernst's portraits confirm she was the subject of the book, with her *visage perceur de murailles*, whose strange magnetism Eluard caught with the single terrifying line *Elle m'aimait pour m'oublier, elle vivait pour mourir*. He never conveyed desolation as ruthlessly again, his misery based on a love whose loss he recognised would haunt him to the end of his days, as was to be the case. The collection also reveals how Gala stimulated artists who loved her. "Eluard whose poetry never seems to me to come to the boil,"[504] was temperamentally a gentle poet who needed outward emergencies to raise his game. Paradoxically it was not heat, but the freezing wind of Gala's indifference that brought him to the boil in this, his finest book. However, the work is not just about Gala, but is also a portrait of the *ménage à trois* treading water after Saigon. We can see how, as the triangle dissolved, it stretched the considerable literary and graphic skills of the authors to express the confusion Gala still provoked. The result is a chilling picture of love and solitude; terse, vast and complete. With it the passion of the *ménage* broke surface for the last time, like a startling fin, and gradually subsided into memory.

In 1925, a year after their return and when *Au Défaut* appeared, the trio was therefore still active, like a smouldering volcano, with Gala's lovers squirming in her orbit. She appeared in a range of their work, haunting *Histoire Naturelle* as we have seen, which closed with her as Eve, turning away from everyone. In Gala's own copy of *Au Défaut du Silence* she kept a tense and cryptic note from Ernst. It is the only shred of evidence we have of their intimacy, apart from the art made for public consumption.[505] "Gala, my little Gala / Please forgive me. I love / you more than anything and more than ever. / I can't understand what's happening to me . . ." Ernst had found himself in the role of supplicant that she liked her men to adopt. It confirmed her authority.

Gala kept her lovers on a tight leash, and the battle of wills that ensued was part of her attraction, as we can see from Ernst's description. He spoke of this power struggle to Dorothea Tanning, who said of the portraits for *Au Défaut du Silence*, in which Gala's unyielding pupils stare back, "he made hundreds of drawings of them—did he know why?—because at last the eyes were exorcised. Not however, before he was desperate to be free. 'Why? What happened?' I ask. 'She didn't want me to paint' is all he would say."[506] Ernst never allowed anyone to dominate him; "I was born with a very strong feeling of needs of freedom."[507] Hence tension—which has its attractions.

In 1927 Ernst married Marie-Berthe Aurenche, whose ultra-respectable parents would have no truck with their son-in-law socialising with his ex-mistress. This seems to explain, in part, Ernst's increasing separation from Gala and Eluard at that time. Marie-Berthe, perhaps defending her claim to Ernst, was responsible for starting an

argument one evening with Eluard that ended in a fight. "Last night at Breton's, I had a fight with that pig Max Ernst, or rather he punched me unexpectedly in the eye . . . ," Eluard wrote to Gala.[508] The black eye from Ernst was provoked by an offensive remark about Gala, made in her absence, by Marie-Berthe. The brawl, which released suppressed resentments, marked a change of gear and the start of three years during which Ernst and Eluard drifted apart, a separation that ended only when Gala settled with Dalí. After that, freed from her gravitational interference, Ernst and Eluard struck up their friendship again. Until then, however, Eluard had suffered alone, without Ernst, and without Gala, who was spending time touring with her lovers. He was threatened by Ernst's independence and complained to Gala, for example, that after months of silence all he had was a postcard from him. "Better than nothing," he grumbled.[509] He had plenty of time in the TB clinic to mull things over and feel gloomy, but, as so often with Eluard, affection won. "My Dear Max, Nothing will ever destroy our friendship," reads the dedication to his collection of poems, *Défense de Savoir*, published in the spring of 1928.

Eluard's love letters to Gala from that period make alarming reading, as his longing somersaults the further she drifts from him. "I have but one desire: to see you, touch you, kiss you, speak to you, caress you, adore you, look at you, I love you, I love you, you alone, the fairest, and in all women I find only you: all Woman."[510] In French the final clause with its recurrent t-sound, has a clock-like tick, *dans toutes les femmes, je ne trouve que toi: toute la femme*. These letters are proof of the amazing sexual vitality that made her Eluard's Everywoman and Ernst's Eve. Eluard returned to Paris from his sanatorium to struggle with sadness. He composed *Nuits Partagées*, (Shared Nights), which he told Gala was ". . . an especially beautiful text, one of the most serious, one of the deepest I have ever written about our long life, yours and mine."[511] Living alone in a Paris apartment with silent passages and empty rooms, he looked back at the life they had shared and saw it as a long journey coming to an end, a voyage like the one they had recently made. *Au terme d'un long voyage*, it begins, "At the end of a long journey, I can still see that corridor, that gloomy burrow, that warm darkness where a breeze blows in drifting off the surf . . . I can still see the room where we once feasted on desire." He then describes a dream voyage with her, through the darkness, into caverns and memory, over *le théâtre du monde* and ending exactly as it had begun. "At the end of a long journey," when "it may be I'll never approach that door again, the one we both knew so well, perhaps never to re-enter that room."[512] *Nuits Partagées* is further proof of the positive effect of Gala on Eluard's work, for the piece is, as he recognised, an especially beautiful text, distilled from the sorrow she had induced.

However wilful and self-indulgent Gala seems in retrospect, we should beware of blaming her. The complexities of their relationship, with its unusual frankness, based on her directness and his candour, have been clouded by her silence. Eluard speaks clearly in his books and letters, and in the memoirs of his friends. All Gala's letters have been lost, so we have almost no idea of what she sounded like, no idea of her inner voice, caught off guard. Eluard burned all her letters to him, and all those she wrote to

her family in Russia were also destroyed. She survives therefore reflected in the eyes of others, a mute witness, an enigma. What is certain is that she soon became extremely promiscuous and businesslike about it, as she showed Jimmy Ernst, Max's son. Jimmy, by then a young man, was asked by her if he'd like to have sex, and when he declined the offer she turned on him and unleashed a torrent of abuse. By the late 20s she had found her wings as an independent sexual adventurer, abetted by Eluard, who saw Gala having sex with others as both disturbing and arousing. He even proposed they try a sexual threesome with one of her new lovers, André Gaillard, a young poet whose affair with her ended with his suicide, possibly the result of Gala's brutal insensitivity.[513] Gaillard, who had befriended Eluard too, died in December 1929, his corpse recovered at the foot of a cliff in Marseille by Blaise Cendrars. It would be interesting to hear what Cendrars made of Gala, whose path kept crossing his. Eluard himself was as promiscuous as she was, but it is clear from his candid letters to her about his affairs, and from his work too, that those pleasures were skin deep. Gala had occupied the depths of his imagination once and for all, and as they drifted apart he suspected there would never be a substitute, even when he slipped comfortably into a new marriage in 1934.

In the 30s a corner was turned, and the moment marked Gala's peak as an idol, an event illustrated by *La Femme Visible* (The Visible Woman), a collection of Dalí's writing, published by Les Editions Surréalistes in Paris in 1930. The title page features a close-up photograph of her eyes that had been retouched by Max Ernst, who added the sea and a long low horizon. Her eyes, like twin moons, float over a coastline evoking the emotional and geographical distances she had covered with him. It is the image of a Surrealist Muse at work; she is simultaneously Eluard's wife, Ernst's lover and Dali's partner, photographed by their friend Man Ray.

The title of Dalí's book, *La Femme Visible*, plays with gender reversal based on HG Wells's *The Invisible Man* (1897) (*L'Homme Invisible*). Dalí's title revealed, for those in the know, what had happened when Gala found her way into his contorted, self-regarding world. It was an entrance from which he never recovered, as from then on it was Gala who wore the trousers. This is made clear from the remark she made to a startled Roland Penrose and Lee Miller: "*Voyez que j'ai bien fait de plaquer Max Ernst: il n'arrivera à rien. Tandis que Dali, depuis que je l'ai pris en main, voyez quel succès!*" (Didn't I do well to ditch Max Ernst: he's a loser. But as for Dalí, just look at the success he's become since I took over!)[514]

This was said in 1936, when Ernst and Penrose were very close, and together with Eluard formed a mutually supportive trio (which can be seen at work for instance when Marie-Berthe had a mental breakdown, and Ernst needed the others' help). An equally revealing moment occurred when Eluard and Ernst were overheard, in Penrose's apartment in Paris, having a conversation whose implications ricocheted not only from Ernst to Penrose but between Ernst and Eluard too. Max was denigrating Roland's painting, and saying he would never make it as an artist. "If he is so hopeless, then why do you encourage him?" asked Eluard. "It is always good to have rich friends like Penrose," came the cynical reply".[515]

Fig. 129 Alexander Liberman, Max Ernst with *Après moi le Sommeil*, painted in memory of Paul Eluard. Huismes, France, 1959. Silver dye bleach print, 33 x 49.5 cm. The Getty Research Institute.

During the 30s Eluard returned intermittently to his memories of the Pacific in work such as *L'Habitude des Tropiques*, while Ernst painted jungle-covered ruins, each going over ground familiar to the other. Ernst spoke up uncompromisingly for Eluard in 1938, when, during a violent turn in the civil war between the Surrealists, he was ordered by Breton to "sabotage" Eluard's work as a poet, on account of his Communist sympathies. For Ernst, Breton's order deserved pride of place in the roll call of infamy. Eluard meant more to him than the rest of the Surrealists.[516] Their friendship took a new turn when Ernst moved to the south of France in the late 30s, and re-introduced an element of long distance between himself and Eluard, a division that grew wider when war broke out. A challenge therefore confronted their friendship and it is a sign of its strength that they kept in touch, despite the chaos of the decade which followed. They were unable to meet for years, initially due to the German occupation and then to the Atlantic divide. Most of the surviving clues to their friendship at that time come from Eluard, who seems to have done his best to keep it alive. When Ernst was rounded up following the Nazi invasion of France, Eluard may have saved his life. Treated as

Fig. 130 Max Ernst, *Après moi le Sommeil*, 1958, oil on canvas, 130cm x 89cm Musée National d'Art Moderne, Centre Georges Pompidou, Paris. S/M 3389.

an enemy alien by the Vichy authorities, Ernst was interned in a concentration camp at Les Milles, close to Aix. Eluard, who was soon to be on the run himself as a result of his activities in the Resistance, wrote to an eminent French politician, and with a carefully worded letter sent to the right man at the right time secured Ernst's release.[517] Ernst was re-arrested and then escaped, to arrive in New York in 1941 and begin nine years in the US. His adventures there and Eluard's transformation in Europe into a Grand Old Man of French literature unrolled independently. During those wartime and post-war years Eluard kept Ernst in mind. No record of Ernst's feelings about Eluard at that time have surfaced, but judging from the recurrent presence of Angkor Wat in the pictures he painted then and from the autobiographical nature of his work, Eluard must have figured in Ernst's thought. Especially when friends from Europe, such as Penrose, came to stay in Arizona.

Eluard's thoughts about Ernst, on the other hand, are tangible. In June 1945 for example, after the Liberation of France, and in the cold and chaos which ensued, he encouraged a Paris gallery to hold a show of Ernst's work. In 1947 he published a collection of his own poems, illustrated, once again, with pictures by Ernst, who by then was in Arizona.[518] "We have come down the canyon from Flagstaff and the weekly visit to the supermarket, liquor shop, . . . and a stop at the post office where there is a package from France," wrote Dorothea Tanning, recalling a trip from their isolated home above Sedona to the local metropolis, "Open it. Astonishingly its title reads *Huit poèmes visibles* by Max Ernst and Paul Eluard."[519] Ever affectionate and attentive, Eluard was sending smoke signals to his friend across the Atlantic, from Paris to the American South-West.

The last occasion on which the two friends met was in 1949–50, when Ernst and Dorothea Tanning visited Paris for the first time since the war. While Ernst nosed his way cautiously back into a bombed-out Europe, Eluard was leading the life of an important political figure, travelling widely promoting Communism. Other Surrealists scattered by war were re-establishing contact, so news of each other would have reached the friends via the bush telegraph. Details of this final brief encounter are scant, but it seems that the visitors were caught in the crossfire between Breton and Eluard, who had fallen out over Eluard's politics, and that Ernst had to tread carefully as he wanted to see both men again.[520] We do not yet know where nor when they met and must assume that they separated hoping to see each other soon. Ernst and Dorothea Tanning returned to Arizona in October 1950 and only revisited France in 1953, by which time Eluard was dead.

We began this journey with the idea that artistic activity is a voyage and the result of traffic between two worlds—between imagination and external reality. Creative life, it is fair to say, is driven by the need to make good the shortfall between them. Everything we have learned here about the road to Surrealism confirms this, as does the picture with which our voyage ends, Ernst's *Après moi le Sommeil* (Sleep will follow when I've gone). Inscribed on the back of the canvas, *après moi le sommeil à Paul Eluard Max Ernst 1958*, the picture was rehearsed in a smaller version, *Le Tombeau du Poète: Après moi le sommeil* (S/M 3388). This title exposed Ernst's graveyard theme and confirmed what he

Left and below: The Reunification Palace (Hoi Truong Thong Nhat), once the symbol of the South Vietnam Government, has been retained almost as it was in the 1960s. The roof was used as a helipad in April 1975, enabling a massive evacuation of staff just before the palace was overrun by soldiers from the north.

Left: There are several tourist attractions including the Museum of Vietnamese History (pictured) housed in an old French colonial building near the zoo. However, it is the War Remnants Museum (formerly the Museum of American War Crimes) that is most popular with foreign visitors. It provides a chilling reminder of the American War in Vietnam. Armoured vehicles, weapons and other war paraphernalia are displayed.

Right and opposite top: The city is situated on the Saigon River 80 km (50 miles) inland. Many attractions are near the river in District 1 and include several beautiful colonial buildings, such as the Ho Chi Minh City Town Hall, General Post Office (opposite top), Opera House and Notre-Dame Cathedral (right).

Opposite below left: The city's historic hotels of the Caravelle, Continental, Rex and Majestic have been saved, rejuvenated and restored. It was the Continental Hotel that featured in the Hollywood movie 'The Quiet American' based on the Graham Greene novel of the same name. Rooftop bars are popular in the city but none has more nostalgia than that at the Rex Hotel (pictured) as wartime journalists would gather here daily to be briefed on the war by the military and possibly have a refreshing beer or two. Gleaming new hotels, such as the Sofitel, the Novotel Saigon Centre and the Pullman Saigon, are symbols of economic growth and healthy tourism arrivals.

Above: Markets selling fresh produce and food are an important part of the city's landscape; Ben Thanh Market is the biggest and most popular with locals and tourists. Built by the French as a municipal marketplace, it now offers an extensive selection of local souvenirs, fresh produce, imported goods and tasty treats. Freshly ground local coffee is a popular item, especially the hard-to-get and expensive 'ca phe chon' (weasel coffee).

Right: A landmark building, the People's Committee Hall (formerly the City Hall or Hotel de Ville de Saigon) was built between 1902 and 1908. Since 1975 it has served as the Headquarters for the HCMC People's Committee and is not open to the public.

Above: Ho Chi Minh City's inner core has a population density of over 40,000 per km² (100,000/sq mile).

Right: One of the most impressive buildings is the Municipal Theatre of Ho Chi Minh City or the Saigon Opera House. This fine example of French colonial architecture was built in 1897. Initially an 800-seat theatre, it became the Assembly of the Lower House of South Vietnam until 1956 but reverted to the Opera House in 1975. It stands in front of the famous Caravelle Hotel which was once home to foreign correspondents during the war.

Above and left: Cholon or District 5, just 5 km (3 miles) west of District 1, is often referred to as the city's Chinatown as it retains many Chinese features from its temples and architecture to its food stalls. It dates back to the 18th century when people from China's southern provinces settled here. The name translates as 'big market' and the district offers a dazzling array of dining options. It is also home to the gigantic Cho Ray Hospital. Discover the best of Cholon by visiting the large central market (pictured) which is lively, busy, hot and crowded but always fascinating. It is mostly popular for local shoppers who come to purchase their fresh daily requirements, especially ingredients for cooking.

Left: While HCMC still retains many elements of its past and of traditional life, most young Vietnamese want to emulate their counterparts in the West. District 1, on the western side of the Saigon River is the area considered by the locals as downtown or the CBD (Central Business District). Here, Dong Khoi Street (pictured) is considered the most fashionable, lined as it is with cafés and international designer brands that especially appeal to the young and trendy. Neighbouring streets, such as Hai Ba Trung, Thi Sach, Le Thanh Ton and Thai Van Lung, are also experiencing rapid transformation.

Mekong Delta and South

One of Asia's great rivers, the Mekong, ends its 4,350-km (2,703-mile) long journey from its source in China's Tibetan Plateau when it flows into the Eastern Sea (South China Sea) off Vietnam. Being the world's 12th longest river, it is a valuable resource for millions of people in China, Myanmar, Laos, Thailand, Cambodia and Vietnam who live near it. Lush green vegetation and crops line the flat landscape criss-crossed with streams and backwaters.

This page: As the river enters Vietnam it branches into several channels that cover most of the southern lands. The fertile delta extends over Cambodia and Vietnam and is the 'rice bowl' for large areas of both nations, where many different crops and fruits are grown and fish raised. People move around the waterways on boats and many houses are built on stilts to protect them from the ever-present threat of flooding.

Left: My Tho, Can Tho, Chau Doc and Vinh Long are the main towns on the delta and taking a boat ride is an essential tourism activity. My Tho is the main departure point for day-visit tourists to explore the Mekong. These well organized and structured trips enable visitors to see life along the Mekong River and some of the islands in the delta. Visitors can observe agricultural activity, fishing fleets and villages plus take a sampan ride through some of the wetlands.

Below: Near Vinh Long, the Cai Be Floating Market is a colourful morning market, while Cai Rang Floating Market is close to Can Tho. Traders advertise their wares by attaching fruit or vegetables to tall bamboo poles strapped to the masts of their vessels. Others ply the waterways selling prepared meals, such as 'pho' and even serving delicious cups of coffee.

Phu Quoc

The 528-km² (204-sq mile) island of Phu Quoc (Vietnam's largest island) is about the same size as Singapore. It was once a prison but has been transformed to such an extent that it is now perfect for those seeking an isolated island in the sun. There are daily flights from Ho Chi Minh City to the island and ferry services from Ha Tien in the south-west of the Vietnamese mainland near the Cambodian border to Ham Ninh, 100 km (62 miles) away on Phu Quoc's east coast.

This page: Its year-round sunshine, near-deserted beaches and relatively remote location are starting to garner the attention of adventurous tourists. Many consider the beaches here to be the best in Vietnam. They stretch 20 km (12 miles) south from Duong Dong. Visitors not only come to dive and snorkel in the clear waters but also to mountain bike, kayak and trek into the hilly interior peaked by Chua Mountain at 565 m (1,854 ft).

Above: Duong Dong is the principal township situated on the western seaboard. The main resorts, such as the MGallery La Veranda Resort, are located along a 20-km (12^1/$_2$-mile) stretch of beautiful sands to the south. Watersports, mountain biking and diving in the An Thoi Archipelago to the south are just some of the recreational activities on offer.

Left: In addition to tourism, farming (especially of pepper), fishing and fragrant fish sauce ('nuoc mam') production are important industries. Phu Quoc produces some six million litres (1,560,000 gallons) of premium grade fish sauce and many connoisseurs of 'nuoc mam' argue that the island produces the best in the country.

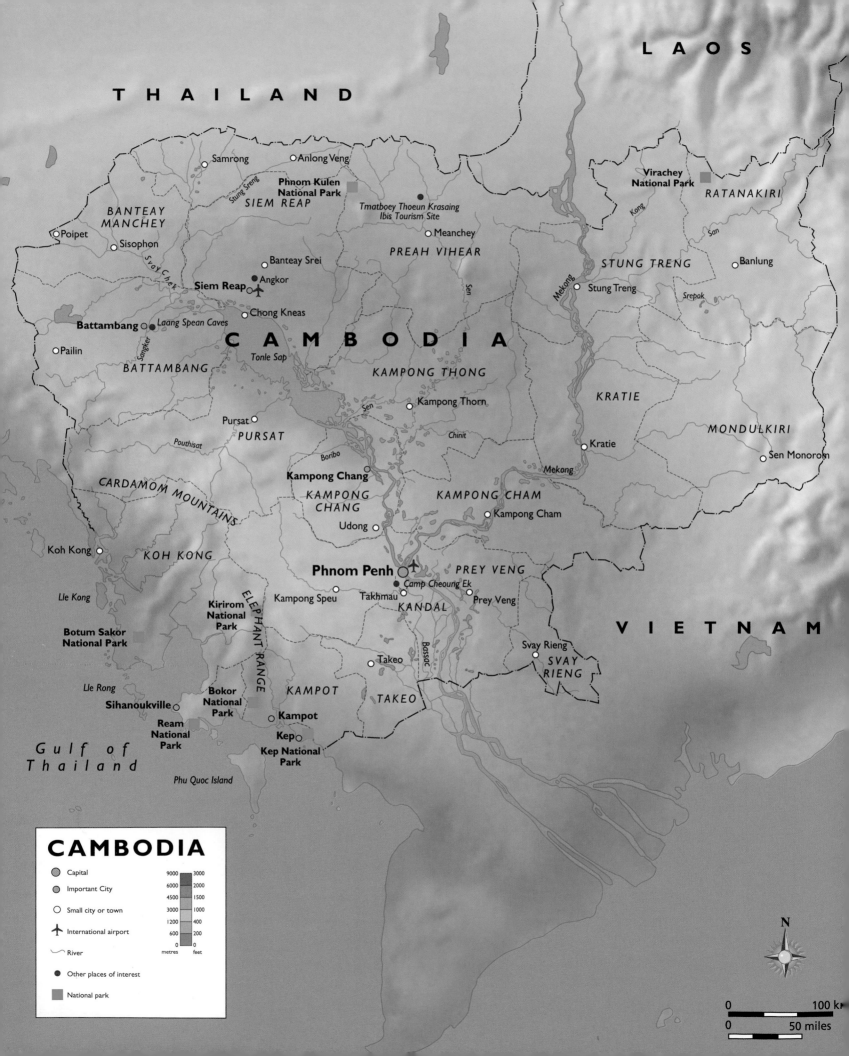

LAOS

THAILAND

Samrong

Anlong Veng

Stung Sreng

**Phnom Kulen
National Park**

SIEM REAP

Tmatboey Thoeun Krasaing
Ibis Tourism Site

**Virachey
National Park**

RATANAKIRI

*BANTEAY
MANCHEY*

Poipet

Sisophon

Banteay Srei

Meanchey

PREAH VIHEAR

Kong

STUNG TRENG

Banlung

San

Svay Chek

Siem Reap ✈

Angkor

Sen

Mekong

Stung Treng

Srepok

Battambang ● Laang Spean Caves

Chong Kneas

C A M B O D I A

Pailin

Sangker

BATTAMBANG

Tonle Sap

KAMPONG THONG

KRATIE

MONDULKIRI

Pursat

Sen

Kampong Thorn

PURSAT

Pouthisat

Chinit

Kratie

Sen Monorom

Boribo

Mekong

CARDAMOM MOUNTAINS

Kampong Chang

*KAMPONG
CHANG*

KAMPONG CHAM

Kampong Cham

Udong

KOH KONG

Koh Kong

Ile Kong

Phnom Penh ○ ✈

● Camp Cheoung Ek

PREY VENG

**Kirirom
National Park**

Kampong Speu

Takhmau

KANDAL

Prey Veng

**Botum Sakor
National Park**

ELEPHANT RANGE

VIETNAM

Svay Rieng

*SVAY
RIENG*

Ile Rong

Sihanoukville

**Bokor
National Park**

KAMPOT

Takeo

Bassac

TAKEO

**Ream
National
Park**

Kampot

Kep

**Kep National
Park**

*Gulf of
Thailand*

Phu Quoc Island

N

| 0 | 100 km |
| 0 | 50 miles |

CAMBODIA

HOME OF THE GREAT KHMER CIVILIZATION

A country of astonishing natural beauty and home to the incredible temples of Angkor, Cambodia is one of Southeast Asia's most fascinating destinations. The fact that the country is now firmly on the itinerary of many cultural travellers, however, is nothing short of remarkable.

Above: *The heat of chillies and the sourness of limes are common features of Khmer cuisine.*

Above: *The huge stone faces of the Bayon in Angkor are some of Asia's most iconic imagery.*

Few nations have expressed mankind's creativity so beautifully through art and architecture but also plunged so far into the depths of cruelty and inhumanity as Cambodia. Over the past two millennia, a nation powerful in battle and gifted in the arts asserted its regional dominance, crowning its achievements with the wondrous Angkor, an expansive 400-km^2 (155-sq mile) site that encompassed the capitals of the Khmer Empire from the 9th to the 15th centuries. Cambodia's recent history, however, couldn't be further removed from its former glories. In the 1970s, the country's name became known for the brutal reign of the Khmer Rouge and its haunting legacy of genocide. Remarkable then that today Cambodia is a youthful and optimistic country determined to move forward rather than look back.

Above: Monks walking in the shade of trees on the road from Angkor Thom.

Left: Once lost to time and hidden in a dense forest, Angkor is now one of Southeast Asia's most visited attractions.

Phnom Penh is a city revitalized. The skyline of Cambodia's once sleepy capital has been pierced by its first high-rise building and the red dirt roads, now sealed, are filled with gleaming SUVs and swarms of buzzing motorcycles.

For a city that has endured more than its share of bloodshed and destruction, today's youthful exuberance and palpable energy are welcomed by residents and visitors alike. Confirming that the country's future is indeed bright, the bourgeoning capital city is now home to exquisite Buddhist temples, chic boutiques and relaxed riverside dining and entertainment venues, all of which make a visit interesting and exciting.

Yet despite the positive change being witnessed today, any time spent in Phnom Penh must still include reflective visits to the sites of the country's horrific past. Two of the most visited places in Phnom Penh are still Camp Cheoung Ek, one of many infamous Killing Fields sites, and Tuol Sleng Genocide Museum, a former high school that became a torture centre known as S-21.

Above left: Phnom Penh is rapidly evolving into one of Southeast Asia's most vibrant and energetic cities.

Above: The mysterious stone carvings of Angkor captivate all who see them.

Opposite: Relatively undeveloped, it is still possible to discover deserted beaches.

Beyond the capital there is also much to explore. Without question the biggest draw for travellers is the UNESCO World Heritage Site of Angkor, an area so vast and inspiring that it requires several days to explore. Aside from the temples of Angkor there is the nearby town of Siem Reap to discover, Tonle Sap Lake and its floating villages, museums, bird sanctuaries, thriving markets and an emerging arts scene. Further west of Siem Reap, the historic town of Battambang has some of the finest examples of colonial-era architecture in the country and is also surrounded by verdant countryside and peaceful villages where life still moves at the speed of an ox-drawn cart.

Cambodia's 450-km (280-mile) coastline is once again attracting visitors who are discovering near deserted beaches and islands lapped by crystal-clear waters. Located just a few hours' drive from the capital, the resort towns of Sihanoukville, Kampot and Kep, once popular haunts of the former French colonials, now lure Phnom Penh's middle class to golden beaches.

For the visitor, Cambodia is a land of contrasts inhabited by resilient, forward-looking people whose art and culture continues to inspire. For these reasons and more, a personal journey to enchanting Cambodia is truly one of discovery.

Above: In Cambodia, the rules of the road are relaxed to say the least.

GEOGRAPHY AND CLIMATE

Bordered by Laos, Thailand and Vietnam, tropical Cambodia covers 180,040 km² (69,514 sq. miles), just half the size of neighbouring Vietnam. Divided into 20 provinces, Cambodia has a fertile central plain, the rice basket of the country, that is bound by two mountain ranges. The mighty Mekong River enters Cambodia from Laos and spills into the enormous Tonle Sap Lake, the source of the largely agrarian population's supply of freshwater fish.

The Cardamom Mountains in the southwest of the country include Phnom Aural, Cambodia's highest mountain at 1,770 m (5,807 ft). An extension of the Cardamoms, the Elephant Range runs south and southeast, at points rising to elevations of up to 1,000 m (3,280 ft).

Around two-thirds of the country has forest cover but in recent years much of this has become degraded by continued legal and illegal logging. Cambodia's remaining virgin forest is at risk but there are some safe havens and ecotourism is slowly gaining ground in the country. With its many endangered birds and fragile habitats, Cambodia attracts birdwatchers particularly to the Tmatboey Thoeun Krasaing Ibis Tourism Site outside Siem Reap. The site was established by the Wildlife Conservation Society (WCS) to protect an endangered bird, the ibis. The ecotourism project protects the only known site where both Giant and White-shouldered Ibis breed and can be regularly sighted. The birds are found in the forest and villagers nearby have established hides from which they can be seen and work as guides to take visiting birdwatchers to them.

Cambodia also has an extensive coastline with beautiful beaches and islands. Few, however, have been developed and still wait for the country's tourism numbers to increase and the industry to mature.

Cambodia's climate is tropical and monsoonal with cool, wet and dry seasons of a similar length. The temperature and humidity are generally high and constant throughout the year with only small variations from an average of around 25°C (77°F). The cool season runs from November to February and, although daytime temperatures can still reach 30°C (86°F), evenings can be pleasantly cool. The hot season from March to May can top 40°C (104°F) but the rainy season that follows from June to October is more bearable as sporadic storms clear the air.

Left: Cambodia's wetlands are the habitat of several endangered species.

Above: Sunset in the sleepy riverside town of Kampot.

Left: Planting rice is a family affair. Everyone helps out to ease the burden of the backbreaking work.

A BRIEF HISTORY OF CAMBODIA

Cambodia's history is a story of a rise to greatness and regional dominance, followed by gradual decline and one of mankind's most notoriously dark and brutal periods.

The earliest recorded evidence of human habitation in Cambodia was discovered in the northwest at the caves of Laang Spean. Here, pottery believed to date from the sixth millennium B.C. was unearthed. Archaeologists working in eastern Kompong Cham also discovered Neolithic and Bronze Age artefacts such as polished stone tools and pottery dating from between 3,000–500 B.C. Neolithic adzes have also been found in the Angkor region and Battambang Province.

Early Khmer settlements existed in what is today southern Vietnam as long ago as the first century. The coastal towns are known to have been important trading posts for merchants from India and China. In the sixth century, most Khmers were settled along the Tonle Sap and Mekong where they cultivated rice and caught the rivers' bountiful supplies of freshwater fish. The loose amalgamation of separate states, the most important of which was known as Funan, would later became unified as the Khmer Empire with the magnificent city and temples of Angkor at its heart.

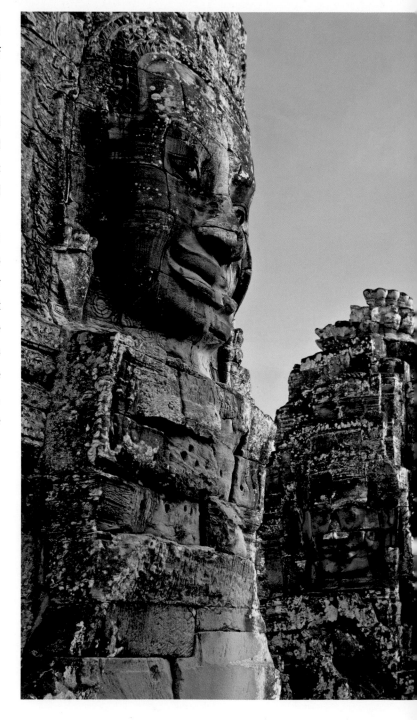

These pages: Once the seat of Southeast Asia's greatest empire, Angkor fell into decline during the 15th century. For years it was lost to an encroaching forest until in 1907 a team of French archaeologists began restoration work that continues today. Angkor encompasses over 1,000 sites, the greatest of which is Angkor Wat, a magnificent temple constructed in the 12th century for King Suryavarman II.

The Khmer Empire

In the eighth century, Jayavarman II became the country's first monarch. Under his reign, an advanced irrigation system was implemented in Angkor that enabled the Khmer Empire to flourish. Jayavarman II is also credited with building the first of the great Angkorian temples. During the 10th and 11th centuries, many of Angkor's important alliances fractured and a succession of kings were involved in conflicts and power struggles. Under the reign of Suryavarman II wars were fought with Champa or what is today central Vietnam. It was also Suryavarman II who ordered Angkor Wat to be constructed as a devotional act for the Hindu god, Vishnu. In 1177, Champa reaped revenge for its earlier defeat by sailing up the Mekong and into the Tonle Sap, sacking Angkor and executing King Dharanindravarman II. A year later, however, Champa was beaten by the Khmer army and Jayavarman VII was crowned.

In the years that followed some of Angkor's greatest temples were built including Angkor Thom, at the heart of which sits the spectacular Bayon, and Preah Khan, Ta Prohm and several more.

From the eighth to the 13th centuries, the Khmer Empire ruled over a vast region encompassing what today are Cambodia, northeast Thailand, southern Laos and southern Vietnam. However, five centuries of dominance were waning and in 1431 Angkor felt the full force of neighbouring Thailand's power when they attacked and captured the region, then moved the capital to Phnom Penh. Thailand's force was still being felt in 1794 when they held the provinces of Siem Reap and Battambang.

Above: Murals on walls within the compound of the Silver Pagoda date from 1903.

Top: Wat Thommanon is one of Angkor's smaller but no less beautiful temples.

The French Colonial Era

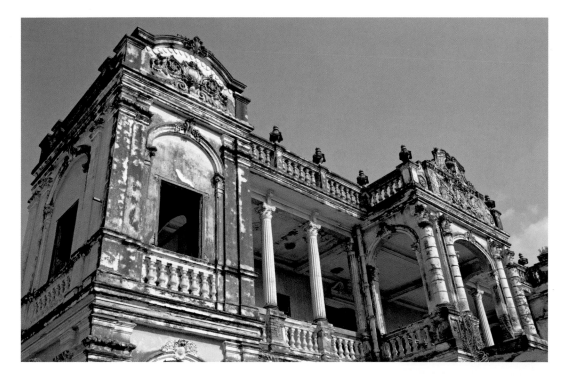

Left: Many of the French colonial-era buildings in Phnom Penh have fallen into disrepair and are desperately in need of renovation.

Below: Fortunately some, like this building in Kampot, have been restored.

In the early to mid-1800s, much of Cambodia was a vassal state of Thailand, with the east of the country being controlled by Vietnam. When the French arrived in the region they viewed Cambodia's weakened state as an opportunity to expand their power in Indochina. In 1863 King Norodom's hand was forced into signing a treaty of protection with the French. A year later Cambodia was annexed and became a French colony. Despite an initial rebellion by the Khmers, 75 years of French rule followed. For Cambodia's impotent monarchy, however, colonization was seen as necessary for the survival of the royal court. The French also regained control of Battambang and Siem Reap – which translates as Thais defeated – from Thailand.

Following World War II there was growing resistance to French rule and the Khmer Issarak or "Free Khmer" movement was formed to fight for independence. In 1953, King Norodom Sihanouk threw his weight behind Cambodia's bid for freedom by dissolving parliament and declaring martial law. On 9 November 1953, Cambodia declared independence, an action that was internationally recognized in May of 1954.

The Rise of the Khmer Rouge

In 1970, Prince Sihanouk was toppled by a U.S.-backed coup, a move that further destabilized the country. In 1973, the U.S. began an eight-month bombing campaign dropping hundreds of thousands of tons of bombs across Cambodia. Many rural Cambodians sought refuge in Phnom Penh, one of the few places that was not being bombed, and the population grew to over two million. In 1975, two weeks before the fall of South Vietnam, the Khmer Rouge regime came to power under Solath Sar, or Pol Pot as he was also known. The years that followed were the most bloody and brutal in Cambodian history.

Under the leadership of Pol Pot and his henchmen, Cambodians were marched out of Phnom Penh and forced to work in collective farms. Educated citizens were massacred and the calendar was started at Year Zero. Estimates vary, but over 1.7 million people are thought to have been massacred under the regime and many more died of hunger and disease.

In 1978, Vietnamese troops overthrew the Khmer Rouge but when they withdrew from the country civil war broke out and several groups, including the Khmer Rouge tried to gain power. The United Nations worked for a peace settlement that resulted in elections in 1993 and Norodom Sihanouk was once again crowned. The Khmer Rouge leader, Pol Pot, escaped justice and died aged 73 in 1998. Shortly before he died he was held prisoner by former Khmer Rouge members who had accused him of betraying the movement he had once led.

In 2001, Cambodia's King Sihanouk signed legislation for a special tribunal to prosecute members of the Khmer Rouge. A series of delays and squabbles over the financing of the UN-backed trial prevented the judicial process from moving forward. Many saw the delays as a ruse to derail the trials. Those that have faced the courts have received light sentences.

A Brave New Future

For the past two decades Cambodian politics have been dominated by Prime Minister Samdech Hun Sen, a former soldier in the Khmer Rouge. Despite considerable challenges and a widening division between rich and poor, Cambodia is enjoying a period of peace and relative stability. It is also experiencing huge investment from countries such as China and Korea. With increased development, a youthful population and increased tourism, Cambodia and its resilient population are now bravely looking towards a new and brighter future.

Left: Mines on display at the Landmine Museum on the outskirts of Siem Reap are a permanent reminder of Cambodia's deadly legacy.

Opposite: Monks walk past the Independence Monument in Phnom Penh. Built in 1958, it is a memorial to Cambodia's war dead and to independence from the French five years earlier.

PHNOM PENH

Situated at the confluence of three rivers, the Mekong, the Tonle Sap and the Bassac, Phnom Penh bristles with the energy of a youthful population of over 2 million. With investment pouring in from China, the dusty red dirt roads are long gone and a new modern skyline is quickly emerging.

Although the pace of change in the city is remarkable, architectural gems from the French colonial era can still be found in a network of side streets, along with the Central Market, a stunning art deco building and now home to Phnom Penh's gold traders. Highlights include the beautifully restored Royal Palace and Silver Pagoda, and the National Museum with its inspiring collection of Khmer art and sculpture.

This page: In the last few years, Phnom Penh has experienced a boom in construction and an explosion of traffic on the roads. However, more traditional and sedate methods of transport still remain (above). Guaranteed to assault the senses, local markets are chaotic and colourful places to explore (right).

Left: Some of the former French mansions have been restored and are used by international organizations such as UNESCO.

Above: The Foreign Correspondents Club or FCC in Phnom Penh is a popular bar, restaurant and hotel overlooking the Mekong River. The former French colonial-era villa is open to non-members.

The Royal Palace

Left: The Royal Palace complex dates from 1866. It houses Buddha statues and religious and royal artefacts including an emerald Buddha encrusted with jewels. The Throne Hall, shown left, was the second to be built on the site and is topped by a 60-m (197-ft) spire. Inside, the ceiling is decorated with beautiful murals of scenes from the Reamker.

Above: Hor Samran Phirun pavilion within the palace grounds was built in 1917 to house musical instruments and regalia for royal processions. Several other ornate pavilions in the grounds include an original constructed as an open-air venue for classical Khmer dance.

The Silver Pagoda

This page: The Silver Pagoda, part of the Royal Palace compound in Phnom Penh, has a floor covered with 5,000 silver tiles. Among the many treasures housed here is a solid gold Buddha weighing 90 kg (198 lb) and encrusted with 9,584 diamonds. It is also known as Wat Preah Keo Morokat or the Temple of the Emerald Buddha and was traditionally the place where royal ceremonies were held. Several stupas here contain the ashes of former kings and queens of Cambodia.

The National Museum

This page: *The distinctive ochre-red building of the National Museum in the heart of Phnom Penh houses a wonderful collection of over 5,000 Khmer works of art and sculptures. Streets around the museum are renowned for the boutiques and shops selling arts and crafts.*

Wat Phnom

Below: Wat Phnom features a large seated bronze Buddha and other images and painted walls that depict his earlier reincarnations, along with scenes from the 'Reamker'. The temple is extremely popular with local worshippers.

Above: Wat Phnom is the hilltop temple from which Phnom Penh takes its name. Thought to date from 1372, the temple is accessed by a stairway guarded by carved lions and serpents or 'nagas'. The stupa contains the ashes of King Ponhea Yat who is credited with moving the capital from Angkor to Phnom Penh in 1434 after it was sacked by the Siamese.

The Central Market

This page: The fabulous Psar Thmei, more commonly known as the Central Market, is a striking art deco building dating back to 1935. Here you can buy just about anything including shoes, clothing and souvenirs. The market, which has recently benefited from restoration work, can be accessed by four main entrances that lead into the central dome. Once a fresh produce market, the area within the main dome now houses gold and jewellery traders.

SIEM REAP

As the gateway to Angkor, Siem Reap is Cambodia's most visited town. Located just eight km (five miles) from the ancient temple sites, the town has benefited from the massive influx of tourists and the establishment of many new luxury hotels and resorts.

Although everyone who stays in Siem Reap is there for daily visits to Angkor, the town and surrounding area should not be overlooked. A visit to the Angkor National Museum explains the history of Angkor in a clear and concise manner and is an excellent and informative precursor to a trip to the ruins. It also includes a stunning collection of over 1,000 Buddha images. Golfers also come from all over Asia to play at the Phokeethra Country Club.

Above: *Angkor National Museum is an excellent facility purpose built to house the many treasures of Angkor.*

Below: *Colourful Siem Reap has much to offer including excellent restaurants, bars and boutiques.*

Right: Regarded as one of the finest hotels in Southeast Asia, the Raffles Grand Hotel d'Angkor in Siem Reap invites guests to experience the ambience of a bygone era, outstanding service and modern day conveniences.

Above and right: Siem Reap now has several golf courses including the Phokeethra Country Club located just 20 km (12 miles) from the town centre. Golfers come to enjoy the beautiful tropical course with sweeping fairways and attractive green fees.

Chong Kneas Floating Village

This page: The floating village of Chong Kneas provides visitors with a fascinating break from the temples of Angkor. Located a 20 minute tuk-tuk ride from the centre of the town, this village is a ramshackle collection of stilted houses and floating homes that move with the seasonal rise and fall of the Tonle Sap.

This page: There are two communities at Chong Kneas. The Cambodians tend to inhabit the stilted houses, while the Vietnamese are totally waterborne.

TEMPLES OF ANGKOR

The truly magnificent UNESCO World Heritage Site of Angkor encompasses more than 30 temples and ancient buildings spread over a vast area. Angkor Wat itself covers an area of one square kilometre (247 acres) and comprises three levels and a central tower. The entranceway is particularly impressive. Inside the confines of the temple, the inner and outer walls are covered with exquisite bas-reliefs.

Angkor Wat

The Angkor period began in 802 AD when Jayavarman II established the cult of Devaraja or God King and declared himself a universal monarch. Following his death in 850 AD, Angkor was ruled by a succession of 38 kings until the end of the Angkor period in 1432 AD when the capital was relocated to Phnom Penh. High points of the empire were during the reign of King Suryavarman II from 1113–1150, a period that saw the construction of the magnificent Angkor Wat. From 1181–1220, under the instruction of King Jayavarman VII, Angkor's infrastructure was greatly expanded and many monuments built including Angkor Thom, the Bayon and Preah Khan. Angkor suffered gradual decline during the 14th century. The eventual relocation of the capital has been attributed to several factors: increasing attacks by the neighbouring Thais, pressure on natural resources from the large population and drought.

Left: There are several Buddha images within the confines of the ancient temple that are still cared for by monks from a nearby temple and presented with daily offerings.

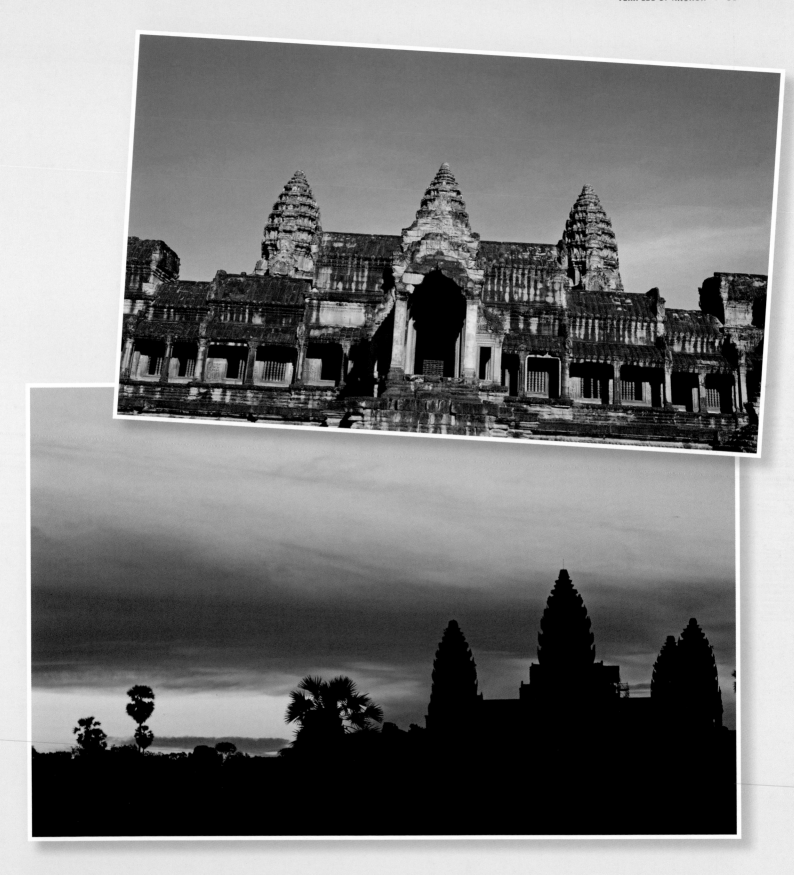

Above: Regarded as the jewel in Angkor's crown, Angkor Wat is one of the wonders of Asia and a beautiful sight, night or day. At daybreak, the temple grounds are crowded with visitors waiting to watch the sunrise over the distinctive towers.

Right: The Apsara, a female nymph from Hindu mythology, is one of the most common images carved on the walls of Angkor Wat and other temples at the expansive site.

Above: Worn away by time and the elements, this Apsara at Angkor Wat is an almost ghostly image.

Above: The extensive galleries at Angkor Wat feature a wealth of exquisite bas-reliefs depicting Khmer legends and scenes from the 'Reamker'.

Opposite: It is impossible not to be impressed by the sheer scale and beauty of the temple. It is advisable to return to Angkor Wat at different times of the day to experience the changing quality of light. The galleries are particularly atmospheric.

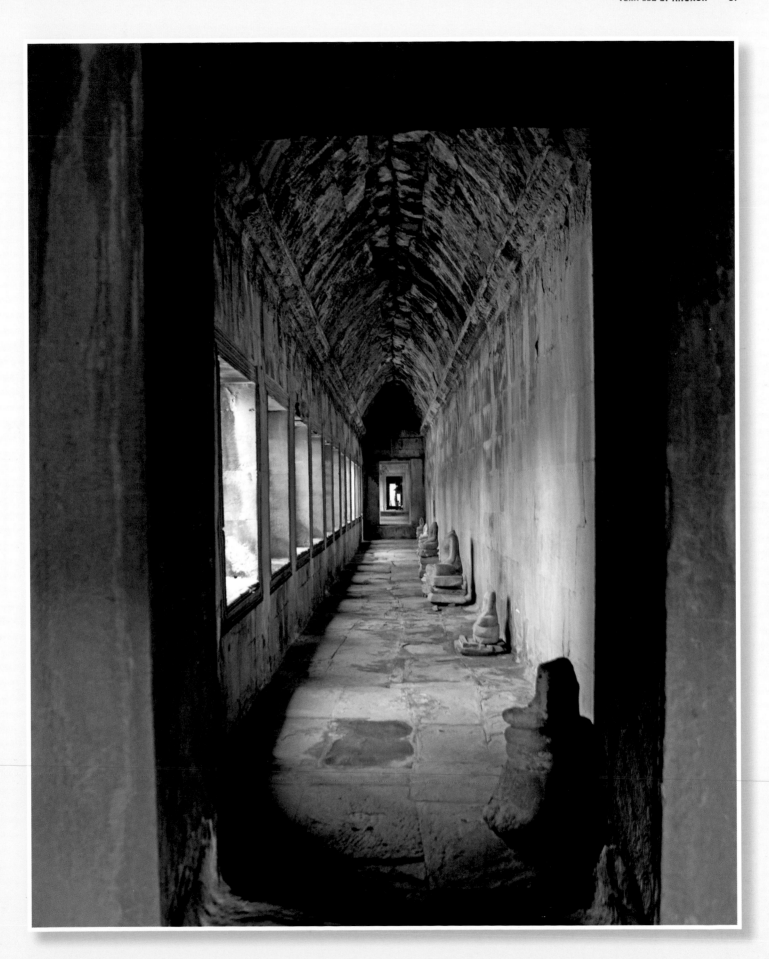

Angkor Thom

Angkor Thom dates from the 12th and 13th centuries and was the last capital of the Khmer Empire. Enclosed by a moat and a three-km (one and three quarter-mile) wall, the area is entered through an impressive gateway.

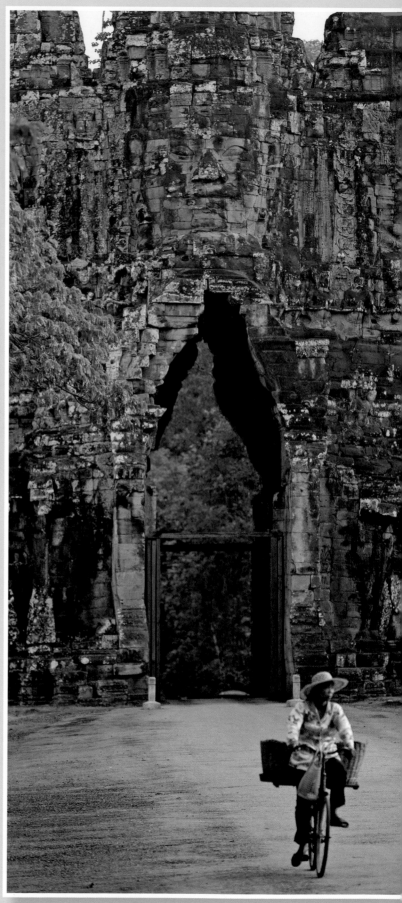

Above and right: Today, Angkor Thom is one of Asia's most enchanting sights but at the height of the Khmer Empire must have been truly breathtaking. The Chinese diplomat who gazed upon its splendour in 1296 described it as a 'truly astonishing spectacle' with golden towers, bridges and Buddha images.

Bayon

At the heart of the Angkor Thom complex is the Bayon with 54 towers, most of which feature four massive carved faces.

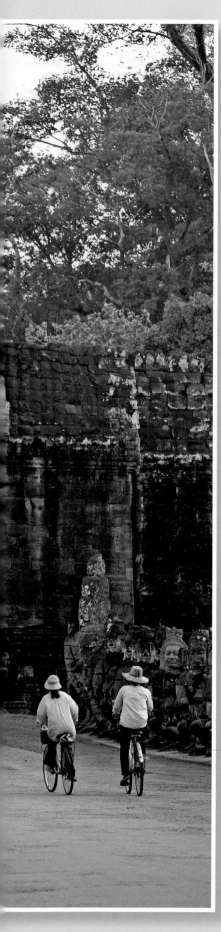

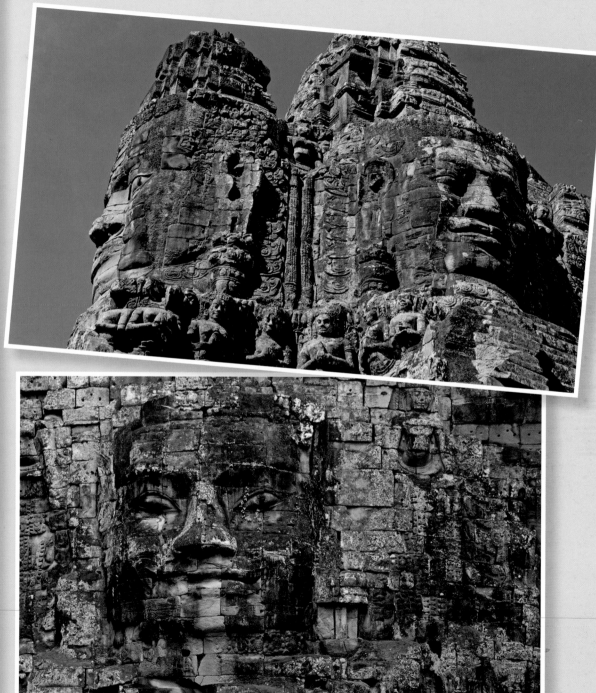

Above: *Located at the centre of Angkor Thom, the Bayon is undoubtedly one of the Angkor's most visually impressive and moving temples.*

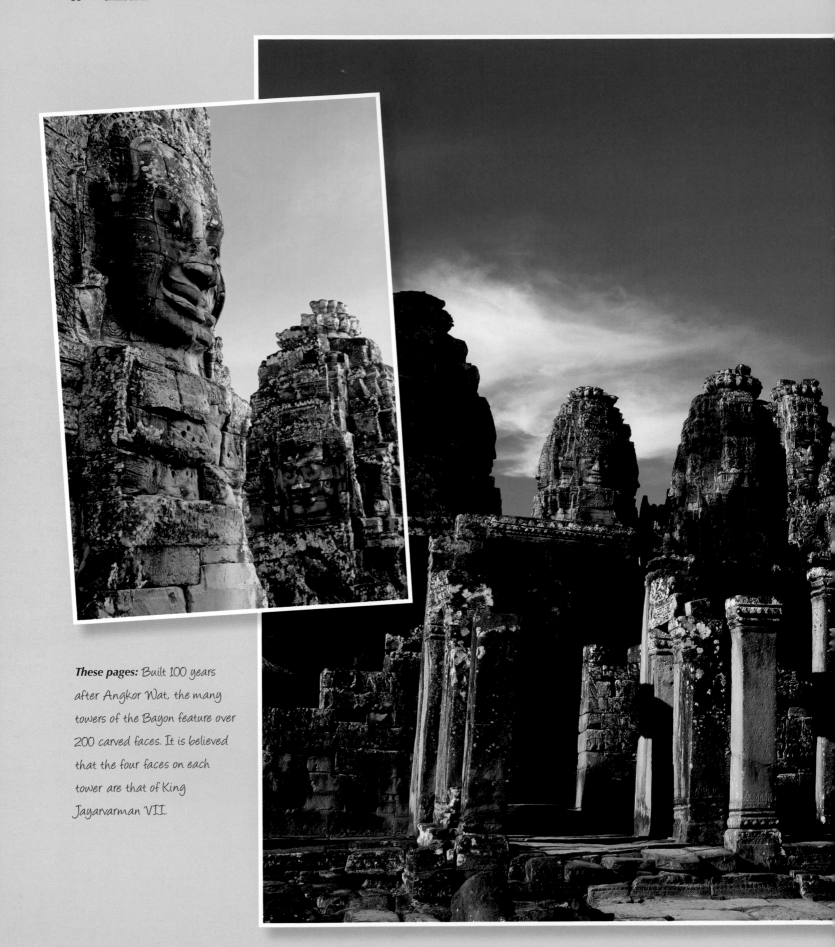

These pages: Built 100 years after Angkor Wat, the many towers of the Bayon feature over 200 carved faces. It is believed that the four faces on each tower are that of King Jayavarman VII.

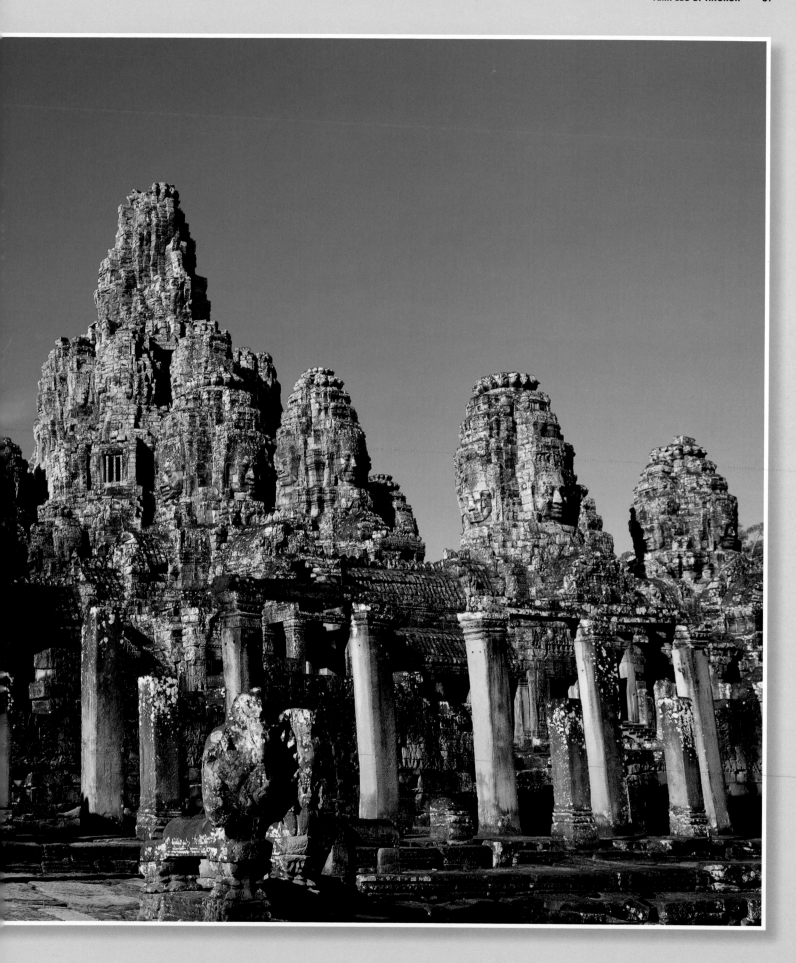

Ta Prohm

Ta Prohm is a sprawling temple complex and the site of some of Angkor's most memorable imagery. The main temple was lost to jungle for centuries. When the site was reclaimed, the massive trees that straddled the walls were left in place. It is a fascinating temple to explore and great for photography. Bayon and Ta Prohm were used as sets in the film *Tomb Raider*.

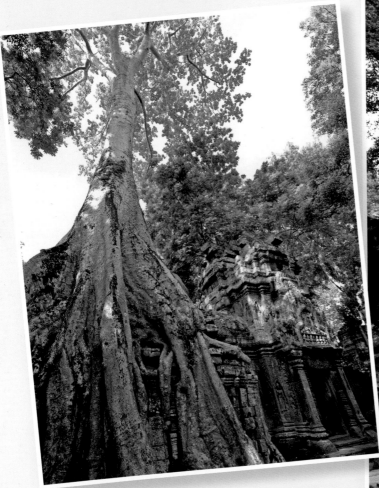

Above and right: Constructed from the mid-12th century to the early 13th century, Ta Prohm is one of the largest sites in Angkor. Inscriptions found at the site but now removed to a museum stated that Ta Prohm controlled 3,140 villages in the area.

Phreah Khan

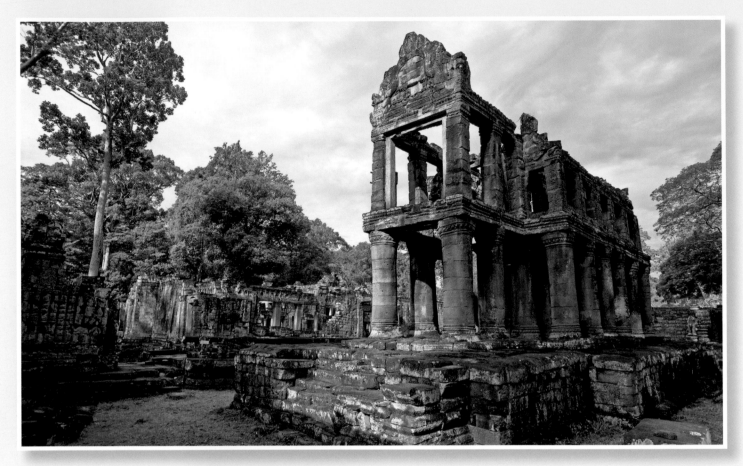

This page: Phreah Khan, meaning 'sacred sword' dates from around 1191 and was built during the reign of King Jayavarman VII. Although it is a Buddhist temple, it also features shrines honouring Hindu deities. Similar to Ta Prohm, Phreah Khan has been encroached upon by the forest. This, combined with its covered galleries and passageways, make it a very atmospheric temple to explore.

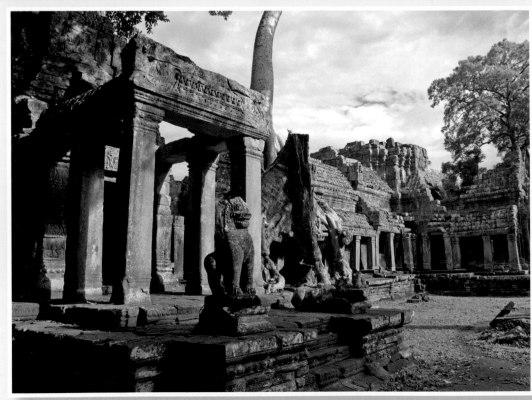

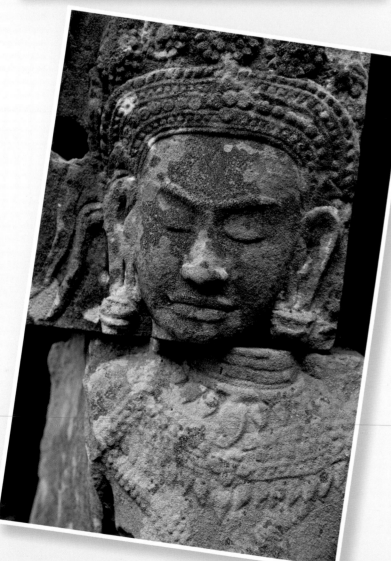

Above: The main sanctuary at Phreah Khan features four covered passageways, although many sections of the roof have now collapsed, leading to the central stupa.

Left: One of the joys of exploring the temples of Angkor is discovering exquisite carvings among the ruins.

Above left: Phreah Khan encompasses over 57 hectares (140 acres) and is accessed by a long paved causeway lined with carved figures of gods and demons.

Banteay Srei

There are several fine temples beyond Angkor, one of the best being Banteay Srei. It is worth taking the 38 km (24-mile) ride out here, if only to enjoy a drive through the beautiful countryside. The temple is constructed of sandstone that has a pinkish tinge and its delicate bas-reliefs are in excellent condition. Due to looting, the sculptures at the site are replicas. The remaining originals can be seen at the National Museum in Phnom Penh.

These pages: Banteay Srei, or the Citadel of Women, is a Hindu temple dedicated to Shiva. The temple has been dated to 967 and was rediscovered by the French in 1914. It features some of the most intricate and impressive carving to be found at Angkor. The pink sandstone temple is particularly beautiful in the early morning or evening light.

Battambang

The town of Battambang is 175 km (109 miles) west of Siem Reap. It is possible to hire a taxi and visit the town as a day excursion but an overnight stay is recommended. Visitors can enjoy a pleasant day wandering the streets of the old town, exploring temples and markets, and dining in open-fronted restaurants.

Below: Once an important administrative town for the French, Battambang has its own unique charm. Although some areas are rundown and neglected, many of the old buildings are now benefiting from restoration.

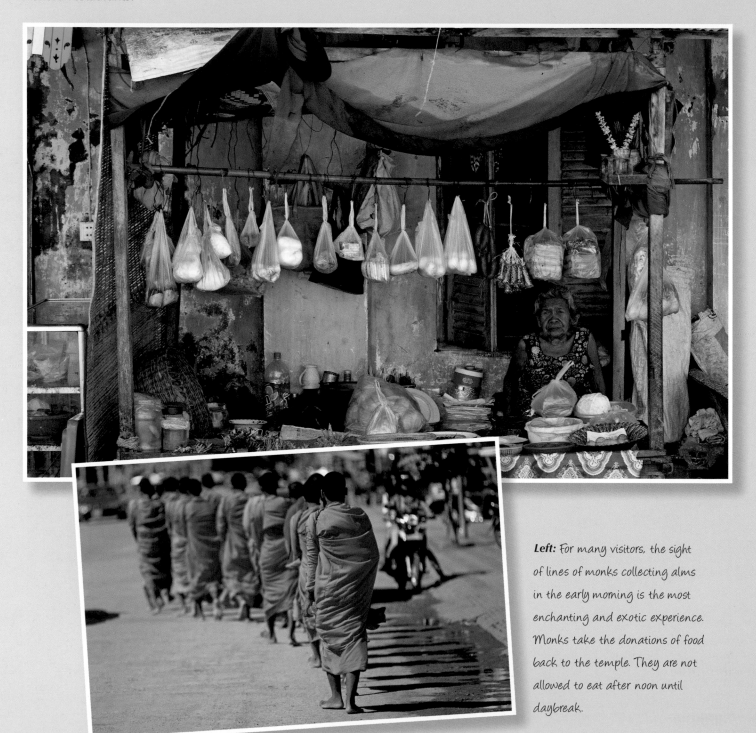

Left: For many visitors, the sight of lines of monks collecting alms in the early morning is the most enchanting and exotic experience. Monks take the donations of food back to the temple. They are not allowed to eat after noon until daybreak.

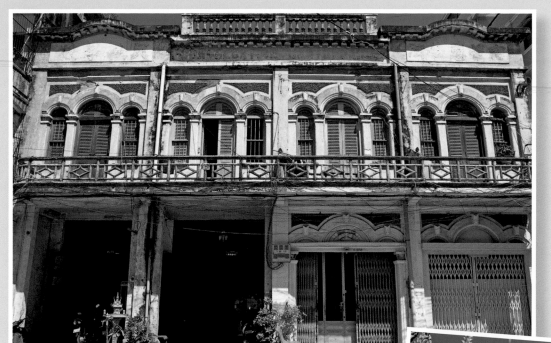

Left and below right:
Battambang has many of Cambodia's best preserved colonial-era buildings dating from the early 1900s and several beautiful old temples. The busy commercial town is also the second largest in Cambodia and sits at the heart of an area renowned as the 'rice bowl' of the country.

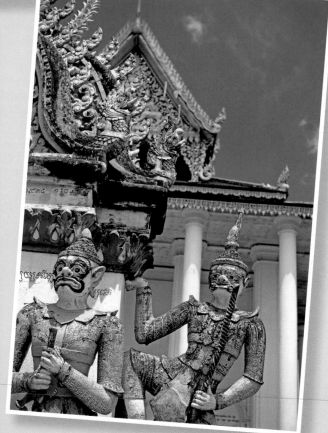

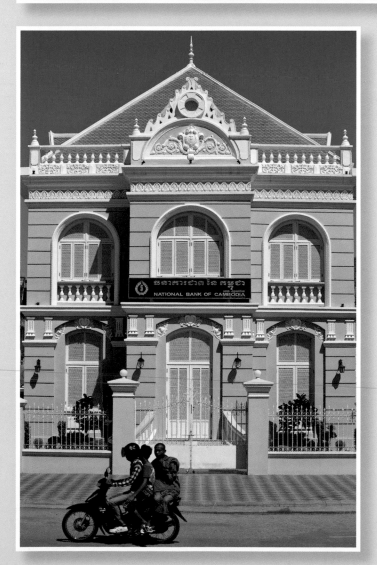

Left: This classic French period building on Battambang's riverfront and now owned by the Bank of Cambodia has been lovingly restored to its former glory.

SOUTH COAST

Cambodia is blessed with an extensive coastline of beautiful and mostly deserted beaches and islands. Popular getaways during the French colonial era, they exude an ambience of faded charm and life that moves at an unhurried pace. Still very much free of the commercialism and over development found in neighbouring Thailand, Cambodia's sleepy resort towns are once again finding favour with lovers of sun, sea and sand.

Sihanoukville

Sihanoukville is a port and resort town 160 km (100 miles) southwest of Phnom Penh. Visitors can enjoy empty beaches, fresh seafood, clear blue sea and nearby islands.

Right: Cambodia's southern coastline is lapped by crystal-clear waters. Boats wait at the jetty to take visitors out to near deserted islands.

Opposite: Ochheuteal Beach in Sihanoukville is becoming increasingly popular with overseas visitors. The three-kilometre (nearly two-mile) stretch of sand is lined with bars and restaurants serving freshly grilled seafood. Fishing boats offer trips to nearby islands.

Above: Ochheuteal Beach is the perfect place to relax and enjoy an ice-cold beer as the sun sets.

Left: A hawker at Ochheuteal Beach offers freshly cooked langoustine. Fishing boats along the coastline head out to sea in the early evening, returning at daybreak with their catch.

Right: Constructed in 1966, the monument of the two golden lions in Sihanoukville is the town's most distinctive landmark. It acts as a roundabout on the road to Ochheuteal Beach.

Opposite: The monument at Independence Square on Ekareach Street in Sihanoukville marks the country's liberation from colonial rule and honours its war dead.

Kampot

While the nearby resort town of Sihanoukville has long since woken up to tourism, Kampot still slumbers. With its quiet streets, riverfront cafés and bars and French colonial architecture, this enchanting town has a relaxed ambience and is easily explored on foot or by bicycle.

This page: Kampot is beginning to benefit from Sihanoukville's increasing number of visitors. The town makes an excellent base for a few day's relaxation and exploring Bokor National Park, waterfalls and farms growing the famous Kampot pepper. Tuk-tuks can be hired by the day or the hour and are a convenient and trouble-free way to get to see all the sights.

Kep

Kep is another delightfully laidback beach town with more faded French charm. Once a popular weekend destination for Phnom Penh's wealthy, the promenade is lined with abandoned villas that remind visitors of its former glory and future potential. A big attraction on the seafront is the Kep crab market. Each morning, Vietnamese girls gather on the promenade to sell their catch.

This page: From daybreak, girls haul their catch of fresh crabs onto Kep's promenade and crowds gather to barter for a good price. Every now and again, a basket will be returned to the water and a new one hauled ashore. Next to the crab market, a row of restaurants serves up a variety of seafood and, of course, crab.

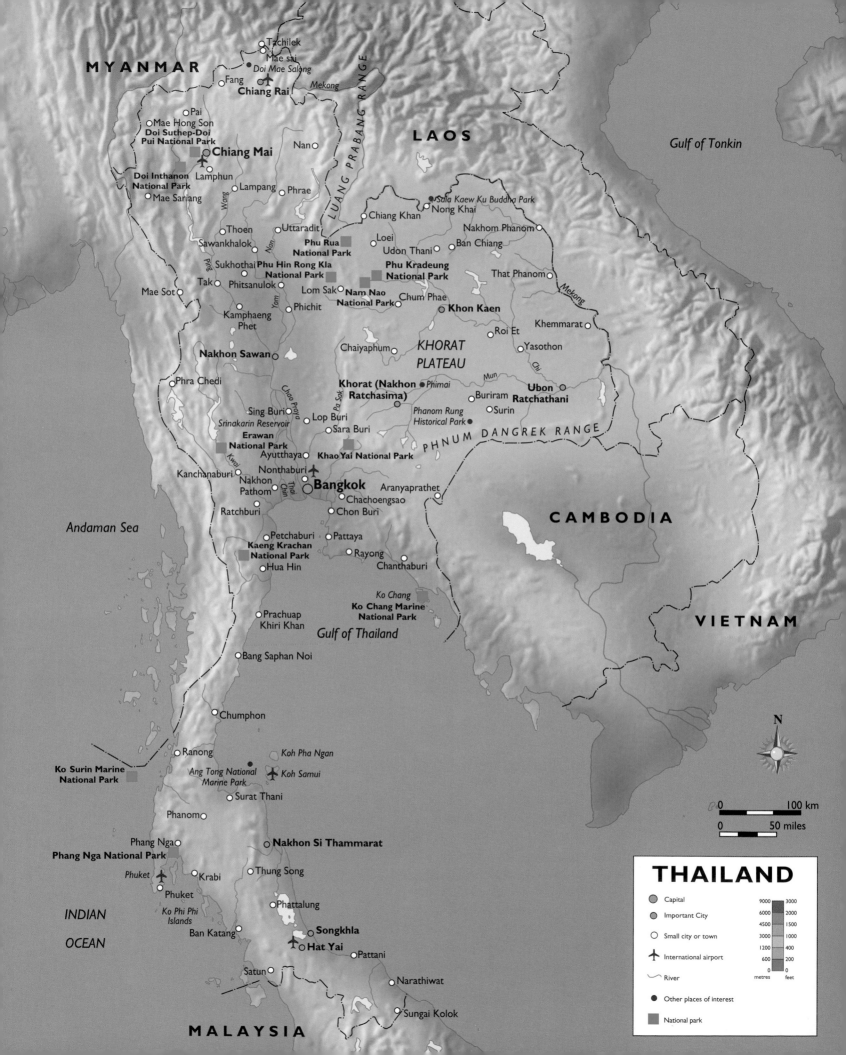

MYANMAR

Tachilek
Mae sai
Doi Mae Salong
Fang
Chiang Rai

Pai
Mae Hong Son
Doi Suthep-Doi
Pui National Park
Chiang Mai
Lamphun
Doi Inthanon
National Park
Mae Sariang

LAOS

Gulf of Tonkin

Nan

LUANG PRABANG RANGE

Mekong

Nong Khai
Sala Kaew Ku Buddha Park

Thoen
Uttaradit
Chiang Khan
Nakhon Phanom
Sawankhalok
Loei
Phu Rua
National Park
Udon Thani
Ban Chiang
Sukhothai
Phu Hin Rong Kla
National Park
Phu Kradeung
National Park
That Phanom
Tak
Phitsanulok
Lom Sak
Nam Nao
National Park
Chum Phae
Khon Kaen
Mekong
Mae Sot
Phichit
Khemmarat
Kamphaeng
Phet
Roi Et
Chaiyaphum
KHORAT
PLATEAU
Yasothon
Nakhon Sawan
Khorat (Nakhon
Ratchasima)
Phimai
Ubon
Ratchathani
Phra Chedi
Buriram
Surin
Sing Buri
Lop Buri
Phanom Rung
Historical Park
Srinakarin Reservoir
Sara Buri
PHNUM DANGREK RANGE
Erawan
National Park
Ayutthaya
Khao Yai National Park
Kanchanaburi
Nonthaburi
Nakhon
Pathom
Bangkok
Aranyaprathet
CAMBODIA
Ratchburi
Chachoengsao
Chon Buri

Andaman Sea

Petchaburi
Pattaya
Kaeng Krachan
National Park
Rayong
Hua Hin
Chanthaburi

Prachuap
Khiri Khan
Ko Chang
Ko Chang Marine
National Park
Gulf of Thailand

VIETNAM

Bang Saphan Noi

N

Chumphon

Ranong
Koh Pha Ngan
Ko Surin Marine
National Park
Ang Tong National
Marine Park
Koh Samui

Surat Thani

Phanom

Phang Nga
Nakhon Si Thammarat

Phang Nga National Park
Krabi
Thung Song
Phuket
Phuket
Ko Phi Phi
Islands
Phattalung

INDIAN
OCEAN
Ban Katang
Songkhla
Satun
Hat Yai
Pattani

Narathiwat

MALAYSIA
Sungai Kolok

0 100 km
0 50 miles

THAILAND

● Capital
● Important City
○ Small city or town
✈ International airport
〜 River
● Other places of interest
■ National park

metres	feet
9000	3000
6000	2000
4500	1500
3000	1000
1200	400
600	200

THAILAND

LAND OF INTRIGUE AND ADVENTURE

A country of intrigue and adventure, Thailand's exotic mix of glistening temples, extraordinary annual festivals, idyllic tropical islands and genuinely hospitable people has made it one of the world's most popular and rewarding tourist destinations. The country is home to a distinctive culture that enables old traditions to sit comfortably within a prosperous and progressive society, and which enriches the lives of all who visit.

One of the original 'Asian tiger economies', over the past two decades Thailand has survived boom and bust, undergone recovery and experienced political upheaval, yet, despite this turbulence, it still welcomes all travellers with a warm and gracious smile. Most visits to the country begin and end in Bangkok, a cosmopolitan and bustling metropolis of over ten million citizens. A city of contrasts, here ostentatious mega malls and towering skyscrapers overshadow serene temples and vibrant local markets, motorcycle taxis whisk businessmen to modern SkyTrain and underground stations, ferries carry them across the Chao Phraya River and chic restaurants compete for custom with delicious street-side dining. And then, of course, there's the notorious risqué nightlife at the infamous Patpong, Soi Cowboy and Nana Plaza. Big, bold and brash, Bangkok is truly a city that never sleeps.

Top: Although Thailand is developing extremely quickly, beneath the brash modern exterior and traffic-clogged streets there are pockets of calm and tranquillity that reveal the more spiritual side of Thai people.

Left: Thai temple architecture is extremely ornate and colourful. Even new temples built with the donations of worshippers still adhere to the forms and conventions of the past.

Rich Cultural Heritage

The northeast of Thailand, a group of 18 culturally diverse provinces collectively known as Issan, is one of the country's most fascinating, but little visited, regions. Here, travellers can discover ancient ruins such as Phimai, a temple structure that predates Angkor in Cambodia, and Khao Yai National Park, a haven for endangered wildlife. The north attracts adventure tourists and nature lovers who after a few days exploring the city of Chiang Mai head to the mountains and perhaps trek through inspiring scenery to gain insight into unique hill tribe cultures, go white-water rafting or enjoy more leisurely pursuits such as bird watching. Central Thailand contains the fascinating UNESCO World Heritage Site of Ayutthaya and paradise awaits travellers in the south where luxurious resorts and spas overlook the pristine white sand beaches and the crystal clear waters of the Andaman Sea.

Whether experiencing the vibrancy and creative energy of bustling Bangkok, exploring the rural heartlands of the northeast, discovering the hill tribes of the mountainous north, or simply lazing on a beach down south, the sheer variety of sights and sounds in enchanting Thailand are capable of creating memories to last a lifetime.

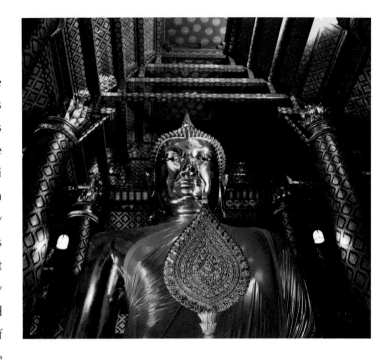

Above: Many temples feature enormous Buddha images that are an attraction for worshippers from all over the country who come to make merit by offering donations. The image pictured here is of a 19-m (62-ft) high Buddha at Wat Phanan Choeng in Ayutthaya.

Left: At the Poi Sang Long ordination ceremony boys entering the monkhood have their heads shaved and are dressed in beautiful costumes before being paraded through the town.

GEOGRAPHY & CLIMATE

Situated in the heart of Southeast Asia, Thailand encompasses an area of 513,115 km² (198,129 sq miles), bordering Laos to the north and east, Myanmar to the west, Cambodia to the east, and Malaysia to the south.

Thailand is divided into four main regions with a total of 77 provinces. The central plains are comprised of 24 provinces. A network of rivers and canals makes this the most fertile part of Thailand, supporting vast fields of rice, sugar palm plantations and a variety of fruits. In the northeast, commonly known as Issan, both Lao and Khmer influences can be seen and felt within the ancient temple ruins, and in the distinctive cuisine and the region's dialect.

The mountainous north is home to Thailand's hill tribe population. The region is also renowned for its unique

Above: Although many in Thailand's south are involved in the tourist industry, communities of fishermen who make their living from the sea still exist.

Left: Northern Thailand is known as the garden of the country and produces a wide variety of fruits and vegetables on the slopes of deforested hillsides.

Lanna cultural traditions and architecture that includes some of the country's most majestic temples.

Bound by the Gulf of Thailand and the Andaman Sea, the south is a beach paradise with beautiful islands scattered off the coast attracting visitors from around the world.

Thailand benefits from a tropical climate with average high temperatures of 35 °C (95 °F). There are three overlapping seasons; the monsoon lasts from May to October, when it turns moderate to cool until February. Temperatures and humidity then begin rise throughout the hot season, peaking in April.

Above left: Promthep Cape on the island of Phuket is a popular location to enjoy fabulous sunsets. Located at the southernmost tip of the island, the viewpoint on the rocky cape is fringed by tall, elegantly proportioned sugar palms.

Above right: Orchids are grown commercially in the north but the forests are also the habitat of rare wild species.

Right: Much of rural Thailand's central plains and the northeast are given over to rice paddies.

A BRIEF HISTORY OF THAILAND

Thailand has a long and fascinating history. Archaeological excavations in the northeast indicate that there were people living in the area over 2,000 years ago. The most famous discovery in recent years was the prehistoric find at Ban Chiang. Here, during the mid-1960s, a wide range of earthenware pots were discovered, the earliest believed to date from 2100 BC while production continued up until AD 200. Other archaeological sites of significance have been unearthed at Baan Prasat near Khorat in northeastern Thailand and Baan Koh Noi near Sukhothai.

By the 6th century Dvaravati period, thriving agricultural communities had been established as far north as Lamphun and south to Pattani. The collection of city states lasted until the 11th century when it quickly declined under the political domination of Khmer invaders.

Thailand's Sukhothai period from 1238 to 1438 is regarded as the beginning of Thai history. At its height, the kingdom is thought to have wielded dominance from Nakhon Si Thammarat in the south, to Luang Prabang in northern Laos, and Martaban in Myanmar. Sukhothai is considered by historians to be the first true Thai kingdom and, with nine kings ruling over two centuries, a stable period of history. King Ramkhamhaeng, the second king, established a system of writing which became the basis for the modern Thai script. The king also promoted Buddhism which gave birth to classic forms of Thai religious art.

The production of glazed ceramic wares was extremely important to the economy of Sukhothai. Pots from the many kilns just outside the city and in nearby Sri Satchanalai were exported all over the region. To this day, sunken trade vessels in the Gulf of Thailand and in Malaysian waters continue to be discovered by marine archaeologists and reveal yet more secrets from the Sukhothai period.

Above right: Elephant imagery was commonly used in Sukhothai period religious architecture. This picture shows one of 24 elephants that surround the 'chedi' at Wat Sorasak, a 15th-century temple just north of the old city.

Right: Wat Phra That Lampang Luang is said to be the oldest wooden temple in Thailand, dating back to 1476. Inside, wooden panels depict scenes from the Buddhist scriptures and show foreigners being welcomed.

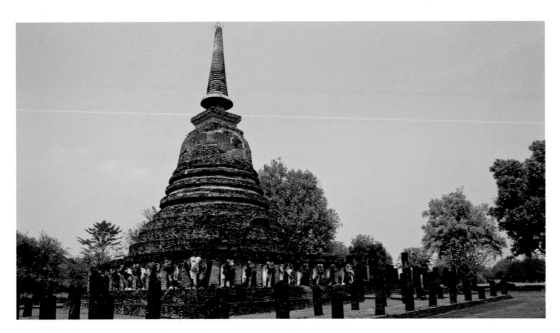

Left: The Sukhothai Historical Park covers a vast area and is best explored by bicycle. The central area is surrounded by a moat and features 21 magnificent temples.

Below: In Chiang Rai, a bronze statue has been erected to honour King Mengrai (1259–1317).

Rise & Fall of Ayutthaya

Following the death of King Ramkhamhaeng, Sukhothai's influence began to decrease. With the demise of King Thammaracha in 1438, the last king of Sukhothai, the kingdom became a province within the now dominant kingdom of Ayutthaya.

During the 14th and 15th centuries, Ayutthaya became increasingly powerful and its rule began to expand its reach eastward to include Angkor in Cambodia. By the mid-16th century Ayutthaya was sacked by an invading Burmese army and, along with Lanna in north Thailand, came under their control. Although Thais regained both areas by the end of the century, Burma invaded Ayutthaya again in 1767, winning a fierce two-year battle. During this time large numbers of Ayutthaya's manuscripts, religious sculptures and temples were destroyed.

New Capital in Thonburi

In 1769, after the fall of Ayutthaya, a new Thai capital was established at Thonburi. Set on the banks of the Chao Phraya River opposite present-day Bangkok, Thonburi was ruled over by King Thaksin. With the kingdom still in turmoil, Thonburi remained the capital for just 15 years, collapsing because of disorder at the end of his reign.

Below left: *After Sukhothai, Ayutthaya is considered Thailand's next most important historical site. Built in 1357, Wat Yai Chai Mongkhon features an enormous 'chedi' and Buddha images.*

Below: *Even though the temples fell into disrepair centuries ago, the Buddha images are still revered, being regularly draped in yellow robes and given offerings of incense and flowers by worshippers.*

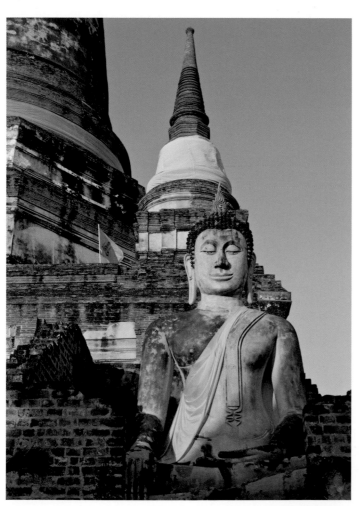

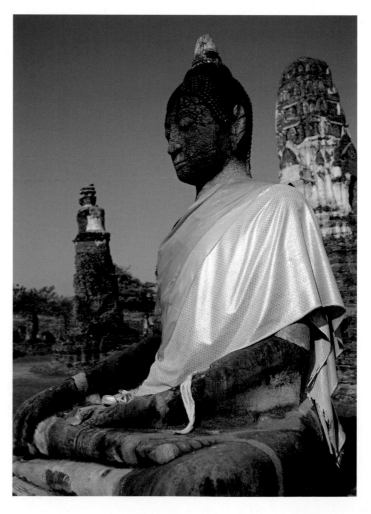

Ratanakosin Period to the Present Day

In 1782 King Rama I was crowned. As the first king of the Chakri dynasty, he promptly moved the capital across the river to Bangkok. In 1809 Rama II, son of Rama I, took the throne and ruled until 1824. King Rama III (ruled 1824–51) began to develop trade with China and increase domestic agricultural production.

King Mongkut, Rama IV took the throne in 1851 and quickly established diplomatic relations with European nations and used his skill to avoid colonization. He also began a period of trade reform and modernization of the Thai education system. His son, King Chulalongkorn, Rama V (ruled 1868–1910), continued this tradition with

the modernization of the legal and administrative systems, and the construction of railways. During his 15-year reign from 1910 to 1925 King Vajiravudha (Rama VI) introduced compulsory education and other reforms.

In 1925 the brother of King Vajiravudha, King Prajadhipok Rama VII (1925–1935) ascended the throne. Seven years later, a group of soldiers and civil servants mounted a bloodless coup d'état which led to the establishment of a constitutional monarchy. A key military leader, Phibul Songkhram, took power and maintained control until after the end of the Second World War. Rama VIII, Ananda Mahidol, became king in 1935 but was assassinated in mysterious circumstances in 1946. He was succeeded by his younger brother, Bhumibol Adulyadej, Rama IX. In the same year, under Rama IX's reign, the country's name was officially changed from Siam to Thailand or in the Thai language, *prathet Thai*, literally 'land of the free'.

His Majesty King Bhumibol Adulyadej, Rama IX remains on the throne today. Highly revered by the Thai people, he is the world's longest reigning monarch.

Left: Thailand's king is deeply revered and his image is to be seen everywhere.

Above: In central Bangkok a road has been named to proclaim the people's feeling for the king.

BANGKOK

Bangkok, or *Krung Thep* as it is known to locals, is all things to all people. Here, the modern world collides with deep-rooted culture and traditions. Rise early and witness Buddhist monks collecting alms from local shopkeepers, or find the young and old in quiet contemplation within the grounds of a secluded temple before heading to school or work. The morning rush sees workers crossing the mighty Chao Phraya in river taxis, commuting by bus, or travelling above the city streets in the air-conditioned comfort of the SkyTrain to avoid nightmarish traffic congestion. A city of many charms, even those who are not easily seduced end up falling for Bangkok.

Below: In the past few years the quality of life in Bangkok has improved immensely. Gone are the days when visitors spent a night in the city and moved on. Bangkok is now a destination in its own right.

Below: Bangkok's layout and architectural style often leave visitors bemused but there are some truly impressive structures such as Bhumibol Bridge on Rama III Road.

Above: Bangkok's skyline is constantly evolving. In recent years a series of elevated walkways linking SkyTrain stations with shopping malls and office blocks has been constructed.

Above: The SkyTrain carries commuters above the congestion, making the city a breeze to get around. There is also an efficient underground system called the MRT.

Left: The eight-lane Sathorn Road passes through the heart of Bangkok's financial district.

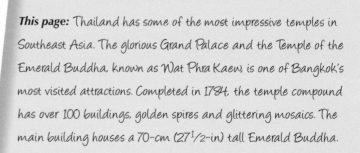

This page: Thailand has some of the most impressive temples in Southeast Asia. The glorious Grand Palace and the Temple of the Emerald Buddha, known as Wat Phra Kaew, is one of Bangkok's most visited attractions. Completed in 1784, the temple compound has over 100 buildings, golden spires and glittering mosaics. The main building houses a 70-cm ($27^1/2$-in) tall Emerald Buddha.

Opposite page: Wat Arun, or the Temple of the Dawn, is situated on the banks of the Chao Phraya River and can be reached by boat. The 79-m (259-ft) pagoda is decorated with fragments of porcelain plates and bowls. The temple is particularly beautiful at sunset or when viewed from the deck of an evening rivercruise boat.

Right: Wat Pho, or Wat Phra Chetuphon as it is also known, is famous for a huge Reclining Buddha. The 46-m (151-ft) long and 15-m (49-ft) high figure was constructed in 1832. The Buddha is in the position of passing into nirvana. The enormous feet feature mother-of-pearl inlay decoration showing the 108 auspicious characteristics of Buddha.

Above: Situated on an 8-hectare (20-acre) site, Wat Pho is also one of the largest in Bangkok. Wat Pho is also a centre for the teaching of traditional Thai medicine and massage.

Right: The temple has 95 'chedis' of varying sizes, the largest of which were built to commemorate the first four kings of the Chakri dynasty.

Left: The Giant Swing, or Sao Ching Chor, is a distinctive Bangkok landmark. Once used in Brahmanic ceremonies long since discontinued, the original swing was replaced in 2007 to honour the King of Thailand. Nearby shops around Bamrung Muang Road sell Buddha images and religious supplies making it a fascinating area to explore.

Above: Wat Suthat is renowned for 19th-century murals and a beautiful 13th-century 8-metre (26-ft) tall bronze Buddha image with the ashes of King Rama VIII in its base. In the cloisters there is also an unusual black Buddha image.

Left: Wat Benchamabophit, also known as the Marble Temple, is unusual in that it is one of the few temples in Thailand to feature western-style stained glass windows with Buddhist imagery. It also has beautiful old monks' quarters.

Above: Bangkok's Chinatown is a bustling district of crowded alleyways, restaurants, gold shops and temples. During the cooler months visitors may also be lucky enough to see an outdoor performance of a traditional Chinese opera.

Right: If you think Bangkok always moves at full speed, rise early and head along to Lumpini Park and watch the Chinese locals exercising or practising their controlled 'tai chi' moves in the shade.

Above: Jim Thompson House is the beautiful former home of the late American silk trader. The house – now a museum – consists of several traditional teak houses brought together to make one splendid home.

Left: Vimanmek Teak Palace is the world's largest teak building. It was originally constructed for King Rama V in 1868 as a summer palace on the island of Koh Si Chang but relocated to the current site in 1910.

THE CENTRAL PLAINS

A network of rivers flowing down from the north feed into the 24 provinces that make up the central plains; a flat and fertile region known as the 'rice bowl' of the country. The region also has many manmade waterways that are used for irrigating the fields and navigating the vast area.

Ayutthaya

Ayutthaya is one of the most culturally and historically interesting towns within easy reach of Bangkok. The ancient ruins have been encroached upon by the new town, creating an interesting blend of ancient and modern.

Above: The 'chedi' at Wat Yai Chai Mongkhon is surrounded by lines of Buddha images draped in saffron robes. The temple was built at the request of King U Thong in the 14th century.

Below: *Wat Yai Chai Mongkhon is one of the most impressive 'chedis' within the Ayutthaya Historical Park. Visitors to the site can climb up the steps and enjoy fabulous views from the base of the central 'chedi'.*

THE EASTERN SEABOARD

The eastern region of Thailand comprises the provinces of Chonburi, Rayong, Trat, Chanthaburi, Chachoengsao and Prachinburi. The area is extremely varied and includes industrial zones in Chonburi, and the beach resort city of Pattaya, along with beautiful countryside.

Pattaya

Set beside a glorious sweeping bay and a white sand beach, Pattaya is a favourite destination for those wishing to flee Bangkok at weekends and for long-haul travellers seeking fun in the sun. At night, Pattaya comes alive. The city is transformed from a quiet town into a noisy and neon-lit warren of bars and massage parlours.

Above: In the 1970s, Pattaya was nothing more than a small fishing village. Today it is a booming city known as the party capital of Thailand. In recent years, the Tourist Authority of Thailand has tried to clean up Pattaya's image, but without conspicuous success.

Left: Those seeking to get away from the crowded beaches of Pattaya and its rowdy nightlife can take a trip to nearby Koh Lam.

WESTERN THAILAND

Western Thailand encompasses many interesting provinces, some of which are a comfortable driving distance from Bangkok. Highlights include Prachuap Khirikhan and the royal resort town of Hua Hin, and Kanchanaburi, the location of the infamous bridge over the River Kwai built by POWs in the Second World War.

Much of western Thailand is a flat and fertile expanse of land covered with fruit trees and coconut palm plantations and is irrigated by an extensive network of canals. Samut Songkhram Province is well irrigated and as a result intensely agricultural. The area is renowned for coconut palms, guava, lychees and in recent years a vineyard. Salt is processed in a series of man-made lakes and there are also several floating markets in the area.

Above: Rise early in the morning and you'll see monks walking down the beach at Hua Hin to collect alms from locals and hotel guests.

Left: There are several floating markets in the western region and within easy driving distance of Bangkok. Nowadays they function purely as a tourist attraction.

Hua Hin

As the location of the King of Thailand's summer palace, Hua Hin had always found favour with wealthy Bangkok Thais long before it was discovered by Western tourists. Today, it is not just big city Thais slipping away for a weekend of clean air and fresh seafood who visit the town. Hua Hin is now squarely on the map as a premier holiday destination and is attracting visitors from around the world. Hua Hin is an excellent family destination, a paradise for golfers and an idyllic place for retirees wishing to escape the dark and cold European winters.

Below: Hua Hin Hills Vineyard produces some of Thailand's better quality vintages, namely Monsoon Valley Wine. Visitors can enjoy wine tasting in the restaurant and elephant rides through the vines.

Above right: The beachfront is lined with seafood restaurants and international five star resorts.

Right: The beautiful railway station is one of the oldest, best-preserved examples in Thailand.

Kanchanaburi & the River Kwai

Bordering Myanmar, Kanchanaburi Province is home to the infamous bridge over the River Kwai and the haunting museum dedicated to the memory of those who perished constructing the Death Railway for the Japanese during the Second World War. It is hard to reconcile the brutality and suffering endured here with the region's beauty, yet it is heartening to see just how many people travel from around the world to pay their respects.

Top right: *Two well-tended cemeteries in the centre of Kanchanaburi are the last resting place of the thousands of soldiers who lost their lives in the Second World War.*

Above: *Although this is not the original bridge over the River Kwai, the structure that now spans the river is lit up every night and creates a beautiful, if thought-provoking, sight.*

Above: *Visitors to Kanchanaburi can travel by train through beautiful countryside to the Hellfire Pass Memorial Museum, an honourable tribute to the war dead.*

NORTHEAST THAILAND

The northeast of Thailand consists of 18 culturally diverse provinces collectively known locally as Issan. Culturally rich and populated by fun-loving, resilient and hard-working people, Issan is one of the country's most fascinating regions but also the least visited. With only two per cent of tourists visiting the northeast, many travellers to Thailand are missing out on a beautiful and distinctive part of the kingdom.

Below left: A street-side vendor sells bundles of lemongrass, ginger, coriander and other essentials of Thai cuisine.

Khorat

Khorat, also known as Nakhon Ratchasima, is the gateway to Issan and is the northeast's largest city. Although the province is largely rural and undeveloped, the city itself has benefited from commercial investment and attracted migrants from towns and villages across the northeast. The surrounding districts have much to offer visitors, including Phimai, one of Thailand's most impressive ancient temples.

Left: The old town of Khorat was once enclosed by a defensive wall. Only small sections remain. During the 14th century, Khorat and nearby Phimai were under the rule of the Khmer empire.

Above: Regional Issan food is loved all over Thailand. Famous dishes include the spicy papaya salad, 'som tam', and grilled chicken or 'gai yang'. In the northeast, sticky rice is preferred to steamed rice.

Left: Although hypermarkets are changing shopping habits in Thailand, morning markets in Khorat are extremely popular. Locals come each day to buy freshly cooked food for their breakfast as well as fresh vegetables, fish and meat.

This page: A shrine in front of Khorat's western gate honours Thao Suranaree, a heroine who is said to have helped defeat Lao invaders by getting them drunk (above left). A festival is held to celebrate the occasion every March. In Khorat, and many other rural towns, samlors, three-wheeled bicycles, are still used to transport produce and people (below).

Located 15 km (9 miles) from Khorat, the town of Dan Kwien is known for producing earthenware pottery (above right). Although pots have been produced in the area since the 15th century, today the work is anything but traditional. Dozens of stalls line the road selling all kinds of decorative items for the home.

Phimai Temple

Issan is scattered with remarkable ruins that chart its fascinating history. Of the many ancient temple sites, the most spectacular is Phimai, not far from the booming town of Khorat. Easily reached from Khorat by bus, the ruins of Phimai are an essential part of any itinerary for the northeast. The temple structure is actually Khmer and predates Angkor in Cambodia. During the glory days of the Angkor Empire, Phimai was directly connected by road to Angkor.

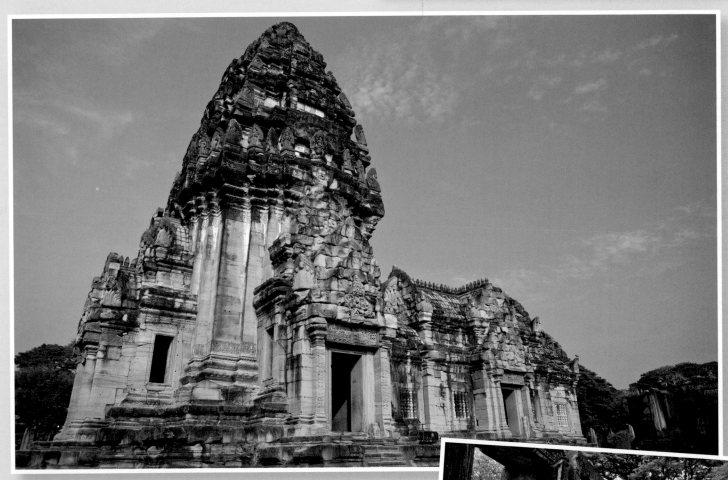

This page: During the Khmer period, Prasat Hin Phimai was an important temple. Construction is believed to have been carried out in the 10th century under the orders of the Khmer King Suryavarman I. The ancient monument is laid out in a rectangle measuring 565 by 1,030 m (1,854 by 3,379 ft) and is surrounded by a moat. The structure is the largest and arguably the most impressive stone edifice in all Thailand. The outer walls and the lintels of the tower are decorated with exquisite carvings depicting episodes from the Ramayana.

Buriram

Buriram is one of Thailand's larger provinces and a former centre of Khmer culture. A highlight of any visit to this area is Phanom Rung Historical Park, a magnificent Khmer site dating back over 1,000 years to the Angkor period. The impressive stone ruins of Phanom Rung are the finest example of Khmer monuments in Thailand.

Ubon Ratchathani

In the southeast of Issan the town of Ubon Ratchathani marks the start of the rainy season retreat with Thailand's largest and most spectacular candle festival. The event includes a candlelit procession of intricately carved beeswax candles, many of which are several metres tall, and commemorates Buddha's first sermon after attaining enlightenment more than 2,500 years ago.

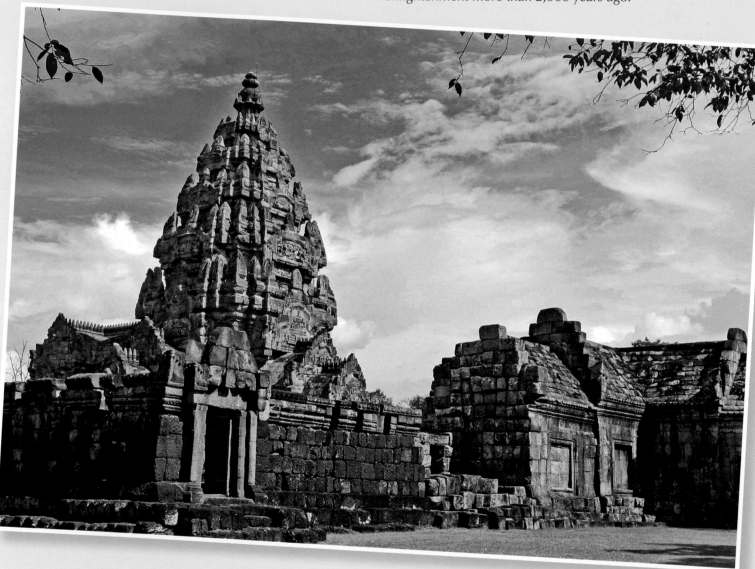

Above: Situated on the site of an extinct volcano, Phanom Rung was originally a religious site for Hindu worship but later became an important Buddhist temple. Further additions were made during the 15th–18th centuries. Recently the ancient temple has benefited from significant restoration work carried out by Thailand's Fine Arts Department.

North of Issan

The northern reaches of Issan should not be overlooked by travellers. In Nong Khai visitors can enjoy evenings dining beside the Mekong River and cross into neighbouring Laos via the Friendship Bridge. There's also the stunning Sala Kaew Ku Buddha Park to explore. Further west in Loei, one of Thailand's least visited but most beautiful provinces, attractions include the Phu Kradeung National Park. During the cool season, Thais come to climb Phu Kradeung Mountain and enjoy the views and pleasant climate.

Above: Just outside Nong Khai, the impressive Thai-Lao Friendship Bridge opened in 1994. Spanning 1,170 m (3,840 ft) across the Mekong River, the bridge now includes the first rail link between Thailand and Laos. The bridge was also instrumental in transforming Nong Khai from a sleepy and seldom visited riverside town into a popular travellers' stopover with many floating restaurants and bars.

Below: Created in 1978 by the shaman, Bounleua Sulilat who fled Laos during the country's political upheaval, the enormous sculptures in Sala Kaew Ku Buddha Park are an intriguing mix of Hindu and Buddhist imagery. Before coming to Thailand, Bounleua had also built the Xieng Kuan Buddha Park outside Vientiane.

NORTHERN THAILAND

The north of Thailand is a beautiful, mountainous, forest-covered region bordering Myanmar and Laos. It consists of 18 provinces including Chiang Mai, Chiang Rai, Nan and Mae Hong Son. Farming flourishes in the fertile northern valleys and the area produces much of Thailand's annual crops of fruits and vegetables.

Many people travel to Chiang Mai and the north for trekking in the mountains. The area is populated by six major hill tribes, the Karen, Hmong, Lahu, Yao, Akha and Lisu. Each tribe has distinctive clothing, customs and language. Popular attractions also include elephant camps, orchid farms and stunning temples.

Below: Northern Thailand's rolling hills and beautiful scenery attract nature lovers and cultural travellers. A network of excellent roads winds through the hills and a jeep or motorcycle hired in Chiang Mai offer excellent ways to explore the region. The cool season months of November to February are the best time to visit the north when the mornings and evenings are pleasantly chilly, but the afternoons warm.

Left: There are several elephant camps around Chiang Mai, the best of which is the award-winning Elephant Nature Park in Mae Taeng district. The founder, Lek Chailert, was named 'Asian Hero of the Year' by 'Time' magazine. The park endeavours to let the elephants live as natural a life as possible.

Above: Orchids flourish in the highlands of northern Thailand. There are many farms selling cultivated orchids in the Mae Rim district of Chiang Mai.

Sukhothai & Baan Koh Noi

Home to magnificent temples, ruins and monuments, the Sukhothai Historical Park is a UNESCO World Heritage Site and draws thousands of visitors every year. The historical park is divided into five zones that can be explored by bicycle. The Ramkhamhaeng National Museum within the site gives visitors an interesting historical perspective and is a good starting point before exploring the park. Nearby Baan Koh Noi receives fewer visitors, but is also home to impressive temple ruins.

Below: Sukhothai is located 427 km (265 miles) north of Bangkok and 300 km (186 miles) south of Chiang Mai. In November it is also the site of the biggest Loy Kratong festival.

Right: The hand of the huge Buddha image at Wat Si Chum in Sukhothai is covered with gold leaf rubbed onto the fingers by the thousands of worshippers who pray before it.

Left: Less visited than Sukhothai, but nevertheless well worth seeing, are the temple ruins at Baan Koh Noi. An hour's drive from Sukhothai, the site has many impressive temples, an interesting museum and many ancient kilns where high quality pottery was produced.

Below: Approaching Wat Si Chum along the pathway, the face of the enormous Buddha is first glimpsed through an opening in the front wall. The temple is located outside the walls of the old city at the northwest corner.

Lampang

Legend has it that the northern town of Lampang was once called Kuk Kutta Nakorn, meaning 'city of the white cockerel'. Today, the town is famous for ceramics with a distinctive chicken motif, and as being the only town in Thailand with horse-drawn carriages.

This page: The lovely northern town of Lampang should not be overlooked. It has much of interest to captivate visitors for several days. The most famous temple in the area is Wat Phra That Lampang Luang which features a 45-m (148-ft) 'chedi' (above left). In the reign of King Rama VI the first railway line from Bangkok to the north of Thailand was completed and on 1 April 1916 Lampang station opened. One of the early steam trains still stands outside the station. Today, travellers can alight at Lampang and explore the town before heading further north to Chiang Mai. Years ago, Chinese settlers established ceramics workshops producing noodle bowls. Today, Lampang is the centre of Thailand's ceramics industry with many factories located on the outskirts of town.

Chiang Mai

Chiang Mai is the largest city in the north and is a provincial capital. Chiang Mai's tree-lined streets, stunning temples, historic sites, bustling markets and varied nightlife make it one of the nicest cities in Thailand to visit.

This page: The northern provincial capital, once a sleepy backpacker haven, has expanded rapidly in recent years. Yet despite the obvious challenges associated with rapid development, Chiang Mai remains a city of character and a province of undeniable beauty. The distinctive Lanna culture and the easygoing charm of the northern people are huge natural assets. The city wins the hearts of all who visit. Attractions include Doi Suthep, a 1,600-m (5,249-ft) peak overlooking Chiang Mai and the site of the famous temple Wat Phra That Doi Suthep. Another famous temple, Wat Chedi Luang, was constructed in the 15th century but an earthquake in 1545 destroyed the massive 'chedi'. Even what remains today is a remarkable sight. The Ping River flows through the centre of Chiang Mai. Visitors can enjoy trips down the river and dinner cruises in the evening when the air is cooler. Alternatively evenings can be spent dining in riverside restaurants or shopping for unique local crafts in the markets.

Chiang Rai

Known as the 'Gateway to the Golden Triangle', the city of Chiang Rai lies in a fertile valley 180 km (112 miles) north of Chiang Mai. The town has a less commercial feel than Chiang Mai and consequently a more relaxed atmosphere. Mountainous and bordered by the mighty Mekong River, Chiang Rai Province is a playground for those seeking adventure and stunning scenery.

This page: Wat Rong Khun is one of Chiang Rai's most spectacular attractions. This beautiful temple is the ongoing work of the renowned Thai artist, Chalermchai Kositpipat, and skilfully blends traditional Buddhist art with modern concepts. The unique building is entirely white and decorated with thousands of pieces of mirrored glass. Inside, it contains murals and paintings with some very surprising imagery. Outside, a hole with dozens of hands reaching upwards for help is the artist's interpretation of hell. The temple also includes artworks that warn about the dangers of smoking and drinking. Located 13 km (8 miles) from Chiang Rai, Wat Rong Khun is particularly impressive when visited on the night of a full moon.

Golden Triangle

Once renowned for opium production, the Golden Triangle, known locally as Sop Ruak, is now a major tourist destination. Today's legal vice is gambling and here, where the borders of Laos, Myanmar and Thailand converge, many cross into the neighbouring countries to try their luck at the tables of the casinos.

This page: Nine kilometres (5¹/₂ miles) from the historic town of Chiang Saen and at the confluence of the Mekong and Ruak Rivers, the Golden Triangle is an area of outstanding natural beauty. At a local temple, visitors can enjoy views over Laos and Myanmar. Nearby, the Hall of Opium recounts the Golden Triangle's infamous past and also serves as a drug education centre. The fascinating museum also includes an information centre for research and education on opium, opiates and other narcotics. The museum is one of the best in Thailand and has received several awards. The area is home to many hill tribes, particularly Akha (shown here) who used to be involved in opium production. Today they make a living from growing crops such as sweetcorn, pineapple and cabbage or selling their handicrafts.

Doi Mae Salong

Doi Mae Salong is a historic village situated in a beautiful mountain setting north of Chiang Rai. With an elevation of 1,800 m (5,905 ft) , a trip to the area ensures breathtaking panoramic views and dramatic sunsets. The air is refreshing all year round and from November until February it can be quite cold. Doi Mae Salong mountain range is renowned for its tea plantations cultivated by local hill tribes.

Top right: The road from Chiang Rai winds through stunning countryside, eventually arriving at the tea plantations.

Above: There are many Akha and Lisu settlements in the area whose inhabitants work in the tea plantations.

Left: Wat Acha Tong, or the Temple of the Golden Horse, was established by an ex-Thai boxer turned Buddhist monk to help care for orphans. The monks are renowned for collecting alms on horseback.

Mae Hong Son

The provincial capital of Mae Hong Son is a scenic and vibrant town and a centre for tourists seeking adventure in the surrounding mountains. The townspeople are predominately Shan, also referred to as Thai Yai, and local temple architecture shows the strong influence they have exerted over the region in the past. Hill tribe people scattered throughout the mountains and frequently seen in the town's markets include Karen, Lisu, Lahu and Musoe. Mae Hong Son is one of the country's premier destinations for trekking and soft adventure.

This page: The road from Chiang Mai to Mae Hong Son and onward to Mae Sariang is nothing short of spectacular, boasting hundreds of hairpin bends as it winds through the thrilling mountainous terrain. It is understandably popular with adventure motorcyclists and 4-wheel-drive enthusiasts who also take advantage of the numerous dirt trails that lead off into more remote areas. The rewards are great; Mae Hong Son has a unique character, people and cuisine that make it one of Thailand's most fascinating regions.

SOUTHERN THAILAND, ISLANDS AND BEACHES

The south of Thailand encompasses many of Thailand's most popular holiday destinations including Phuket, Thailand's largest island.

Phuket

Phuket (pronounced *pooket*) is Thailand's largest island (930 km²/360 sq miles – about the size of Singapore) and is known as the Pearl of the Andaman. The interior of Phuket is tree-covered and hilly with land rising to over 500 m (1,640 ft). In the lowland areas there are many rubber and coconut plantations, once an important occupation for islanders but now increasing sidelined by tourism.

This page: Famous beaches include Kata Beach, one of the most beautiful in Phuket. The fabulous stretch of sand is washed by crystal clear waters and lined with palm trees. Surin Beach occupies a curved bay below the foothills north of Kamala. The area is dotted with some of Phuket's most prestigious resorts and high-end boutiques. This has given the quiet and beautiful beach an air of exclusivity – a world away from brash Patong. With a large marina on the island, Phuket attracts members of the international yachting fraternity and also plays host to a huge annual regatta.

Right: A Buddha image in a recess of the outer wall at Wat Chalong. Dedicated to two venerable monks, this is considered to be Phuket's most important temple. In 1876 when Chinese tin miners on the island rebelled, it is believed that they sought sanctuary in Wat Chalong.

Phuket Town

Phuket Town is the island's commercial centre and is situated to the southeast of the island. Despite the recent boom in modern development, the town is still home to some splendid Sino-Portuguese architecture.

Below: The historic Phuket Town is a charming area to explore. Wander down the Dibuk, Thalang, Phang Nga, Yaowarat and Krabi roads to discover Phuket's past.

Right: Phuket has some of Thailand's finest examples of period architecture but it is only in recent years that this has started to be valued as a local asset. Even so, many buildings are still in need of protection and restoration.

Patong

Patong is Phuket's most famous and most developed beach. For some it is the heart and soul of a holiday in Phuket, for others a tourist trap that is best avoided. The 3-km (2-mile) long stretch of sand is lined with shops, bars and good seafood restaurants, and also offers great leisure activities including windsurfing and kite surfing, sailing, swimming and sunbathing. Patong also has a reputation as the centre of Phuket's vibrant nightlife. It is here that you will find most of the rowdy pubs, clubs and go-go bars.

This page: Of the six beach districts of Phuket that offer evening entertainment, Patong is by far the liveliest. By day, the shoreline buzzes with the sound of jet skis and the sky is filled with paragliders towed by speedboats. At night, Bangla Road and Soi Sunset are packed with bars and western-style nightclubs while Soi Sea Dragon is home to some raunchy entertainment and the majority of the go-go bars. This is definitely not the destination for those in search of a quiet beach holiday, Thai culture or authentic cuisine.

Phang Nga

Phang Nga Province is blessed with turquoise waters and striking rock formations. As the location of the famous James Bond island in *The Man With The Golden Gun*, it is also one of the most recognizable and most visited destinations in Thailand. Day trips by boat are available from Phuket.

Right: The location for the movie, 'The Man with the Golden Gun', the distinctive rock formation called Khao Tapoo, or Nail Island, is now simply referred to as James Bond Island.

Opposite: Long-tail boats wait to ferry visitors to James Bond Island. The downside of the island's fame is that tourists come here in their thousands and a once deserted beach heaves with souvenir sellers.

Below: Ao Phang Nga National Park covers an area of 400 km² (154 sq miles) and protects the largest area of primary mangrove forest remaining in Thailand. It encompasses more than 42 large and small islands.

Koh Samui

Once a haven for backpackers, Koh Samui is now one of Thailand's most popular travel destinations. Large numbers of visitors come to enjoy an idyllic climate, white sand beaches, water sports and a vibrant nightlife. Situated 700 km (435 miles) south of Bangkok but only an hour and a half by air, the island is easy to reach. The 250-square kilometre (97-square mile) island is at the edge of the Ang Tong National Marine Park which includes 80 other islands, only six of which are inhabited.

Opposite above: Koh Hong or Room Island in Krabi takes its name from the eroded caves and lake which can be reached through a narrow opening from the sea. Fearless locals can also be seen in the caves climbing bamboo ladders to collect swallows' nests for birds' nest soup.

Below: The biggest and busiest beach on Koh Samui is Chaweng Beach, on the eastern side of the island. The majority of the island's hotels, bars and restaurants are clustered around Chaweng and it is also the centre of the busiest nightlife.

Krabi

Idyllic islands and beaches, clear waters, tropical rainforest and protected national parks have gained Krabi a well-deserved reputation as one of the world's most beautiful destinations. Around the island of Phi Phi Don a wide range of interesting activities including climbing, caving, diving and snorkelling can be enjoyed.

Left: Located one hour from Krabi Town, Koh Hong is popular with day trippers who come to enjoy the powdery sands of Pelay Beach and snorkel in the azure waters which are teeming with tropical fish and coral formations. For the more adventurous, the island's limestone outcrops offer rock climbers over 100 challenging routes.

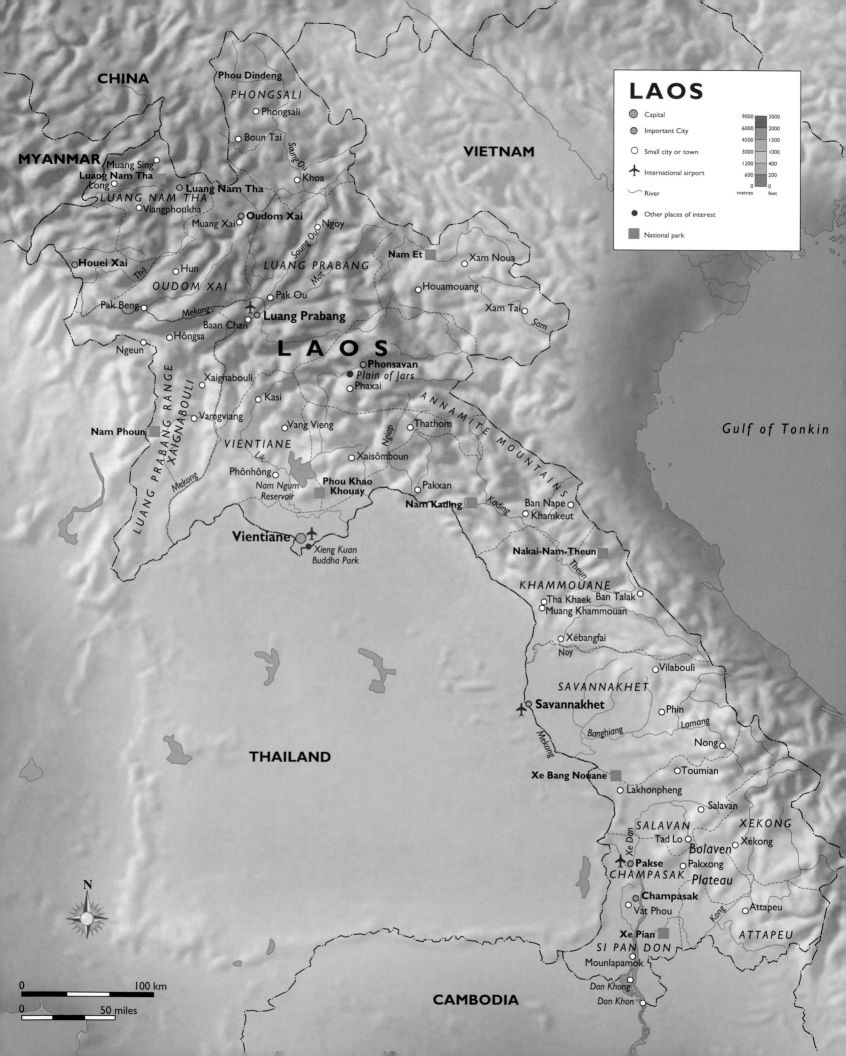

CHINA

MYANMAR

VIETNAM

PHONGSALI
Phou Dindeng
Phongsali

Boun Tai

Khoa

Muang Sing
Luang Nam Tha
Long
LUANG NAM THA
Luang Nam Tha

Viangphoukha

Muang Xai
Oudom Xai
Ngoy

Houei Xai
LUANG PRABANG
Nam Et
Xam Noua

Hun
OUDOM XAI

Houamouang
Xam Tai

Pak Ou

Sam

Pak Beng
Mekong
Baan Chan
Luang Prabang

Hôngsa

Ngeun
L A O S

Phonsavan
Plain of Jars
Phaxai

LUANG PRABANG RANGE
Xaignabouli

Kasi

Thathom

ANNAMITE MOUNTAINS

XAIGNABOULI
Vamgviang

Vang Vieng

Nam Phoun
VIENTIANE
Xaisômboun

Lik
Phônhông

Phou Khao
Khouay
Pakxan

Gulf of Tonkin

Mekong
Nam Ngum
Reservoir

Nam Kading
Ban Nape
Khamkeut

Vientiane

Xieng Kuan
Buddha Park

Kading

Nakai-Nam-Theun

Theun

KHAMMOUANE

Tha Khaek
Ban Talak
Muang Khammouan

Xébangfai
Noy

Vilabouli

SAVANNAKHET

Savannakhet
Phin

Banghiang
Lamang

Nong

THAILAND

Mekong

Xe Bang Nouane

Toumian

Lakhonpheng

Salavan

SALAVAN
XEKONG

Xe Dan
Tad Lo
Xékong

Bolaven

Pakse
Pakxong

CHAMPASAK
Plateau

Champasak
Attapeu
Vat Phou

Kong

Xe Pian

ATTAPEU

SI PAN DON
Mounlapamok

Don Khong
Don Khon

CAMBODIA

N

0 100 km

0 50 miles

LAOS

COUNTRY OF MYSTERY AND INTRIGUE

Few countries conjure up such a sense of mystery and intrigue in the traveller's mind as mountainous, landlocked Laos. Regarded as Southeast Asia's sleepy backwater, for many years Laos' communist government ensured that the country remained closed to the outside world. Unconcerned by neighbouring Thailand's dash for modernity, Laos resolutely moved at its own pace. When the door was finally eased open for travellers in the early 90s, it revealed a beautiful country with a fascinating culture and an ethnically diverse population.

Today, Laos is well and truly awakening from its slumber. The capital, Vientiane (pronounced Vien-chan) bustles with renewed energy and is benefiting from considerable Chinese and Korean investment. In the vibrant city, with its new-found wealth, an abundance of shining SUVs and an emerging middle class, it's hard to believe you are in one of Asia's poorest nations. Many of Laos' attractions, however, lie beyond the capital. Here, the rural population still ekes out an existence as subsistence farmers, fishermen, market traders and merchants. For many in the countryside, little has changed. That in itself is part of Laos' enduring appeal for visitors.

Above: Boat trips down the Mekong River add a new perspective to travel in Laos.

Left: A young girl runs past a colonial-era building in the southern town of Pakse.

Opposite above: A small golden Buddha image outside a temple in Luang Prabang.

Opposite below: Linten girls, one of the many ethnic hill tribe groups in northern Laos.

Rich Cultural Heritage

Laos is a destination for the true cultural traveller. The country's greatest asset, apart from the genuinely warm and welcoming population of just over 6 million citizens, is its rich culture and stunning natural beauty. In the north, the splendours of the UNESCO World Heritage town of Luang Prabang attract thousands of visitors each year who enjoy relaxed days wandering streets lined with colonial-era French architecture and discovering ancient temples, and languid evenings of alfresco dining beside the turbulent

Opposite: Old wooden Buddha images at Vat Xieng Thong, Luang Prabang.

Opposite below right: A group of monks heading back to the temple in a minibus.

Below: The entranceways to Lao temples are always beautifully decorated.

waters of the Mekong River. Further north, Luang Nam Tha, a mountainous forested land and home to the country's many hill tribes, attracts trekkers and nature lovers. On the outskirts of Phonsavan, rolling hills are scattered with mysterious stone jars that still manage to confound archaeologists. Equally hard to fathom is the fact that the sparsely populated landscape also bears the scars of the world's heaviest aerial bombardment and a deadly legacy of American unexploded ordnance. Southeast of Vientiane, the rugged province of Khammouane is emerging as another eco-travel hotspot, while in the far south, Champasak Province is home to the UNESCO World Heritage Site of Vat Phou, a magnificent 1,000-year-old temple ruin that is testament to a glorious past. Travelling still further south, the mighty Mekong has devoured the landscape to create a unique region known as Si Pan Don, or 4,000 Islands, before it spills over the border into Cambodia.

Whether exploring the rich cultural heritage, engaging with colourful hill tribes or enjoying a leisurely cruise down the Mekong River, laidback, landlocked Laos never fails to inspire and enchant.

GEOGRAPHY AND CLIMATE

Bordered by China, Myanmar, Thailand, Cambodia and Vietnam, tiny Laos encompasses 236,800 square kilometres (91,425 square miles). Laos is an elongated country divided into 18 provinces. Seventy-five per cent of the country is mountainous with a total of 40 per cent forest cover, although this is rapidly being removed by legal and illegal logging and the construction of hydroelectric dams.

Laos' fertile floodplains, lush valleys and hillsides have been sculpted by irrigation channels and rice paddies. Here, seasons are marked by the colours of burnt sienna when the soil is tilled, the brilliant green of gently swaying young rice plants and tones of yellow ochre at harvest time.

Some of the country's most rugged and dramatic landscapes are found in the north. Here, the forested terrain can reach 2,800 m (9,190 ft). Despite the logging and a seemingly uncontrolled trade in endangered wildlife, Laos is still home to many rare plants and animals. On the country's eastern border, the long chain of the Annamite Mountains rises in places to 2,500 m (8,200 ft). In the valleys of the north and east, the mainly agrarian population grows rice and other cash-crops, such as sweetcorn, lettuce and a wide variety of herbs.

In central Laos, the land around Vientiane is used for rice production and other crops. The area is also known for the Nam Ngum Reservoir, which borders Phou Khao Khouay, one of the country's 27 national parks and areas of biodiversity conservation.

In the southeast, the 1,300-m (4,265-ft) Bolaven Plateau enjoys a cooler micro-climate. On the plateau, the area around the town of Pakxong is the centre of Laos' arabica coffee industry. Visitors to the area enjoy beautiful scenery, national parks, cascading waterfalls and hill tribe villages.

In southern Laos, protected areas in parts of Champasak and Attapeu Provinces are home to Asian Elephants, Asiatic Black Bears, gibbons, tigers and the highest recorded number of Laos' bird species. Further south, the intriguing landscape of Si Pan Don attracts travellers, many of whom come to try and glimpse the endangered Irrawaddy Dolphin in the waters of the Mekong Delta.

Laos enjoys a tropical climate with average high temperatures of 35°C (95°F). There are three overlapping seasons. The monsoon lasts from May to October followed by the cool season which runs until February. During this period, it can be extremely fresh and cold in the evenings and early mornings, particularly in the north but usually warms up during the day. Temperatures and humidity begin to rise towards the end of February, with the peak of the hot season being in April.

Opposite left: Rice is still harvested by hand. The backbreaking work is often carried out by the whole family.

Opposite right: During the cool season, the waters of the Mekong recede and vegetables are planted in the fertile soil.

Above: The valleys of northern Laos are covered with rice paddies.

THE MEKONG

It's impossible to overestimate the importance of the Mekong River to the people of Laos. From its source in Tibet's Jifu Mountains, the Mekong enters the country in the northwestern province of Luang Nam Tha where the borders of China, Laos and Myanmar converge. The mighty river continues its journey the entire length of Laos, for much of the time forming a natural border with Thailand, before widening to almost 14 km (nearly nine miles) during the height of the rainy season at Si Pan Don, then flowing into Cambodia.

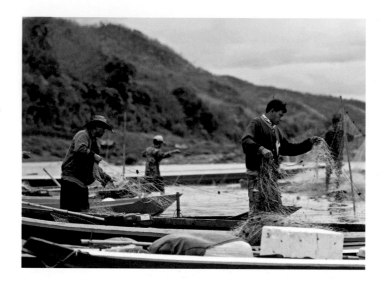

Above: Fishermen on the Mekong checking their nets.

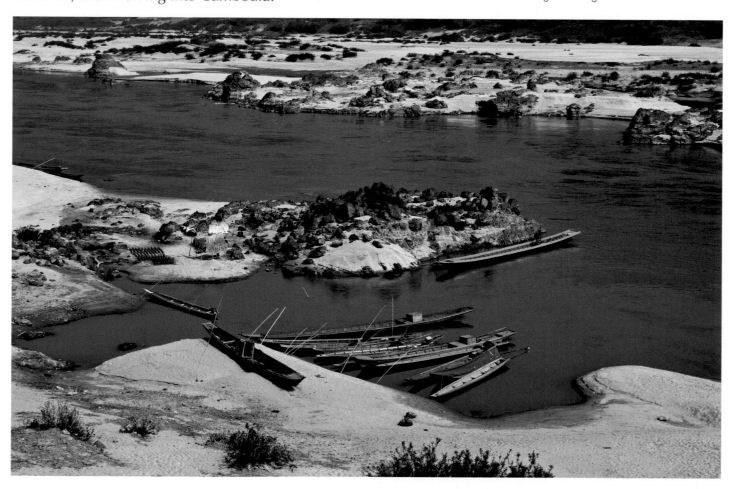

Above: During the hot season, navigation of the Mekong can be difficult as the water level drops considerably and rocks are exposed.

Above: Mekong sunsets can be really dramatic. In many towns, riverside restaurants are the perfect place to end the day with a delicious meal and an ice-cold Beerlao.

Above: An incredible variety of fish is caught in the Mekong and sold fresh in the country's many morning markets.

Known in Lao as the *Mae Nahm Kong* (literally 'mother river'), the Mekong feeds the nation with a huge variety of freshwater fish, which along with rice grown on the massive fertile floodplain that runs from Xayabouri to Champasak, is the mainstay of the Lao diet. In the cool and dry seasons, its fertile banks and islands are planted with a wide variety of vegetables.

The Mekong is an essential trade route for goods from China and its many tributaries provide access to remote villages. The river is also still used in the Buddhist ceremonies that follow a cremation, carrying the ashes of the deceased in a simple earthenware jar to the bottom of its murky waters and on to the next life.

Yet despite the huge numbers of Laos' rural population who depend on the river for their livelihood, the Mekong and its bounty face an uncertain future. A series of hydroelectric dams constructed in the valleys for the export of energy brought a much needed inflow of money to the nation and earned it the nickname, the 'battery of Asia'. Now controversial dams at several locations on the Mekong are planned raising concerns about the environment.

A BRIEF HISTORY OF LAOS

Archaeological evidence of ancient ceramics and bronze artefacts reveals that Laos was inhabited by scattered settlements as long as 10,000 years ago. It is known that peoples began migrating into what is now Laos during the 8–10th century AD from southern China and northern Vietnam.

Above: The former royal palace in Luang Prabang is now the National Museum.

Laos' first recorded history, however, is in 1353 when King Fa Ngum ruled over Lan Xang, the 'land of a million elephants', from Muang Sawa, or what is now known as Luang Prabang. King Fa Ngum is also credited with making Theravada Buddhism the state religion. A warrior king, he is said to have taken possession of a golden Buddha image known as the Pha Bang from the Khmers, which prompted the city's name to be changed to Luang Pha Bang, meaning

Great Pha Bang. King Fa Ngum was succeeded by his son, Phaya Samsenthai who married two Thai princesses and ruled over a burgeoning state for 43 years. This relatively stable period of Lao history was followed by a century of turbulence and a dozen or more rulers.

In 1560, King Setthathirath moved the capital to Vientiane – then known as Wieng Chan – a change designed to diffuse increased aggression from neighbouring Myanmar.

During the reign of King Suriya Vongsa in the 17th century, Laos is said to have enjoyed a golden age and began attracting attention from Europe. Following King Suriya Vongsa's 57-year reign, the kingdom of Lan Xang was broken into three parts by a feudal power struggle, namely Luang Prabang, Wieng Chan and Champasak. Later in 1763, Luang Prabang was taken by Burmese armies and Champasak by the Siamese.

Colonial Rule

The Siamese went on to increase their power and by the end of the 18th century controlled Wieng Chan and Luang Prabang. However, the expansion of European dominance in the region saw the Siamese relinquish power to the French and in 1893 Laos became a colony of French Indochina. This was also the period in which Laos established its present-day national borders. Today many fabulous colonial-era buildings remain in Laos, although many are in a state of disrepair.

During the period of French colonial rule, Prince Souphanounvong sought out support from Vietnam for the formation of a Lao communist movement and in 1950 established Lao Issara, or the Free Laos Resistance, to fight and expel the French.

Above: Monks walk past a statue of King Sisavang Phoulivong. He is holding the Lao constitution in his right hand. Crowned in 1905, he reigned until his death in 1959.

Above right: Luang Prabang and the southern towns of Tha Khaek and Savannakhet have some particularly fine examples of French colonial buildings although many are now in need of restoration.

A Secret War

Laos gained independence in 1953 but suffered two decades of civil war including secret saturation bombing by the U.S. Air Force. During the Vietnam War, U.S. planes dropped more than two million tons of bombs over Laos—double the amount dropped over Germany during World War II. Between 1964 and 1973, the USA flew 580,000 bombing missions over Laos — one every nine minutes for ten years. On a per-capita basis, Laos remains the most heavily bombed nation in history. UXO units from the U.K. and Australia have been working in the country for years and continue to do so today, trying to clear the unexploded ordnance. Over 87,000 km² (33,590 sq miles) of land are considered as being at risk, rendering vast areas of farmland in this predominantly agrarian countryside unusable. There have also been 20,000 casualties due to UXO since 1974, many of them children, and 300 Laotians continue to be injured or die each year.

Above: The deadly legacy of unexploded bombs still claims many victims every year.

Raise the Red Flag - The Creation of Lao PDR

In 1975, the Pathet Lao mounted a coup d'état that deposed King Sisavang Vatthana and ended six centuries of royal rule. When the new Lao People's Democratic Republic was formed, some 300,000 lowland Lao royalists, around 10 per cent of the population at the time, fled the country. Many of these were middle-class businesspeople, skilled workers and civil servants, and it is clear that even today this loss of educated citizens continues to severely restrict the nation's social and political development.

Following the creation of Lao PDR (still the official name of Laos), the country suffered severe economic decline and political isolation to become one of the world's poorest nations. In the early 90s, the government slowly began to promote private enterprise and encourage foreign investment. Today, with large amounts of foreign aid as well as investment and income from the sale of hydroelectric power to Thailand, there is increased prosperity for connected individuals and the new middle class. Wealth is slow to trickle down, however, and the majority of Lao people remain in poverty.

Challenging Times Ahead

Following a period of rather frosty relations, perhaps thawed out by the prospect of cheap electricity from new hydroelectric dams, Thailand is now a large investor in Laos. In reality, and as a result of its period of relative isolation during a time when the rest of Southeast Asia was booming, Laos seems to have retained many of the endearing qualities and culture which Thailand has already lost or is in danger of losing.

Laos remains one of the world's last self-proclaimed socialist republics, although its socialist principles are hard to detect in modern-day Vientiane. In recent years, Vietnam

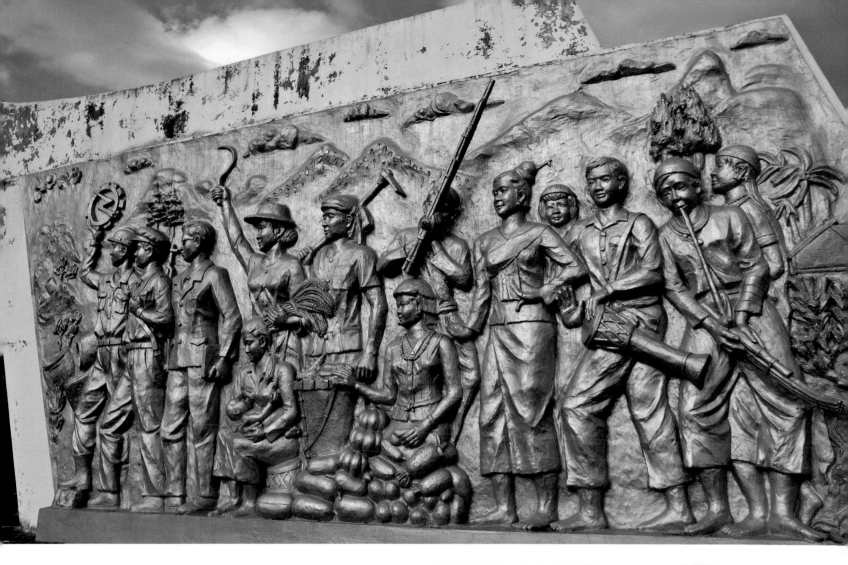

has become the largest investor in Laos, followed by China and Thailand. The Lao government has signed dozens of contracts with China including concessions for agribusiness industries, particularly rubber, timber, mining and telecoms. Thousands of Chinese migrants have also established themselves in northern Laos and Vientiane. This has caused many to express concern about the future of Laos' natural resources and question the wisdom of allowing such a huge influx of migrant labour to take root in the country. The future for Laos is indeed challenging.

This page: Just outside the town of Phonsavan there are several war memorials that commemorate the thousands of Pathet Lao soldiers who lost their lives during the Indochina Wars and to honour Vietnamese soldiers who fought alongside them.

VIENTIANE

Pushed up against the Mekong River, Laos' capital city, Vientiane, is experiencing a renaissance. Once known for its distinctly sleepy atmosphere and laidback lifestyle, the city has been awoken by a youthful population, trade with neighbouring countries and a renewed sense of optimism.

Today, the enchanting city welcomes visitors from around the world with a smile but signs of its history are plentiful. The colonial legacy of the French is now reduced to crumbling architectural gems, tree-lined avenues and crusty baguettes sold in the morning market. Communism, too, has left its mark with austere buildings, khaki uniforms, golden epaulets, reams of red tape and an economy in tatters. A visit to the Lao National History Museum, formerly known as the Lao Revolutionary Museum, on Samsenthai Road provides a fascinating place to get an overview of the country's past.

As the gateway to Laos, Vientiane is an endearing city with a rich history and valued cultural traditions, all enlivened by the buzz of modernity.

Patu Xai

Right and below: *Patu Xai, or Victory Gate, dominates Lane Xang Avenue. A sign on Patu Xai states that construction was never completed 'due to the country's turbulent history. From a close distance it appears less than impressive, like a concrete monster.' In fact the huge edifice is worth a visit and there is a good view across the city from the top.*

That Luang

Above: That Luang is considered the spiritual heart of Laos. Although legend says that the site had a temple as long ago as 300 B.C. construction of the golden stupa began in 1566 and was completed in 1641

Left: In 2010, Vientiane commemorated 450 years as the capital of Laos by building a new temple beside That Luang.

Above: Beyond the outer wall of That Luang several golden Buddha images stand in the shade of a large bhodi tree.

Vat Si Saket

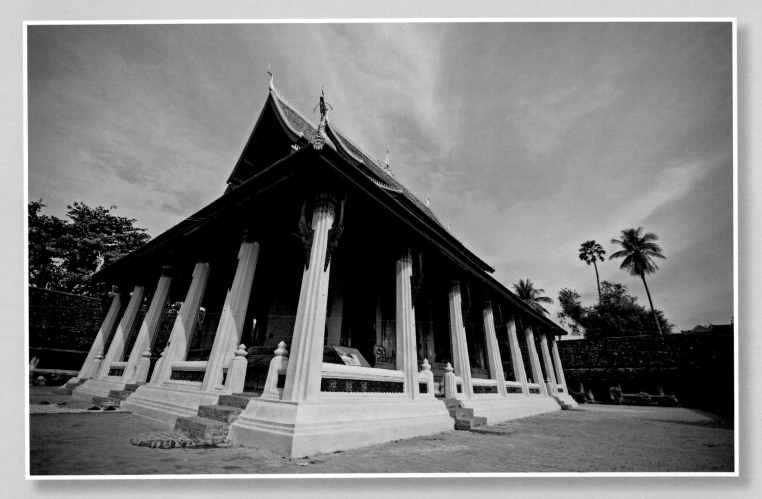

This page: Vat Si Saket is one of the oldest and most atmospheric temples in Vientiane. The temple was built in 1818 and is one of the few to have survived an attack on Vientiane by the Siamese army a decade later. The temple's central 'sim' or ordination hall is surrounded by a walled cloister. In addition to rows of large Buddha images, recesses in the cloister walls house 6,840 silver and ceramic images.

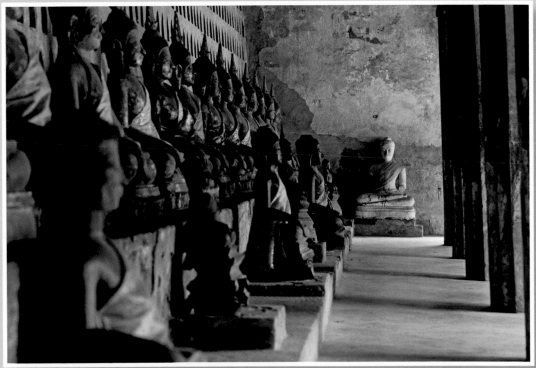

Vat Inpeng

Right and below: *Located in the heart of Vientiane, Vat Inpeng features a stunning carved frontage, an ornate doorway and a colourful painted wall depicting the life of Buddha.*

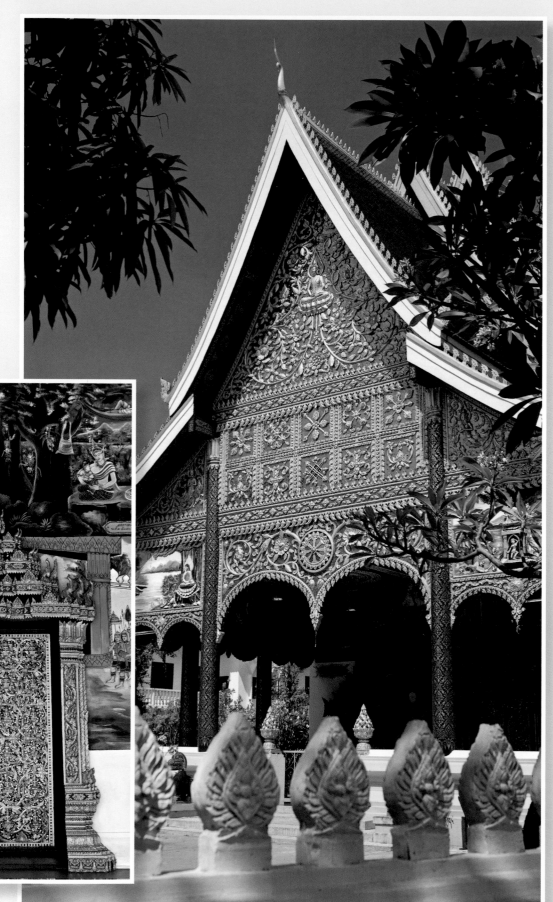

Lao National History Museum

Right: The Lao National History Museum, formerly known as the Lao Revolutionary Museum, on Samsenthai Road gives the visitor an overview of the country's past.

That Dam

Right: That Dam or the Black Stupa is a crumbling Vientiane landmark. Although today weeds and plants grow in the brickwork, local folklore says that it was once covered with gold. Legend also says that it is inhabited by a seven-headed snake, known as a 'naga', that protects Vientiane.

AROUND VIENTIANE

It is also worth venturing beyond the environs of the city. Day excursions include trips to the dam, Ang Nam Ngum, Phou Khao Khouay National Park and Xieng Kuan Buddha Park.

Xieng Kuan Buddha Park

A visit to this spectacular site created by one of Laos' great eccentrics, is essential. Located on the banks of the Mekong River, 25 km (15½ miles) south of the city and just 3 km (1¾ miles) from Friendship Bridge, the park was established in 1958 by Bounlua Sulilat, a shaman priest.

This page: The park has over 200 concrete Buddhist and Hindu statues portraying Bounlua Sulilat's vision of earth, heaven and hell.

Vang Vieng

The setting is undeniably beautiful but despite its natural assets there's no sitting on the fence when it comes to opinions about Vang Vieng. To the backpacking fraternity it is simply heaven; for the true cultural traveller it is an example of how damaging tourism can be to local society. The once sleepy riverside town, perfectly located to break up the journey between Vientiane and Luang Prabang, is now overrun with cheap guesthouses and noisy bars. However, you can escape the hustle and bustle by hiring a bicycle and heading out of town to explore the peaceful countryside and quiet villages, all with a backdrop of stunning karst mountain scenery.

Below: Vang Vieng has a reputation as a party town with many bars and music venues open into the early hours.

Right: A good way to discover the surrounding area is to hire a boat and boatman to navigate the shallow river.

NORTHERN LAOS

Mountainous and remote, northern Laos attracts eco-tourists, trekkers and cultural travellers. Here, bottle-green peaks stumble towards the horizon, an intricate web of rust-coloured trails clings to the hillsides, leading the adventurous off into a fantastic landscape inhabited by dozens of different hill tribes, and valley floors are carpeted with paddy fields.

For many, the highlight of northern Laos is the UNESCO World Heritage town of Luang Prabang, a charming and relaxed town set beside the Mekong River. The north is also the location of the mysterious Plain of Jars, one of the country's most fascinating archaeological sites.

Luang Prabang

A jewel-encrusted ring slipped over a slender finger of land at the confluence of the Mekong and Nam Khan Rivers, Luang Prabang is a city of many charms. Circled by mountains, the beautiful town has some of the most outstanding examples of regional architecture, a unique blend of local and European-style buildings constructed by the colonial powers during the 19th and 20th centuries. With its magnificent temples and continued adherence to local traditions, Luang Prabang is recognized as the seat of Lao culture. Acknowledging its importance to mankind, the town was designated a UNESCO World Heritage Site in 1995 and the old part of the town has benefited from a considerable amount of restoration work.

The World Heritage label has worked for and against Luang Prabang. It is no longer the sleepy Laotian town it once was. Yet despite its changes and an ever-increasing influx of tourists, Luang Prabang has managed to retain its dignity and charm. Visitors can explore ancient temples and vibrant markets, shop in chic boutiques, enjoy quiet moments of contemplation in cafés and savour local cuisine in al fresco riverfront restaurants.

Above: *Many youngsters in Luang Prabang receive their education in the temples. Despite the monastic life, the temptations of the material world are hard to resist.*

Right: Every evening in Luang Prabang there is a vibrant night market selling a wide variety of colourful crafts and gifts, such as these hill tribe dolls. Many of the people selling their wares at the market are in fact from hill tribes and have benefited from the town's boom in tourism.

Left: Although not as spicy as Thai food, chillies are an essential ingredient in Lao cuisine. In the north they are dried in the sun and pounded into a spicy dip known as 'jao bong'.

Above: Ringed by rolling hills, the riverside town of Luang Prabang is best visited during the cooler months from November to February when the climate is pleasant and mornings crisp and fresh.

Vat Haw Phra Bang

This page: *Haw Phra Bang is a relatively new temple structure. Designed to house the Phra Bang, Luang Prabang's most revered Buddha image, construction began in 1963. During the Lao New Year, the golden image is ritually cleansed in a ceremony that attracts worshippers from near and far.*

Phou Si

Above left: In the centre of Luang Prabang, Phou Si, a 100-m (328-ft) hill, offers views across the town. There are several temples on the hill with large Buddha images.

Above: At night the chedi at the top of mount Phou Si is illuminated.

Left: From the summit there is a clear view of the former palace and surrounding countryside.

Vat Xieng Thong

Above and above right: The temple features a wonderful mosaic of the tree of life, elaborate carvings and beautiful gold stencilled designs that recount stories from the Buddhist scripture. Vat Xieng Thong is one of the few temples in Luang Prabang that charges an entrance fee.

Right: Luang Prabang has over 30 splendid old temples, the most magnificent of which is Vat Xieng Thong. Built in the 1560s, the temple benefited from royal patronage until the revolution in 1975.

Vat Mai Suwannaphumaham

Left and below: Located close to the former palace, Vat Mai Suwannaphumaham or the 'new temple' was the temple used by the Luang Prabang royal family in the days before the revolution.

Vat Sensoukharam

Left: Dating from 1718, Vat Sensoukharam features a three-tiered roof typical of the Luang Prabang style. Inside and out, the temple's deep ochre walls are stencilled with beautiful gold designs. The 'sim' or ordination hall also contains some fine Buddha images. The name means 'temple of 100,000 treasures' and is said to refer to the number of stones taken from the Mekong to build it.

Morning Markets

Left: Luang Prabang's morning markets are fascinating places to explore. An array of local vegetables and specialities are available, along with fresh fish from the Mekong and wild food. Typically markets begin at daybreak.

Pak Ou

Below and right: Two hours upstream from Luang Prabang, the Pak Ou caves are two limestone chambers set in a steep cliff face. The reward for the strenuous climb is the sight of the dozens of Buddha images enshrined here. Along route boats often stop at Ban Xang Hai, a centre for distilling the infamous rice whiskey.

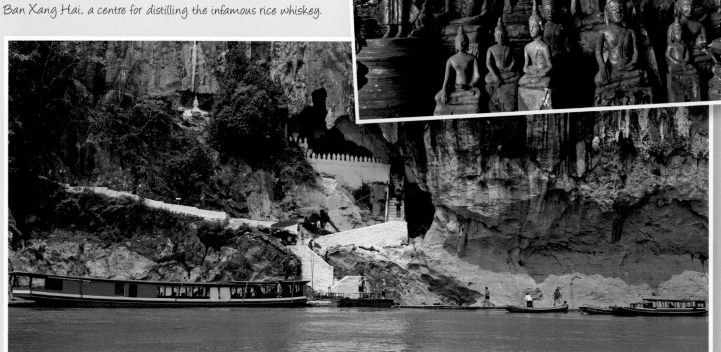

Luang Nam Tha

Located on the edge of the Nam Tha National Park, the town of Luang Nam Tha is an excellent base for exploring the upper north. There are many hill tribes in the area including Linten and Akha. The town itself is a sleepy hamlet with a colourful market and good restaurants and bars in which to relax and share tales after an inspiring day's trek.

Below and right: Visitors to Luang Nam Tha can enjoy an early breakfast of 'foe' in the morning market before spending a rewarding day exploring hill tribe villages in the surrounding countryside.

Left: Akha villages are usually a collection of simple thatched roof homes that cling to the upper reaches of Luang Nam Tha's mountainous landscape.

Right: Luang Nam Tha attracts eco-tourists who want to discover hill tribes such as this Akha woman (right) and Tai Dam (far right). Other ethnic groups in the area include Hmong, Kamu, Lahu and the Linten.

Above: A newly built chedi or stupa on a hill overlooking Luang Nam Tha is a good vantage point for surveying the town and valley below. The golden chedi was constructed in 2009 and is reached by a steep road at the northern end of the town.

Opposite above and below: The valleys around Muang Sing district are fertile and the hill villages are home to various ethnic peoples.

Muang Sing

Muang Sing in Laos' far northwestern corner, near the borders of Myanmar and China, is a good place to see some of the country's most colourful hill tribe people. The town itself is very small and doesn't have a great deal to offer beyond the bustle of the morning market but is a popular base for treks into the hills. Visitors will notice the influx of Chinese migrants and trucks with Chinese licence plates. The region is currently being exploited for its natural resources, such as timber which is all heading for China.

Phonsavan and the Plain of Jars

Phonsavan is the provincial capital of Xieng Khuang, a region that holds the unfortunate title of the most heavily bombed area in Laos. The chief attraction here is the Plain of Jars, the main site of which is located just five km (three miles) from the quiet market town.

Right: Phonsavan is an essential destination on any travel itinerary in Laos. Although the town itself is an ordinary provincial centre, it is surrounded by the mysterious Plain of Jars. There are three sites within easy reach of the town, all of which have an extensive collection of the stone jars but there are also many more minor sites in the area.

Above: As a result of the U.S. campaign to carpet bomb Laos during its war on Vietnam, many of the jars were damaged. Huge bomb craters are visible and when visiting the sites it is important to stick to pathways cleared by UXO teams as there is still a large amount of unexploded ordnance in the area.

Phongsali

Reached by a rough unsealed road, the far northern town of Phongsali has a character unlike any other town in Laos. The majority of the population in this intriguing mountain hamlet are *Phu Noi*, an ethnic group also found in Vietnam, where they are known as *Khoong*.

Above: *A remote mountain town ringed by mountains, Phongsali feels more like China than Laos.*

Right: *In the Phonsavan area, villagers use so-called 'bomb-boats' made from fuel tanks jettisoned by U.S. planes during bombing raids over Laos.*

CENTRAL LAOS

Bordered by the Mekong River to the west and Vietnam to the east, the landscape of central Laos includes an expansive floodplain covered with rice paddies and remote mountainous areas that contain seven National Biodiversity Conservation Areas. Visitors to the principal towns of Tha Khaek and Savannakhet can enjoy the faded charm of colonial-era architecture, fresh markets and Mekong sunsets.

Above: The central region of Laos is the country's 'rice bowl'.

Left: Towns in the region also have many examples of French colonial architecture.

Above: In Laos, most people buy fresh food from the market every day.

Right: Rice planting and harvesting in Laos are still done by hand. The backbreaking work involves uprooting seedlings from the nursery, gathering them together in bunches and replanting in rows in another paddy field.

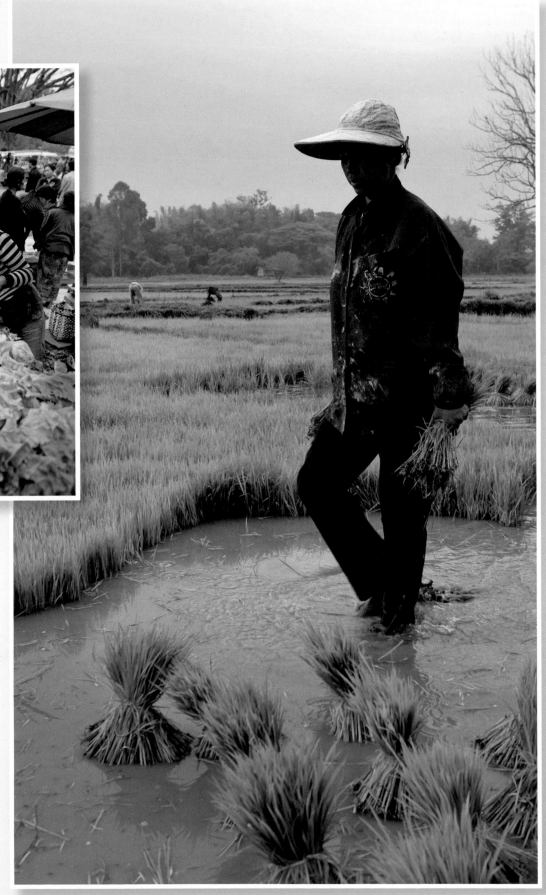

Tha Khaek

In recent years, Khammouane Province has become increasingly popular with eco-tourists who come to explore the lakes, forests and spectacular limestone karst scenery. Located 580 km (360 miles) southeast of Vientiane, the provincial capital of Tha Khaek is now connected to Nakhom Phanom in Thailand via the third Friendship Bridge to be built. The town is a pleasant stopover before heading further south.

This page: The tree-lined streets and administrative buildings that are still used today are a legacy of the French rule.

Savannakhet

With a Friendship Bridge spanning the Mekong to Mukdahan in Thailand, Savannakhet is an increasingly important trade junction between Thailand and Vietnam. The province is also the most highly populated area of Laos. Affectionately referred to as Savan, the town has many beautiful old French buildings dating from the colonial period which are in need of restoration. On the outskirts of the town, the Savan Vegas casino tempts Thai gamblers to the tables.

This page: The old quarter of Savannakhet has some fine examples of French colonial building but after years of neglect many are in a state of disrepair.

This page: The large morning market at Savannakhet sells almost anything you could need, including fresh produce and sticky rice baskets. There is seemingly no limit to the amount of shopping that can be carried on a motorcycle.

Above: A detail of the wall of Vat Sainyphum.

This page: Located a short distance from the Mekong River, Vat Sainyphum is the largest and most colourful temple in Savannakhet. Although there has been a temple on the site since the 1500s, most of the buildings here date from the 19th century. The temple also includes a school for teaching novice monks.

SOUTHERN LAOS

In the south, the Mekong River breaks away from the Thai border and passes through the market town of Pakse, then carves the intriguing landscape into 4,000 islands before continuing its journey into Cambodia. The region also embraces the Bolaven Plateau, the home of Lao coffee.

Right: A massive hilltop Buddha image overlooks Don Khong, the largest of the 4,000 Islands.

Above: The 4,000 Islands is one on Laos' most beautiful areas but also one of its most popular with backpackers. The island of Don Det attracts droves of travellers who enjoy cheap riverside accommodation and days lazing in the sun. Fortunately there are several quieter islands to explore which are still unspoilt.

Pakse

The largest town in Champasak Province, Pakse sits at the confluence of the Mekong River and the Se Don, from which it gets its name (Pakse means 'mouth of the river Se'). The town is home to the biggest fresh market in Laos as well as a daily riverfront pig market where locals haggle with Vietnamese traders for the best price for their livestock. Peaceful evenings in Pakse can be spent dining on floating restaurants as the sun sinks into the Mekong.

Left: Vat Luang in the centre of Pakse is also the location of a monastic college. The ashes of a former Lao prime minister are entombed here.

Above: Pakse is renowned for Dao Heung, the biggest fresh market in Laos. Take the riverside road and you will also see a Vietnamese pig market, which operates every morning from daybreak.

Bolaven Plateau

Lying just east of Pakse, the expansive Bolaven Plateau's altitude and cool climate made it the location for coffee plantations during French rule. When Laos gained independence the industry went into decline but in recent years has enjoyed a revival. Today, hundreds of villagers tend coffee bushes and there are also several large commercial plantations, mainly around the town of Pakxong. Organic Pakxong coffee can be found for sale in the markets across Laos.

Below: Almost all villages in the area are involved in growing coffee beans. After harvest, the raw beans are laid out to dry in the sun before being sold on to roasters and suppliers. Although most of the coffee is low-quality Robusta and still sold within the country, in recent years more Arabica bushes have been planted and the improved quality means that exports are increasing.

Above: The orange cloth around the trees has been tied by monks in a ceremony to protect them from being cut down for timber. Once regarded as one of Southeast Asia's most untouched nations, Laos is now suffering from rampant legal and illegal logging.

This page: *The Bolaven Plateau is an area of unique landscape between the Mekong River to the west and the Annamite Mountains to the east. The plateau features several rivers and many cascading waterfalls. In recent years, the area has begun to attract an increasing number of tourists keen to explore the landscape and ethnic villages on guided treks. A popular stopover is Tad Lo, a scenic hamlet set beside a multi-tiered waterfall. Due to the elevation of the Bolaven Plateau it enjoys a pleasant micro-climate but can be very chilly from November to February.*

Champasak

The sleepy riverside town of Champasak draws visitors who come to see the nearby temple of Vat Phou. Located 12 km (7½ miles) from the town, the UNESCO World Heritage Temple dates from the sixth century but was a part of the Khmer Angkor Empire between the 10th and 13th centuries. As one of the most significant historical sites in Laos, it is an essential feature on any travel itinerary.

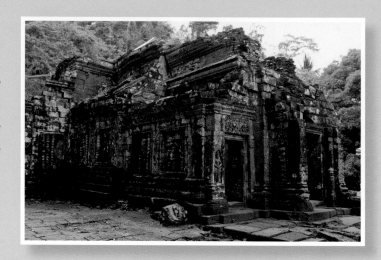

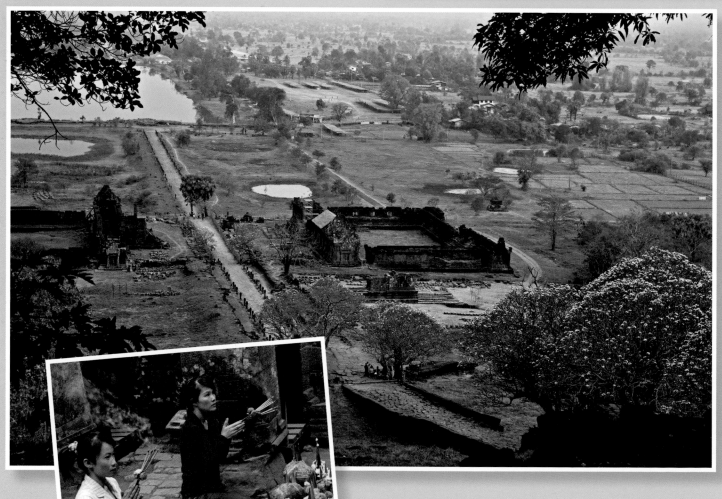

Above and opposite: Vat Phou is Laos' most important religious site. The temple complex comprises six levels. The steep climb up to the top level of the temple ruins ensures a spectacular view across the surrounding area.

Left: Once at the top Lao visitors and other Buddhists make an offering of flowers, candles and incense at the shrine.

Si Pan Don – 4,000 Islands

Just south of Champasak, the Mekong widens, creating an area of islands and sandbars know as Si Pan Don, the 4,000 Islands. Varying in size with the seasonal rise and fall of the Mekong, many are uninhabited. Larger islands such as Don Khong, Don Det and Don Khon are extremely popular with travellers. Don Khon is also the location of the famous Li Phi Falls.

Above and right: The southernmost islands of Don Det and Don Khon are connected by a bridge built by the French for a narrow gauge railway. Although the line has long since been removed, an old rusting train can still be seen there.

Below: On the 4,000 Islands, life moves forward at a slower pace but there are many interesting temples and villages to explore.

Above: The Li Phi Falls, also known as Tat Somphamit, are a series of violent rapids located on the western edge of Don Khon. The sight is particularly impressive at the height of the rainy season in September. The Li Phi Falls are used by local fishermen who risk life and limb building large wooden traps here, a considerable feat as the current is extremely powerful. In the waters further south, boats can be hired for trips to try to spot the endangered Irrawaddy Dolphin.

Left: Many of the waterways around the 4,000 Islands are more peaceful than the Li Phi Falls and can be explored by kayak. In the main stretches of the Mekong River, hundreds of fishermen can be seen laying nets or hauling in their catch.

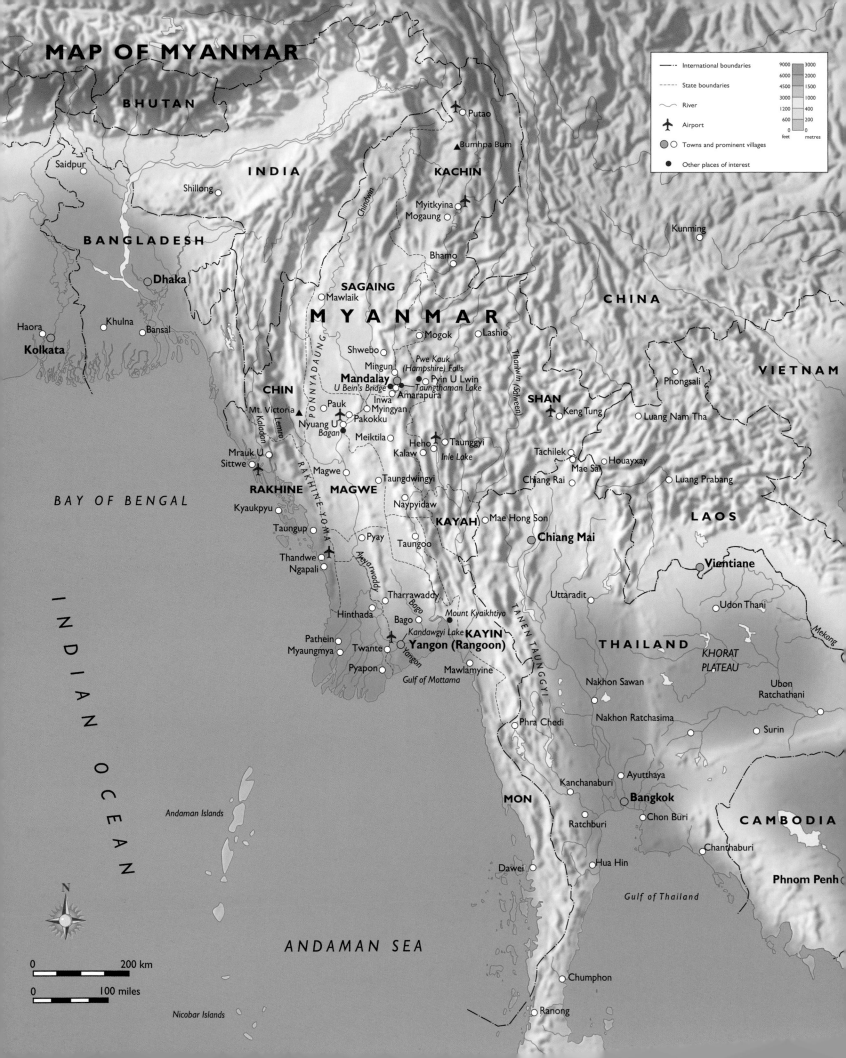

MAP OF MYANMAR

BHUTAN

INDIA

BANGLADESH

Saidpur

Shillong

Dhaka

Haora

Khulna Bansal

Kolkata

KACHIN

Putao

Bumhpa Bum

Myitkyina
Mogaung

Bhamo

Kunming

CHINA

SAGAING

Mawlaik

MYANMAR

Mogok Lashio

Shwebo

Mingun Pwe Kauk
(Hampshire) Falls

CHIN

Mandalay Pyin U Lwin
U Bein's Bridge Taungthaman Lake
Inwa Amarapura
Myingyan
Pauk
Pakokku
Nyuang U Meiktila
Bagan

Mt. Victoria

Mrauk U
Sittwe

RAKHINE

Magwe

MAGWE

Heho Taunggyi
Kalaw Inle Lake

SHAN

Keng Tung

Tachilek
Mae Sai

Chiang Rai

VIETNAM

Phongsali

Luang Nam Tha

Houayxay

Luang Prabang

BAY OF BENGAL

Kyaukpyu

Taungup

Thandwe
Ngapali

Taungdwingyi

Naypyidaw

KAYAH Mae Hong Son

LAOS

Pyay

Taungoo

Chiang Mai

Vientiane

INDIAN OCEAN

Tharrawaddy

Hinthada

Pathein
Myaungmya

Bago

Twante

Pyapon

Kandawgyi Lake

Mount Kyaikhtiyo

KAYIN

Yangon (Rangoon)
Yangon

Mawlamyine

Gulf of Mottama

Uttaradit

THAILAND

Nakhon Sawan

KHORAT
PLATEAU

Udon Thani

Ubon
Ratchathani

Surin

Mekong

Nakhon Ratchasima

MON

Phra Chedi

Kanchanaburi Ayutthaya

Bangkok

Ratchburi Chon Buri

CAMBODIA

Chanthaburi

Dawei

Hua Hin

Phnom Penh

N

Gulf of Thailand

Andaman Islands

ANDAMAN SEA

0 200 km

0 100 miles

Nicobar Islands

	feet	metres
	9000	3000
	6000	2000
	4500	1500
	3000	1000
	1200	400
	600	200

— International boundaries

- - - State boundaries

River

✈ Airport

⬤ Towns and prominent villages

● Other places of interest

MYANMAR

LAND OF THE GOLDEN ZEDIS

I n 1898, in "Letters from the East" Rudyard Kipling, recounting his journey by steamer sailing up the Irrawaddy Delta to Rangoon, wrote "Then, a golden mystery upheaved itself on the horizon…a shape that was neither Muslim dome nor Hindu temple spire…the golden dome said: 'This is Burma, and it will be quite unlike any land you know about.'" The celebrated English novelist and poet was describing his first view of the region's most sacred Buddhist site, the Shwedagon Paya, a magnificent 99-m (325-ft) gilded zedi crowning Singuttara Hill.

Right: The rather grand City Hall in central Yangon dates from 1936.

Below: The Shwedagon Paya is a highlight of any visit to Yangon. The pinnacle of the zedi is encrusted with 2,317 rubies and 5448 diamonds.

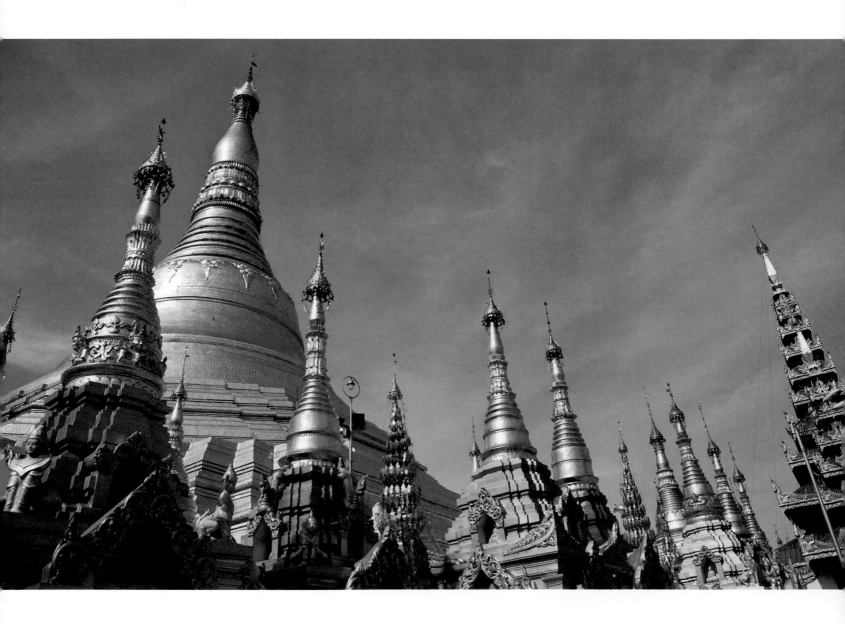

Today, over a century since Kipling's observations, the country now known as Myanmar is the last frontier of discovery for cultural travellers in Southeast Asia. An intriguing land of shimmering temple spires and archaeological wonders, extraordinary ethnic diversity, astonishing natural beauty, and warm and welcoming people, this 'golden land' still remains unlike any other.

The gateway to Myanmar is the former capital, Yangon (known to the British as Rangoon). Here, the faded glory of imposing British architecture draws the admiration of visitors but is also a pertinent reminder of a more enduring colonial-era legacy – a turbulent history. Yet the youthful population now looks forward and on the city's bustling streets there is a palpable sense of optimism. Today's Yangon is a city of contrast. Buildings of red-brick and crumbling stucco are fronted by billboards advertising the latest 'must-have' gadgets while Buddhist mantras of non-attachment are whispered within the confines of sacred temples; muscular SUVs with blacked-out windows roll past ageing trishaws laden with smiling ladies cradling fresh produce from the market; street vendors sell posters of Aung San and his daughter Aung San Suu Kyi, who endured years of house arrest. Unchanged in some ways yet also energetically looking to the future, chaotic with pockets of calm, deeply complex yet often starkly black and white, Yangon's heady cocktail is as refreshing as it is intoxicating.

Above: Many of Yangon's architectural gems from the colonial-era are partially covered with billboards resulting in an intriguing blend of old and new.

Below: In rural Myanmar, life moves at a slower pace than elsewhere. Bullock carts are still a common means of transport.

Right: At Bagan, hundreds of zedis are scattered across a vast area. As the evening light fades, the brickwork of the crumbling temples takes on a warm glow.

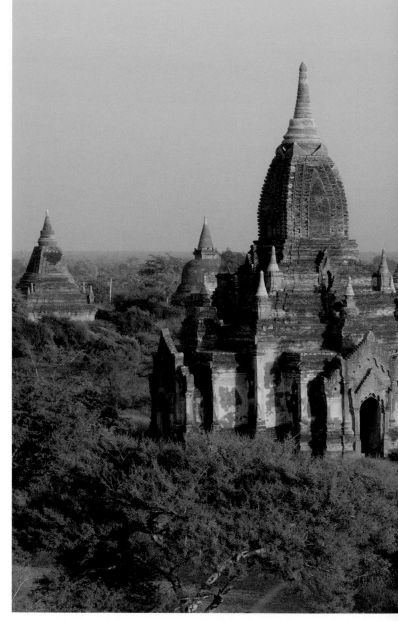

In rural Myanmar time is marked by the slow turn of bullock cart wheels, the seasonal rhythm of "sow and reap" in the paddy fields and by a calendar of religious festivals and boisterous temple fairs. It is here, beyond Yangon, that Myanmar's true beauty and character are revealed. In Bagan and Mrauk U, ancient zedis (Buddhist shrines containing sacred relics) dating from the 11th century stand in testament to Myanmar's past splendours and as inspiration for travellers of our time. The mere mention of Mandalay still has the power to conjure up images of an exotic and unfamiliar land, of sweltering nights beneath a mosquito net and a lazy ceiling fan, and flotillas of paddle steamers drifting down the Ayeyarwaddy River (known to the British as the Irrawaddy). After exploring the burgeoning city's many nearby sights such as U Bein, the world's longest teak bridge, and the zedi-strewn Sagaing Hill, travellers can board a luxurious cruise ship and sail down the mighty river. Further north, leg rowers, jumping temple cats and the floating gardens of Inle Lake provide a glimpse of local curiosities and unique traditions, while further north still hill tribes and pristine forests are a draw for cultural tourists and nature lovers.

Above: A fisherman on Inle Lake using the unique leg-rowing technique while setting his nets.

Below: The 70-m (230-ft) reclining Buddha at Chauk Htat Gyi Temple in Yangon was built in the mid-60s to replace an earthquake-damaged image.

No visit to the country is complete without making a pilgrimage to the precariously balanced Golden Rock and to the two monumental reclining Buddha images at Bago. While the perfect end to a memorable journey can be found at idyllic resorts in Ngapali, an undeveloped coastline of pristine beaches where fishermen cast their nets wide into azure waters.

The combination of Myanmar's beauty and diversity, its rich culture and history, and its charming people make it one of Asia's most rewarding and truly enchanting destinations. Discovery awaits.

GEOGRAPHY AND CLIMATE

Situated on the western edge of Southeast Asia, Myanmar encompasses an area of 677,000 km² (261,228 sq. miles), making it the second largest nation in the region after Indonesia. The country spans 936 km (581 miles) from east to west and 2,051 km (1,275 miles) from north to south, sharing its borders with Thailand and Laos to the east, China to the north-east, and India and Bangladesh to the north-west. Myanmar's extensive coastline runs for 2,800 km (1,740 miles) along the Andaman Sea, the Gulf of Mottama (formerly known as the Gulf of Martaban) and the Bay of Bengal.

Below: Rolling hills and the valley surrounding Mandalay seen from the road to the former British hill station of Pyin U Lwin.

Left: The boat from Sittwe to Mrauk U passes through a beautiful and fertile landscape where rural subsistence farmers catch fish, harvest rice and tend buffalo.

Below: Myanmar's forests are home to an incredible diversity of wild orchids.

Myanmar also shares a 2,204-km (1,370-mile) land border with China and an extensive 1,338-km (831-mile) land border with India. It is perfectly situated to act as the gateway to Central Asia and to benefit from the region's rapid development.

Rich in natural resources, Myanmar has huge potential for growth. For many years, China has been the country's largest trade partner and investor, supplying consumer goods, durables, machinery and equipment, while importing Myanmar's timber, agricultural produce and minerals, such as coal, tin, zinc, marble and limestone. However, it is the possibility of large-scale discoveries of oil and gas that could see Myanmar quickly become a major supplier to neighbouring, energy-thirsty nations.

A rural nation comprising 14 states, Myanmar is blessed with a range of landscapes, flora and fauna. Vast tracts of forest are home to incredible biodiversity and wildlife, such as Tigers, Leopards, flying squirrels, porcupines, gibbons, Asiatic Black Bears, Asian Elephants and 52 types of poisonous snake. Unique animals include the Red Panda and the Myanmar Snub-nosed Monkey, a species only discovered in 2010. Found in Kachin State in north-eastern Myanmar, the monkey is already under serious threat from increased logging and development. It is thought the population is only around 300 individuals.

Teak forests thrive in the mountainous northern reaches of Myanmar and the country holds 75% of the world's reserves. Wild orchids can also be found in great profusion and there are 841 recorded species. However, populations are said to be dramatically declining as a result of logging and an illegal trade with collectors.

In the far northern Kachin State, at the foot of the Himalayas, mountain peaks rise to almost 6,000 m (20,000 ft) and primary forest still stands. It is from here that the lifeblood of Myanmar, the mighty Ayeyarwaddy, winds its way south for 2,000 km (1,242 miles), fertilizing the country's rice bowl as it does so, eventually spilling out into the delta. Other major rivers include the Chindwin which starts its journey in the northern state of Sagaing flowing down to meet the Ayeyarwaddy between Mandalay and Bagan, and the Thanlwin (also known as the Salween) which makes its way through Shan, Kayah, Kayin and Mon states, for a time serving as a natural border with Thailand, before finally emptying into the Gulf of Mottama. To the west and south of the delta are white sand beaches and pristine tropical islands.

Above: A fleet of small fishing boats in a tributary of Yangon River waiting for high tide.

Below: A farmer near Sittwe in western Myanmar cutting and bunching sheaves of rice during November's harvest.

Myanmar enjoys a monsoon climate with three seasons. The rains last from May to October, the cool season from November to February and the hot season from March to June. Torrential rains can make travel during the monsoon season difficult as many roads are not sealed. The highland regions usually enjoy a longer period of pleasantly cool weather while in the central plains the season of extremely hot, dry weather is extended. The delta and coastal regions are the most humid. The mean annual temperature is 27°C (81°F) with average daily temperatures in Yangon ranging from 18–32°C (64–90°F) in the cool season and from 30–38°C (86–100°F) in April during the hot season.

Below: For years the coastline of Ngapali Beach has remained an idyllic getaway but it seems destined to become a major tourist hotspot lined with resorts.

Right: Two girls, their faces covered in tanaka powder, trawl the marshland around Inle Lake for freshwater shrimps and small fish.

A BRIEF HISTORY OF MYANMAR

Myanmar's fascinating and often turbulent history charts the glorious golden period of Bagan, raging battles with neighbouring Thailand, Anglo-Burmese wars and years of British colonialism, a struggle for independence, and a period of self-imposed isolationism followed by optimism for a brighter future.

Below: The 12th-century Dhamma Yin Zi Ka Pagoda in Bagan has pentagonal terraces instead of the usual Bagan-style square base.

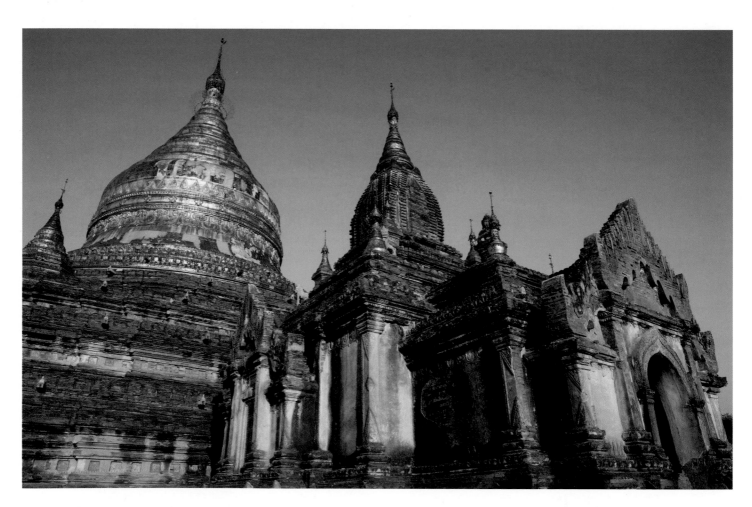

Early History

Archaeological evidence of human habitation in Myanmar dates back to 2,500 B.C. The first recorded settlers were the Pyu who migrated into northern Myanmar in the second century B.C. and established several city states. By the eighth century the Pyu capital of Halingyi was destroyed by marauding forces from the Nanzhao kingdom in southern China. In around the sixth century, the Mon who are believed to have migrated from east India, established a kingdom known as Suvarnabhumi or the Golden Land around Bago. They are also credited with bringing religion and their distinctive arts to Myanmar, however, many written works were destroyed during violent conflicts with the Bamar.

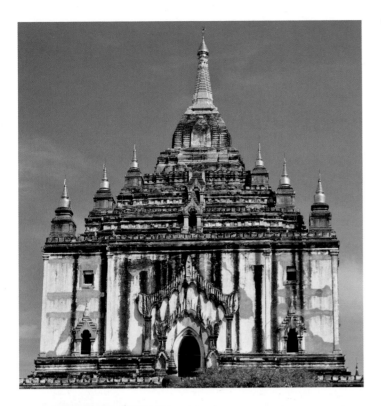

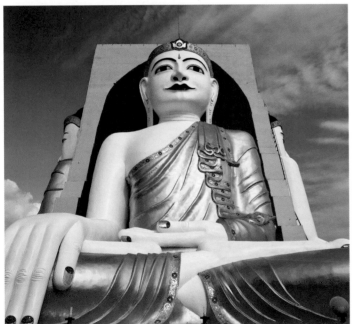

The First Empires

Some 1,500 years ago, the Bamar, who originated in what is now Yunnan in China, migrated down the Ayeryarwaddy river valley and into Upper Myanmar, eventually replacing the ethnic Mon as the dominant presence in the area. In the ninth century, the Bamar established settlements just north of Mandalay before founding Bagan. The Bagan period is known as the Golden Age of Myanmar history. Following the conversion of King Anawrahta to Buddhism, his army engaged in a sortee against the Mon king, Manuha, taking Buddhist scriptures and relics, and capturing monks. Securing victory over the Mon in 1057, the Bamar entered a period of religious fervour during which many of Bagan's greatest temples were built and it became the capital of the country's first empire. Architectural gems of the period include the Shwezigon Paya and the Shwesandaw Paya.

By the mid 13th century Bagan was already in serious decline and when it eventually fell to invading Mongol troops in 1289, the country was divided into rival states, including Ava (also known as Inwa) which remained the capital until it was sacked by the Shan in 1527.

Top: *Towering above the other monuments of Bagan, the magnificent white Thatbyinnyu Temple was built for King Alaungsithu who reigned from 1113 to 1163.*

Above: *One of the four enormous Buddha images at Kyaik Pun Paya in Bago.*

Right: *Buddha images and wall paintings inside Nagayon Paya, Bagan.*

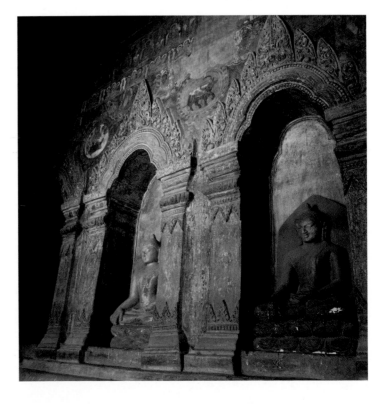

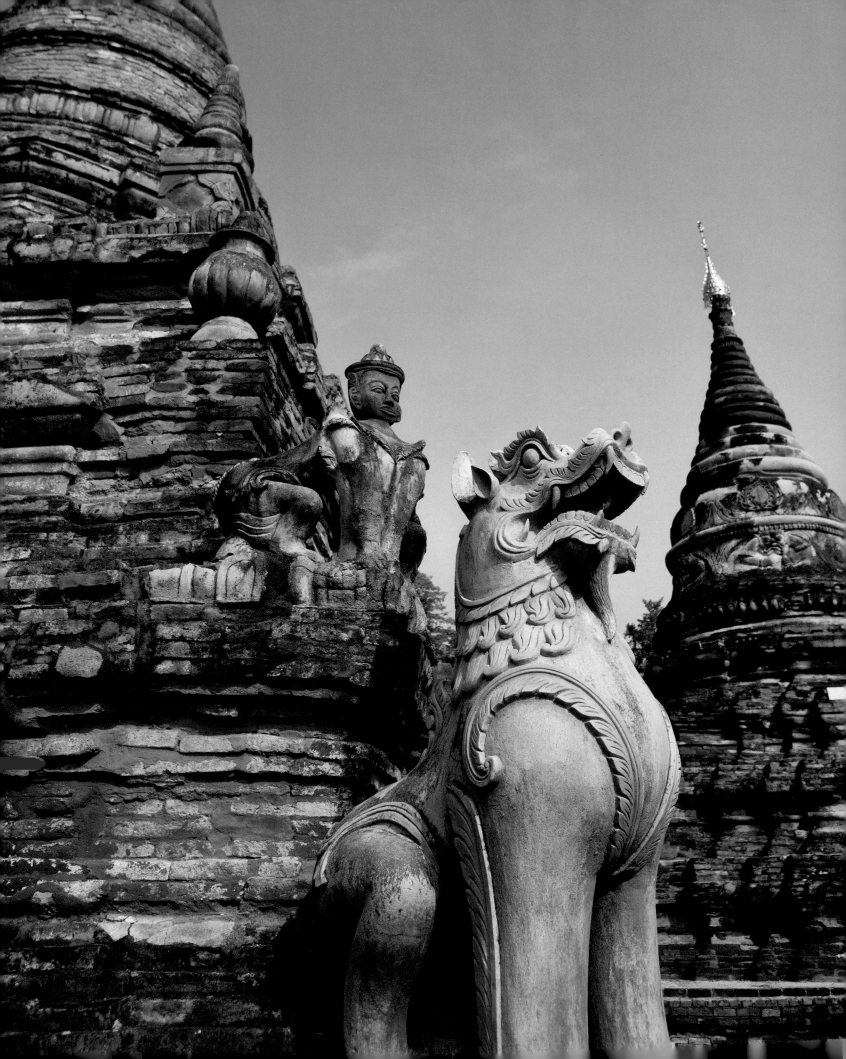

In 1550, King Bayinnaung unified disparate kingdoms and led a successful attack on Siam, present-day Thailand. However, following the king's death, Myanmar's second kingdom quickly declined. By this time the Mon had established a presence in Ava, only to be displaced by King Alaungpaya in 1752. After a short eight year reign, the king died at just 46 years of age and was succeeded by his son, Hsinbyushin.

Between 1759 and 1824, Myanmar's Konbaung Dynasty grew in strength and confidence. Establishing a new capital in Yangon, it sought to spread its influence in Arakan (present-day Rakhine State) and Assam in India but by doing so drew the wrath of the British Empire.

The British in Myanmar

Determined to expand their territory and secure a bounty of natural resources, the British instigated the Anglo-Burmese war of 1852, taking control of the south. After further conflict in 1885, they wrestled Mandalay from the last royal, King Thibaw and brought the entire country under the control of the Empire.

Britain is said to have found Myanmar the hardest country within the Empire to control. The problem lay with the majority Bamar rather than the other indigenous groups who were granted relative autonomy over their states by the British (a factor which has been attributed to recent conflicts and struggles for independence by the Karen and Shan). While the British helped themselves to teak, oil, gems, rice and other resources, resistance from the Bamar grew.

In 1938, as protests escalated, British police killed a university student during a demonstration and in another incident, British soldiers fired into a monk-led protest in Mandalay, killing 17 people. A number of monks also died in prison. As strife within the country continued, the British Empire separated Myanmar's administration from India but more trouble followed including violence by the Bamar against Indian and Chinese settlers brought in by the British.

One student involved in protests was Bogyoke Aung San, Aung San Suu Kyi's father. As part of a group known as the '30 Comrades', he sought support for the independence movement, eventually receiving training from the Japanese for his Burmese National Army. Aung San aligned himself with invading Japanese forces during the Second World War as they tried to push the British out of Myanmar. However, after witnessing the brutality of the Japanese, he realized that he had jumped out of the frying pan and into the fire and switched allegiance to the Allied forces. The Chindit Campaign against the Japanese followed at a cost of 27,000 Allied soldiers' lives.

Opposite: A short distance from Mandalay the crumbling zedis at Inwa are a reminder of the ancient capital's former glories.

Above: Many of Yangon's splendid colonial-era buildings are in need of restoration.

Continuing Strife

In 1947, Aung San signed papers in London to guarantee self-rule. At elections his Anti-Fascist People's Party secured a convincing victory against the Bamar opposition led by U Saw, who took just three seats. Shortly after, Aung San and six of his cabinet were gunned down and in 1948 U Saw was convicted and hanged for the murders by the British.

From 1948 to 1962, there was widespread conflict and internal struggle in Myanmar, and in 1958 Prime Minister U Nu accepted 18 months of military rule to restore order. In 1962 General Ne Win led a military coup, abolished the constitution and established socialist economic policies that were to have disastrous consequences on the economy. Ne Win went on to create the Burma Socialist Program Party (BSPP), the only political party allowed in the country.

In 1974, at the funeral of former UN Secretary General U Thant in Yangon, student demonstrations broke out and, in an act that echoed the British crackdown of 1938, ended in government troops storming a university campus, killing several students and declaring martial law.

During mass demonstrations on August 8, 1988, military forces turned on demonstrators. Following the violence, Aung San Suu Kyi made her first political speech and became leader of the opposition. That year, a group of generals deposed Ne Win and established the State Law and Order Restoration Council (SLORC). More demonstrations and violence followed.

At elections in 1990, Aung San Suu Kyi's National League for Democracy party secured 392 of the 485 seats in parliament but SLORC refused to accept the results. In the years that followed, Aung San Suu Kyi was put under almost permanent house arrest and many of her party and other political activists imprisoned.

In 2002, the government commissioned the construction of a new capital city, called Naypyidaw, or the Abode of Kings, 460 km (300 miles) north of the former capital, Yangon. All government ministries and military officers were relocated there in 2005, a city of imposing buildings and eight-lane highways.

Left: Inscriptions on the base of the Victory Monument in Mahabandula Garden, formerly known as Fytche Square, with the grand old Yangon courthouse in the background.

Opposite top: A poster seller displays images of Aung San Suu Kyi and her father in the streets of Yangon.

Opposite bottom: Colourful key rings are also now on sale.

A Time for Optimism

In April 2010, cabinet ministers resigned their military commissions in order to prepare for elections that resulted in Prime Minister Thein Sein being appointed as leader of the Union Solidarity and Development Party. On November 7, 2010, Myanmar held its first elections in 20 years, although Aung San Suu Kyi and her party were not allowed to stand.

In December 2011, US Secretary of State Hillary Clinton made a landmark visit to the country and held meetings with Aung San Suu Kyi and President Thein Sein, resulting in improved relations with the wider world. On 1st April 2012, Aung San Suu Kyi was allowed to take part in parliamentary by-elections. She enjoyed a sweeping victory for her party, The National League for Democracy, and paved the way for further democratic reforms.

YANGON AND ITS ENVIRONS

The former capital of Yangon is located in Lower Myanmar at the convergence of the Bago and Yangon rivers and 30 km (18 miles) from the Gulf of Mottama. Once heralded as the jewel in Southeast Asia's crown, today Yangon is an uncut diamond patiently waiting for the hand of a skilled craftsman to bring back its sparkle. But it is the city's neglected colonial-era architecture, temples and trishaws, and bustling markets that create its unique character and make it so appealing.

Above: The Karaweik on the eastern shore of Kandawgyi Lake is, a reproduction of a royal barge in the shape of a legendary bird.

Left: In the early morning and late afternoon, impromptu markets set up along the streets of central Yangon.

Opposite page: In the 19th century Captain Alexander Fraser of the Bengal Engineers created the Victorian style layout of the city streets and declared the Sule Paya the centre of Yangon.

Shwedagon Paya

It is impossible not to be moved by the beauty of the Shwedagon Paya. Located on Singuttara Hill and rising 99 m (325 ft) from its base to pierce the sky, the golden zedi dominates Yangon and can be seen from over 80 km (50 miles) away.

The term paya means 'holy one' or 'holy place' in Myanmar language. Within the expansive temple grounds, the ambience changes throughout the day and it is well worth visiting the paya on more than one occasion. Open from 4 a.m. until around 10 p.m., the temple can be accessed by a stairway at one of four entrances, each lined with shops selling religious imagery and souvenirs. For those who cannot manage the climb there is also a lift at one of the entrances.

This page: The west gate of the Shwedagon Paya is guarded by two huge mythical lion-like creatures known as 'chinthe', as are the other three gates. Upon entering, visitors are faced with a long stairway leading up to the temple.

This page: Two visits to the Shwedagon Paya are essential. At the crack of dawn, visitors will see many Buddhist monks and nuns in moments of reflection, prayer and meditation; by night, when the sky darkens and the spotlights come on, the magnificent zedi can be experienced in all its glittering golden glory.

This page: In the heart of central Yangon, the Sule Paya is one of the city's most recognizable landmarks. The central 46-m (151-ft) octagonal zedi and the small shops that encircle it act as a traffic roundabout in the centre of a busy intersection.

Left: A trio of Buddha images at Sule Paya have been adorned with silken robes by worshippers during one of Myanmar's many religious festivals.

Below: Located in a Yangon suburb, the 70-m (230-ft) reclining Buddha at Chauk Htat Gyi Temple is an impressive sight. Built in 1966, the soles of the feet are embellished with 108 auspicious Buddhist symbols.

Yangon Markets

For atmosphere and photographic opportunities, visit the expansive Hledan Market at the intersection of Insein and University roads, or Theingyi Zei on Shwedagon Paya Road. Both markets offer an insight into life in Yangon and also sell just about everything imaginable. It's also worth exploring side streets around Theingyi Zei in the late afternoon, as there are many fresh produce vendors in the area. Thiri Mingalar Zei on the outskirts of the city is another excellent morning market. Tourist trinkets and textiles can be found at Bogyoke Market, also known as Scott Market.

This page: A stroll through a Yangon market is an experience to savour. The bounty of fresh ingredients are laid out like paints on an artist's palette, and the air filled with the sound of friendly banter and the persistent sales pitch of vendors.

Colonial-era Architecture

Yangon has some of the finest examples of British colonial-era buildings in Asia. Most have fallen into a state of disrepair, nevertheless they do add to the city's special charm and hopefully will soon benefit from restoration.

Top right: Yangon's colonial-era ambience is very much alive at its most celebrated hotel, The Strand. This grand old dame dates from 1901 and has welcomed distinguished guests including Somerset Maugham, George Orwell, Sir Noel Coward and Rudyard Kipling, to name but a few. After a period of decline, the stately hotel was saved and has now been restored to its former glory with cool marble bathrooms, teakwood floors, lazy ceiling fans and traditional Burmese lacquerware. Today's travellers still enjoy the pleasures for which it was once renowned: a welcoming and knowledgeable General Manager, personalized service, tempting afternoon teas and the distinct feeling that you are part of its rich history.

Below right: A fine example of colonial-era architecture at the corner of Strand Road. It awaits careful restoration to bring back its splendour like the stately Strand Hotel

Around Yangon

Although Yangon has much for travellers to discover, it also makes an excellent base from which to visit nearby sights and attractions. Highlights within easy reach of the city include the deeply moving British War Cemetery, the town of Bago and Myanmar's most sacred religious site, the Golden Rock.

This page: Formerly known as Pegu by the British, the town of Bago is 80 km (50 miles) from Yangon and a convenient rest stop on the way to the Golden Rock. Attractions for visitors include Shwemawdaw Paya (right), the Four Figure Paya, a 76 m (250 ft) reclining Buddha at Naung Daw Gyi Mya Tha Lyaung (below), the Snake Monastery, home to an enormous python, and cheroot factories.

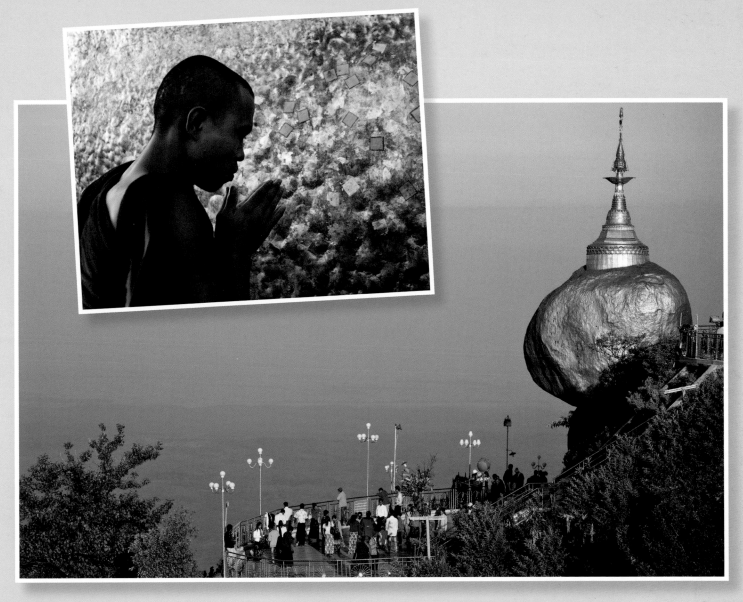

This page: *The magnificent Golden Rock, also known as Mount Kyaikhtiyo, is one of Myanmar's most sacred Buddhist sites. Roughly three hours' drive east of Yangon, it is a place of pilgrimage for Buddhists from all over Asia who come to pray and rub gold leaf on the precariously perched rock. As with many sites of pilgrimage, getting there requires effort. A nail-biting truck ride takes you halfway up the mountain, then the rest of the steep climb is done on foot. If you want to experience both sunset and sunrise here, make sure you stay at the hotels at the top – just a 10-minute walk from the actual site.*

CENTRAL MYANMAR

Myanmar's heartland is home to its biggest attraction – Bagan. Here, travellers can explore the many ancient ruins by horse and cart or view the expansive site from above in a hot air balloon. Cruise ships also arrive at Bagan having sailed down river from Mandalay.

Bagan

Lying 140 km (90 miles) south-west of Mandalay on the banks of the Ayeyarwaddy, ancient Bagan is one of the highlights of a visit to Myanmar. Bagan was the capital of the first empire and, at its peak from A.D. 1057 to the mid-1200s, was home to over 4,000 Buddhist temples. Although many ruins collapsed during a powerful earthquake in 1975, 2,217 important sites remain. The main temple sites and ruins are scattered across a 40-km² (16-sq. mile) plain.

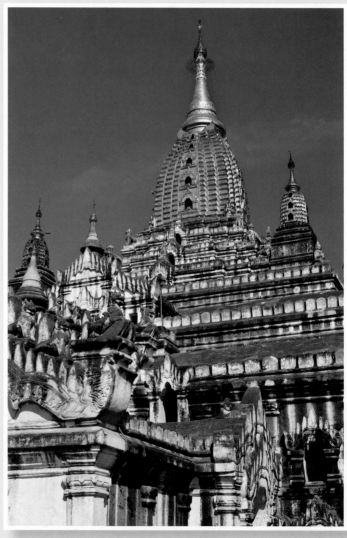

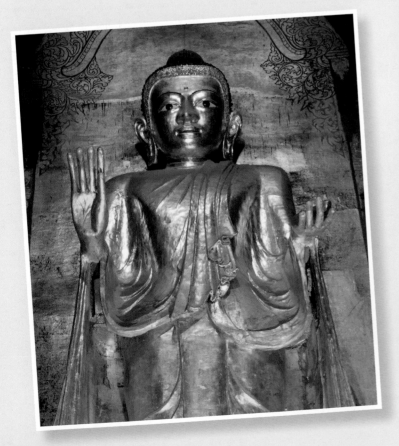

This page: Built around 1105 for King Kyanzittha, the Ananda Paya is one of the masterpieces of Bagan. Within the temple four 9.5 m (31 ft) images represent the Buddha after he attained nirvana. The north and south facing images have the 'dhammachakka mudra' hand position symbolizing Buddha's first sermon.

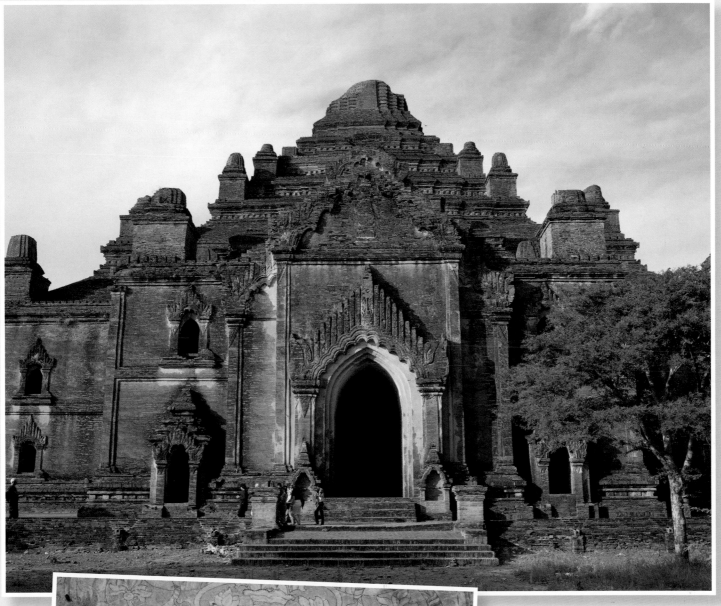

This page: *Dhammayangyi Temple, the largest structure in Bagan, was built for the ruthless King Narathu who reigned from 1167-70 and is said to have murdered his own father so that he could ascend the throne. The temple passages feature golden Buddha images and walls adorned with the remains of beautiful frescoes.*

Right: A horse and carriage passing through Tharabar Gate in the old town. Many visitors to Bagan choose this leisurely form of transport to explore the monuments.

Below and below right: Frescoes on the stuccoed interior of the Sulimani Guphaya, one of the top attractions among the hundreds of temples and pagodas at Bagan. The temple's apt name means 'crowning jewel'.

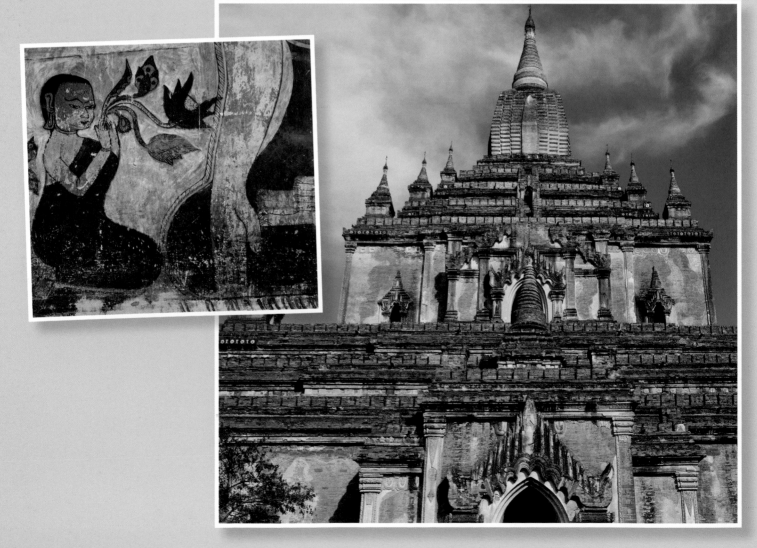

Right: Towering above the other monuments of Bagan, the magnificent white Thatbyinnyu temple was built for King Alaungsithu (1113–1163). From the terraces visitors enjoy a panoramic view of Bagan and the distant hills.

Above: Bupaya, an unusual golden gourd-shaped zedi on the eastern bank of the Ayeyarwaddy was built in 1975 to replace the original after it fell in the river following a powerful earthquake.

Right: Several temples at Bagan can be climbed to gain a view of the surrounding area. At sunrise and sunset, Shwesandaw Paya and Pyathada Paya draw the crowds.

This page: One of the best and most inspiring ways to see Bagan is from the air. 'Balloons Over Bagan' offer hour-long sunrise and sunset flights in hot air balloons that float over the thousand-year-old ruins and temple spires. The once-in-a-lifetime experience is the perfect way to appreciate the sheer scale and majesty of one of the world's most important religious sites. Following a magical flight, the landing is softened by a celebratory glass of Champagne.

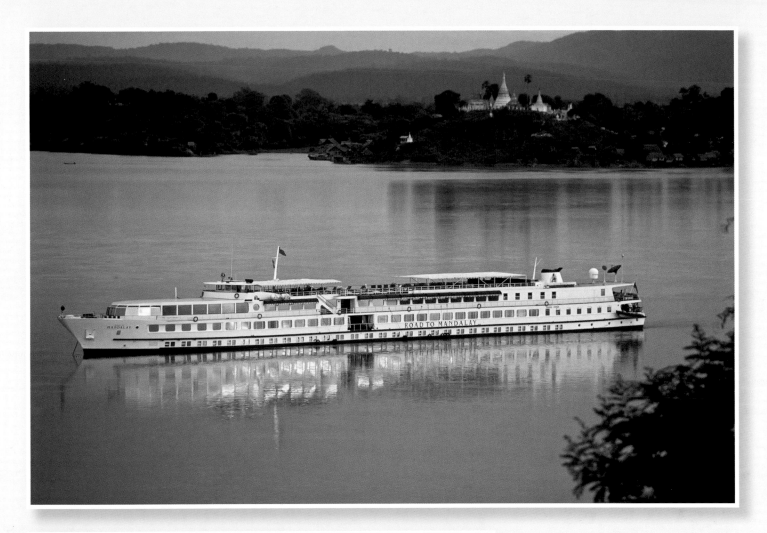

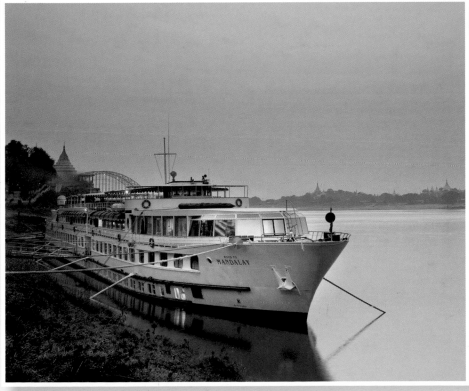

This page: For many visitors to Myanmar, cruising down the Ayeyarwaddy provides the perfect combination of luxury and adventure. The 'Road to Mandalay' run by Orient Express Hotels is a palatial cruise ship that plies the mighty river from as far north as Bhamo, down to Mandalay and on to Bagan. Passengers pass through some of the country's most beautiful scenery, stopping en route to explore towns and important cultural sites, such as Sagaing, Pyin U Lwin hill station and the temples of Bagan. Evenings are spent on board enjoying vivid sunsets from the deck, fine dining, insightful lectures on local culture and a variety of entertainments.

EASTERN MYANMAR

In the east, the many historic wonders and beautiful temples of Mandalay and the surrounding area make it an essential part of any travel itinerary. At Inle Lake it is hotels on stilts above the water, boat trips through floating gardens and bustling hill tribe markets that are the main sights to be seen.

Inle Lake

Inle Lake is one of Myanmar's most popular tourist attractions. Located 35 km (21 miles) from the town of Heho in the Shan State, the shallow lake covers over 110 km² (40 sq. miles) and is surrounded by villages inhabited by Intha, Shan and other ethnic groups and hill tribes including Pa O and Padaung. Most visitors stay on stilted resorts over the water and around the edge of the lake, and make excursions by boat to colourful morning markets in nearby villages.

Above: At Inle Lake, life is waterborne. In this unique destination there are waterside temples, floating markets, floating gardens growing vegetables, and stilted villages and hotels above the water.

Left: In the early morning, young monks paddle boats from house to house collecting alms from devout Buddhists.

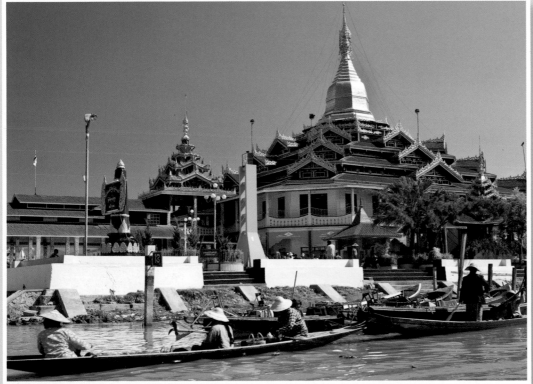

Above: *A trio of fishermen using distinctive traditional fishing baskets. The large conical baskets are pushed to the bottom of the shallow lake and the fish caught within are speared.*

Left: *Phaung Daw U Paya is the most sacred temple in the Shan State. In September or October, the Buddha images are paraded around the lake in a boat.*

Mandalay

Situated on the banks of the Ayeyarwaddy, Mandalay is Myanmar's second largest city. In recent years it has boomed, attracting thousands of Chinese immigrants, a frenzy of construction and a rapid increase in traffic. As a result it has lost much of its former charm but among the chaos are many attractions and it makes an excellent base from which to explore Sagaing, U Bein's teak bridge and the former hill station of Pyin U Lwin.

Above: In recent years, Mandalay has boomed and the once traffic-free streets now buzz with motorcycles and cars.

Right: Two huge white 'chinthe', a mythical lion-like creature, stand guard at the southwest entrance to Mandalay Hill.

Opposite page: Rows of white zedis at Kuthodaw Paya. From the top of Mandalay Hill, visitors can take in a panoramic view of the city.

Above: *A fisherman rows across Taungthaman Lake near U Bein's Bridge towards the Spiral Temple.*

Right and opposite page: *15 km (9 miles) from Mandalay at Amarapura is the 12- km (3/4 mile) U Bein's Bridge, the world's longest teak bridge. The bridge connects two small communities and spans a vast area which during the dry season is used for farming peanuts, sesame and other cash-crops. When the rains come, it floods and provides a daily catch for local fisherman. Farmers can also be seen rounding up their ducks in the late evening. In years of excessive rain it is not unknown for the bridge to be completely submerged. The middle section includes concrete posts, replacements for teak pillars that were washed away a few years ago.*

This page: Shwenandaw Kyaung is an exquisitely carved teak temple and one of Mandalay's most important historic temples. Built in the 19th century for King Mindon, it is the only surviving section of the former royal palace complex.

This page: A short distance from Mandalay, Sagaing Hill is scattered with temples and golden zedis. At Umin Thounzeh temple, 45 Buddha statues sit within a crescent-shaped chamber. The nearby town of Sagaing is situated on the western bank of the Ayeyarwaddy River and in AD1315 was the capital of an independent Shan Kingdom.

NORTH-WESTERN MYANMAR

A truly fascinating part of the country, the northwest region offers attractions for cultural travellers and beach lovers alike. Highlights include an adventurous river trip from Sittwe to the Mrauk U to explore historic temples and lazy days on Ngapali Beach for the perfect end to a memorable trip.

Ngapali Beach

Fringed by gently swaying coconut palms, Ngapali Beach is an idyllic three-kilometre (two-mile) stretch of white sand lapped by the clear waters of the Bay of Bengal. Just 45 minutes flying time from Yangon, the area is quickly attracting developers keen to exploit its natural beauty. Visitors can enjoy lazy days on the beach, snorkelling trips, watching fishermen land their catch at daybreak, and sampling delicious seafood in the restaurants that line the beach road.

Right: For years, Ngapali Beach has been Southeast Asia's best kept secret; an idyllic stretch of white sand enjoyed by Yangon's middle class and a handful of expats. Even now it still retains the charm and tranquillity that neighbouring Thailand's beach resorts lost 20 years ago. Boat trips can also be taken further up the coast where the beaches are totally deserted.

Sittwe

Sitting at the mouth of the Kaladan River, Sittwe is an important port in Rakhine State. Its close proximity to Bangladesh and a bustling fish market give the town a unique ambience. The British forces landed at Sittwe in 1825 and the small fishing village quickly became an important trading centre. Today, it is the starting point for boat trips to Mrauk U.

This page: In the early mornings and late afternoons, Sittwe's market comes alive with trishaw drivers angling for business, and fisherman trying to sell their meagre catch.

Opposite page: A pleasant evening can be spent on the jetty of this busy little fishing town watching the boats come and go.

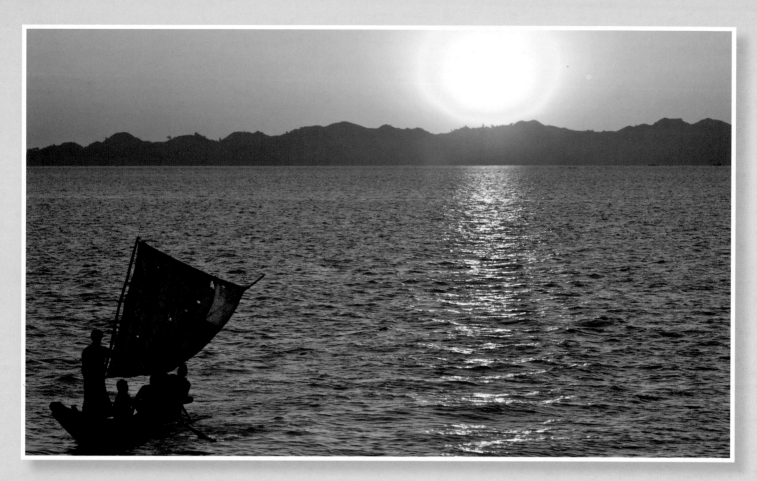

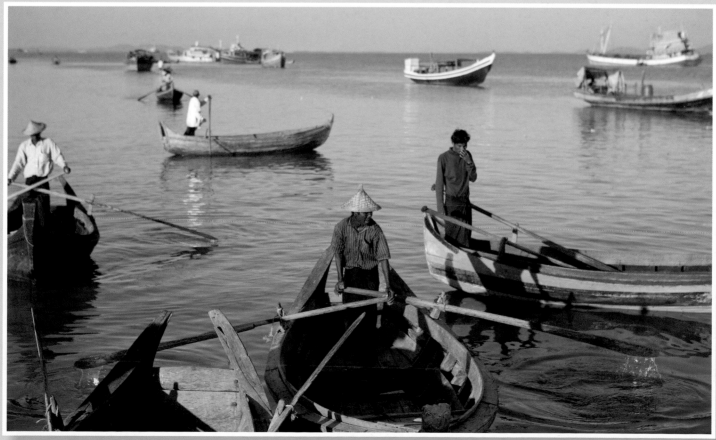

Mrauk U

The former capital of Rakhine State in western Myanmar, Mrauk U – pronounced Mror Oo – is an atmospheric town reached by a six-hour boat journey from Sittwe. The town and surrounding countryside are scattered with temple ruins, many of which are still used by local people and monks. Travel another couple of hours up the Lemro River and you'll enter the lower reaches of the Chin State. Most of this mountainous area is currently off limits to travellers but a handful of ethnic villages can now be visited with a guide. The main attractions for tourists, in addition to the outstanding natural beauty, are the few remaining Chin women who sport impressive facial tattoos.

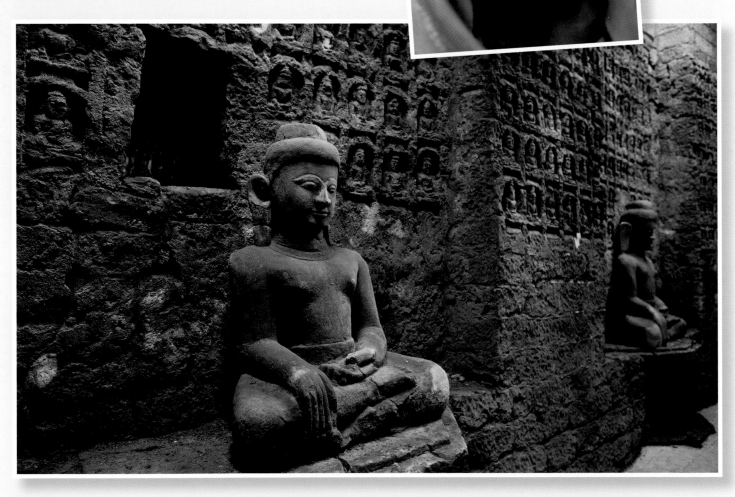

Above: *Buddhas in a passageway of Kothaung Paya, the 'shrine of 90,000 images'. The temple which dates from 1553 is the largest in Mrauk U.*

Top: *The tradition of facial tattooing among the tribes of the Chin State was carried out on girls between the ages of seven and 15, a painful process to endure that is no longer practised.*

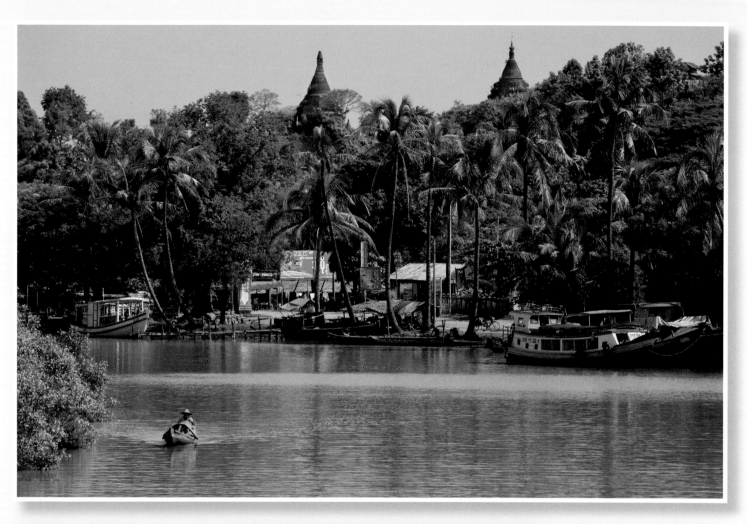

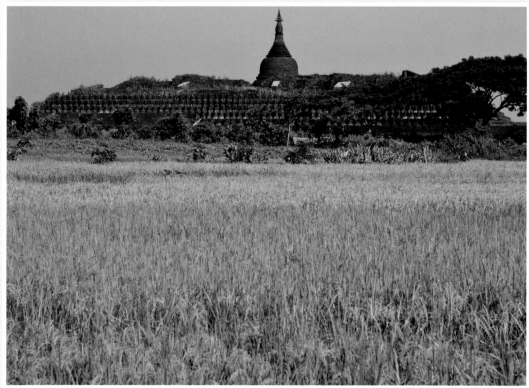

This page: The approach to Mrauk U is made by boat. Two ancient zedis atop a hill are the first sign that this is no ordinary town. Many days can be spent here exploring hundreds of ruins in the area. One of the most impressive sites is Kothaung Paya, seen here across the rice fields. In addition to the images that line the passageways, the outer terrace has 108 small zedis.

Right: In the 16th and 17th centuries Mrauk U was a wealthy city within Arakan, a powerful independent state encompassing the fertile valleys of Kaladan and Lemro. Its proximity to the Bay of Bengal and India made it an important trading centre. However, in 1784, Arakan was attacked by King Bodawpaya and became part of Myanmar's Rakhine State. Mrauk U is also renowned as the site of the first Anglo-Burmese War in 1825 but after victory, the British moved their troops to Sittwe. Today, Mrauk U's former glories can be seen from a hill near Ratanabon Paya, the most popular spot to enjoy the sunset. Ringed by smaller zedis, Ratanabon's bulk dominates the view. The temple was built in 1612 by Min Khamoung and became known as the 'pile of jewels' because it was rumoured to have a hoard of gold hidden within.

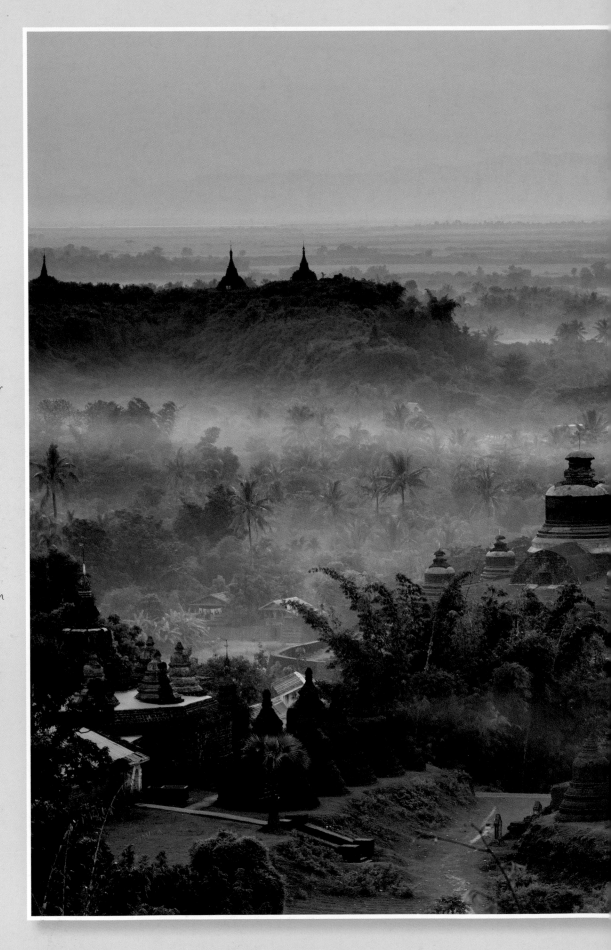

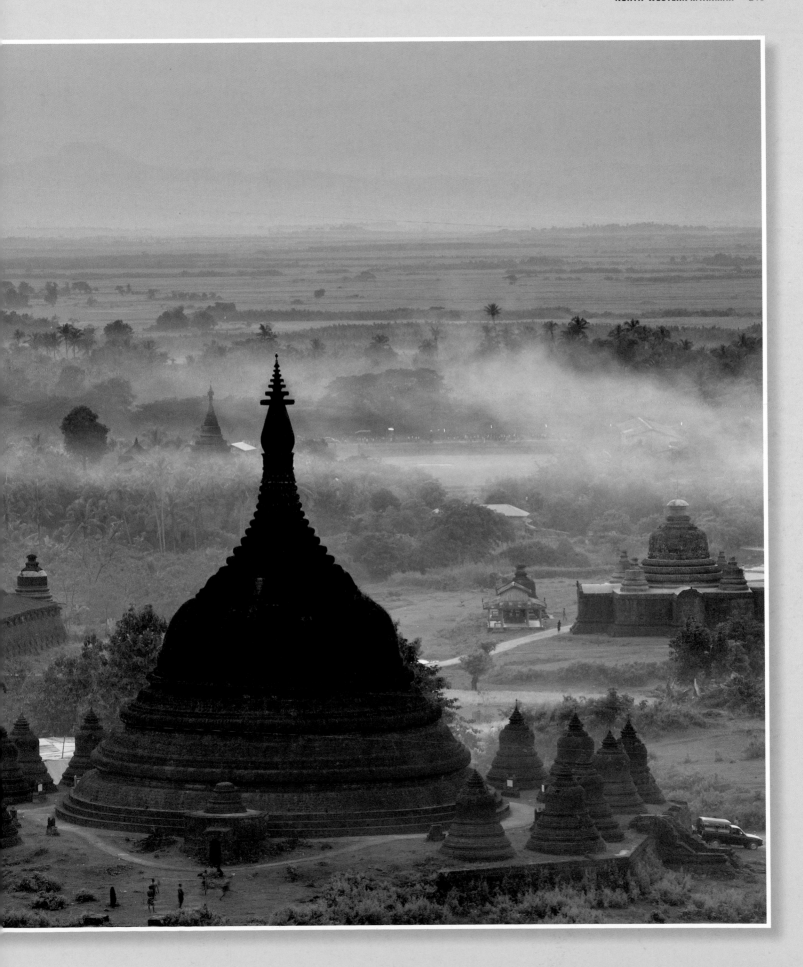

INDEX